D120961

PIERO DELLA FRANCESCA
Roberto Longhi

R. Longhi

PIERO DELLA FRANCESCA

Roberto Longhi

Translation and Preface
by David Tabbat

With an Introduction
by Keith Christiansen

STANLEY MOSS – SHEEP MEADOW BOOK
RIVERDALE-ON-HUDSON, NEW YORK

Introduction: *Roberto Longhi's Piero della Francesca*
Copyright © 2002 Keith Christiansen

Translator's Preface: *Piero, Longhi and the Fields of Color*
Copyright © 2002 David Tabbat

Piero della Francesca Translation
Copyright © 2002 David Tabbat

Editorial Notes by David Tabbat
Copyright © 2002 David Tabbat

Published by Stanley Moss-Sheep Meadow Press.
Originally published in Italian by Sansoni, Firenze.

All rights reserved. No part of this publication may be reproduced or transmitted in any
form or by any means, electronic or mechanical, including photocopy, recording, or any
information storage and retrieval system, without permission in writing from the publisher.

All inquiries and permission requests should be addressed to:
The Sheep Meadow Press
Post Office Box 1345
Riverdale-on-Hudson, New York 10471.

Designed and typeset by S.M.
Distributed by The University Press of New England

Printed on acid-free paper in the United States by McNaughton & Gunn. Typeset in
AGaramond. This book meets the guidelines for permanence and durability of the
Committee on Production Guidelines for Book Longevity of the Council on Library
Resources.

Library of Congress Cataloging-in-Publication Data

Longhi, Roberto, 1890-1970.
 [Piero della Francesca. English]
 Piero della Francesca / Roberto Longhi; introduction by Keith Christiansen;
 translation, preface, and notes / by David Tabbat.
 p. cm.
 New translation of the third, 1963 ed. of Longhi's work, originally published in 1927.
 ISBN 1-878818-77-5 (alk. paper)
 1. Piero, della Francesca, 1416?-1492--Criticism and interpretation. I. Title.

ND623.F78 L613 2000
759.5--dc21

 00-026564

ACKNOWLEDGMENTS

We gratefully acknowledge a contribution from the Eugene V. & Clare E. Thaw Charitable Trust toward the publication of this book.

We are grateful for a contribution from Furthermore grants in publishing, a program of the J.M. Kaplan Fund.

Color illustrations are courtesy of Scala, Florence.

Black and white illustrations are reproduced from Art Resource, New York.

CONTENTS

INTRODUCTION

Roberto Longhi's Piero della Francesca

It is difficult to overestimate the impact of Roberto Longhi's *Piero della Francesca*, which appeared in 1927. Simply stated, it formed the twentieth-century response to the artist and laid out much of the terrain for subsequent scholarship. If, today, Piero seems to us the central figure of fifteenth-century painting, it is in large part because Longhi placed him there. The book is one of those rare things: a brilliant piece of art historical scholarship that is also a masterpiece of criticism and a tour de force of writing. The first two qualities were apparent even to those who knew the book only second-hand, through its French and English editions (the English translation was by Leonard Penlock and appeared in 1931). But only now, with David Tabbat's splendid new translation, is it possible for those lacking the skills or patience to tackle Longhi's elaborate sentences, with their idiosyncratic syntax and inventive vocabulary, to get a feeling for the qualities that have earned him a place in anthologies of Italian literature. Anyone who doubts the ingenuity required to pull off this task need only glance at the mind-bending opening sentence of Longhi's book, with its rich cadences and labyrinthine complexity. It would be impossible to render this dazzling, two-hundred word twister into English without breaking it into several sentences. However, in Penlock's case the result was leaden, and he sometimes lost his way in the maze of ideas and allusions. (A parenthetic aside evoking the young Giotto etching the image of sheep on a stone in the Mugello valley turned, inadvertently, into "a sheep scratched by Giotto.") David Tabbat's achievement in capturing the flavor of Longhi's style seems to me truly remarkable. And since with Longhi idea and language are inextricable, the gain is considerable.

This book will come as a revelation to English-speaking students who think of art history as an arcane discipline heavy with the musty air of the archive. Longhi was too great a historian not to pay careful attention to the factual basis of our knowledge of Piero, his patrons, and his art, but he believed writing history involved an act of criticism, and he wrote from a position of conviction. His object was to establish values, and he did not hesitate to overturn accepted pieties. To put Piero at the center of the stage of Renaissance painting required reassessing the prominence traditionally accorded to Florentine painting and the humanist praise heaped on Andrea Mantegna, and it meant taking a sweeping view of Western painting from

Giotto to Cézanne in which mannerist and baroque art appear as detours. Longhi accomplished all of this, but so subtly that we are won to his point of view without elaborate demonstration.

Although he was thirty-seven when it appeared, Longhi's book on Piero is very much the product of youthful literary ambition. Its style is self-consciously elaborate and the vocabulary filled with clever neologisms. Of all his writings it is the one most strongly marked with a period character. At times the succession of descriptive passages can seem too much of a good thing. Indeed, by the time the book was reprinted for its third edition in 1963, even Longhi found certain parts a bit overwrought and revised them—despite his declared convictions that books are the product of a specific moment and circumstances and should not be altered.[1]

The book can be divided into three sections. The first is a critical essay on Piero's art. We begin with his incomparable evocation of Piero's response to a work by the Sienese painter Sassetta that arrived in Borgo San Sepolcro in 1445. (As it turns out, we now know that Piero worked on an earlier, discarded version of the altarpiece.) We then proceed to the art Piero encountered in Florence in 1439, with some marvelous paragraphs devoted to Fra Angelico ("Gospel in Color, Explained to the Novice," is his pithy characterization of Angelico's paintings). There follows a long descriptive characterization of the celebrated cycle of frescoes of the story of the cross in the church of San Francesco, Arezzo—by any account Piero's greatest achievement. It is this section that captivated a generation of readers and that formed the basis for the twentieth-century view of Piero as a forerunner of modernism.

Piero della Francesca appeared in the influential series of monographs published by *Valori Plastici*—Longhi had been invited to write the book by Mario Broglio, who had founded the journal *Valori Plastici* in 1918. It was, by extension, linked to the ideals of metaphysical painting promoted by Giorgio de Chirico, Carlo Carrà, and Alberto Savinio. Piero's art was certainly a major point of reference for the work of these artists. However, Longhi later denied any connection between *Pittura metafisica* and *Piero della Francesca*. We may doubt this, for Longhi kept abreast of contemporary events (in 1914 he had written a book on the futurist sculpture of Boccioni). Nonetheless, it is true that his primary frame of reference was post-Impressionism. ("My modern culture, formed in the years around 1910, was based—I am obliged to repeat yet again—not on Cubism nor, even less, on *[pittura] metafisica*, which lay in the future, but on the post-Impressionist moment represented by Cézanne and Seurat . . ."[2]) Through his evocative language Longhi introduces readers to a world of light and color, geometry and form—*formacolore* was the formula he coined—that purposefully linked

Piero's world with that of Cézanne. In this he was of one mind with the great English apologist for post-Impressionism, Roger Fry.

Greek sculpture had provided a common point of reference ever since Piero's art was "rediscovered" in the 1840s, and it too reappears in Longhi's text, together with analogies with Old Kingdom Egyptian sculpture. His point was not to affirm any archaeological interest on the part of Piero. Indeed, he had censored Mantegna's "archaeological mysticism" in no uncertain terms. When he declared that Piero's "earliest and most precious rediscovery [was] the reinvention of a spontaneously archaic style," he was, once again, situating the fifteenth-century artist within the mainstream of modernism and its rejection of an over-emphasis on naturalism and literary content. Here again we may point to an analogy with Fry, who in a letter to the poet Robert Trevelyan dated 1913 described Piero as "the greatest artist of Italy after Giotto, incomparably beyond all the men of the High Renaissance. He's an almost pure artist with scarcely any dramatic content or indeed anything that can be taken out of its own form."[3] Where the two men differed— and differed profoundly—was in the way this critical evaluation resulted in a restructuring of historical interpretation.

This brings us to the second portion of Longhi's book, which has to do with Piero's place in the Renaissance. This is the section that has had the most profound effect on subsequent generations of scholars, and it is the one that should be required reading for every student of the Renaissance. In it Piero becomes a pivotal figure—perhaps *the* pivotal figure: seminal not only for the history of painting in the Marches, where Piero's influence is easy to establish, but in Ferrara, Rome, and, most signally, in Venice. (His possible role in shaping Provençal and French painting is also hinted at.) Longhi is the creator of what might be called the pan-Piero thesis, which sees his influence wherever in the Italian peninsula the geometry of perspective and poetry of light come together in a vision of calm beauty. It is a measure of the force of his observations that so much of what he conjectured has assumed the aura of fact. I, myself, do not subscribe to this view of Piero as the central figure of the Renaissance, and I certainly do not think he played a major role in the development of Venetian painting (Longhi's central thesis). That Antonello da Messina ever saw a work by Piero seems to me doubtful: surely what is at issue are parallel sources and interests. Similarly, although Giovanni Bellini made a trip south along the Adriatic and may well have studied Piero's fresco of of Sigismondo Malatesta in the Tempio Malatestiano, the only work in which Piero's influence can be pinpointed is in the great *Coronation af the Virgin* at Pesaro. For the rest, Mantegna, Antonello, and Pietro Lombardo were of far greater consequence. Yet the fact remains that Longhi's polemical position

commands attention precisely because it reorders the universe of the Renaissance in such an imaginative and radical way: reorders it according to his own hierarchy of values.

The third part of the book consisted of the critical apparatus on which Longhi constructed his image of the artist. It is the portion that would require considerable updating, as the literature on Piero has exploded in the last four decades. First was a summary of documentary and biographical notices relating to Piero. Then a brief catalogue—really a listing—of his works, both surviving and lost. Then came a survey of the literature on Piero—what Italians refer to as the *fortuna critica* of the artist. Particularly in the *fortuna critica* Longhi sparred brilliantly with his predecessors and salvaged a continuous history of the artist. It is a scholarly masterpiece that has never been surpassed.

Included here is Longhi's 1950 essay on Piero in Arezzo. If, historiographically, the 1927 *Piero della Francesca* is the more important publication—a book whose spell Kenneth Clark was unable to shake free of in his own monograph on the artist[4]—the 1950 essay provides a condensation of Longhi's thoughts on the artist. The language is more accessible, the ideas even more provocative. It has aged far less than the 1927 book, and many readers will find it the most satisfying of the two publications. In it the reader can experience the mature Longhi, who has left behind him the self-conscious, attention-grabbing language of his youth to write from a position of confident authority. In 1950 he had, in fact, been appointed to a position at the University of Florence and was widely recognized as the most eminent critic of Italian art of his time. He remains the key Italian critic of the twentieth century.

Keith Christiansen

Notes

1. On this see Giacomo Agosti, "Da Piero dei Franceschi a Piero della Francesca," *Piero della Francesca e il novecento*, M. M. Lamberti and M. Fagiolo dell' Arca, eds., Venice, 1991, pp. 203-4.

2. *Piero della Francesca*, 3rd ed. (1963), p. 168.

3. Denys Sutton, *The Letters of Roger Fry*, New York, 1972, p. 369.

4. Clark drew abundantly on Longhi's book, of which he wrote, "It is, if possible, too brilliant and the total impression it leaves upon the mind is strangely unconvincing. But it is full of learning, insight and ingenuity, and is not likely to be superseded." Kenneth Clark, *Piero della Francesca*, New York, 1951, p. 2, note 1.

TRANSLATOR'S PREFACE

Piero, Longhi, and the Fields of Color

Nowadays, the inclusion of Piero della Francesca in any list of the greatest Italian painters strikes us as natural, even inevitable. But it was not always so;[1] and the recovery of Piero as a major artistic personality was, in no small measure, the accomplishment of the celebrated Italian critic and connoisseur Roberto Longhi.[2]

First published in 1927, Longhi's *Piero della Francesca* marked both its author's first full-dress monograph—two more, on Ferrarese painting and on Caravaggio, were to follow[3]—and the first major book on the painter by a great art historian. This is not to say that Piero was precisely an unknown figure at the time. As early as the mid-sixteenth century, Giorgio Vasari had dedicated a highly laudatory biography to him in the *Lives of the Artists* (although the praise must, perhaps, be read through the lens of Vasari's local patriotism: after all, Piero's native Borgo San Sepolcro is not far from Vasari's own Arezzo). Over the centuries, we continue to find references to Piero; but he was generally regarded as an essentially regional master, one whose descendants were to be sought no farther afield than in such Central Italian artists as Signorelli or Perugino.

By Longhi's time there was, however, already a perceptible increase in the interest surrounding Piero's work. Not only had a certain amount of recent scholarship been devoted to the artist, but painters themselves were showing a new awareness of him; the broad, frieze-like, light-paletted works of such French painters as Puvis de Chavannes and Seurat, filled with figures caught in a sort of tranquil suspended animation, might have been quite different without the example of the Arezzo frescoes (of which, as Longhi tells us in a footnote, copies were installed at the Ecole des Beaux-Arts in Paris in 1880).

In another sense, Piero's perfect equilibrium between form and fictive depth on the one hand, and frankly two-dimensional surface decoration on the other, so carefully analyzed by Longhi in all his writings on the artist, presents many analogies with the work of such an influential artist as Cézanne; in the Frenchman's work, too, sky, trees, and buildings all seem, at times, equally tactile and equally close to the picture plane, even if they are often bathed in a light more pessimistic than Piero's own.

So Longhi's book was, in its sphere, the most useful sort of break-through: one relevant to the concerns of the moment, bringing together vast amounts of valuable information and offering highly stimulating and focused interpretations of the artist's works, style, and historical position.

What does it have to say to us today?

The first thing to be noted about the book, perhaps, is that it is most beautifully written. (The late connoisseur Sir John Pope-Hennessy, a man not always generous in his praise, once went so far as to term it "poetic."[4]) Metaphors abound, and are generally as apt as they are ingenious; the vocabulary is vast and delicately scented with mannerism; sentences are of nearly Proustian (and entirely D'Annunzian) length, variety, and rhythmic complexity; the tone of voice soars, drops, exhorts, mocks. Make no mistake about it: this is great writing, thrilling in its easy abundance and range of tropes. Does that make it less reliable as art-historical testimony than the grayer, less personal prose we are used to from today's academics? I do not think so. Longhi's aestheticizing, late-Romantic style may be at a double remove, temporal and national, from our own; but it is always harnessed to some specific purpose. The writer always knows precisely what he is trying to tell us, and succeeds in doing so with the utmost clarity while keeping us spellbound into the bargain.

The style of *Piero della Francesca* is less densely theoretical than that of Longhi's first important article, devoted to "Piero dei Franceschi and the Development of Venetian Painting." (It may, perhaps, serve as a sign of the young Longhi's linguistic dandyism that he chose the historically justifiable but less familiar version of the artist's name for this earlier effort.) Since the 1927 book translated here is a formal monograph, it contains passages devoted to historical and critical exposition, and others—the great set pieces, if you like—devoted to the meticulous description of individual works of art: Longhi's celebrated (and controversial) "verbal equivalents."[5]

The whole texture, in fact, functions like some marvelous eighteenth-century opera, divided into recitatives and arias. The recitatives move along at a good discursive clip, serving to convey information and get us from one place and key to another as elegantly, efficiently, and entertainingly as possible:

These works clearly reveal [Piero's] confrontation with the fact of Masaccio as an experience to be acknowledged and then, if possible, dodged. . . .

But when we come to the arias, the tempo slows, the strings set up a gentle

accompaniment figure, and the oboe begins to intone a long-phrased, richly embroidered melody, admirably catching something of that utter stillness so characteristic of Piero's paintings:

> Within the encircling, very Italian hills, bearing the signs of an agriculture so ancient as to have itself become something like a form of spontaneous animal life, in a month so free of warfare or partisan strife that the riverbed winding its way through the countryside is unstained by blood, broken lances, or shattered fragments of armor, wandering, instead, clean and dry and bearing only the dun impress of a few weeds, gleams the mortar of a distant city. At this windless hour, the reflecting water sends back a perfect image of the sky and the hills. Against this water, the figure of Christ stands out sharply

Such swift shifts from bright wit to deep lyricism—and the lyricism embedded in the wit, and the wit in even the most lyrical of passages—constitute one of the great pleasures of Longhi's prose. But they also serve a deeper purpose, helping the reader to look very carefully at every picture and keeping him alert to every bit of information.

But just how reliable has the information in Longhi's monograph, a rather elderly one by this time, remained? The formal analyses are still matchless: no other connoisseur gifted with such an eye has ever had a comparable talent for the expression of what he saw in a picture, and no other book, perhaps, can give you such a clear idea of how Piero's paintings actually work.

As for the chronology that Longhi tried to establish for Piero's works, based on what he called artworks' tendency to "dispose themselves in a historically developing series" when viewed in purely stylistic terms, several observations need to be made. The first, perhaps, is that in the world of Piero studies, there is almost no such thing as an uncontroversial dating anyway. The second is that Longhi's method, relying as it does almost entirely—at least in theory—upon the internal stylistic evidence and the sequence it suggests, cannot always offer much of a secure and natural toehold for coordination with external, more or less documentable dates. (The contemporary historian Carlo Ginzburg has drawn attention to the various difficulties arising from the distinction between internal and external dating systems;[6] while, in a recent monograph, Maurizio Calvesi has interestingly attempted to link the iconography of the Arezzo fresco cycle to mid-fifteenth-century military events along the Danube—and if he is right, then even many widely accepted aspects of the chronology will have to be reconsidered.[7]) All things considered, Longhi's

chronology, despite its more controversial aspects, has long been a shared point of departure for discussion of the issues involved.

Where issues of iconography are concerned, Longhi's book shows its age rather more seriously; but this is nothing more than the reflection of his fundamental lack of interest in such problems. Longhi was a connoisseur, interested in issues of stylistic development and attribution; but problems of subject matter held no particular charms for him. (One might also recall that the first edition of his book appeared before the rise of the school of icono-logical studies associated with the Warburg Institute and with such figures as Wind and Panofsky.) Carlo Ginzburg has rightly pointed out[8] that Longhi would never have accepted a traditional but obviously spurious attribution with the same lazy nonchalance he displayed in repeating the old, clearly improbable explanation of the mysterious Urbino *Flagellation*, linking it with the assassination of Oddantonio da Montefeltro. I myself would add that Longhi displays a similarly incredible offhandedness in taking for granted, as he does in the present monograph, that it was Piero himself who chose the scenes to be represented in the fresco cycle at Arezzo.

Certain of Longhi's ideas clearly reflect his late-Romantic turn of mind. It is, for example, a recurring theme in his work that great, particular-ly advanced artists are destined to encounter social opposition and over-whelming incomprehension; and so we read in *Piero della Francesca* that in Florence, given the local orientation towards *disegno* (linear draftsmanship) as the basis of art, Piero's influence not only failed to fall on particularly fertile ground—which is, generally speaking, true—but was actively and "quickly stamped out," as though by some sort of Thought Police. And given Longhi's concern for the integration of every artist's style into the meticulously woven web of stylistic interrelationships, we are startled to find him suddenly assert-ing that art every now and then returns for renewal to some mysterious, ever-flowing "subterranean spring." (Dyed-in-the-wool Jungians, however, might beg to differ with me on this last point.)

Still, we would probably be mistaken were we to believe that Pope-Hennessy's adjective "poetic" was meant, in some way, to carry a double edge of meaning, an implication of poetic imagination and verbal facility outrun-ning solid content—although it is quite true that Longhi is widely regarded, even by his detractors, as "a stylist of intoxicating powers."[9]

For the simple fact is that in *Piero della Francesca* Longhi did his homework very thoroughly indeed. Not until 1971, with the publication of Eugenio Battisti's massive monograph, was Longhi's book to be matched for

sheer comprehensiveness. For all its serene charm and gentle narrative flow, the biography of the artist included in Longhi's volume (and translated here) makes scrupulous use of all the documentary evidence available in Longhi's day—and we might add that precious little new material has come to light since then.[10] The author's notes on the individual paintings illustrated in the book (also translated here) constitute something like the first great *catalogue raisonné* of Piero's works, a catalogue updated in Longhi's subsequent editions of 1942 and 1962. (It is especially fascinating to follow the progressive reunification over the decades—if only, as it were, in the mind's eye—of the *disjecta membra* of the great, dispersed Augustinian polyptych originally painted for the artist's native town of Borgo San Sepolcro.) Longhi's original volume also featured a massively complete bibliography, likewise updated from one edition to the next, as well as a lengthy *Fortuna storica,* translated here, offering a commentary on the published literature on Piero from the Renaissance down to Longhi's day.

The heart of the book, however, remains the beautifully written and intellectually challenging essay entitled "The Art of Piero della Francesca"; and the very fact that Longhi has chosen to treat the painter's life and his works separately is a reflection of his theoretical approach to the art-historical discipline.

In 1914, right at the outset of his career, Longhi proclaimed a credo from which he was never, in the essentials, to deviate:

> To set forth the relationship between two works is also to set forth the concept of Art History, at least as I understand it; and that is, nothing else than the development of figurative styles. . . .[11]

As will be immediately apparent, this approach, in its relentless concentration upon objects in and of themselves, excludes as essentially extraneous to artistic content many areas that other art historians have fruitfully cultivated: economics and patronage, social and religious context, iconography. Longhi's viewpoint is quintessentially that of an aesthete and connoisseur. At the same time it comes, in its insistence upon each style's evolutionary dependence upon its predecessors, very close to the positivist and Darwinian ideas that had become current in the natural sciences.[12]

A few years later, expanding upon his theoretical premises, Longhi wrote of his

> . . . single historical studies, always carried out using that "pure" figurative method, that is to say, always by means of a precise stress upon all the formal elements which, observantly examined in the relationships between one work and another, inevitably dispose themselves in a historically developing series. . . . For this history of forms, criticism of the figurative arts has no real intellectual need of biographical or chronographical assistance. . . .[13]

Here, then, is the probable reason for which Longhi, in planning his monograph, chose to write a "Life" and a "Works," rather than a "Life and Works": the treatment of Piero's painting required space and freedom to follow its own logic, unencumbered by too many biographical constraints.

For Longhi, a work of art was, above all else, an object possessed of distinctive stylistic traits; and the art historian's most important task was to identify and define those characteristics, and then to trace their ancestry and their aftermath in subsequent art, thereby integrating them into a web of relationships between works and artists. The primary evidence to be used in this pursuit—whatever the available documentation—was none other than the art itself.

In the case of the art of Piero della Francesca, Longhi had begun formulating his answers to the issues of style, origins, and influence as early as the first major essay of his maturity, the 1914 "Piero dei Franceschi e lo sviluppo della pittura veneziana" ("Piero dei Franceschi and the Development of Venetian Painting").[14]

Of the three artists credited in Longhi's youthful essay with an especially direct impact on the young artist from Borgo—Paolo Uccello, Andrea del Castagno, and Domenico Veneziano—only the last-named was still included in Longhi's list by 1927 (and this may be one reason why Longhi did not choose to include his masterly early essay in his monograph on the artist). Instead, Longhi now proposed a much more elaborately articulated web of influences, Sienese and Florentine, recent and less recent. (A particularly striking insight, in my opinion, is the one concerning the likely impact on Piero of Maso di Banco's great frescoes of *Scenes from the Life of Saint Sylvester* in the

Florentine church of Santa Croce, handled with a coloristic breadth and an architectonic serenity of form anticipating Piero's, albeit couched in the four-teenth-century idiom derived from Giotto.)

But if Longhi changed his mind over the years on the issue of Piero's formation, he was never to waver from the view already set forth in his essay of 1914 with regard to Piero's style and influence.

Longhi believed that Piero's greatest stylistic achievement lay in his understanding of the way in which illusionistic three-dimensional form and a broad, calm coloristic treatment of the two-dimensional painted surface could be reconciled into a harmonious whole—a "slow, sure irrigation of the fields of color"—through a sensitive use of perspective, thereby eliminating the need for any disturbingly over-active "calligraphy" in the delineation of objects; the important thing was that, for any animate or inanimate object depicted, the section lying congruent with the picture plane be treated as a section of one of the regular geometric bodies, so as to achieve an ideal synthesis between the demands of perspectival illusionism and pure, serene surface decoration. Longhi further noted that Piero's somewhat abstract simplification of forms was obtained by rotating each object to the angle at which the section aligned with the picture plane most closely resembled one of the regular Euclidian shapes, and by keeping chiaroscuro modeling to a minimum. (The rotation in space of the regular bodies was a topic upon which Piero, a trained mathe-matician, actually wrote a treatise).[15]

The idea of the picture plane's intersecting the shapes represented upon it did not, of course, originate with Piero. It had been inherent in the Florentine Brunelleschi's groundbreaking experiments with a geometrically constructed system of illusionistic perspective, and was extensively discussed and illustrated by Leon Battista Alberti in his *De Pictura* of 1435. But Alberti conceived of the picture plane as, first and foremost, a "window" giving onto the fictive space on the far side of the frescoed wall or painted panel.[16] What was new in Piero's conception and use of perspective was, in Longhi's view, the equal (although not greater) importance that it accorded the picture plane as a flat surface bearing a frankly decorative coloristic scheme possessed of its own tensile strength—a tensile strength paradoxically reinforced by the char-acteristics of perspective itself.[17]

In his 1914 essay on Piero, Longhi offers this elegantly evocative for-mulation of perspective's potential for the simultaneous organization of fictive depth and real surface:

The perspective movement [in Quattrocento Florentine painting] has been condemned as naturalistic or, still worse, scientific. And yet, that's not the way matters stand. It can even be demonstrated that perspective was the most abstractly idealistic element to have appeared in art up to that time. . . .

Think of the spatial appearance of the simplest perspective representation, such as that of a street of uniform buildings, where the two lateral triangles of the structures, the uppermost triangle of the sky and the one at the bottom representing the road, make up a pyramidal cavity. You will understand how the perspectival intention—however many details of landscape and figures it may include—will tend, artistically speaking, to reduce itself to this way of undertanding forms: a sensation of regular volumes. . . .

Perspective, when understood in the manner I have set forth, simultaneously resolved the problem of coloristic composition. The depth synthesized by means of the converging lines prepared the way—between the lines themselves—for four regular and simply juxtaposed surfaces, four triangular zones: one of blue sky, another of white roadway, two triangles of rosy-hued buildings. Once filled with the substance of color, these triangles answered color's primordial need, as composition, to lie upon regularly juxtaposed surfaces, undistracted by any energetic or fussy outlines[18]

Ever ready for a polemic against other art historians, Longhi goes on:

Piero's spaciousness is an architectural spaciousness obtained through the regular spacing of regular volumes.

This determines his need for monumental human form, statuesque and detached poses, arrested gestures, and that whole complex of appearances mistaken by psychological criticism for a sense of impassiveness, pride, and hieratic heroism. Instead, it would be easy to demonstrate that all this is nothing other than the inevitable outcome of the perspectival vision.[19]

(The primary target of this little jeremiad was almost certainly Longhi's arch-rival, the famous connoisseur Bernard Berenson, who had written of Piero in his *Italian Painters of the Renaissance*, "He was what would commonly be called impassive, that is to say, unemotional, in his conceptions. . . . He loved impersonality, the absence of expressed emotion, as a quality. . . ."[20])

In the 1927 monograph that constitutes the bulk of the present book, Longhi develops the technical implications of this issue, arguing that, while some artists first invent a figure as an expressive idea and only afterwards sub-

ject it to the mathematical discipline of perspective, Piero's people begin, like the rest of the objects in his paintings, as pure geometric forms, and only afterwards are elaborated into recognizable figures, "guardians of space."

Such a psychologically intense and dramatic art as Masaccio's, with its extreme plasticity of forms, would, in fact, have been quite incompatible with the perspectival synthesis of form and color.

Masaccio and the whole tradition that descended from him did not treat perspective as an art, but only as a scientific means to make us perceive how objects in space grow gradually smaller. . . .

[His] spatial effect is obtained illusionistically, by means of the chiaroscuro plastic relief of forms. . . .

Piero's great merit lay in understanding that it was necessary to contain the snaky meanderings of functional line[21] within the inexorable pipelines of perspective so that, properly irrigated, the vast fields of color might all burst into flower together.[22]

Longhi even invented a neologism to express what he took to be the indissoluble perspectival union of form and color in Piero's work: *formacolore*, formcolor. (But when a colleague once attempted a similar, if feebler, expression with *la forma e il linguaggio*, "form and language," the witty and perfidious Longhi genially suggested, "Certainly, my dear Ragghianti. Form, language—why don't we just call the whole thing *formaggio*—cheese—and be done with it?"[23])

Crucially for his view of Piero's impact on later European painting, Longhi held that the painter's perspectival synthesis of form and color led him to a new, sunlight-suffused type of painting.

The greatest depth created through the convergence of straight or broadly curving lines was equivalent to a wall of colored surfaces. . . . Piero created, in fact, something like pure painting, in that he returned to the full and wondrous range of Gothic color, but enveloped it within the unified tonality achievable by means of the rendering of sunlight. . . . Thus, the inescapable neutrality of the individually lively Gothic hues was raised . . . to coloristic harmony by means of daylight, which created a unity of tone.[24]

Longhi thus perceived in Piero's art nothing less than the direct antecedent of Venetian "tonal painting"—an approach characterized by an

overarching harmonization of tonality and lighting, rather than by hard edges and abrupt coloristic disjunctions, and one in which effects are achieved by treating colors on a light-dark scale. From Giovanni Bellini to Giorgione and Titian, from Veronese through such non-Venetian masters as Caravaggio, Velázquez, Rembrandt, and Rubens, right down to Delacroix and even the Impressionists, variants of the tonal painting that first came into being in Renaissance Venice were to dominate European art for generations to come, ousting the more linear and draftsmanly style represented by the Florentine tradition—and by many other schools, too, including the Venetian Gothic of which Giovanni's father Jacopo Bellini had been a leading proponent. Longhi, in a word, places the example first set by Piero della Francesca at the very heart of High Renaissance, Baroque, and much subsequent painting throughout Europe. It is a bold claim.

Longhi believed that Piero's perspectival synthesis had had a particular impact on two masters working in Venice—the peripatetic Antonello da Messina and the homegrown Giovanni Bellini. As Longhi put his viewpoint in 1914:

> They followed Piero with new creations, after silently dividing up his inheritance.
>
> Antonello developed the problem of perspectival monumentality in the human form, which reduces itself, for him, to an extreme abstraction of ideal volumes. . . .
>
> Giovanni Bellini, more complex, without rejecting the problem of form—too ingrained in him for that, thanks to his training as a draftsman—deals with it in such a fashion as to resolve the problem of color in ever richer ways.[25]

Longhi cites numerous works by each artist which would have been, in his view, unthinkable without the direct or mediated example of Piero's painting—seminal pictures such as Antonello's highly architectonic *San Cassiano Altarpiece*, the prototype for several later Venetian works, or Bellini's great altarpiece at Pesaro, with its newly imposing figures and its view of a richly colored landscape seen through an aperture in the throne, in such a way as to form a strikingly decorative picture plane.

As for the precise manner in which Antonello and Bellini might have come into contact with Piero's art, Longhi offers several plausible, if quite undocumentable, hypotheses. In this context, it ought to be remembered that now-vanished frescoes by Piero were then to be seen in places much fre-

quented by artists: in the Vatican and elsewhere in Rome, for instance, where the unmistakable impact of Piero's style is still testified to by the work of Melozzo da Forlì. Piero also worked at Ferrara—a city not far from Venice, and even closer to Padua, that hotbed of artistic activity where Giovanni received part of his training (albeit in the hard and linear manner of his brother-in-law Andrea Mantegna, itself derived from the metallic style of Squarcione). The frescoes of such a painter as Francesco del Cossa, in the Palazzo Schifanoia at Ferrara, tell us much about the ability of Piero's example to inspire a broadening of the "fields of color" in an artistic center where frenetically agitated line had long reigned supreme.

In his essay of 1914, Longhi draws paradoxical attention to Piero's little *Saint Jerome with a Donor*, now in the Accademia at Venice and possibly in the city from an early date; he calls it "the most Venetian picture in Venice" because of the way in which the asymmetrical disposition of the figures and the broad, flat expanse of bright-hued background landscape at the center combine to bring the decorative intensity of the color right up to the picture plane. The implicit suggestion is that the little, light-flooded panel might have proved a revelation to those Venetian artists ready to read its message aright. And in a note to the monograph, Longhi goes so far as to suggest that Piero might even have put in an appearance in Venice during his sojourn at Ferrara, since "the road is not a long one." Longhi himself would have been the first to recognize that such hypotheses were nothing more than speculation. What is certain is that many artists—and many works of art—did journey from from one town to another, bringing news of distant artistic events without leaving behind them any written trace easily retrievable at this late date.

In any event, Longhi remained confident, as always, that it was the visual evidence that mattered most.[26]

Other art historians, before and after Longhi, have generally recognized Antonello da Messina's debt to Piero.[27] The great tradition of Venetian tonal painting that was to conquer Europe began, however, with Giovanni Bellini and continued with Giorgione and Titian; and here, art historians' readiness to perceive much Pieresque influence has been less universal, even if this part of Longhi's thesis has likewise found important adherents. (Sir Philip Hendy, formerly director of London's National Gallery, writes that "Giovanni Bellini, the founder of the Venetian school of painting, seems to owe much to

Piero" and credits Longhi with having been the first to draw attention to the link between the two artists.[28])

The more frequent tendency has been to explain the birth of the new Venetian painting—insofar as any simplified explanation is possible—as, first and foremost, the result of interaction between the tendency toward rationalized space and generalization of form typical of Italian (as opposed to Northern European) art on the one hand, and the novel possibilities opened up by the new medium of oil paint on the other; these technical possibilities were revealed to Venetian and other Italian artists through increasing contact with the art of Bruges and the other Northern centers where the oil medium had become habitual.[29] (Given Venice's status as a major center of trade, the city was much visited by foreign artists and artworks.) Other specifically Venetian circumstances—the special play of light over the city's rich surfaces, for example—have also been adduced.[30]

There is, of course, no incompatibility between Piero's influence and the exploration of the new oil paint medium as contributing factors in the birth of the new Venetian style. In any event, the value of Longhi's *Piero della Francesca* is in no real sense dependent upon its interpretation of the afterlife of Piero's art—a topic regarding which, in fact, the author at one point simply refers the reader back to his own essay of 1914 for a more detailed analysis of Piero's impact on Venetian painting. For all its stimulating profusion of informed and acute speculation regarding Piero's formation and aftermath, the heart of the book remains its loving and eloquent account of Piero's own creations, an account still unmatched in its combination of visual sensitivity with glitteringly gorgeous, witty writing.

In addition to "The Art of Piero della Francesca," readers of the present volume will have the opportunity to discover Longhi's touching, carefully documented biography of Piero, originally published as part of Longhi's monograph of 1927. They will also encounter another remarkable *tour de force*: Longhi's eagle-eyed survey of virtually everything written about Piero from the artist's day to the historian's own. If the tone is occasionally acerbic, the judgments expressed are nonetheless balanced and coherent. The book also includes the notes that Longhi progressively appended to the successive editions of his book in 1927, 1942, and 1962; insofar as practicable, these have been regrouped in order to bring together all those notes dealing with a

given painting or other topic, while still identifying clearly the year in which each individual note first made its appearance. Longhi did not key his footnotes into "The Art of Piero della Francesca" by means of footnote numbers; and that policy has been respected here, so as not to disrupt the essay's smoothly readable qualities.

I have equipped both Longhi's authorial notes and his biography of Piero with extensive editorial notes of my own. These are intended to serve a dual purpose: to help non-specialist readers get their bearings amidst Longhi's extensive cast of artistic characters and works and, crucially, to bring the state of the scholarship down to the present day. A great deal has been published on Piero since Longhi wrote; and I hope that these editorial notes—necessarily incomplete as they are, given the vastness of the literature—will help keep Longhi's masterpiece useful in the same sense as any contemporary monograph, by apprising readers of the ideas set forth in more recent scholarship.

The volume also includes one additional text by Longhi: "Piero in Arezzo," first published separately in 1950 and later included in the definitive edition of his *Piero della Francesca*. While the essay offers an analysis of Piero's great fresco cycle closely paralleling, in its essentials, the one found in "The Art of Piero della Francesca," it is well worth having for the beauty of its writing; it also contains some stimulating new reflections on the stylistic relationship between painted wall decorations and the buildings in which they are found.

Longhi's monograph on Piero has appeared once before in English translation—but in a rather tortuous and leaden, if valiant, version.[31] The plain fact is that Longhi's work is hair-raisingly difficult to translate. It is no easy task just to ferry the structure and literal meaning of many of his sentences—ecstatic labyrinths of dependent clauses—into English, a language offering few of those grammatical signposts (agreement of noun and adjective by number and gender, agreement of verb ending with subject) that help readers thread their way through the Italian original without feeling the strain.

And then, of course, there is the additional challenge of capturing every inflection of Longhi's lyrical, ironic, hortatory tone of voice. It is one of Longhi's characteristics (especially in the earlier part of his career) that he goes in for the far-fetched, difficult, exhibitionistic word—and, not infrequently, he goes to the extra trouble of spelling it oddly, too, just to make sure that the reader won't fail to note his precious linguistic dandyism. (An example is his use of *celi* instead of the more usual *cieli*, "skies.") There is a certain danger of "normalization" in ironing all of this out in the interest of user-friendliness—

although, at the same time, the translator cannot but feel the desirability of producing a readable text!

Longhi's metaphors, too, are often exasperating, either because they are impossibly mixed and shifting, or else because they're so lightly touched in, so underworked, as barely to justify their presence at all. A translator who respects the original in such cases—as I have generally tried to do—risks getting blamed for apparent defects not of his own making; and so I have sometimes chosen to render the literal sense while exorcising the ghostly simile floating in the background. More often, however, I have allowed such unnerving hauntings to continue undisturbed. I have, in fact, taken it as no mean part of the challenge to let the reader feel how much the occasional excesses of Longhi's style actually contribute to his greatness as a writer, registering with the sensitivity of a seismograph every tiniest movement of a ceaselessly inventive mind.

After all, a Longhi incapable of getting exuberantly drunk on his own verbal champagne wouldn't be Longhi—or at any rate, he would be a Longhi far less worth having than the one we've got. If this edition enables English-speaking readers to discover in Longhi's *Piero della Francesca* not just a ground-breaking monograph, but also some of the most beautiful writing on art in existence, then it will have achieved its purpose.

David Tabbat

Notes

1. For appraisals of Piero's work over the centuries, see O. del Buono and P. de Vecchi, *L'opera completa di Piero della Francesca*, Milan, 1967, pp. 10-14 and R. Longhi, "Fortuna storica" in *Piero della Francesca*, Florence, 1980, pp. 115-169, translated in the present volume as "Piero's Reputation over the Centuries."

 References to Piero occur only rarely in the centuries following his death; and when they do, they are almost invariably concerned more with his skill in perspective and in geometrical construction than with his other artistic qualities. After Vasari's generous and intelligent praise in the 1568 edition of the *Vite*, we find no real recognition of Piero's stature until Luigi Lanzi's *Storia pittorica della Italia* of 1795-96. Lanzi gives Piero his full due as a virtuoso in geometry and perspective; but he also recognizes the artist as "one of history's epoch-making painters." Anticipating a thesis of Longhi's, Lanzi asserts that "painting owes much to his examples in the imitation of the effects of light." Lanzi's sensitive appreciation, however, was to remain an isolated instance for many decades to come.

2. A brief biographical sketch is here in order. Longhi was born in 1890 at Alba in Piedmont. In 1911 he took his degree in art history at the University of Turin, where he studied under Pietro Toesca; he wrote his thesis on Caravaggio, who was to remain a particular interest throughout his life. Following a period as a teacher of art history in the *licei* (high schools) of Rome, he was "taken up," around 1920, by the great collector and dealer Alessandro Contini Bonacossi, who gave him the opportunity to travel throughout Europe and helped launch him upon his career as a connoisseur. In 1924 he married the writer Lucia Lopresti, who was herself to have a distinguished career under the pen name of "Anna Banti." Longhi was appointed in 1934 to the chair of art history at the University of Bologna, and in 1949 to an analogous post at the University of Florence. Throughout his career, he was involved with a series of art-historical and critical magazines: following publication of several articles (dealing with contemporary as well as earlier art) in periodicals such as *La Voce* and *L'Arte*, he briefly co-edited the magazines *Vita Artistica* (1927), *Pinacotheca* (1928-29), and *La Critica d'Arte* (starting 1938); in 1943 he founded *Proporzioni*, which appeared only four times, the last in 1963; in 1950 he founded the monthly *Paragone*, which was to remain one of his interests practically to the end of his career. Longhi died in Florence in 1970.

3. Longhi's dense but brilliantly written *Officina ferrarese* of 1934 (expanded 1940-

1955, reprinted Florence, 1980) remains to this day the basic text on painting in Ferrara. (Cf. Marco Bona Castellotti, *Conversazioni con Federico Zeri*, Parma, 1988, p. 20.) Longhi's *Caravaggio* (Rome, 1986) is meant for a broader audience. The chronology it seeks to establish has been largely superseded by that of more recent scholarship, especially that of Sir Denis Mahon, but Longhi's lifelong investigation into the sources of Caravaggio's startlingly original style remains both a fundamental chapter in Caravaggio studies and an exemplary demonstration of the Longhian methodology at its best. (Cf. esp. "Quesiti caravaggeschi: i precedenti," an article from 1929 now in RL, *Me Pinxit e Quesiti caravaggeschi*, Florence, 1968, pp. 97-143. The article is available in an English translation ("Caravaggio and his Forerunners") by D. Tabbat and D. Jacobson, in RL, *Three Studies*, a Stanley Moss-Sheep Meadow Book, Riverdale-on-Hudson, 1995, pp. 91-157.)

4. John Pope-Hennessy, *The Piero della Francesca Trail*, London, 1991 (Italian translation, *Sulle tracce di Piero della Francesca*, Turin, 1992, p.8).

5. For a detailed discussion of the theoretical underpinnings of Longhi's "verbal equivalents" to works of art and the controversies they engendered, see D. Tabbat, "The Eloquent Eye: Roberto Longhi and the Historical Criticism of Art," in RL, *Three Studies*, A Stanley Moss-Sheep Meadow Book, Riverdale-on-Hudson, 1995, pp. ix-xxx; now also in the journal *Paragone Arte* XLVII (nos. 557-559-561), Florence, 1998, pp. 3-27 and (in Spanish) in the catalogue *Pasión por la pintura: la Colección Longhi*, Madrid, Fundación la Caixa, 1998, pp. 40-57.

It may be fruitful to view Longhi as the last great exponent of the tradition of *ekphrasis*, much practiced in antiquity and revived by Humanist scholars at the courts of Renaissance Italy; this tradition involved the detailed, highly literary description of a real or imaginary work of art. (For a thorough discussion of *ekphrasis* in the Renaissance, see Michael Baxandall's superb, if slightly mistitled, *Giotto and the Orators*, Oxford, 1971.) It was not by chance, nor in a spirit of unalloyed admiration, that Zeri noted that Italian culture "is basically a court culture, a verbal culture of rhetorical rhythms, at which Longhi was a master" (quoted in M. Bona Castellotti, op. cit., p. 21).

6. Carlo Ginzburg, *Indagini su Piero*. Nuova edizione con l'aggiunta di quattro appendici, Turin, 1994, esp. pp. 25-26.

7. Maurizio Calvesi, *Piero della Francesca*, Milan, 1998, p. 86 et seq.

8. C. Ginzburg, op. cit., p. xviii.

9. These words were applied to Longhi by the distinguished English art historian, the late Sir Francis Haskell. (Cf. *The New York Review of Books*, February 6, 1997, p. 36.) The late connoisseur Federico Zeri stated his conviction that Longhi was one of the two greatest Italian writers of the twentieth century, independently of subject matter; the other, he said, was D'Annunzio. (Cf. M. Bona Castellotti, op. cit., p. 21.)

10. The new documentary material has to do mostly with the earlier history of the family from which Piero sprang, with his early master Antonio d'Anghiari, and with payment for the Misericordia altarpiece painted for Borgo San Sepolcro. (For these topics see respectively R. Lightbown, *Piero della Francesca*, New York, 1992, pp. 11-12; J. Banker, "Piero della Francesca as Assistant to Antonio d'Anghiari" in *The Burlington Magazine*. CXXXV, I (1993), pp. 16-21 and F. Dabell, "Antonio d'Anghiari e gli inizi di Piero della Francesca" in *Paragone* 318 (1984), pp. 74-94; and E. Battisti, *Piero della Francesca*, Milan, 1971, p. 221, emended by J.H. Beck in *Prospettiva* 25, 1978, p. 53.)

11. RL, *Breve ma veridica storia della pittura italiana*, Florence, 1980, p. 36.

12. Such ideas were very much in the air among the art historians of the day. The hypothetical analogy between the development of artistic style and that of biological species becomes explicit, for example, in a passage written by Longhi's older contemporary, initial model, and eventual rival Bernard Berenson: "I, for one, have been for many years cherishing the conviction that the world's art can be, nay, should be, studied as independently of all documentation as the world's fauna or the world's flora. . . . Then, and only then, and chiefly for the convenience of naming, might one turn to documents. . . ." (Cf. B. Berenson, *The Sense of Quality*, New York, n.d., p. vii.) There are further references to the methods of botanical taxonomy in the work of Heinrich Wölfflin, perhaps the leading German art theorist of the time; see his *Classic Art*, London, 1968, p. xi. The scientific positivism of the late nineteenth and early twentieth centuries thus appears to have pervaded the outlook of certain "formalist" practitioners of art history who, whether consciously or not, sought to validate their "aesthetic" methodology by likening it to that of natural science. For a somewhat fuller treatment of this issue, see D. Tabbat, op. cit., p. xxx, note 30.

13. RL, review of *Luca Giordano* by E. Petraccone in *L'Arte*, 1920, pp. 92-93; now in RL, *Scritti giovanili*, Florence, 1956, p. 255. The contemporary connoisseur Mina

Gregori, who studied with Longhi, notes that whatever his theoretical premises, Longhi, like any connoisseur, used any and every type of available evidence in his work. (Cf. M. Gregori, "Il metodo di Roberto Longhi" in G. Previtali, ed., *L'arte di scrivere sull'arte. Roberto Longhi nella cultura del nostro tempo*, Rome, 1982, pp. 126-140.

14. RL, "Piero dei Franceschi e lo sviluppo della pittura veneziana" in *L'Arte*, XVII, 1914; now in RL, *Scritti giovanili*, Florence, 1956, pp. 61-106.

15. Piero della Francesca, *De quinque corporibus regularibus*, of which a manuscript copy survives in the Vatican. For bibliographical details of modern publications of Piero's writings, see R. Lightbown, op. cit., pp. 236-237.

16. L.B. Alberti, *On Painting*, C. Grayson, trans., M. Kemp, ed., London, 1992.

17. Qualities that Longhi perceived as central to Piero's art—the geometricization of form, the emphasis upon the the picture plane's true nature as a frankly decorative two-dimensional surface—were also crucial to much Modernist painting; one has but to think of Cubism or, a few years later, of the critic Clement Greenberg's oft-repeated observation that successive generations of modern painters had made the picture plane look flatter and flatter. These analogies help us understand how it was that, following centuries of relative neglect, Piero della Francesca became an icon of modern taste. It is important to remember, however, that—whatever Longhi's reading of Piero's formal qualities—there is no verbal evidence that Piero himself consciously thought of the picture plane as anything other than the traditional illusionistic "window."

18. RL, "Piero dei Franceschi . . ." in *Scritti giovanili*, cit., pp. 63-64.

19. Idem., p. 67.

20. In his early *The Central Italian Painters of the Renaissance*, Berenson had written of Piero: ". . . he was what would commonly be called impassive, that is to say, unemotional in his conceptions. . . . He loved impersonality, the absence of expressed emotion, as a quality in things. . . . He never asks what his actors feel. Their emotions are no concern of his." (Now in B. Berenson, *The Italian Painters of the Renaissance*, London, 1952, p. 110.) The great connoisseur was to reiterate this conception of Piero's art half a century later in a small volume significantly entitled *Piero*

della Francesca. The Ineloquent in Art, New York, 1954.

The personal relationship between Berenson and Longhi, incidentally, comprises one of the more colorful stories in the by-no-means peaceful annals of artistic historiography. The young Longhi, an enthusiastic admirer of Berenson, proposed to translate the latter's *Italian Painters of the Renaissance* into Italian, and his offer was initially accepted. Later, assailed by growing doubts about Longhi's linguistic equipment and flamboyant prose style—and what he took to be a certain tendency on Longhi's part to slant the translations to reflect his own aesthetic convictions—Berenson withdrew his authorization. The ensuing rupture was aggravated in following years by the two men's competition for hegemony as the supreme arbiter of attributions in the field of Italian painting; Longhi's attack on the elder connoisseur's entrenched position culminated in the publication in 1934 of Longhi's *Officina ferrarese*, which contained, along with much else calculated to offend Berenson, a caustic allusion to his celebrated "lists" (giving Berenson's attributions of most known Italian paintings) as "that new timetable of the Italian artistic railways which many people, out of mental cowardice, take as Gospel" (RL, *Officina ferrarese*, 1934, p. 9). (E.K. Waterhouse, reviewing Longhi's book in *Burlington Magazine*, LXVIII, 1936, pp. 150-51, felt moved to write: "His two principal aims appear to be to establish as rigorous a chronology as possible, and to be as rude to Mr. Berenson as the large vocabulary of the Italian language allows.") The rift between the two critic-connoisseurs was not healed until 1956, when their scholarly (and commercial) wars were behind them; Longhi composed a glowing eulogy on Berenson (published in RL, *Critica d'arte e buongoverno*, Florence, 1985, p. 259) upon the occasion of the latter's being awarded an honorary degree by the University of Florence. Cf. esp. F. Bellini, "Una passione giovanile di Roberto Longhi: Bernard Berenson," and G. Previtali, "Roberto Longhi, profilo biografico," both in G. Previtali, ed. *L'arte . . .* cit., pp. 9-26 and pp. 141-70 respectively; also M. Secrest, *Being Bernard Berenson*, New York, 1979, pp. 285-386, and the entry for 1916 in the "Cronologia" in RL, *Da Cimabue a Morandi: saggi di storia della pittura italiana scelti e ordinati da Gianfranco Contini*, G. Contini, ed., 5th ed. Milan, 1987, p. lxxxv.

21. "Functional line" was, like "tactile values" and "ideated sensations," one of the theoretical concepts introduced by Berenson in his *Italian Painters* and used by the critic throughout his career. It denoted an active line that served to define, energize, and even confer volume upon bodies. In the eulogy Longhi composed upon the occasion of Berenson's being awarded an honorary degree by the University of Florence in 1956, he praised the usefulness of the latter's terms—although he himself rarely drew upon them.

22. RL, "Piero dei Franceschi . . ." in *Scritti giovanili*, pp. 65, 67-68.

23. Elsa de' Giorgi, *L'eredità Contini Bonacossi*, Milan, 1988, p. 229.

24. RL, "Piero dei Franceschi . . ." in *Scritti giovanili*, p. 73.

25. Ibid., p. 77.

26. More than once over the course of Longhi's career, it happened that documentary evidence turned up after the fact to help confirm a conclusion originally reached on the basis of the visual evidence alone. A good example is offered by Longhi's early intuition that the Milanese Mannerist Simone Peterzano had played an important role in forming the style of the youthful Caravaggio. Cf. "Caravaggio and his Forerunners," a translation by D. Tabbat and D. Jacobson of Longhi's "Quesiti caravaggeschi: i precedenti" in RL, *Three Studies*, a Stanley Moss-Sheep Meadow Book, Riverdale-on-Hudson, 1995

27. Berenson was among the writers who sensed that there might be important affinities between Piero, Antonello, and Giovanni Bellini; but his reading of their purport was very different from Longhi's. He writes, rather noncommittally, that Antonello "seems to approach" Piero in his "sense of space" and that his "architectural proportions" are, like Piero's, "sumptuous and impressive." But he also portrays an Antonello whose late works are indebted to Giovanni Bellini's both formally and in general spirit. Of any direct debt of Bellini's toward Piero there is no trace in his account. (Cf. B. Berenson, *Italian Painters*, cit., p. 143, n.)

28. P. Hendy, *Piero della Francesca and the Early Renaissance*, London, 1968, p. 35. Discussing Longhi's 1914 article "Piero dei Franceschi e lo sviluppo della pittura veneziana," Hendy writes: "It is more than half a century since Roberto Longhi published a now famous article on Piero della Francesca and the evolution of Venetian painting. His thesis was among the most illuminating in the literature of painting; for the undeniable fact to which he drew attention, that it was Piero whose pictures showed Antonello da Messina and Giovanni Bellini how to see and paint, has a significance far beyond its immediate context. It was from the school that these two founded in Venice that the subsequent European tradition put forth its several branches." (Hendy, op. cit, p. 9.)

Writing prior to the publication of Longhi's groundbreaking article,

Berenson made Giovanni Bellini himself, rather than Piero, the true begetter of the new type of painting that was destined to conquer first Venice and then Europe. "Giovanni Bellini, hitherto an adept of the plastic vision, began all at once to visualize in still another mode, which, to differentiate it from the linear and the plastic, I may call the commencement of the pictorial mode. This happened because he had a revelation of the possibilities of colour. Before his day, except in a rudimentary way at Verona, colour, no matter how enchanting its beauty, was a mere ornament added to the real materials, which were line in the fourteenth century, and line filled with light and shade in the fifteenth. With Bellini, colour began to be the material of the painter, the chief if not the sole instrument with which his effects were to be produced. Yet Bellini never dreamt of abandoning the shapes which the plastic vision had evolved; he simply rendered them henceforth with colour instead of with line and chiaroscuro; he merely gave up the plastic-linear for the plastic-pictorial." (B. Berenson, *Italian Painters*, cit., p. 172.) It must be granted, at the least, that this vision of Bellini's evolution—with its somewhat magical-sounding, if perhaps accurate, "all at once"—is theoretically quite compatible with Longhi's hypothesis regarding Piero's impact on Giovanni Bellini. Was the sudden change Berenson noted precipitated by a new awareness of Piero's art?

29. For the most recent accounts of oil paint's triumphant entry into Venetian art, see the exhibition catalogue *Renaissance Venice and the North*, B. Aikema and B.L. Brown, eds., Milan, 1999, and P. Hills, op. cit. The new medium had been perfected earlier in the fifteenth century in Flanders; and so the issue of its impact is inseparable from that of the reciprocal influence of Northern and Italian painting. Although most of the the Venetians—Lorenzo Lotto being the great and lonely exception—exploited its possibilities for the development of tonal painting, the medium itself could also facilitate, as it had in the hands of many a Northern master, a painting of bejeweled, discrete details; and Longhi, in "The Art of Piero della Francesca," is somewhat alarmed to see Piero himself developing an interest in such painting during the latter part of his career.

30. In a recent book, Paul Hills—one of the most visually sensitive of all art historians—assigns little importance to Piero's influence in the transformation of Giovanni Bellini's art, but does draw attention to certain specifically local material aspects of the environment the Venetian artist knew. Hills writes of Bellini's "curvilinear construction of the world, which recalls the sphericity, blown and spun, of glass vessels. To describe Giovanni's achievement purely as a synthesis of Florentine space and Flemish light, as has been done, is to miss the Venetian dynamic, at once vitre-

ous, marmoreal and aqueous, of his space-encircling arcs." (P. Hills, *Venetian Colour.*
Marble, Mosaic, Painting and Glass 1250-1550, New Haven and London, 1999, p.
122.) Hills further draws attention to Venice's role as a center of printing as a prob-
able factor in the development there of tonal painting: he suggests that the acute sen-
sitivity to shades of light and dark required to produce or read a monochrome print
contributed to the growth of the new pictorial sensibility. (Idem, chaps. 7 and 8).

31. RL, *Piero della Francesca*, Leonard Penlock, trans., London, 1930.

THE ART OF PIERO DELLA FRANCESCA

In reconstructing, to the extent permitted by a cautious respect for probabilities, the artistic environment in which it was historically possible for Piero della Francesca to make his appearance as a personality among painters, we shall not indulge in those efforts to understand the child psychology of genius so dear to Romantic criticism. We might be tempted to give it a try, were our business the rediscovery of his earliest artistic efforts as a young boy (an undertaking, we believe, nearly as difficult as finding sheep etched by Giotto on the stones of the Mugello). Similarly, we shall set aside the references of earlier critics in their accounts of Piero's origins to Gentile da Fabriano and Ottaviano Nelli, to the miniaturists of Perugia and Gubbio, and to other such artists. Dictated by a provincial laziness that unfailingly turns to homey or strictly municipal solutions, these explanations are not worth much more than the above-mentioned psychological accounts. Instead, we shall turn our attention to the very young Piero's probable dealings with that gossamer art of Siena which, from the mid-Trecento on, habitually reached Borgo San Sepolcro by way of Anghiari, and which still found, during the days of Piero's adolescence, a hospitable reception from Piero's fellow-townsmen for one of its finest expressions: the *Saint Francis Polyptych* by Stefano di Giovanni, called Sassetta.

But here, too, we shall tread with greatest caution; for it seems to us that the proper evaluation of the relationship between Piero and Siena has suffered both from certain factual errors and from a recurrent tendency to extend unduly the natural borders of Sienese art.

To cite only what one might call the most pernicious among the factual errors: a glance at the historians active during the first decades of the nineteenth century, such as Passavant, is sufficient to tell us that the "Sienese" view of Piero's origins was essentially the result of the then-current, mistaken attribution to him of the lateral parts surrounding the San Sepolcro *Baptism*.

Whether because of the easily verified law according to which, in the treatment of a historical problem, some effects of an error persist even after the facts of the matter at hand have become clear; or, perhaps, because the factual error still led to some marginal thoughts that were, themselves, basically right (or, most likely, because of a combination of both these factors), truth and error are still closely interwoven in Cavalcaselle. This last-named writer, in fact, having forcefully rejected the ascription to Piero of the clearly Sienese scenes surrounding the *Baptism*, indulges in a hunt for traces of Siena in the predella and pilasters of the *Misericordia Altarpiece*, rather than subjecting

these parts to close scrutiny. After an appropriate emphasis on Vasari's then newfound reference to Piero in his *Life* of Domenico Veneziano, and on the document that had just turned up in support of that reference, stating that, in the thirty-ninth year of the Quattrocento, Piero "was with" Domenico; after using these documents to formulate a new historical context for Piero; and having coined, largely on the same basis, the academic but meaningful definition of Piero's art as "Umbro-Florentine," Cavalcaselle still insists on the "Sienese substance" that he thinks he can perceive in the artist from Borgo San Sepolcro.

Faced with such insistence, one cannot help wondering about the germ of sound reasoning that must surely lie hidden beneath so many distortions; and the probable answer is that the truth must be arrived at circuitously, starting from farther off, given that, during the Trecento, Sienese art had made the rounds of Western Europe at least once. This art set out in the century's earliest decades, bearing its fragile and rich burden of treasure chests limned in the hues of Paradise, Oriental fabrics seen by golden pupils shot through with azure, bits of sweetly tender valley-scapes, low mountains as yielding as a newborn babe's cheeks, Petrarchesque rosy complexions, miniature battles fought out on bastions of fresh-baked bread: all in all, a delicate sort of pilot's chart, bound by a sweetly rhythmic symbolic line. Having come into the Po Valley, Bohemia, and France, it re-emerged, ever more decorative and preciously adorned, after many a presentation at court, increasingly enriched with grains of truth—then homeward, with its curious devotees close behind it, not without leaving several good friends here and there, even in Florence.

One may suggest that even the appearance of Sassetta's ecstatic Saint Francis in San Sepolcro, during the days of Piero's adolescence, ought to be evaluated in rather different terms from those commonly used.

To be precise, this picture arrived there when Piero, already back from his apprenticeship with Domenico Veneziano, was in a position to have taken cognizance in Florence, more completely than he could ever have done in his hometown, of the epochal current developments in painting, and thus, also, to have decided upon his stance regarding the spiritual and intellectual tendencies of which Sassetta was a representative.

When Sassetta was working in Siena on his altarpiece showing Saint Francis in glory, meant for the latter's devotees at San Sepolcro, he actually had a perfect spiritual brother in Florence, in the person of Masolino. To one deeply versed in the culture of the period, the names *Stephanus de Senis* and *Masolinus de Florentia* even sound alike. Of course, there were subtle individual differences between the two: Masolino was used to feasting, so to speak,

upon sumptuous court fare, whereas Sassetta entered the monastery garden through the back gate; but, at bottom, their art was the same. We certainly don't mean to deny the significance of assertions that the *Saint Francis Polyptych* was revealed to Piero's gaze, in all its splendor, at the very moment when he was about to tackle the *Misericordia Altarpiece*; and we are quite sure that, had the figure of Saint Francis that constituted the center of Sassetta's great work been sufficiently well-known in Cavalcaselle's day, the partisans of a Sienese origin for Piero would have made ample use of this new term of comparison. We, too, shall use it; but, insofar as possible, we shall do so with discretion.

To us it seems, in fact, that the *Saint Francis*, now in the Berenson collection, is a unique event in all of Sassetta's work, revealing above all the extent to which the painter tried to overcome his usual limitations in the search for something new. Here the evocation of an insubstantiality both readily apparent and, in fact, positively celebrated in the little narrative scenes that surrounded the Saint makes way for the strictness of simple outlines, for a solemn immobility seeming to derive more from the desire to assume the immutable outline of a dogma, than from any oscillating breath of ecstatic spirits caught up in a linear spiral of superhuman raptures. *Stasis*, not *ecstasis*.

Here, just where we might practically have been expecting the miracle of utter disembodiment—to the extent that this may be demanded of representational art—the patriarch Francis exists, instead, as a volume within the great sack of the tunic, which truly does fold as it comes into contact with his feet; and those feet really are planted upon the King of Violence, as no fourteenth-century Sienese artist had ever planted them. So the relationship is no longer between ever-intensifying degrees of insubstantiality—flame-like lines, for instance, and haloes of heavenly hues; but instead between, on the one hand, Matter, formed into that grave figure of the Saint, and, on the other, Spirit, or at least whatever can suggest the latter in art: I mean the most dazzling semblance of ether in the cherubs' nimbuses, in the great golden cloud surrounding the Saint.

Now, this is the very same relationship between Earth and Heaven posited by Fra Angelico; and we are very near believing that the mind of the Sienese painter was here tempted by a wish to take on Angelico's manner. This moment in Sassetta's art thus brings us back, once again, to the gates of Florence.

And there's more. Beneath that great polished hollow trunk of the Saint (just like the adapted tree trunks that centuries of devotion have turned into brown idols), and in a deeply felt spatial relationship with his calm ascent, a low, far-off, rippling body of water shimmers its way toward the

many-coved shores beneath the encircling hills. This is the art of perspective: it, too, freshly invented, nowhere else but in Florence.

These are the proofs that, starting from San Sepolcro, a Sienese artist points out, twice over, the road to Florence, even before the one leading home. And yet there can be no doubt that a model of this kind induced Piero to certain fruitful meditations. In Florence, he had certainly had opportunity to appreciate the graphic and chromatic symbolism of the Trecento, to measure with his eye the gaping vortex of the mine dug by Masaccio, to ponder at length the brand-new artifice of perspective; but upon returning home, ready to set off on his journey down the road to fame, but also, as it were, softened up and recaptured by the moods of his childhood, he might plausibly reflect afresh on the possibility of sticking to the path on which he had already set his feet, when he found himself faced with a work in which so subtle a painter as Sassetta had pungently drawn the line between the two centuries, one in which an arcane, yet earthly and material, hieratic spirit arose in the middle of the still-blooming flower bed of the Trecento's coloristic ellipses.

Piero may have expressed the problem we have been formulating as a dilemma far more simply, saying, "The figure of the Saint is good, and the landscape looks real and seems to go into the distance, but the rest is the art of our grandparents, all full of devotion." This is possible. And yet there must be a reason that, a few short years after the apparition at San Sepolcro of that huge and measured idol of Saint Francis, another idol appeared, sheltering the members of the local Confraternity in the shadow of its mantle: the tall scarlet trunk of the Madonna of Mercy.

So we must return to the very place that Sienese guest in San Sepolcro was pointing toward: Florence. There, from 1435 or so on, or perhaps even as early as 1430, we can, in fact, meet up with Piero as a very young apprentice.

And it will be understood that in dealing with so outstanding a mind and temperament, we shall not limit ourselves to working out his contacts with his contemporaries alone, but also with earlier masters. For it is certain that Piero, having decided to follow a major thoroughfare that was, at the same time, a personal way, did not study only such modern events as the fierce plasticity of Masaccio and Donatello; the mysterious perspective manner of Paolo Uccello; the elegant medieval classicism of Nanni di Banco, Lorenzo Monaco, and Michelozzo; the "gossamer Renaissance" of Masolino, with its exquisite mixture of Sienese, medieval, and Gothic elements; or the subtler but related Renaissance of the still-young Domenico Veneziano. No: for he

found himself face to face, as well, with all the manifestations of Giottesque painting that still dominated Florentine walls.

For example, among the most singular steps taken by a follower of Giotto was the one taken in the treatment of space by that mysterious pupil who, whether we choose to call him Maso di Banco or Giottino, painted the sublime frescoes of *Scenes from the Life of Saint Sylvester* in the Bardi Chapel at Santa Croce. Here is a new vastness of conception, where the figures, while occupying grander, more capacious architectural receptacles, are placed further back within their slice of infinite space: a nobly schematic, strangely Classical design which, while losing something of the neat efficiency of Giotto's gestural language, makes for an equivalent gain in majestic power of dominion. The sorts of chromatic alliances demanded by so simply curved and grave a scheme were well understood by this master, and show analogies with Pietro Lorenzetti's conceptions of around 1330. The use of vast areas of color foretells Piero della Francesca's own in so many ways as to leave no doubt regarding Piero's grasp of the significance of the Trecento Florentine's striving after a synthesis of form and color.

Indeed, we can never see the Bardi Chapel frescoes without sensing in them a vague premonition of certain ideas that will flower on the walls of the choir at Arezzo. Those broad expanses of light-hued wall, against which the figures convey their actions with such calm clarity; those architectural backgrounds so often occupied by slabs of polychrome marble; those broadly flowing draperies, where a straight strip of solid color frequently denotes the suture and juxtaposition of the outlines, just as a listel articulates masses in architecture—all this may well be called an anticipation of Piero. Just as long as we remember to take it as such only within the context of Maso's period, when space is still abstract and symbolic, and the people in paintings still belong only partially to themselves.

In the scene where Sylvester resuscitates the bull, the animal is modeled with all the strict force of an Egyptian relief; in the one where he baptizes the Emperor, the thinking behind the architecture at the right is a distant hint of that embodied in the portico where Solomon meets the Queen of Sheba at Arezzo; and when Sylvester resuscitates the two sorcerers, it's like an imprecise but perceptible sketch of the scenes of the *Invention of the True Cross* and of its *Restitution*. The sacramental gestures of adoration or benediction express a calm, a mastery, a sense of order most suggestive of further similarities between the two painters. The younger of the two cannot but have been pleased by his sense of kinship with the elder. We repeat, however, that this recognition must not lead us into a light-hearted attempt to cross the divide between the two artists' conceptions; were you to try it, at a certain point you

would be brought up short by the chasm of Masaccio.

Having discreetly imagined Piero's Florentine dialogues with his four-teenth-century prophets, let us now watch him as he mingles with his con-temporaries or converses with the recently deceased.

These are the decisive years when Alberti, recently returned to Florence after his long exile, perceives ". . . first of all in yourself, O beloved Filippo [Brunelleschi], and in our good friend the sculptor Donatello, and in the others, Nencio [Ghiberti] and Luca [della Robbia] and Masaccio, such parts in every praiseworthy thing as come not second to any famous ancient practioner of these arts, whosoever he may be." It is not our present task to seek out in detail the innermost meaning of this lofty catalogue; but let us offer, at least, a quick summation of the way in which it alludes not just to individuals, but also to various stylistic tendencies.

Alberti's list mentions Masaccio, meaning a style in dramatic relief, one in which tradition was submerged and summed up with a conviction of real existence and power such as not even Classical art itself had ever dreamed of: a style before which the world of Trecento art collapsed like a cardboard shed. An impatient, unprecedentedly domineering personality had dragged a handful of men in apostolic garb into enacting the first events of life after the Flood; treading the still-sodden earth, they confront a Nature humiliated and nearly blotted out by the cataclysm. It was terrifying when you realized who all this thunderous energy was aimed at.

As for Brunelleschi, who was only slightly less ambitious than Masaccio, he thought up a cupola that would "cover with its shadow all the peoples of Tuscany." But when one entered his buildings, still fragrant with mortar, it was as though space had come to know itself for the first time; for it was from ancient monuments, however gutted and cavernous, that he had derived the norms for his famous "harmonic proportion," which was spatial poetry.

When it came to Lorenzo Ghiberti and Luca della Robbia, and par-ticularly to the latter, matters were more clear-cut. Despite seductive compli-cations of Gothic line in Ghiberti, and with no such residues in Luca's case, both were seeking after clearer rhythms and simpler cadences. Ghiberti some-times, as in the flying angels on the reliquary of the three Christian martyrs, and Luca at all times thus show themselves to be the continuators of a culti-vated tradition of Classicism that had persisted throughout the Middle Ages, reaching, in the Trecento, those summits that are the sculptures of the façade

of Orvieto Cathedral. After Luca, that Classical tradition was ready, with no real interruptions, to take Perugino, Fra Bartolommeo, and Raphael himself by the hand.

Alberti cites Donatello. Time after time, this sculptor made his own whatever was in the air. Sometimes he was a Classicist, sometimes horrendously naturalistic, sometimes tremendously plastic; and always with genius, and always at the first try.

But these were not the only figures surrounding Piero in his youth; and Alberti's catalogue, being deliberately restricted to recently formed mountain peaks, is incomplete and commits some serious injustices.

Let us pass over Nanni di Banco, despite his having even more of a Greek air about him than did the cunning Ghiberti; let us pass over Michelozzo, who sometimes achieved a similiarly golden antique simplicity. But in painting, alongside Masaccio's, and even after the latter's death, Masolino's art was very much alive. Continuing at some points the manner of medieval Classicism, composing at others a prelude to perspective as poetry, it showed itself, for the rest, the heir to Sienese pictorial culture, with all the transformations the latter had undergone over the course of a hundred years of journeys devoted to discovery and collecting throughout Western Europe.

There was the art of Fra Angelico, hesitating undecided at the crossroads of the various artificial Elysiums cultivated by such innovators as Brunelleschi, Masaccio, and Paolo Uccello. Fra Filippo Lippi and Andrea del Castagno were laboring to extract from the bodies created by Masaccio and Donatello an "essence of outline" capable of living—even apart from those bodies—a life of its own.

Besides all these, there was yet another master, perhaps the most subtle of them all, versed in every secret of art and also in some others, considered matters of technique, but ready to transform themselves into a painting of light and of illuminating intimacy thanks to the providential creative impulse of those days. This master was Domenico of Venice, and Piero "was with him" in 1439.

For the young Piero, as for all the others in those days, Masaccio was the ineffable revelation of a new naturalness, practically freed from subservience to any stylistic principle, but capable, just like Nature itself, of generating an infinite number of such principles. One did not demand of Masaccio a rule for proper composition or good coloring, but instead something like the unveiling of the secret of bodily existence in a physics ennobled by action.

That grave and primeval humanity thus stood forth before Piero like an unchallengeable precedent; without humankind as painted by Masaccio, Piero's own would have been different. Still, this is not to say that the two artists' races are closely related; in Piero's we find, so to speak, Man as Masaccio had first roughly sketched him, but who now, no longer left alone to overcome a hostile environment by the force of his own plastic and moral isolation, turns every circumstance to his own account: land, dress, light, colors. But the precedents for this newly contemplative and contemplable humanity were not so much in those rare moments of relaxation—the perspective in the birth scene on the *desco da parto*, the group of squires in the predella of the Pisa Altarpiece—when Masaccio allows himself a bit of that "ornamentation" which Landini claims he is utterly without; rather, they are to be found in other painters entirely.

Here comes Masolino, cultivating his crop of affably sociable men who always show the soft, sweet stuff they are made of, whether they be naked or richly garbed. One could imagine no more hospitable settings than the ones he has prepared to receive these, his children: the long keyboards of rose-hued porticoes of old Imperial Rome, transformed into monastic loggias, come to an end beneath the Alpine foothills of Lombardy, where a group of the faithful, draped like ancient philosophers who have come back to live at Saint Louis' court, bury the body of the Baptist after his comfortable ascension. A partial thaw melts the ice of the River Jordan, flowing down from the north as though its headwaters were in the Saint Gothard Pass; and on that first morning, Christ is already rosy as a peach-flower, while the surrounding neophytes, caught in the act of taking off their shoes in preparation for baptism, are the most bashful recruits in the world.

In Masolino's picture of the founding of Santa Maria Maggiore, one can imagine the pure air of that miraculous summer dawn in Rome, where the arches of the disused aqueducts, abetted and led on by a host of clouds, make straight for the famously livable hills of Latium. Here is a sense of the poetry of unoccupied landscape; with means scarcely more advanced than those of the school of Giotto, but already helped out by the first hint of Brunelleschian arches, it composes a most sweet prelude to the mysteries of perspective.

Nor is this the only area in which Masolino sets himself apart from such of his contemporary relations as Gentile da Fabriano or Pisanello. He also differs from them in the no longer crepuscular or nocturnal substratum of his colors; these are, instead, tinged with the promising pink of the eastern horizon at dawn. There is no shadow powerful enough to extinguish that glow at the world's edge. This is a presentiment of the same luminous naturalness which, appearing at the same time, and in more subtle form, in Domenico

Veneziano as well, will reach in Piero the splendor of high noon.

Masolino's extreme delicacy of intonation is a natural proof of his intentions as a colorist; and it so happened that other, apparently unrelated events also played their part. For example, we do not know where the precise meeting point was of art with fashion; at any rate, it is certain that fashion was spreading itself astonishingly wide, with an unspeakable display, on a human ground, of motifs drawn on so large a scale that before they had run their full course, they had to be cut into bits of color, because they had run out of formal support. Think of the angel's garment in Masolino's Goldman Annunciation, with its motif of a few huge, separate roses, overly open and practically pressed, a detached and repeated print, not intertwined; or of those cuts of velvet that, without catching the light, cover the women's bodies in the frescoes at Castiglione d'Olona; or of the design of the tapestries of Arras around 1430. Think, too, of the appearance of that incredibly ornate headgear, *mazzocchi* for the men, onion-shaped bulbs for the women; of the broad, depilated, arched brows of the elegant ladies of those days who, whenever they came together for some social occasion, must have looked like clusters of Oriental domes in veined alabaster. You will readily see what a painter who adored fashion and color might make of such things.

Here, then, in Masolino, is another vague prelude to Piero.

His Salome, sitting to receive the Baptist's head in the fresco cycle at Castiglione, already shows the breadth of handling and the relationship between brow and neck we shall meet with once more in Piero; and in the procession accompanying her on her way to present the terrible gift to Herod, we find a certain ritual stillness, heralding the solemnity of manner that will forge these rather slight elements into a grander and more integrated art.

It is even worth noting how, when in proximity to Masolino, a painter who was perhaps Lombard, taking as his subject nothing more than the displays of clothing and the ceremonial side of high society at play, gave us, in the frescoes in Milan's Palazzo Borromeo, scenes of a gravity so spacious as to foretell—without, however, making enough of this gravity in artistic terms—the frescoes at Arezzo.

To get back to Masolino: add the touch of medieval Classicism that, having perhaps entered his mind because of his sojourns in Rome and his association with Masaccio, sometimes made it possible for his figures to appear fairly well-proportioned, if still imprecise and sluggish. At this point, you will have grasped all the ingredients in Masolino's art, and there were many, that might have aroused a sympathetic response in Piero, the others being, as we have said, the ones having to do with broader coloring, a manner of clothing in harmony with such colors, and the first rays of natural light.

At the very time of the young Piero's sojourn in Florence, Paolo Uccello, still afflicted—as a consequence of his fancy dress nocturnal hunts in the game reserves of the Gothic—with nyctalopia (a disorder causing one to see best in dim light), had also reached the threshold of the new art; he was thinking of ways to create art out of the perspective "intersections" propounded by Brunelleschi and Alberti, so as to escape the romantic imprecision with which Masolino had treated space in the works we have just been discussing.

It was no longer so much a problem of environmental exactitude, such as the one Masaccio had posed himself, with the probable help of Brunelleschi, in the Santa Maria Novella *Trinity* or the Brancacci *Healing of the Woman Possessed*; Uccello cherished, instead, a hope of overcoming poetically the very exactitude of the play of perspective itself.

Broken lances, crossbows, ring-shaped headgear, and cut-glass vases were, so to speak, the first toys this enthusiastic grown-up selected for his perspective game. The result, after just a few years, was those stupendous battle-pieces where the entire world seemed caught up in a magical net, and where vision seemed, at one and the same time, both as inflexible as any law of crystallography applied, but on a grander scale, to the whole cosmos, and as fantastic as a dream.

Paolo's arrival at art by way of the equations of corners is the demonstration that the lyrical world of exploration for its own sake arose, in those heroic and revolutionary years, side by side with the world of scientific research. Alongside the pursuit of the measurements of space, there appeared a feeling for space that spread astonishingly once Brunelleschi had discovered, encoded in the vastness of ancient buildings, the beauty of metrical relationships embodied in the "harmonic proportion."

So the newcomers among the painters had to make a poetic decision as to how the grim, blind space that Masaccio's men had been, so to speak, the first to tread ought now to be inhabited. Masaccio's figures, living in space as though continually conquering it by sheer force of energy, thereby denied its spaciousness, their only goal being an unprecedentedly powerful expression of form. This was, in short, a negation of everything that was not a pure and simple exaltation of the abstract physicality of things, of their "existence": a negation, first and foremost, of color, which belongs, rather, to the world as "appearance."

Having seen that Masolino and others were, instead, increasingly sen-

sitive to the new beauty of a broad and peaceful, if superficial, coloring, we are led to inquire how this sensitivity was to be harmonized with the already present emotional demand for a space that might be lived in, should one so wish, as far as the farthest horizon.

It was here that perspective came to the rescue. By constructing, through an effort at synthesis, shapes according to their countable and measurable surfaces, it succeeded in presenting them all as a projection upon a plane, ready to be clothed in calm, broad areas of color. This was how Masolino's field of color might truly be welded to the volume of bodies and made to permeate them; and it should be noted that the word "volume" is here used with its precise original meaning, since the thing it denotes had just been discovered at that very moment. Although no one challenged Masaccio's assertion that bodies had weight, they were now discovered to possess, as well, a further, mysterious essence of measurement; and this made it possible for volumes, their surfaces covered in colors bearing a unified relationship to one another, to take their places in an overall "harmonious proportion" of the picture as a whole: this unity I have called, on other occasions, the "perspective synthesis of form and color."

Paolo Uccello treated his poetic invention with the strictness of cryptography. Individual bodies combined with the background connecting them to form a veritable wall of color. Observe how bits and pieces of the middle and far distance float between the uplands of a geometric and, alas, rather dehumanized humanity. Between the dismayed faces of warriors donning, on their heads, geometrically constructed *mazzocchi*, the orange trees of the groves and the furrows of the field put in their spooky appearance. Steel greaves mix with tree trunks, silver baldrics with the ribbons of winding streams, while the foliage of evergreens shows through between the lances.

The enormous number of "appearances" that Paolo Uccello wanted to squeeze into his pictures, out of pride in his ability to grasp them all in the crystalline clenched fist of perspective, brought him close, in the famous battle scenes and in the *Flood*, to hermetic incomprehensibility. Nonetheless, these works offer a glimpse both of a sublime metrics of bodies within space, or rather of bodies forming an inseparable part of the latter, and also of a perfect fit between spatial volumes and the invisible seams between the perspective planes; and these volumes, once sutured to these planes, offered the best framework for an equivalent distribution of colors. Perhaps all that was missing in order for a world thus transfigured to become perfectly understandable was that it be bathed in natural light.

The art of Paolo Uccello also struck Domenico Veneziano, probable employer of the apprentice Piero in the year 1439, as overly dehumanized. For of all that group of geniuses (the largest number ever to turn up in one town at one and the same time), Domenico was the most reluctant to place his own freedom as a sensitive describer of tiny pictorial nuances in thrall to the laws being imposed with such eagerness, by so many revolutionaries, upon their own creative impulses.

Perhaps because of his knowledge of such sublime Northern miniatures as those in the Eyckian *Book of Hours* in Milan, Domenico may have been the truest heir to the naturalistic *sancta simplicitas* of the Lorenzetti. Only now, every story could be sung forth in the open air of a truthfully luminous setting, from whose corners the dimness sometimes dreamed to lie lurking there had been driven out. Imagine a Masolino or a Sassetta with a sharper eye, one that would not have missed the significance of even the tiniest shadow cast upon a wall by the smallest leaf on a trellis in the as yet uncultivated Rucellai gardens.

This is not to say that Domenico did not understand the favors perspective was bestowing upon painting; but for himself, he glimpsed another, freer kind of painting, shot full of minute observations from one side of the picture to the other, and this vision was naturally the one he tended to pass on to his pupil.

Another of his gifts was for that "friendship among colors" spoken of by Alberti: a talent amply displayed in the *Saint Lucy Altarpiece* in the Uffizi, where the harmony roams free in such Elysian Fields as to leave one with a haunting memory of colors that live even independently of those figures and that architectural setting, as though one were dealing with the border of some Coptic tunic, or a detail from a Persian miniature, or some Hellenistic cup in translucent stone, or a Sienese enamel. Thanks to the reduction of plastic chiaroscuro to a minimum, and the uniformly crisp distribution of a delicate light remaining transparent even in the shadows, the friendship among colors takes on the air of a freshness that everything is drinking up.

Such transparency and coloristic harmony were passed on from master to pupil. But Piero, who had a higher opinion than his teacher did of Paolo Uccello's poetic inventions, continued to decode the difficult noctural lesson of this last-named artist for himself.

In discussions of those days, we frequently find mentioned yet anoth-

er manner of seeing, this one invented by a sculptor, but quickly picked up by painters as well. The quintessential outlines generated by the energy embodied in Donatello's figures thus reappear on painted panels: sometimes, in the work of Fra Filippo, with the purity of Greek vase painting, and sometimes more brutally at the hands of Andrea del Castagno, although it was as yet hard to see where the latter planned to come ashore in his rude canoe.

The lines of Classical drawing reappeared, as practically the only ones able to withstand either the violence of Masaccio's painted humanity or the nobler burden of certain other figures who tried to achieve an air of antiquity. To be sure, it might have been possible, had one so desired, to lock colors into place between such lines. But there could be no doubt that the lines became less vigorous to just the same extent that they surrounded broad areas of calm suitable for coloring; alternatively, the lines, when drawn sufficiently close together to transmit energy, as it were, from body to body, kept the leading role for themselves, and this reduced the breadth and repose of the areas between them available for coloring. And so gaping divisions opened up: works might be strident, or else arid and without lustre. Andrea del Castagno nonetheless painted some figures of *Famous Men and Women* that might have been capable of making a powerful impression on Piero's gaze, with their grandly monumental proportion and generically monumental look. Only today we are practically certain that when these figures appeared in the outskirts of Florence, Piero was already far away and his own boss; and this gives us the right to suspect an opposite truth, which is to say that the gigantic outlines of Castagno's famous figures from Legnaia, like the perspective in his *Last Supper* and the sun-filled tonality of his other frescoes at Sant' Apollonia— above all the proportions and synthesis embodied in the *Pietà*—are, instead, indications of a "Pieresque" movement in Florence, one also perceptible, perhaps, in the youthful Alessio Baldovinetti and in Giovanni di Francesco. There can be no doubt at all, however, that this movement, if it ever did exist, was stamped out within the space of a very few years.

There was yet one more minor factor, or rather, one which, on the brink of becoming major, out of humility shied away from greatness; at least, this is the way Fra Angelico's art strikes us today.

There was perhaps no painter better informed about the latest artistic trends than this supposedly mystical Dominican from Fiesole. The supercilious ease with which he transfers Ghiberti's curvilinear Atticisms to his own angels flying about on a field of blue and gold (and looking like nothing so

much as miniature Victories from Paradise); or with which he appropriates Masaccio's plastic inventions for the little patch of shadow cast by the hood on the back of a Brother wearing his habit to the *Last Judgment* (as though the latter were just another ceremony in the monastery); or employs Paolo Uccello's perspectival devices for his own rows of open tombs, or the carpentry of his *Nativities*, or his many versions of the *Annunciation*: all this shows how easily he might have mastered matters that instead, alas, remained for him nothing more than tools for edification.

For Angelico, the value of his work lay in the unflagging diligence with which he executed it, in the flawless smoothness with which the colors were applied, in the adherence to a simple monastic iconography that made the meaning of the stories plain to the novice and the devout. He thus reduced to a pretty catechism the loftiest aspirations of the formal intellect. Remember that even the grand simplicity of Angelico's figures is not derived from the pictorial symbolism, tending to abstraction, which had proved so vital throughout the Trecento, but rather from the soberly rhythmic vein in medieval Classicism. The problem is that he arrived at his simplicity only by way of a serious impoverishment, reducing his characters to a lowest common denominator of devout poses and sweetly inhibited poses, as though each figure had been carved from an ivory tusk. The results were the frail *turres eburnae* of his Madonnas, those attentively adoring angels, and all those quietly sitting denizens of the court of Heaven. Even his ancient philosophers always have a calmly beatific air, as though reduced to playing the role of honorary thinkers in the Christian Paradise.

As we have said, Angelico had no intention of managing without a knowledge of the mysterious new art of perspective. In fact, we believe he was among the very first to learn something about the latter; except that, having done so, he almost always made what he had learned serve his usual purpose of the Gospel in Color, Explained to the Novice. There is, however, a moment when he seems close to yielding to an heretical passion for this unfamiliar art; we can see it in the *Deposition* and in the large *Pietà* in the Accademia, and even more in the big *Coronation of the Virgin* in the Louvre. Here the box of the world is shut tight and suspended, most likely, in the highest spheres of Heaven; but what goes on inside it is treated with a truly unprecedented spatial awareness, as though the whole thing were cut from a single large rock crystal. If, as seems likely, this work dates from before the fortieth year of the fifteenth century, there is no reason why Piero should not have taken pleasure in looking at it: above all, in the Queen of Heaven, perfectly limned in *profil perdu*, and in the checkerboard floor. But if Piero had complimented Angelico on his perfect perspective, the Dominican would have replied in words not

unlike those we may read in his epitaph: *Non mihi sit laudi quod eram velut alter Apelles—Sed quod lucra tuis omnia Christe dabam—Altera nam terris opera extant altera coelo.* ["May I be praised not because I was a second Apelles—but only because I will give all my riches to your people, O Christ. For there is one set of works for the Earth and another for Heaven."]

Piero was gifted with a brilliant lucidity in his appraisal of the artistic events we have just been discussing. For example, he cautiously investigated the possible relationships that the cultivated formal rhythms of the Classicists might establish, if suitably revised, with the peremptory naturalism of Masaccio's world. At the same time, he was no less aware of the relentless means of measuring space created by Paolo Uccello, no less in love with the transfigured naturalness of Domenico's light, no less interested in Masolino's distribution of expanses of color; but then, he was equally conscious of every other recent and valuable germ of painting, too, and even of the new insistence upon line. He was seeking an art that might subsume all of these influences into one whole, strictly grammatical, yet with no loss of breadth.

His earliest and most precious rediscovery, the reinvention of a spontaneously archaic style, occurred at the very moment when he was thinking through his reform of Classicism; and here we must be on our guard against reading his archaism as a historical recovery rather than as a choice of means. Just as we shall always reject the anachronistic presumption of those who would see, in this choice of means, the outcome of a calculated reconnaissance inside Egyptian tombs, so we must scorn the blather of those who would thoughtlessly expose the genealogical tree of a stylistic development to a repeated soaking in the local air and weather, or the necromancy of those who would willingly bury it beneath the shafts of Tuscan-Doric columns or in the Etruscan tombs of Cerveteri. We think their only purposes are to find a pretext for their own romantic or obscurely sybilline utterances, or to grab a handful of hemp for weaving at the literary gatherings where such people tell one another fairy tales about "the Trojans and Fiesole and Rome."

We shall therefore restrict ourselves to regarding the archaic aspect of Piero as a "choice of means," seeking no explanations beyond the pure and simple persistence of certain underground springs of vision that, at crucial moments, come to the aid of artists thirsty for inspiration, coming to the surface to lead the latters' footsteps back to the main road of the figurative tradition. It should, in fact, be noted that Piero did not arrive at his archaic-looking humanity out of a desire to create individual simulacra, statues, or idols,

but rather, at the very moment at which he was seeking after the measured rhythms that bodies must take on if they are to form, in conjunction with the intervals of space, a single, continuous wall, in a unified perspectival synthesis of form and color and an uninterrupted display of untrammeled Nature: in such a context, there must be room, as well, for the calm contemplation of the undoubtedly anti-Classical virtues of Domenico Veneziano, Masolino, and all of Gothic art.

<center>*******</center>

The earliest works by Piero to have come down to us confirm these events we have been trying to reconstruct on the simple basis of our certainty that he was in Florence sometime between 1430 and 1440. These works clearly reveal his confrontation with the fact of Masaccio as an experience to be acknowledged and then, if possible, dodged; even more clearly, however, they attest to his boundlessly joyful plunge into naturalism, for which the only, partial precedents were to be found in Domenico Veneziano and, so far as the relentless sense of measurement was concerned, in Paolo Uccello who, however, did his measuring by night.

In looking at these early works, it is very difficult to decide whether or not the *Baptism of Christ* comes before the *Misericordia Altarpiece*; but it is certain that no picture demonstrates more clearly than the *Baptism* the way Piero was linked with Sienese culture through the mediation of Masolino and Domenico. As often happens with an artist's youthful works, this one already offers us a quintessence of all Piero's work.

No sooner do we open the book of his art than we encounter, right at the outset, the most harmoniously unified page of his brightly illuminated world.

Within the encircling, very Italian hills, bearing the signs of an agriculture so ancient as to have itself become something like a form of spontaneous animal life, in a month so free of warfare or partisan strife that the riverbed winding its way through the countryside is unstained by blood, broken lances, or shattered bits of armor, wandering, instead, clean and dry and bearing only the dun impress of a few weeds, gleams the mortar of a distant city. At this windless hour, the reflecting water sends back a perfect image of the sky and the hills. Against this water, the figure of Christ stands out sharply, suspended in adoration; to the right stands John the Baptist, his arm raised in a gesture of baptism, his head covered with the natural fleece of his hair, his body clad in a tunic that looks as though it had been cut from bark that had fallen from the nearby tree. So beautifully evident is that tree, with its white

trunk and rich and rhythmic fronds, as to become, itself, practically a person; beside it, and considerably farther back, stands another, smaller one, with a different shape and, I should judge from its foliage, a different temperament. Between these two trees stand three winged adolescents [fig. 1] with the androgynous air one often finds in peasant youths; they appear to be enjoying the goings-on in much the same way as do those naïve lads and lasses whom one often sees holding hands as they look on at some country wedding.

To the right, in the middle distance, another convert is undressing at the water's edge: he is caught at the instant when the garments piled about his head and shoulders form a single, harmonious block, looking as though it were modeled in clay. With his awkward yet measured pose, this *quadratus homo* stands out clearly against the background, which appears, in the form of a branch of the river, between his own more human limbs. Beyond this bit of river some Eastern holy men are gathered, in attitudes of wonder, their draped forms mirrored in it like some bright livery worn by the water itself.

Most certainly, here is a humanity as primeval as Masaccio's own, but more uncultivated than his, and more astonished: a race sublimely rustic, but by no means coarse, having the simplicity of shepherds rather than philosophers; especially those angelic adolescents, who have sprung from the earth like oaks, with their thick ankles, and who, in just a few years, will grow so powerful that no force will be capable of shaking them. They wear garments of contrasting solid colors, whose folds fall as naturally as the fluting of columns once did; and naturally, the bodies wearing such attire are columnar, too. Their hair has grown freely into splendid manes, rudely plaited into compact masses such as the fleeces of animals come to form over time. Their ornaments are few but fitting: simple ribbons or strings of pearls, which do not so much clasp as gently measure the circumference of a bust or an arm. On their heads are wreaths of little leaves or roses, intertwined with such perfect rustic art as to take the form of a flowery *mazzocchio* headdress, and capable of putting us in mind of Alberti's vivid definition of a circle as "that shape on a surface that an unbroken line, garland-like, encloses." Here it is a true garland that confers concrete truth on the circle. As for the gestures, these express a grave, sweet intimacy, like pacts of friendship and wedded tranquility.

There is no conflict here between Man and his circumstances; and to us, this peacefulness seems to be derived precisely from the perfect proportions of the space, seamlessly welding together figures and landscape, foreground and far distance, in the liquid solemnity of the noonday light.

Thus does the Christ forego his seemingly sacramental central position for the sake of all these other actors on an equal footing, occupying these freely flowing spaces. The white trunk of the pear tree, the Baptist in his garb

of tawny bark, the conical tree in the distance to the right, the intensely green mass of foliage, the great patch of bright sky, the three-toned angels—all these, separate yet united, are presences whose interrelationship is created by a marvelous show of colors and whose worth, far from being an individual matter, is entirely contingent upon the whole, so divinely reflected in the eye of perspective. Things would be surely be otherwise were each shape to take on an arrogant life of its own, occupying just so much space as was necessary for it to convince itself and us of its own existence through a play of light and shade; or were the shapes to distort themselves in the pursuit of "graceful" rhythms; or were their outlines compressed by a yearning for energetic movement. Here, instead, the outlines of men and things are reduced to a simple indication, annulling itself as "line" at the moment when, by means of a mysterious divination of measure, the volumes are conjoined, with each emergent shape being assigned its own color which harmonizes with all the other hues in this oneness of natural light.

Then it happens that the real and its reflection each become an illusion of the other; just so, the figures of the holy men appear in the waters of the River Jordan, and the reflection is no less real than the original. Then the whole range of Nature's colors is openly flaunted in the picture, in untainted pigments susceptible, in this extremely clear light, to enhancement by all the most minute variations in natural appearances as well as by certain ornamental details. At the same time, every area of color has about it something immaculate and terse. Things "differentiate themselves" in the light, as Alberti might have put it; and, within the broad scope allowed by the law, each detail has a new freedom to stand out in its own immediacy. Shadows hide in the riverbed, flickering like lizards' tails; leaves crowd thick against the sky, until some rare flash of light squeezes itself between them; on the furrowed hillsides nothing remains visible but the outline of some trees and a few shadows that, having escaped the notice of the torrential sunshine, form trembling blotches beneath the mulberries or under the ridges of the furrows.

Briefly considering the work's historic affinities and precedents, we may state that it is related, more closely than to any other picture, to Domenico Veneziano's altarpiece in the Uffizi. An intimation of optical poetry assures us that, in both cases, we are here being carried off to the same Paradise of color; and this may be taken as evidence of the probable nearness of the dates of execution of the two paintings.

There is even something in Piero's work that takes us back to an earlier generation, for the Christ still has some of the brooding air of the *homus salvaticus* to be seen in the work of Masolino and his circle; although, in Piero's interpretation, he also reminds one of the abnormal heads that form such ter-

Roberto Longhi

rifying lids to certain Etruscan earthenware vases. The Baptist, too, with his rude and transparent profile, is of the same type as the one in Masolino's frescoes at Castiglione d'Olona.

In the light of such demonstrations of the work's primitive character, one is amazed by the complex maturity of the perspective solution imparted in it to shapes and colors, and by the ceaseless hunt for pictorial wealth that it embodies.

Never before had there appeared in Italy such cleanliness of vision, such an outpouring of color, with Nature the equal and ally of Man: a vision in which everything on Earth, from the gravel in the riverbed to the head of Christ, has its rightful place; one not hierarchically and, in the last analysis, theocratically subordinate, but part of a supremely spectacular calm.

To be sure, a few decades earlier there had occurred up North the optical miracles of the Milan *Book of Hours*: bits of a polished cosmos which, as yet imperfect, had collapsed beneath the weight of the ill-founded humility of Jan van Eyck's "as best I can." Since the latter had not had the necessary confidence in the power of art, it was now up to Piero to justify those fragments of inexpressible naturalism by means of a new canon of creation, at once human and endowed with infinite symbolic potency.

And so, instead of richly caparisoned steeds on the threatening shores of Brabant or quail hiding in the furrows of Burgundian estates beneath the gaze of a cross-bow-shaped scarecrow, here, within a southward-facing circle of hills of the Tiber valley, is this peasant Christ. And here too are the holm oaks, the olive trees, the ancient crops and grasses, and all our ancient plants; and here are the steep, dust-whitened roads that lead straight to the wide-open gate of Borgo San Sepolcro when the sun is high.

The *Misericordia Polyptych* [fig. I], commissioned from Piero in 1445 by those among his fellow-townsmen who were members of the eponymous Confraternity, calls for the making of certain distinctions, both as to the identity of the artist—for certain parts of it do not seem to us to belong to Piero, even in their conception—and as to chronology, since it is our opinion that Piero worked at it, intermittently, at several different times.

For now, we shall restrict ourselves to stating that the parts striking us as certainly the work of another hand are the predella and the saints in the pilasters: passages worthy of note only inasmuch as they indicate that at that time Piero had brought with him to San Sepolcro an assistant who was not Sienese, as has previously been supposed, but most certainly Florentine. This

assistant worked on these parts in a state of nearly total independence; with the exception of a few partial accommodations dictated by Piero's proximity, he speaks for himself, showing himself a painter who, unlike Piero himself, insists upon linear motifs; one who, in representing the setting of his scenes, draws not upon Domenico Veneziano, but rather upon the simple, shallow schemes of Fra Angelico. Once we have taken into account the evident haste with which these portions have been carried out, certain traits might lead us to consider the possibility of discovering in them the first efforts of Baldovinetti or Giovanni di Francesco. But this is not the right place to pursue this line of inquiry further; for our present purposes, it will be sufficient to exclude those portions which, as we said at the outset, have formed the basis for ill-founded deductions regarding Piero's origins.

But Piero is to be encountered in person in all the rest; and it is clear that, while periodically adding new parts to the work or revising extant ones after a lapse of time (which is, as we have said, the way we believe the work proceeded), he aimed at, and achieved, an overall unity that remains reasonably convincing even today.

Here it fell to Piero's lot to compose a polyptych such as the Confraternity, still medieval in its tastes, had ordered from him. So the first requirement was that the panel be gilded in accordance with that canon of immaterial, symbolic splendor, handed down from the Byzantines, that had dominated the entire Trecento. Against such a gold background, the Trecento had repeatedly offered flat, ceremoniously symmetrical compositions; as of yet, the members of the Confraternity asked for nothing more. But the artist was already seeking to elude their requirements and to create a field possessing depth: a thing in itself difficult to accomplish and harder yet to harmonize with all that gold. Still, Piero pulled it off rather better than Masaccio had twenty years earlier when he was offered the famous *Pisa Polyptych*, already gilded by a Sienese craftsman. In their plasticity, Masaccio's figures had stood out against that gold background, thereby forcing the viewer to make an effort to ignore the latter; whereas in their simply measured outlines, Piero's seem, rather, to stand out powerfully against the light, like towers against a coppery sunset. How wonderfully they rest against their golden screen! In the architectural partitioning of the polyptych, with its perfect round-headed arches, the saints line up as though standing beneath the bays of some sunlit portico designed by Alberti, themselves becoming at once both the temple and the measurement of the temple, in precisely the same sense in which the *spatial templum* used to be designated and circumscribed by the augurs of ancient Rome; for when we take a closer look at these figures within their two-dimensional scheme, we can see that they both enclose a space and construct them-

selves in measurable depth.

This cannot be claimed equally for all the figures; in some, the sense of measurement is overwhelmed by a plastic force similar to Masaccio's. We are led to conclude that such figures belong to the first phase of Piero's work on the altarpiece: a phase that may be even earlier than the *Baptism*.

We refer, above all, to the two figures of Saint Sebastian and Saint John the Baptist. Both belong to a family intensely rustic and practically animal-like; both are forcefully smitten by the sun, whose rays, even in the sun-filled shade, bake their flanks mercilessly. The Baptist's draperies, for all their purple, are as deeply and painfully eroded as any rock formation. Sebastian's arrows, while casting no shadow—being, as they are, caught right on the tip by the sun—nonetheless tell us that this is the most torrid time of day: the moment when blood is at its most scarlet, and the hermit's dazzled eyes become half-closed slits. Here are, in short, two coarse, monolithic blocks, horrendously exposed by the light, bearing only the slightest proportional relationship to each other and to the rest of the altarpiece, and standing forth prominently right at the entrance to the work. We are thus led to presume that were the large saints that once flanked Masaccio's *Pisan Madonna* ever to turn up, they would have something more to tell us regarding the Masaccio-like appearance of these two figures.

Let us continue our account of the probable order in which the elements were painted. We should say that Saints Andrew and Bernardino already seem better integrated into the pictorial space, being placed not only in a more harmonious relationship with each other, but also in a sort of convergence upon the center of the composition as a whole. As individuals, they seem to belong to an ancient race of philosophers and ascetics that is, however, better informed about keeping a sense of measure and wearing one's draperies with style than about how to take any kind of action. As figures, they appear as gravely outlined shapes against the gold: Saint Andrew certainly recalls Masaccio's apostolic draperies, but his position as guardian of space already seems predestined. He shows off the book he is holding as though it were an inscribed stone slab, and his amaranthine-colored mantle is full of shadows, whose cubic, precisely measured depths mark an advance over the figures of Sebastian and the Baptist. Dark and bright hues are here contrasted in zones less fragmentary, putting one in mind, despite the historical distance separating the two artists, of Velázquez's infallible manner.

The noble friar Saint Bernardino of Siena wears his tunic in dignified folds that begin beneath his hood, with only the slightest narrowing at the waist, continuing almost to the ground, where, just above the feet, they are cut off like a tree stump. Observe, also, the metrical strictness of that straight

and weightless white cord; and of the wheel of the nimbus, revolving about the globe of the head like some flat satellite; and even of the absolutely vertical gesture with which he points out, in the cusp overhead, his beloved source of inspiration, Saint Francis.

The figures on the four little side panels of the upper register seem to us to have been painted at the same time as the two saints just discussed, displaying as they do the same sense of spatial measurement and the same grave equality between figures and field.

On the surfaces of these panels, in part horribly abraded, the most visible of the figures is now the Saint Benedict, who stands with his arms crossed, rigidly encased in his large, milk-white tunic and stiff as befits a representative of early monasticism, leaning upon a slender staff only slightly less white than his habit; here one appreciates the extremely subtle and fitting variety of whites and, in this seemingly inexorable collection of vertical lines, the tiny yet effective departures from a strict parallelism, which are no less intentional than the "optical refinements" that had only recently been rediscovered in Classical architecture.

The Saint Francis is today reduced to a spectre; yet one may still catch a glimpse of how smoothly he has been extruded to fill the meagre volumes of his gray tunic, in much the same way as Saint Bernardino; unlike the latter, however, Francis pushes aside the cloth from his chest with his left hand to show us his wound, and holds out a frail little cross in his right hand.

In the *Annunciation*, the angel has managed to turn an apparently expansive movement into a new and broader stasis, articulated with marvelous rhythm by the caesura of shadow running straight from his girdle to the hem of his robe, which is dyed a mixture of blue and gray; the same rhythm reappears in the additional shadows so beautifully cast by the his angular and spotted red buskins. The rhythm returns anew in his face: although the latter appears in profile, it is displayed, together with the compact mass of hair, in a wondrous new polygonal perspective so that what seems to be a profile is really nothing more than two planes of the polygon, barely indented by the circumflex shadows of the eye socket and mouth.

Facing the angel, the standing Virgin is walled into the broad expanse of her mauve robe and light blue mantle. She is delicately poised upon the two little red outlines of her feet, one of them seen in rounded foreshortening, the other in pointed profile; yet there is no denying the appropriateness of so tiny a base to so large a mass.

Amid these four little panels, another, rather larger one, placed over the central part of the altarpiece, depicts *The Crucifixion with the Sorrowing Virgin and Saint John* [fig. 6-8].

Roberto Longhi

Here once again, it seems to us that the memory of the cusp painted by Masaccio to crown his *Pisa Altarpiece* practically forces itself on the viewer; and here once again Piero gives us the measure of his genius, showing us how much it differs in kind from the great Florentine's genius for plasticity.

The piercing lamentations and desperately disordered gestures that, in Masaccio's little panel, almost compel the viewer to analogous displays of compassion are here replaced by a calmly sorrowful contemplation. Masaccio's Virgin and Saint John are contorted by their active suffering; here, at the sight of a Christ who is, by now, no longer twisted and distorted like Masaccio's, but merely cruciform, in straightforward imitation of the wood He is attached to, the Virgin spreads her arms wide, John does the same, and they seem to exclaim simultaneously, "Oh, woe!" For us, the onlookers, there is the spectacle of those big gestures petrified against the sky: the Virgin's hands, sticking out from her vast black shape, and etched into the background like two separate but equally bare boughs of a tree against the light; and John's arms, which, having traversed space and thrown it wide open, turn rigid within as their draperies fall in noble folds of graduated areas of shade, like the draperies of some ancient Greek sculpture.

This is not a drama, poured so pitilessly into forms as to disturb them. Rather, it is the spectacle of gesture at its most solemn and—consciously or not—its most measured, yet remaining susceptible of connection with deep emotion. To us, it seems that this purely contemplative—and thus, spatial—development of even the most dramatic subject matter is, in fact, one of the loftiest aspects of Piero's style.

Upon our descent from that highest little panel at the altarpiece's center, we can easily see how it dominates all the other parts: not only because of its dimensions but, above all, because it stands atop the great central structure of the *Madonna of Misericordia*.

She opens wide her great blue mantle, revealing its ample scarlet lining and, at the same time, turning the garment into a vast pavilion in which she may shelter and protect the devout donors. The latter kneel in a freely disposed half-circle about her vermilion trunk, serene beneath the tower looming over them like some African giantess, and safe beneath the colonnade of her mantle's folds. The huge structure of this Virgin is the sign of a new and impassive humanity, but also of a new architecture; for within the space of this mantle we may already breathe the air of one of those vast niches designed by Bramante or of the vaulted setting for Raphael's *School of Athens*.

Anyone devoting any thought to the meaning of a structure such as the one Piero confers upon the *Virgin of Misericordia* must conclude that the artist was so satisfied with this kind of crystalline measurement that he decid-

ed to immerse within it both mankind and the godhead. The numerical and volumetric correspondences he had discovered in the distribution of shapes in space must have struck him as adequate symbols of eternity, requiring nothing more than an enlargement of scale. They had seemed so to the ancient Egyptians, too; and in their art and in Piero's alike, we learn that such symbols are impervious to the entire visible and terrestrial world.

There can be no doubt that, out of respect for the supreme sentiment inspired by the divinity, Piero left the Virgin with the predominant placement and dimensions she had had in the Trecento conception. Nor does one doubt that, after the free symmetry of the Baptism, he deliberately chose to submit himself to a symmetry central and rhythmic, and thus easily capable of taking on the value of a symbol. The gold imposed upon the artist by the devoutness of the Confraternity members accentuated this meaning; the result is, in short, a work mysterously iconic and even idolatrous, one that seems to draw upon that sense of unshakable stability that the Egyptians had chosen as the symbol of eternity.

And yet, within the iconograpic submissiveness and the centralized symmetry there lies hidden a deeper sort of measurement, one whose significance surely escaped the devout brethren's notice. We have already felt it in the vast Bramantesque space generated by the Virgin's open mantle; in the petrified freedom of the gestures of grief against the sky in the *Crucifixion*; and in the all-immersing natural light that seems to flow freely through and within the painting, diluting shadows in a brand-new "solar liquid" that confers upon the colors an intense clarity and the beauty of precious stones, and transfiguring them—in a word—beautifully. Think of the blazing range of pomegranate reds in the Virgin's robe and in Saint John's mantle; or of the blues and sun-lit lacquers of the patrons' clothing, the blue-tinted grays, the blacks, the turquoises deep as any black. The head of the Virgin, for all its Isis-like perfection of volume, still trembles in the light with subtle reflections and shadows; just note with what delicacy the light catches her ear or touches the hems and frayed fringes of the fabrics.

One might add a few observations regarding the portraits of the devout donors who, within their freely disposed half-circle, appear sometimes in *profil perdu*, sometimes in perfect profile, sometimes in a foreshortened frontal view. Above and beyond the strict placement of the figures in space, the handling here achieves such a wealth of painterly effects that the execution must have been protracted even after the rest of the polyptych had been finished; we are thus led to suppose that it was with these portraits that Piero brought his complex task to its conclusion.

The little panel showing *Saint Jerome with a Donor*, now in the Accademia at Venice, was painted, if we are not mistaken, sometime between 1440 and 1450; it is significant for the way it reveals, in contrast to the extremely old-fashioned iconography of the *Misericordia Altarpiece* with which it is roughly contemporary, the utter freedom Piero claimed for himself when not constrained by patrons' demands for tradition.

Here it is the very mystery of perspective that makes possible a freedom of composition far in advance of the painter's times.

Here men and saints, of equal stature and status within their landscape setting, share a companionable, comfortably rustic familiarity, the meaning of which is utterly subsumed in the spectacle of the bright and burning time of day.

No more dogmatic centrality shown in the painting's vague mirror! In fact, the mathematical center of the picture is occupied by the far-off apparition of the city whitewashed by men; all about, from the cut tree trunk in the foreground and the tree behind the donor to the shimmering zones of mountains and sky, persons and things freely take their places in space. Man thus loses not only the ability to serve as the measure of the world conferred upon him by the terribly anthropomorphic Florentine ideas of the period, but even his very identifying traits. For example, the donor is always described as being in profile. And yet this view of him, at this moment, expands and impresses itself fully against the spotted landscape, so that were we to try to respect that concept of a "profile," which really has value only in the context of a linear art, we should have to describe the tree as being "in profile" as well! Our consequent incapacity to distinguish between what is "in profile" and what is, instead, "full face" must then lead us to recognize that the stylistic unity of Piero's painting lies precisely in his continual showing forth of everything straight on, "full face," with all things composed on the picture plane like colored clods of earth, juxtaposed in the quivering dazzle of full sunlight.

The point of greatest depth, as given by the measured projection in perspective of the lines, thus coincides, in terms of coloring, with the broadest expanse of surface; and it is this which brings such a difficult, potentially unpoetic stereoptical view back to the sheer poetic ease of a carpet. Here, between the bends in the human figures, a moon-curved bend in the road appears; the heads, with their white patches of baldness or brown patches of hair, are stuck onto the gentle map of the hills, bald here, clad in brown vegetation there; while the red roofs, the black striplings, the straw belt, the tiny and refined writing in Saint Jerome's book, all take on their roles as the last,

intimate bits of punctuation on this brightly displayed page of magical naturalism.

<p style="text-align:center">*******</p>

The little panel, now in the gallery at Urbino, showing the *Flagellation of Christ*, a work that probably alludes to Oddantonio da Montrefeltro's dreadful end, dates from about the same time, probably shortly after 1444, the year of Oddantonio's death.

The perfect fusion of architecture and painting revealed here must be understood as an ideal conjunction of mathematics and painting. It cannot be said that Piero drew upon the givens of architecture to construct this picture of his; rather, he constructed the architecture that suited him, itself a mathematical dream possessing a spatial perceptiveness that not even Brunelleschi had ever created, and of which neither Alberti nor Laurana had as yet provided examples. In a word, he confers upon his architecture the same wholeness he demands of all things, even though architecture gives him the opportunity for a more systematic demonstration of "the power of lines and angles produced by perspective." Throughout the scene, in fact, these lines and angles define a space of crystalline purity, generating, at the same time, a flat and planar design of brighter and darker areas, whether the surface be read vertically or from side to side.

Just as the converging perspective lines are on the point of coming together in a straight line running along the axis of invisibility—as, for instance, in that marble guide, placed beneath the colonnade and extending into the foreground—the third dimension is almost dazzled out of existence by the two-toned effect created by the juxtaposition of the white with those unevenly reddish squares in the flooring. The same effect is produced by those white compartments in the ceiling, separated by dark listels and traversed by black perspective diagonals. Historically speaking, it is worth noting that this architecture, with its smooth, placidly mottled, multicolored surfaces, is of a type of which but a few anticipatory hints were to be found in Florence at the time, and which would come into full flower only in Venice, towards the century's end.

Within these perfect spaces the figures are shown taking part in the narrative subject, whose gestures are among the most expository ever seen: the white limbs of the flagellators arise and flex, producing new, attentively proportioned interlockings of form against the brown framework of the admirable door and within the black ellipse at the center of the mysterious play of the pavement. The robe of the turbaned man falls in two folds, so flut-

ed and parallel as to be indistinguishable from the drums at the base of the nearby columns; Pilate appears as a Pharaonic triangulation against the smooth surface of the second door; Christ is almost more columnar than the ancient column against which He stands.

The gestures of the three men shown on the right, in that courtyard adjacent to the praetorial headquarters, are admirably rhythmical. Their feet—angled like the baseboards of their bodies or like parts of the very ground they stand upon—and their falling draperies create new framing elements within those built-up spaces. Look at the headdress of the brown minister [fig. 9], linked with segments of the polychrome decoration of the loggia in the background and surmounted by the large black staff that seems a magical support for the brightness overhead. The head of the young Oddantonio [fig. 10], beautiful as that of an angel guarding Paradise, stands out like a golden medal against the mass of fronds outside the wall; beyond the big porphyry block of his robe, whose folds seem crystalline spaces, his white and massive legs stand unjointed, like milestones placed at two different points in space.

In short, it seems to us that one of the secrets of this art lay in its ability to confer a positive value, a new fullness, even upon what had been thought of as the intervals between forms. Just look at the interval between Oddantonio's massive ankles or the one separating the stockings of the elderly minister dressed in brocade. In the color scheme, these spaces have the same value as the ankles and stockings themselves. This was the point of draftsmanship that no longer sought to isolate bodies in an attractive linear definition, but rather felt the contours of these bodies as simply the circumscription of a surface, the latter thus being allowed to take on pictorial value only by virtue of its juxtaposition with all other such surfaces, including the zones previously thought of as mere gaps.

Should this to lead us to conclude that Piero's form frees itself from that formal concept of bodily connectedness which is a specific trait of Graeco-Latin figurative culture? If so, then how are we to explain the balanced proportions found even in Piero's individual figures, proportions well deserving of the definition "Classical"? The fact is that the Greeks' idea of proportion was derived from a system of measurement that did not originate with the measurement of humankind, but that was superior to it, stemming as it did from the beauty of those mathematical laws whose symbolic and figurative power the Egyptians had so thoroughly grasped. Egypt had restricted itself to a hierogrammatic transcription of such symbols on a single, unreal plane; and Greece had developed from them—in the "man inscribed in a square" of Aristotle and Myron—a proto-humanistic idol worship, linking those individual measurements in the increasingly eurhythmic series of tem-

ple pediment sculptures. But only after the acquisition—in Florence between 1420 and 1430—of a new awareness of a deeper segment of reality was it possible, through the melding of those ancient bodily proportions into a deep wall of positive intervals, to arrive at the metaphysical sense of a more complex cosmos of appearances.

So immediately did metaphysics, or a dream, spring from the new enthusiasm for new spatial certainties: the abstract metrical law did not condense itself in shapes alone, but also flowed around and about the latter, unnoticed and ineluctable. Amid the placid gestures of embodied statues, other invisible statues—some made of space, others sculpted and hollowed spaces of architecture and landscape—seamlessly took their places, flowing freely, leaving no residues behind them, into the intervals, which thereupon became just as measured and "beautiful" as the bodies themselves. The perspective projection displayed the entire scene, bringing to the surface, for the benefit of the eye, a wall of sumptuous coloristic equivalencies.

Those who remember the mineral splendor of the panel of the Flagellation—the ineffable splendor of the matter in which it clothes form and, under the impulse of the pearly sunlight, substance—are well aware of the beauty and peace dwelling in the paradise of the colors divesting individual forms of their claims to plastic preeminence. Pilate on his throne is covered with blue and purple robes, looking as though they have been pinched from the treasury of the Limoges enamels of the fourteenth century; the overseer of the tortures, in his ash-gray turban and robes, has been blown out of light, just as a glassblower might blow a vase out of glass; the nails in the door are touched by drops of light foretelling the miracles Vermeer would work on the studs of Dutch seventeenth-century chairs; and, on the right, the garments in blue and gold brocade worn by the old minister are unmatched in the European painting of the period, with the sole exception of the clothing of Chancellor Rollin, painted about twenty years earlier by Jan van Eyck. It is all the more admirable that Piero could bring the Northern master's sublime optical intimacy into such harmony with Italian "measurement"; and we must think that we are seeing here the first hints of developments that will manifest themselves more fully about a decade later.

These considerations regarding the style of the *Flagellation* may have prepared us to understand the work's overriding indifference to iconographic tradition. Good heavens! When one thinks how this same subject had been shown just a few years earlier by the follower of Piero who executed the *Misericordia* predella, or by Fra Angelico, one is astonished to see how Piero transforms the scene into one of impassive humanity, in a setting of equally impassive architecture. Here the Christian story appears as a clear and under-

stated spectacle, soothed by the sumptuousness of the surroundings and seeming practically a predestined decorative element of the latter. It is like an event from Homer, set in the atrium of some Aegean palace.

Painted some years later, in 1451 to be precise, the fresco left by Piero in the Tempio at Rimini, showing Malatesta kneeling before his patron Saint Sigismundus, King of Burgundy, also still possesses—despite the serious injuries done it by time and men—the ability to surprise us with its nearly epic treatment of the religious subject we unexpectedly catch sight of in a broad space next to a large window. One need but think of the iconic centrality of the Madonna of Misericordia in order see how, here, the sainted king, who receives the donor as Arthur would a knight, or Horus might Michaelinus, is given a place in the composition that, although certainly elevated, is nonetheless lateral; it is Malatesta who occupies the graphic center, while the painting goes on to annul even this centrality through the free articulation of the background.

The sainted king sits, as it were, walled in and off to one side in the space between the piers, as if to leave the background free for Malatesta's [fig. 11] profile, hermetically enclosed within the compact polygon formed by equal parts of bright face and brown hair and by the damask cape with its isosceles outline. Here once again the architectural framework is an element of continuity: those festoons that seem cut through by the fictive frame, that oculus in which there appears—and there is no telling whether it be more a graphic symbol or an optical reality—the Castellum Sigismundum; and, at the base, those two greyhounds, in mirroring poses that together form one of those supreme designs for a royal throne such as only the woodcarvers of ancient Egypt were capable of imagining. Every person and thing seems to find the gesture that will most appropriately contribute to this calm spaciousness of the pictorial field: King Sigismundus spreads his gold and blue mantle wide on his knees; Malatesta's short cloak falls straight, as though demonstrating one of Euclid's simpler theorems; his red hose cleanly traverse the strips of flooring; and, against the flat architecture, the festoons are saturated in a broadly applied, uniform hue, while the coat of arms cleaves flatly to the cornice, as though in delicate low relief.

In the entire composition there is thus not a single instance of rhythmic symmetry. Instead, there are only the figures: first deeply incised, in an intervallic relationship such as one finds in the most impeccable hieroglyphic slabs, and then set free by the variations in the field of the deeply and fully

measured background. It was the first time such a thing had occurred in art.

It is probable that the Rimini fresco was followed almost immediately by Piero's greatest pictorial undertaking: the series of frescoes on the choir walls of the church of San Francesco in Arezzo, illustrating the legend of the wood of the True Cross.

A quarter of a century earlier, on the walls of the Brancacci Chapel, Masaccio had chosen to treat the most decisive and action-packed events of the Biblical narrative of the Acts of the Apostles, realizing to the utmost their potential for plasticity of form. For his subject matter, Piero turns instead to the popular epic tales that had grown up over the intervening centuries around the earlier Scriptural narration. Such embroideries were particularly luxuriant where the Cross, the very symbol of redemption, was concerned; its vicissitudes were recounted in an enchanted fable that, opening with the days of the first progenitors of mankind, continued in a mixture of legend and history regarding the events of the first millenium after Christ: Constantine's victory over Maxentius, with the help of a little banner bearing the sign of the Cross; the Invention of the True Cross, through the efforts of Saint Helena; the strange theft of the holy wood by Chosroes, King of the Sassanids of Persia, and its recovery by Heraclius who, after overcoming him, carried it back in triumph to Jerusalem.

This was thus a return to a Christian mythological cycle much loved in the fourteenth century (and there is, in fact, but little need to recall how certain parts of the Arezzo frescoes coincide with those by Agnolo Gaddi at Santa Croce in Florence); it is a return not to Holy Writ, but rather to the apocryphal Gospel of Nicodemus, as given poetic form, two centuries before our painter, in the *Golden Legend*.

But it is more important to investigate why, out of all that mass of legend, Piero selected but a few events, leaving many others out.

From the earliest, pre-Christian part of the story, he retains and deeply explores the moment of Adam's death. On the other hand, he is not attracted by the blooming flowers that so enchanted Seth on the latter's visit to Eden, a subject that might well have tempted Masolino; and even the episode of Seth placing seeds in the mouth of the dead Adam is utterly annulled by the gravely resonant dramatic gestures of the surviving generations in the face of the unprecedented event of the death of the world's first man. For the rest, if we except the inclusion of the Annunciation to the Virgin—which allows the artist to omit the principal events of the story of the Cross (meaning, of

course, the ones connected with Christ's death upon it)——Piero sets forth the following: a crowd scene, practically a slice of the working life of his own time, representing the burial of the Cross on Solomon's orders; a scene of judicial mores, as we see them in the torture of Judas the Jew; the two loftily ceremonial scenes of Solomon's meeting with the Queen of Sheba and Heraclius's procession near Jerusalem; two battle scenes, one between Constantine and Maxentius, the other between Heraclius and the Persians; a scene combining courtly and civic elements and showing the discovery and trial of the True Cross; and lastly, the "imperial" scene of an Emperor's dream. But one should note, right from the outset, the prominence reserved for the "visual" battle scenes.

Now, without wishing to draw unwarranted conclusions from such a choice of subjects, we do have the right to ask, at least, whether it does not herald a new and serene universality of interests, one far removed from Masaccio's omnidramatic condensation.

Let us look carefully at the walls of Arezzo, and there will appear before us——above and beyond the initial joyous impression, induced primarily by the colors—a series of supremely spectacular events, each captured at the culminating moment of its visual unfolding.

Here the world, caught up in a more indirect and far-off destiny, appears as an orderly but varied show, where each thing falls in the clearest way into its freely allotted place: the daily toil of Solomon's laborers and God's own miracle, a reception at court and a torture in the courtyard, the built-up city and the ploughed countryside, the captain and the trumpeter, the servant who watches and dreams and the Emperor who sleeps and dreams, the ditchdigger and the queen, the wise man and the buffoon, the rider and his horse, cruppers and mountain ridges, lances and clouds. The appearance of each thing is demonstrated as in some sublime deck of tarot cards laid out before us. One is reminded of the epic sense of that metaphor in which the poet Ariosto, with a perspicacity truly visual, likens the knight who in his madness uproots trees to a bird-catcher who, in order to facilitate his work, clears the fields of grasses. One thinks, as well, of the contrast implicit in Vasari's choice of representative episodes from Masaccio and Piero. For the first, he describes the tragically emaciated figure trembling with cold as he awaits baptism in a fresco in Florence; for the second, the digger at Arezzo who, taking a break from his task, leans on his shovel and listens to the Empress, with that calm interest in the story so typical of peasants.

But I have said there can be no doubt that the initial joy the Arezzo frescoes induce in the viewer is primarily a matter of color. I can never enter San Francesco without feeling afresh that sensation I enjoyed on my first visit,

of being soothed by that "sacred wall" colored in greens and pinks, browns and whites, having now the wholeness of crops growing in the fields, now the freshness of youthful cheeks, now seeming like some rich liquor of the soil. If Masaccio gives us the sense of primeval, practically Adamic form, Piero shows us the color of the world as it was tinged by the arrival of the first pure beam of sunshine. He gives men and women the hue of their sex and race, landscapes and animals their varied garb, metals their shine, armies their show of banners and shields, buildings and garments their rightful appearance as things inhabited by gesture and life.

As we draw closer to the frescoes, other elements of the visible context emerge more or less obviously, but often with ineffable clarity; and our task is now to investigate how Piero has succeeded in bringing them all together so harmoniously within the terms of his style of measurement.

When one looks, for example, at the first scene in order of subject matter, the lunette with scenes connected with the *Death of Adam* [fig. II], one may even be led to wonder in what sense Piero may be called a draftsman.

Here one sees, in fact, bodies enclosed within solemn outlines resembling nothing so much as those of primitive Greek sculptures. The nude body of the young man leaning on a stick, seen from the back, bears an undeniable kinship with the Apollo Omphalos, carved about twenty centuries earlier; some of the naked torsos, including that of the aged Adam, look like anatomical casts of a plasticity so stupendous as to recall the reserved beauty of certain works by Myron; and the interval between the two legs of the youth arriving at the left is analogous to what we may see in the celebrated Tyrannicides.

But the answer to the question regarding style has already been provided above, a propos the *Flagellation*. What was, for the Greeks, a system of proportions that had lost its original meaning, becoming a framework on which ever more rhythmical relationships might be hung, here regains its quality of absoluteness through a new purification of outline—one worthy of ancient Egypt—in which rhythm is extinguished, while the reborn sense of measurement expands to fit the individual volumes together within a cubical space extending as far into depth as does vision itself.

The result of this fitting together, perspective synthesis, has been much weakened in this lunette by the nearly complete abrasion of the backgrounds; perhaps for this very reason, these Adamites have, in part, returned to a statuesque isolation. Nonetheless, the intersections between them, which had been unknown to ancient sculpture and vase painting, remain evident,

Roberto Longhi

having an importance that leaves no room for doubts regarding their syntactical significance in creating an appearance of profound depth. These forms and spaces display themselves, cross over one another, and fit together in fragments, as in a demonstration of optical completeness. Impersonal, they reveal the shape of Man in the circumstances most typical of his ages and clime; in short, they offer his shape in terms of the sublimated animality enclosed within the two magical words that Linnaeus placed at the summit of his scale: *homo sapiens*.

For this reason, gestures here appear as primitive interjections in space, taking on the ritual, nearly gymnastic manner they are wont to have when marked out by the limbs of primitive humanity. Speaking only metaphorically, we are led to say that here, for the first time, men are measuring out their own grief:

> *Io sentii mormorare a tutti: Adamo!*
> *Poi cerchiaro una pianta dispogliata*
> *di fiori e d'altra fronda in ciascuno ramo.*
> (Dante, *Purgatorio* XXXII)

> [I heard them all murmer, "Adam!"
> Then they surrounded a plant barren
> on every branch of flowers and of other foliage.]

It will be readily understood that in this composition, where Piero achieves a marvelous harmony between the various parameters of visibility, and where he also supplies what may be called a supremely noble outline of primitive humanity, many canons are foreshadowed that, through abstraction, might later be converted into facile paradigms for use in so-called Classicism and, in a word, by Italian art once the latter had become more grown-up. It is notorious that Signorelli had in mind the above-mentioned Adamite leaning on a stick when he painted the powerful figure playing on a reed flute in his famous picture of *Pan*. But it is more important and, we think, less well known that the furrowed, thousand-year-old profile of Eve could still be remembered, as a practically unsurpassable model of weary age, even by so tragically plastic a mind and soul as Michelangelo's: to be precise, in his *Cumaean Sybil*.

In the *Meeting of Solomon and the Queen of Sheba* [fig. III], Piero

abruptly introduces us into the ceremonious world of a more elegant and cultivated society. Here he shows himself equally skillful in handling open countryside and landscape hemmed in by architecture, such as the one we see through the vertical striping of the Corinthian columns that had struck Vasari as "divinely measured."

In the landscape, the vastest areas are those formed by the wide sky and the trees which, having grown naturally according to a law of volume, look almost as though they were being carried in procession, at rhythmic intervals, by the figures below them. Within these larger areas there expand, first, the forms of the horses and the equerries, seen frontally or from behind—a simultaneous inversion of form and color such as we have already seen in the two greyhounds in the fresco at Rimini—and then, as well, the ladies gathering to surround, by their placement, an ideal spatial volume that seems to be measured against the mark of the three girdles, all of them placed at the same height on the waists and, as it were, on the same parallel. Such figures are full of the sheer beauty of the gestures, merging and echoing one another in slow, broad curves and narrower intersections.

At this point, one wonders whether there was not, at the root of Piero's pictorial method, an *exercitium geometriae occultum nescientis se mensurare animi*. We mean to say that Piero's creative process, unlike the kind called "inspiration," which moves from the initial impulse to the coldly stylistic revision of the latter, appears to follow the opposite path, postulating, as the initial idea for a picture, a theorem that is then gently cloaked in, and warmed by, spectacle. As Leonardo saw figures in the blotches on walls—or rather, at the opposite extreme from Leonardo—Piero first spied them in the mute framework of Euclid's theorems.

One is, in fact, astonished to discover the extent to which those slow, broad curves and narrower intersections truly belong to supremely beautiful poses of necks and hair styles, girdles and breasts, bellies and necklines.

This derivation of the world and its circumstances from a sort of dreamy stylistic foresight constituting, once established, the basis upon which everything is free to develop within the boundaries of a rich-laden destiny, is truly one of Piero's typical characteristics.

If we carefully select some passages from these admirably crystalline compounds of men and landscape, we will immediately see how, in their supreme pictorial fullness, they express a new freedom.

Between the mountainsides of the necks and foreheads [fig. 14-18] appear the declivities of cheeks, the tender white shafts of necks, the thin slits of eyes, and the primeval vegetation of hair that has grown according to the natural rhythms of the lushest of saplings, and of eyebrows as sparse as grass

Roberto Longhi

at the edge of a ditch. Look how the shadow is not densely clotted like Masaccio's, but intermittently stitched, like cloth of the lighest weave, into those glades, which it just barely darkens, as in Ariosto's verses:

> *Soave ombra di drieto*
> *rendea al collo, e dinanzi a le confine*
> *de le guance divine,*
> *e discendea fin a l'avorio bianco*
> *del destro omero e manco . . .*

> [Gentle shadow behind
> her neck, and before the contours
> of her divine cheeks,
> descending to the white ivory
> of the left and right shoulders . . .]

The colors too sing vibrantly, with prismatic efficiency. Extremes of scale, even black and white, are discovered to be a part of color rather than of chiaroscuro. Pupils are little black disks imprinted on the whites of eyes; ribbons show pure white against black hair; while, around zones of this kind, the dots of pouncing are still to be seen in places. Far from taking on the incisive insistence of an outline, the pouncing is, as it were, effaced by the flat, rich clarity of the colors freely distributed within its borders with the fresh fluency of certain passages in Velázquez or Manet, so that the figures seem bright mirror images of their neighbors.

Nor should we make a secret of the beauty of the clothes; so perfectly functional as to look like human dwellings of the simplest kind, they provide an architecture of bodies within the real architecture, or within the fictive one of landscape. These human capsules are, in fact, quite as impenetrable to the view as the walls of any building. Note how, in that elderly courtier of Solomon's beneath the atrium, the vertical border of the cassock echoes, in a perfect parallel, the light-striped fluting of the column he leans against. The young man with his mantle thrown over his shoulder, and the lady with her hand on her hip who makes a counterpoise to him, both look as though they had been cut from the clean surfaces of an invisible cube. Cubical people, columnar people. Their limbs move but rarely within the chessboard of space, like chess pieces being played by some extremely theoretical-minded champion who is keeping an equal eye on all of them and using them sparingly. Especially memorable, from this standpoint, is the game played out by the courtiers' feet, which are red, black, and white, like those of opposing soccer

teams, with everyone nonetheless looking very sure of his place on the field, as just after some textbook-clean play, with every man in his assigned position.

In short, these men who are descended from Piero's dreamy spatial foresight remain lost in thought, like depositaries or custodians of that law. The gestures of solemn privilege of these ladies and courtiers seem—but only seem—like those of highborn lords or priestesses. For there can be no doubt that, while drawing his involuntary social metaphor from the airs and graces of his time, Piero meant, first and foremost, to assign to all these figures the office of guardians of space and only intended to use them as "demonstrations of surfaces."

We have already alluded to the scene of the *Removal of the Bridge*, which takes on great significance in the apparent absence of a religious subject or, almost, any subject at all. That idler who, for the sheer visual pleasure of it, hangs around watching, without lifting a finger, is a slice of everyday life as reflected in the gaze of a sublimely Italian spectator. This, too, is a scene such as has no equivalent in the polychrome reliefs of Thebes or Memphis, where a desire for hierarchy engraved, against the fluted registers of the backgrounds, the whole scale of human activities, from slave labor to the dynasty in the embrace of the divinity. In truth, though, here Piero also shows us, beneath the work scene, one of an Emperor dreaming and holding converse with Heaven.

It is not to be ruled out that, in his scene of the transportation of a piece of wood, Piero meant to foreshadow Christ's future carrying of the Cross; and given that both episodes involve the identical piece of wood, we find the idea of making the effortful gesture of Solomon's slave coincide with the future gesture of Christ carrying the Cross an exquisite one. In the end, we do not think it is by chance, either, that the head of this weight-bearing servant winds up right in the center of the natural halo formed by the wood grain. If we have mentioned this double overlapping of ideas, it is because we are convinced of the genius evident in, on the one hand, Piero's discovery of the purely visual concordance between a moment of the legend and an episode from the Passion, including the divine aspect of the latter; and, on the other, in his alluding to all this with such discretion and naturalness as to make it look quite fortuitous. This is an allegorical passage such as one does not hesitate to call Dantesque.

Once attention has been drawn to the historical context in which the painter was working (around the middle of the century), we must insist, not

Roberto Longhi

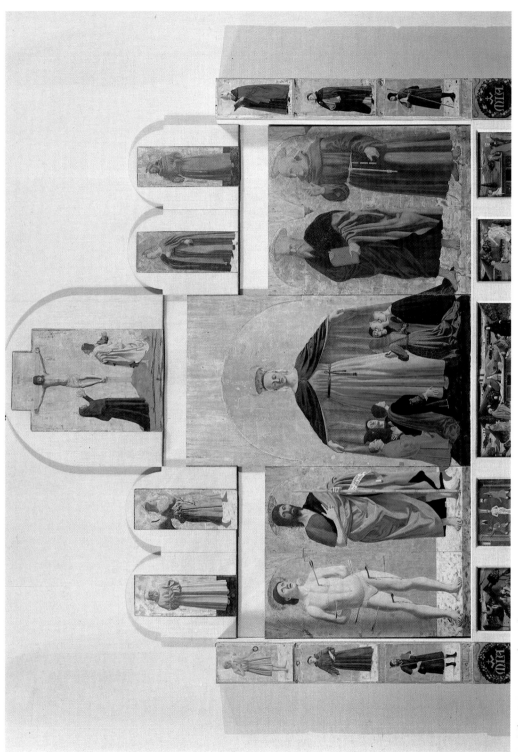

I. *The Misericordia Altarpiece.* San Sepolcro

II. The Legend of the Wood of the Cross. Death of Adam. San Francesco, Arezzo

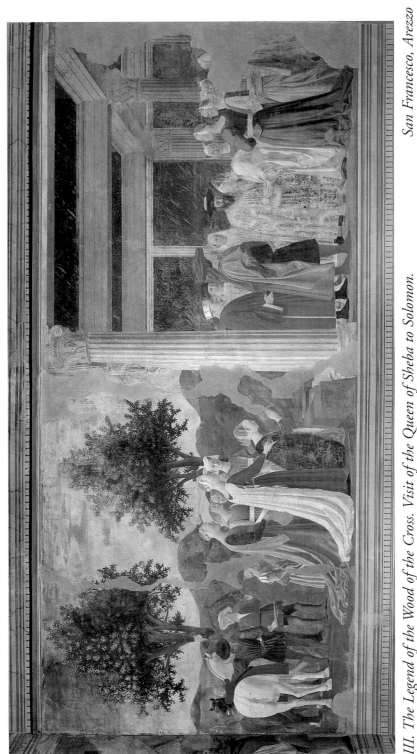

III. The Legend of the Wood of the Cross. Visit of the Queen of Sheba to Solomon. *San Francesco, Arezzo*

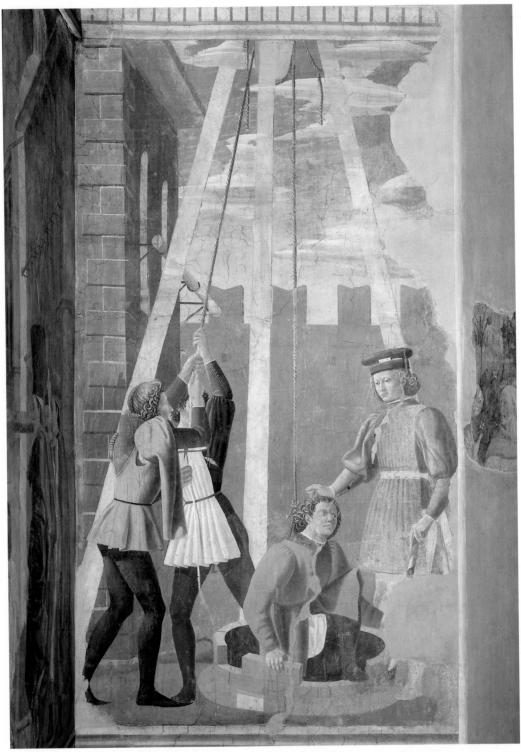

IV. The Legend of the Wood of the Cross. Torture of the Jew.　　　　　*San Francesco, Arezzo*

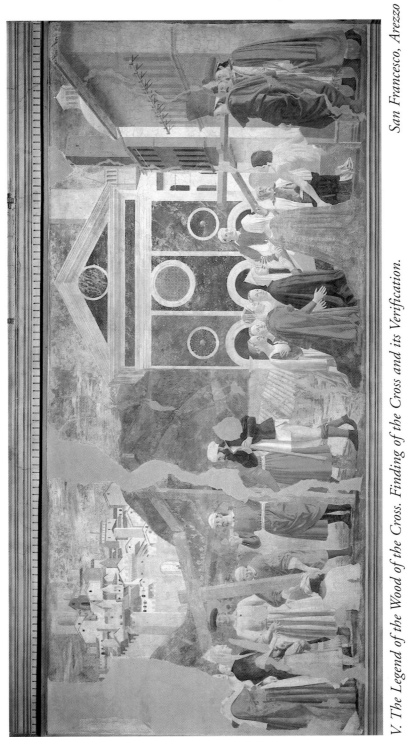

V. The Legend of the Wood of the Cross. Finding of the Cross and its Verification. San Francesco, Arezzo

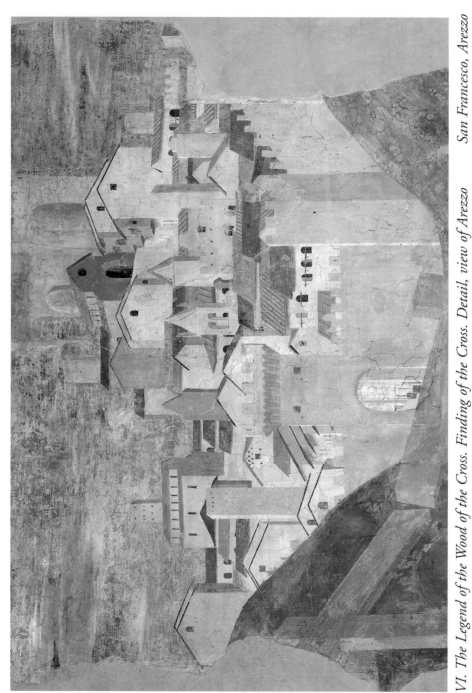

VI. The Legend of the Wood of the Cross. Finding of the Cross. Detail, view of Arezzo San Francesco, Arezzo

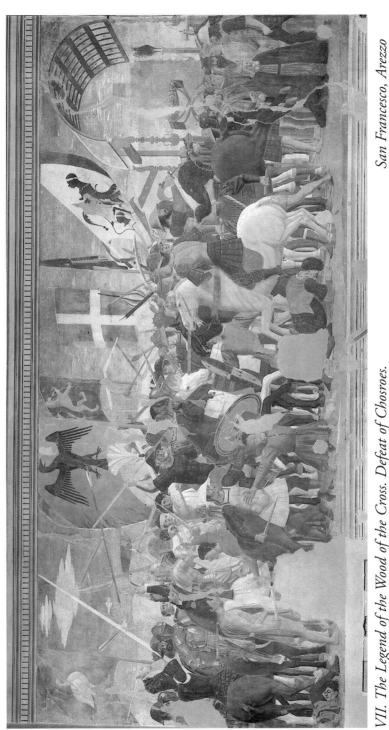

VII. The Legend of the Wood of the Cross. Defeat of Chosroes.

San Francesco, Arezzo

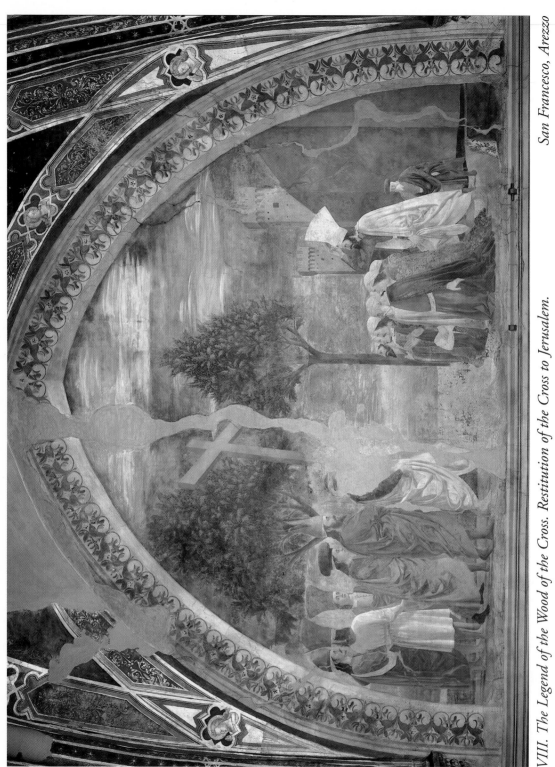

VIII. *The Legend of the Wood of the Cross. Restitution of the Cross to Jerusalem.*

only upon the novelty of such a motif appearing in a Christian mythological cycle, but also upon the newness of the scenic and spatial structure within which it occurs. Here nothing is to be seen but a narrow vertical space, occupied, above, by a steep winter sky which, the better to define depth, bears a ceiling decoration of crisp, cold, sparkling cloudbanks running from the zenith to the horizon, being partially closed off at the bottom by the hump of a brown and loamy hill rather close to the viewer's eye. Within this elementary landscape the action of the three laborers is displayed with maximum visibility—just as in Egyptian low reliefs; on the orders of Solomon (who is hoping thus to elude the Queen of Sheba's prophecy), they are burying, as deep as they can, the holy wood previously used as a bridge over "the stream of Shiloh." Here is nothing else beyond the stiff gestures of the three humble figures who are, I feel tempted to say, launching that planed board into the bowels of the earth as they pass it from hand to hand.

But the natural marquetry of the wood inlaid into the turquoise sky and quartered heraldically upon it, or the intervals created by the laborers' intersecting legs, in an exquisite surface alliteration, have no counterparts, except in the reapers or rowers of the Nile Valley; while the freedom with which all these things are disposed in space is to be found again only in Venetian painting of the full-blown Cinquecento. Here it is no longer the gatherings of the fashionably elegant, but, rather, the semi-undress of laboring poor folk, that gives rise to a beauty of draperies such as Giotto alone had, to some extent, foretold, in his frescoes of the *Resurrection of Lazarus* and *Christ's Entry into Jerusalem* in Padua.

<center>*******</center>

The *Annunciation* [fig. 19-20]—included by Piero in the Arezzo fresco cycle, perhaps as an elliptical reference to the events that were to take place, shortly afterwards, on and around that piece of wood we have watched Solomon's workmen burying—also astounds us, after the floral rhythms of Simone Martini's treatment of the subject, and the balanced masses of Giotto's, and the monastic cleanliness of Angelico's, with its asymmetrical spatial structure. Here, in fact, the spectator can no longer imagine himself placed at the center of the composition, but is shifted to the right; as a result, the very white column—the fourth, and by no means the least important, personage in the scene—tends to occupy the center, for the simple reason that everything is being viewed obliquely.

This is a most civilized scene of courtly or palace life (so much so that there have been those who have sought to identify it as a celestial message to

the Empress Helena); we must go back to Pietro Cavallini, or to Byzantium, to find an analogous majesty in such a subject. And yet, at the same time, there is a powerfully rustic note above that noble Corinthian order, in the stretch of neatly plastered white wall where the beam and its little iron support, together with their cast shadow, form a sort of crude sundial. Here the real cracks in the real wall at Arezzo join forces with the optical illusion and seem truly to run through that upper story, where the frieze, in a motif of little pointy leaves, is of an inexpressible fullness and perfection.

As usual, the figures appear to have been thought out in the same terms as the architecture, which is, once again, on a measured scale created by Piero himself; tectonic, chromatic of surface, and therefore Byzantine, Graeco-Roman; in a word, brand new. Now we can perceive the aesthetic significance of the Virgin's head being placed in a measured relationship with the Corinthian column, her whole body similar to that nearby column [fig. 20]; even the symbolic stylistic potency of the column itself. Who could deny that, were the events of centuries to erase all memory of the Christian legend, such a picture would be thought to represent, instead, a scene of ritual consecration and adoration of a column that had become a fetish, perhaps because of its amazing whiteness, or for the rare beauty of its entasis?

As for pictorial immediacy, just note the freshness of the light on the veil covering the Virgin's head. Practically clotted and dripping with moisture, like cheese in the making, it gives such an impression of being—purely and simply—mural painting, as to look as though it were based on the very roughnesses of the plaster itself; but then these surface accidents form an elemental ornamentation around the image, just as the leaves and bits of vine do around the adjacent capital.

Having, as we have noted, kept silent about the events surrounding the holy wood in Christ's time, Piero resumes his story some three hundred years afterwards, imagining the very famous scene of the *Dream of Constantine*, where he offers us, perhaps, the most unexpected painting from any period of Italian painting: a work in which the nocturnal fable of the Gothic is united with ancient Classicism, and with both Caravaggio's and Rembrandt's constructive luminism, and even with Seurat's weighing up of dust particles. We would not be led into such citations did they not seem to us appropriate to this extremely rare event.

That the vision should be sublimely dreamt and miraculous for the Emperor, wholly invisible to the other figures in the scene, and as superbly

and perceptibly real as a view of the full moon for us spectators: unless we are mistaken, this is what Piero set out to achieve in this short space of wall.

Imagine, then, a large campaign tent in the form of a conical pavillion, supported in the middle by a round shaft; in short, the same kind still in use today for dancing at peasant gatherings in the Italian countryside. It is the absence of any well-defined "period dress" in this tent that conveys to us a supremely poetic sense of "history": one thinks of the tents of the Argives, of Hannibal asleep before the battle of Cannae, of some highborn crusader in Asia. Behind this tent, beneath the watchful stars of an Umbrian night, there parade others, like the peaks of a mountain chain. The Emperor's tent having been flung wide because of the heat of the summer night, a great light at once rains down from overhead, vertically, taking in everything at close range, like an eye of moonlight. The red tent whitens like the barren hump of a volcano; the shadows flatten out at the edge of its fluted folds; and behind closed eyelids the brown Emperor in his white nightcap, his head emerging from the white, folded-back sheets, reverently receives the luminous "announcement." The white servant, seated upon the base of the bed, dreamily opens his eyes; and the light flowing down from above deposits itself on nightcap, arms, knees, like virgin snow on seated statues, whitening, as well, the helmets and shoulder straps of the two guards before coming to a halt at the shadow's edge, just as snow lines up along the lines marked out by the shelter of eaves and roofs. Against this great brightness, which unconsciously indicates the presence of the angel flying upside down beneath outstretched wings, the black lance of the first Praetorian and the mace of the second mechanically traverse the whiteness of the Imperial camp-bed.

Such a blend of mystical, fable-like beauty, calm epic, and historical gravity, of the miraculous and the natural, of astute rhythm and the beautiful synthesis of form and color, had never before been seen in our art; nor, most certainly, in any foreign art, either.

The fable is as enchanting as the most beautiful nocturnal scenes by that French genius who executed the bold miniatures in good King René's *Coeur d'amour épris*; the alert rhythm that suspends between the two guards' helmets a gently concave slope, descending along the Imperial bed and climbing back up the head of the watching servant, is worthy of Raphael at the peak of his powers. The plasticity has the power of Masaccio's, unleashed in what seems a painter's black and white. And the unexpectedly dramatic lighting puts one in mind of the howling that will go up around Caravaggio's dead Madonna or the magical maelstrom of Rembrandt's *Wedding of Samson*.

One wonders whether Piero's mysterious compendium of the basic elements of the loftiest artistic flights known to the memory of Man does not,

perhaps, represent the precise point at which Italians ought to locate their own truest form of classicism.

<div align="center">*******</div>

The scene of *Constantine's Victory over Maxentius* leads one to rather similar considerations; for, while it comes just after the miraculous dream in the sequence of subjects, it is developed as a great, deep-set frieze covering the whole of a vast horizontal rectangle on the right wall.

Here the spectacle is no longer nocturnal, but instead supremely diurnal. It comes into being behind the ineffable, secret veil of a light out of which things seem to blossom anew, more fully displayed, broader, and resplendently bathed in the liquor of sunlight.

Slow, sure irrigation of the meadows of the painting. A huge expanse of horses and men, in the nearly flat low relief of color. Reiterated foreshortenings, flattened breasts, fragmented knees, rounded hooves, perfectly semicircular rear profiles. Round wells of form stagnate, blotchy barren hills compose a patchwork, shafts and lances leave their marks, in liquid ivory amber ebony, upon one side of a blue field of sky roofed with light-edged clouds; while, on the other side is hung out to dry, softly, with no linear borders, the victory banner of the defeated general: a banner without which, I think, [Titian's] Pesaro family would have had no banner, at least in art; lances without which [Velázquez's] lancers at Breda would still remain, I believe, unarmed—in painting!

And, O you incorruptible spheres of pale felt! stay poised upon the pewter of those helmets, until, light-dazzled, you become, upon the blue breast of heaven, medals—awarded for coloristic valor!

In such words did I once attempt to express, even if in an overly romantic style, the effect made by this great painting; and still today, I cannot much alter the summarily visual order of that old impression. If anything, we must add some further notes along the same lines.

We will thus insist upon the superbly showy appearance of this sumptuously civilized warlike parade which, as it traverses the beautiful, rustic, and ancient Italian landscape, comes together to form a scene captured at its resplendent height.

This is the moment when Constantine's cavalry, arriving on the banks of the Tiber, reins in its wondrous steeds. The hooves, delicate as slippers, exhale before them a slight shadow that opens the way; and the intersecting hocks, seemingly wrought in alabaster and colored felt, give rise to an admirably dreamt hedge. On these trunks of animal vegetation blossom the horses: tall, arched, theorem-like. More than energy, they seem to wish to display the well-proportioned nobility of their limbs. In their triangular gait,

there remains perceptible the outline of the triangle; in their straight necks, the straightness of a linear descent; in their round rumps, a roundness enhanced by the red and turquoise arches of their cruppers; just as the studs decorating their harnesses mark, point by point, the theorems suggested in the foreshortenings. If the progenitors of this breed may be presumed to be the horses of the Dioscuri, their sire was surely the stallion ridden by [Uccello's] John Hawkwood.

Atop this most noble animal progeny, there tower like castles the nearly inhuman and yet extremely civilized limbs (or are they, instead, insects' wing cases?)—of the Christian warriors, polished up by the Imperial armorer. Upright upon their steeds, they raise to Heaven the artificial trellis of their monstrously beautiful, terrifying-to-behold helmets, in accordance with the secret learned from the barbaric East; and they erect the stockade of their lances against a blue-roofed sky inlaid with white squares of diminishing cloud. In the center is an ineffable interval of sunlit countryside, observed with the fearful yet loving eye of a peasant who, from the shelter of a furrow, sees his peaceful existence put at risk, as on the day of the battle of Anghiari. He recognizes the tree and the cottage near the bridge over the Tiber, the shadow beneath the mulberry bush, the shrubbery mirrored in the water. But suddenly, as with a deep-drawn breath, the countryside opens up again for Maxentius's flight; behind the crupper of the fleeing general's horse, the pathways over the hilltop reappear, marked by the track of harness and scorched by the noonday sun.

On the right, sticking together, the awkward, weary band of fugitives effortfully climbs the banks of the Tiber. Just look at how all the disorder of a forced retreat is expressed in the desperately jaded gallop of that long, long horse ridden by a Saracen.

This Saracen's horse struck Vasari as "very well hit off in its anatomy"; and we have nothing to object to this remark, so long as we take the term "anatomy" to mean not the study of flayed bodies, but rather a new and beautiful syntax of surfaces: a search for new measurements and proportions in the appearance of the single case that will make possible that case's integration into the synthesis forming the picture as a whole. See how this single lean horse, all by itself, makes an adequate counterpoise to the entire mass of superb palfreys ranged at the left: it crosses the entire right side of the picture, as good as dead, struggling along in its last, forlorn gallop after its efforts on the riverbank, and long and box-like as a coffin. (This may all be seen clearly in the watercolor copy Ramboux made before the fresco was in too poor a condition; even though, if truth be told, he did not perform his task very intelligently.)

We might extend our observations about the horse, noting how the smaller mass of the losers, when compared with that of the winners, spreads itself out and regains lost ground, in terms of coloristic equilibrium, by means of its banners, opening out to show themselves more fully during flight. A large tree and the curving mountains further contribute to this free distribution of colored masses in space, while leaving to the statement of the subject matter all the clarity and narrative and logical coherence it demands.

Here, then, we insist, is a purely chromatic and spatial balance, rather than one subordinate to any rhythms aiming at the elegantly prominent delineation of human actions. This is, in itself, enough to show how wide was the divide between Piero's conception and the ancient Classical one, of which he was carrying out, even if unintentionally, a critical reformation.

If we follow the order of the legend, the next subject is the *Torture of the Jew* [fig. IV]: an episode in the series of events that, after Constantine's victory and in accordance with his wishes, led the Empress Helena to rediscover the Cross in Jerusalem. Once again, it strikes us as significant that out of the great cycle of the legend, Piero has selected for depiction a "visual" fragment; or, if you like, one that lends itself to a transformation from drama into spectacle. This is a scene of judicial mores such as Piero might have observed within the walls of the castles of the Este, the Malatesta, the Montefeltro. It is contemporary, not historical; its historical gravity reaches us, centuries later, by way of a pictorial catharsis. To men of Piero's time, it must have seemed a fragment painted "from life."

How placid, in truth, is the sense of anonymous everyday life with which it is imbued! Here is the usual background, equally divided between a sky filled with interlocking clouds and the silent masonry of the castle courtyard, with its enormous battlements; against this background there stand out, like an inlay, the pyramidal instrument of torture and the angular, intersecting gestures of the two young torturers, posed so as to produce that effect of magical mirroring we have already noted. At one point, in fact, one of these figures, touching the other's knee, seems truly to touch his own reflection; and he is surely astonished to see his own face so sunlit [fig. IV, 21].

Note, also, how there is no focal point of interest in this so-called "subject"; not even in the passage where Judas, emerging from the round well, is seized by the judge who would like to make him confess. Instead, this part is in perfect equilibrium with the rest, and this relationship expresses itself as unity. The two torturers attend to their task of applying bodily force, the

judge concentrates on the interrogation, and all this is perfectly equivalent, in the spectator's impartial eye, to the shadow cast by the rope upon the fold of the judge's robe, or to the clotted sunlight around the mouth of the well, itself made of ashlars so clearly represented as to be countable.

It should nonetheless be noted that the visual effect does not reach us with its usual perfection; for, as close scrutiny of what is known as the "execution" will reveal, this work lacks that touch of the master's hand which would allow it to be deemed autograph. The colors are a few ounces heavier, the "solar liquid" a bit denser and more clumsily curdled. For example, the highlights on the edges of the coarsely worked stones forming the bend in the wall were certainly not put there by Piero's hand. Certain affinities in the drawing lead us to suppose that the same assistant who collaborated on the *Removal of the Bridge*—Giovanni di Piemonte, perhaps—also had a hand in the present scene.

The two closely related stories of the *Invention of the Cross* and its *Trial* [fig. V, 22-24], events instigated by Saint Helena, and the adjacent *Torture of the Jew*, are treated by Piero in a large area on the left wall, obviously conceived by Piero as a counterpart to the *Visit of the Queen of Sheba to Solomon*.

We have here, once again, a solemn blending of landscape with architecture, inhabited in the most natural manner by the spectacle of human occurrences, as they are wont to appear in the slanting light of an Italian afternoon: a light in which lofty events and even miracles themselves are surpassed by the omnipresent sublimity of the day and its light, and the lovely appearance these confer upon shapes and colors.

The viewer's eye, led, as is fitting, to a point directly in front of the dense register formed by the moldings decorating the cornice of the little polychrome temple, sees at the left, issuing forth like some theorem from those thickly clustered axes of vision that architecture is so good at creating, a semicircular group of men within a semicircle of hills crowned by an archetypal old Italian hill town, and, at the right, the open page of the polychrome temple façade. The latter, with its roundels and eloquently measured little arches, forms the background for the square group of persons kneeling before the miracle, itself as natural-looking as any everyday scene of weighing near the gates of the city.

Now take a closer look at the left side of the painting. You will be ravished by the beauty of a columnar humanity, whose clothing, from the waistline down, you might almost take for segments of ancient Doric columns,

hauled from Magna Graecia into Tuscany; these figures seem to test the empty space with their gestures, so as to find the best place to fix themselves within it. Nonetheless, these people are pointing, waiting, listening, resting. Note the spatial rose formed by the Empress's hand and the chamberlain's; the latter figure's head is crowned by a *mazzocchio* headdress that puts one in mind of one of Saturn's rings. See the sharp and perfect shadows at the seams, and the draperies like formations of rock crystal, and the inclusion of shape-defining objects like that ax slung over a peasant's shoulder. At the same time, observe the lovely necessity of these very gestures; it is as though we were faced with an instance of thoroughly understood realism. This is, in fact, just how the scene struck Vasari when he told us of the digger "listening so attentively to Saint Helena . . . that there could be no improving upon him." But this attentiveness is perhaps the contribution of the impartially natural light and of the mathematically calibrated portion of transparent shadow cast by the coarse cloth shirt upon the figure's flesh, or perhaps of the extreme simplicity of the draftsmanship in this dry, sun-embalmed Umbrian column, who lets his spade do duty for the support of one of his feet, in that harmony between Man and his rural implements that so often manifests itself in signs of a near-mystical elegance.

Rather than insisting upon further details, it will be sufficient to point out the apparition of the little walled town [fig. VI]; in its measured piling-up of cubical structures beneath the red and gray inclined planes of the roofs, it is a theorem treating of the modulation of pure volumes. And yet it is filled with mortar, with sunlight shining upon whitewash, with dovecotes, with shadows lurking beneath gutters and eaves. Upon those far-off walls, the real cracks in the fresco look so convincingly realistic that we are surprised to discover that they haven't been reinforced with tiny painted clamps.

Are we overstating the case when we say that never again, except perhaps in certain Provençal villages cemented together by Cézanne's brush, has a rightly understood "impressionism" found such accessible form and synthesis?

As we have said, this scene of the *Invention of the Cross* is linked with the scene of the *Trial* occupying the entire right side of the picture, in a perfect, quickly grasped unity of vision. The dress of the last of the Empress's ladies, in fact, extends far enough to cover part of the heel of the peasant leaning upon his spade; and our eye tells us that this is all quite natural.

This background is rooted in a Renaissance architecture created, if truth be told, by Piero himself, who has combined Tuscan Romanesque models with hints from Alberti. But here it reaches a level of coloristic effectiveness that real buildings will only achieve later on, in the [Venetian] architec-

Roberto Longhi

ture of Codussi and the Lombardi family; in Piero's painted architecture the Classical, the Byzantine, and Brunelleschi's "harmonious proportion" all come together to create an overriding vastness, depicted in all its spatial articulation and rendered all the more real by its calm certainty of measurement. Just as the white circles and semicircles, pure as hierograms, are linked together to enclose the zones of variegated marble, so are the figures drawn, as though by a magnet, into the spaces so well defined by the intervals separating the firm, calm arches (which have no counterpart in art, except in Alberti's arches upon the bell tower at Ferrara). One figure crosses her arms over her breast, while another opens her hands wide and shows them to the light; and there are some who, like the Empress herself, seem practically compelled to clasp their hands upon the plane of elevation of the miraculous Cross. The latter rises up as if to define a large tract of space or perhaps in order to transfer a mysterious burden of anonymous volume from the kneeling to the standing group. The painting thus transmits to its own spatial function the legendary miracle of the holy. The Cross's calm ascent is followed, in fact, by the motion of the youth who, miraculously brought back to life, raises himself from the bier, offering to the light as he does so an archaic athlete's torso so noble that neither the Egyptian sculptors nor Myron ever measured out a nobler one: it gleams less with the play of muscles than with the unpredictable brightness of a pebble in a river of light. To either side of the youth, but, with respect to the viewer's eye, at opposing angles, his parents pray in ritualized, rather idolatrous gestures; I should say that they are praying scientifically. In closing, let us note the form of the rude bier, made from four planed beams rustically joined together, as in some poor cradle or kitchen-press; it nonetheless reveals the same mastery that has fashioned the architecture of the temple and the other buildings, shown in an oblique view—chosen, I presume, for its being "more difficult"—whose effect is to show us how one still enters today into the ancient towns of Italy, with their dark streets catching the sun at the corners, their square red towers, and the big white marble cupola that, seen from afar, leads one to inquire which street leads to the cathedral.

It may not be out of place to make two comparisons between this part of Piero's work and two passages in Masaccio. First, let us point out the difference between this measured miracle and the dramatic violence of the setting—not without its own gravity—in the Brancacci Chapel *Resurrection of Tabitha*; and then let us propose, as a possible ancestor of Piero's bit of townscape, the one imagined by Masaccio in his scene of the *Possessed Woman*: a work that, far from being lost, as is commonly supposed, is instead, if we are not mistaken, perfectly preserved in the admirable little Florentine panel concealed in the Louvre under the name of Pietro da Milano. If forced to choose,

we should prefer the Arezzo passage to this second picture as well, for Piero's way of linking together figures, backgrounds—in a word, everything in the scene—under the sway of a liberal law governing the distribution of volumes in space. Rather than pursuing the matter further, however, we shall content ourselves with merely having touched upon the significance of such comparisons.

Opposite the victory Constantine won over Maxentius without striking a blow, Piero chose to place the very violent one between the armies of the Emperor Heraclius and of Chosroes—the diabolical and heretical King of the Persians who, after stealing the Cross in Jerusalem, had it assembled, along with other symbols of the Passion, into a most singular throne, which Piero has amused himself by depicting, for the "entertainment value" to be got out of the perspective, at the extreme right of the composition.

It would strike us as sheer laziness were anyone to explain the diminished degree of aesthetic satisfaction offered by this *Defeat of Chosroes* [fig. VII, 25-27] as the consequence of Piero's having embarked upon the admittedly difficult undertaking of representing a nearly inextricable tangle of bodies. To the trained eye, the really cogent reason is to be found in the painting's failure to maintain a uniform level of quality throughout; since the superb quality typical of Piero himself is to be seen only in a very few passages, it follows that the translator of his ideas, by visibly relaxing the taut syntactical precision of the zones of color, has robbed the picture of the highest degree of perfection. And we would go so far as to hope that those able to look beyond these moments of slackness in order to restore, in the mind's eye, the autograph text as imagined by Piero, will recognize that here, by a hairsbreadth, Italian art has just missed producing a worthy rival to the famous *Battle of Alexander* painted in ancient times.

One should bear in mind that this "almost incredible mass of the wounded, the fallen, and the dead," as Vasari calls it, is made up of no more than forty or so combatants; this realization will make clearer the subtle thinking of an artist bent, unless I am mistaken, upon providing a visual demonstration that the complexity of such a composition would result not from the sheer number of figures, but rather from the augmentation, in a practically geometrical progression, of a small number of intervals that, simply by maintaining appropriate relationships of measurement, can induce in the viewer the clarity needed for a calm contemplation of the event.

Anyone who looked to the *Defeat of Chosroes* for an advance in the

Roberto Longhi

impression of movement as compared with Paolo Uccello's scenes of the *Battle of San Romano*, or Piero's own *Victory of Constantine*, would surely be disappointed. If movement means expression by means of the self-propelling vitality of an ever-mobile line, then here there is no movement to be found, save for gestures locked in by broken corners and sharp turnings. However complicated the web woven upon the loom of surfaces becomes, you will be able to detect, at most, the transition from a circular to a polygonal outline, not to continuous motion. "Fugued" though they be, the segments of the interconnected surfaces seem to exist only as supports at the edges of the nearly Pelasgic blocks of coloristic masonry.

"There is a rapture of spears and drums" ["V'ha rapimento d'aste e di tamburi"], as Raphael's father, the painter Giovanni Santi, is said to have noted in a verse that is not half bad; and yet the view of this vast stageful of combatants produces a sensation of great stillness.

Against the enormous tent of blue sky are displayed, immediately and simultaneously, clouds and coats of arms; next, above the heads in the wall of warriors, come lances, tubas, maces, battle-axes, and broadswords, issuing forth in involved yet intelligible theorems; still further down, the battle is arriving at its decisive moment, and the great pattern it forms grows progressively denser, like a hedge where a peasant is filling in the gaps. To be sure, in the foreground there are single combats similar to those in ancient Greek sculptural groups; but just overhead is an ongoing intersection and superposition of colored shapes. In this jostle of gestures, one sees dark heads standing out starkly against the rumps of white horses; vanquished and victors, in frontal view, profile, *profil perdu*, stare one another in the eye at close range; and weapons are brandished across accoutrements like just-lowered drawbridges. The tightly controlled gestures, angled or straight, interlock firmly with harnesses and liveries, and form, just as these do, bits and pieces of the chromatic composition, as though they were all pieces of a puzzle: an example is the passage between an arm dealing a blow and the man falling with his throat cut in which there appears the impassive, emblematic moon-sliver curve of the white horse and, just above it, the coat of arms on the banners.

Here Piero was probably pausing to establish, and practically to classify, a handful of definitions of exotic races and of gestures expressive of emotions; if even the most atrocious instances are treated with noble restraint, within certain gaps in the wall of combat, surely, there are still to be seen unseemly grimaces, and profiles somewhat exaggerated in the interests of incisive characterization. We must conclude that here too we are dealing with the inadequacies of the translator who, while following Piero's cartoon closely, has had ample opportunity to lower significantly the quality of the entire compo-

sition, save for that one-third of it or so executed by the hand of Piero himself.

To be precise, we detect Piero's hand in the group of warriors on the left, who possess, in fact, the same clean sharpness as Constantine's cavalry, even though, in the present painting, they are disposed more picturesquely, and in less of a parade-ground order. The figure of the trumpeter [fig. 26] in the large white conical hat, his hand foreshortened as it holds up the trumpet, and the pair of young warriors with Ethiopian features [fig. 27] are two supremely fine passages. But right nearby, in the same register, the quality deteriorates in the white-haired rider waving his lance who is placed alongside Heraclius. The same thing occurs in the foreground: of those two youths holding bossed shields and engaging in a sort of gladiatorial show, the one on the right displays far less pictorial subtlety than his companion. Nearer the center, the episode of the Christian seizing the barbarian who sues for mercy with the Classical gesture of the defeated Scythian is, as painting, far too coarse to be ascribed to Piero, despite the excellently rustic flavor of the bluish shadow cast by the white dish of the helmet on the old soldier's face—a fine trope, reminding one irresistibly of some Umbrian peasant working in the fields.

The artistic quality sinks even lower as we move to the right. Over the outline pounced by the master small errors of measurement and slight cloudings of the solar liquid appear: blemishes sufficient to produce an impression of stiffness and coarse coloring. There are superb ideas behind the figures of the warriors occupying the background; yet the extent to which the painting has become a matter of sheer routine is apparent in the awkward hand of Chosroes's son and the grossly chalky lighting in the beheading of the Sassanid king. Piero has not deigned to apply his brush even to the portraits of his Aretine patrons; if he has done so at all, it is only in very small areas.

The master's own hand reappears, however, in the greater part of the lunette depicting the *Restitution of the Cross to Jerusalem* [fig. VIII, 28-30], in which the artist personally brings this cycle of the most outstanding episodes surrounding the holy wood to a conclusion. We have already seen the cycle open, on the facing lunette, with the moment of Adam's death; now Piero closes it with a solemnity only slightly inferior to that found in the initial scene.

Although the subject here is a strictly ceremonial one, even less than in the lunette with the Adamites can we speak of a centralized, symmetrical

Roberto Longhi

composition or of rhythmically counterpoised parts. The center is occupied by a deep hiatus of barren landscape; while the composition, in its equilibrium based on color alone—so different from those purely abstract and arbitrary solutions often derived from nothing but relationships between figures—is in a state of ongoing development off to the sides, such as is typically to be seen in the Cinquecento painting of the Veneto. Here there is nothing abstract about the way these inhabitants of Jerusalem rest against the the broad background, or about the continuous linkages-by-juxtaposition of figures, plants, and wide expanses of the dark-shadowed wall, which is pulled back so deeply into space as to run up against the sky inlaid with the usual segments of cloud.

That grave and solemn line of priests following in Heraclius's train constitutes one of the most nobly eminent processions ever seen on Earth. Here once again the figural group is controlled through the science of full or broadly rounded intervals. Note, for example, the escutcheon-shaped space between the two priests crowned with conical headdresses: possessing the rich beauty of an ancient cantharus, it is created by the outlines of two poses that, far from being identical, are each other's inversions.

Is it permissible to draw attention in this work to the point where Piero, in his pursuit of illustrative effectiveness, seems to have insisted too much upon solemn religious symbolism? Unless we are mistaken, it is his love of the latter that has induced the painter to crown the mitred bishop who follows immediately on Heraclius's heels with a bifurcated tree, as though the man were a large sacred stag or some Nordic hero. We hope to be forgiven what may, after all, be merely a matter of personal taste, if we suggest that Piero has been needlessly heavy-handed here in his emphasis upon a symbolic coincidence.

Let us return to the more genuinely pictorial import of the scene. We should point out the element of abstract beauty—like that of a shaded sphere—in the delineation of the young priest's face, fixed at the same point of rotation that will shortly afterwards be chosen by Antonello da Messina when he comes to paint his sublime portraits. We should note, as well, the many-faceted beauty of the Bishop's purple draperies, where the branching folds of Florentine art seem to compose themselves into a brand-new crystalline structure similarly destined to constitute a future example for all those painters from the Veneto still in their boyhood at the time Piero is working (and which does, in fact remind us irresistibly of the diamond-hard points in the draperies of the Vicentine artist Montagna). Last, let us draw attention to the admirable melding of gesture and stationary pose, action and stillness, in the two priests who, arm in arm, bring the procession to so natural a close.

The first of the pair, turning as if to make some comment regarding the proceedings, shows us his back; and his simple white cassock possesses a luminosity legible in the transparency of the shadows and reflected highlights, similar to what we have observed in the figure of the turbaned Oriental in the *Flagellation*. This priest's face, too, reduced to the sharpest possible quarter-view and crowned with a hat like a turret, has the abstract outline of an object whose beauty must be described using some epithet to be sought within the vocabulary of pure form. His companion, on the other hand, seen in full profile, reacts to the other's question with an imperceptible reflex movement that confers upon the profile itself an almost animal nobility such as no one but Piero has ever given to a human being without dragging him down from his privileged rank in the social order.

To the right, forming a compact and well-proportioned group [fig. 28], the devout of Jerusalem have fallen on their knees before the approaching Cross; their profiles are shown in varying degrees of intersection, so that each one seems practically to help complete the definition of its neighbor, without, however, influencing the firmly grounded mass or taking on any individually expressive dominant role. In the head of the lean, clean-shaven youth behind the white-bearded old man, for instance [fig. 29], we think Piero has struck an excellently delicate balance between the need to imbue a profile with the energy necessary for its adequate characterization and the overall color-composition's requirement that every last residue of "draftsmanship" be refined away; here the last traces of graphic line echo as sheer notes of tonality. Last, in the latecomer about to uncover his head [fig. 30], we have a desperate and exemplary riddle of the "synthesis of form and color": the man vainly seeks the roundness of his great turret of a hat, reduced by its whiteness to a flat ivory inlay against the distant walls.

The pictorial decoration of the choir at Arezzo is completed by several individual figures who form a sort of marginal annotation to the large-scale scenes we have been examining. Two of them appear in the irregularly shaped areas to the sides of the large window; others function practically as painted pilaster strips adorning the spaces near the entrance to the choir; and there are two more on the entrance under-arch, where Piero had only to complete the portion begun by Bicci di Lorenzo, who had, by that point, already finished frescoing practically the entire vault—although this last is itself a zone in which it is possible to discover two additional heads inserted by Piero.

In accord with their placement in the irregularly shaped spaces next to

the large window, the two grandiose figures of *Prophets* are, like all the scenes in this zone, side-lit out of an interest in "optical realism." The one on the left, however, who has sometimes been identified as Jonah, is rather feebler than the other; the handling of the folds in his draperies leads one to suppose an involvement of the same assistant who had been entrusted with the predella of the *Misericordia Polyptych*. The other figure, much more powerfully painted, is, we believe, entirely by Piero's hand, except for some restored areas in his costume. His head, beautifully poised upon an indescribably rounded neck, has a new-minted purity related to that of the fair Oddantonio in the *Flagellation*; while the draperies, in their practically mountainous plasticity, recall the finest passages in Masaccio. So do the feet, shown in a less measured and perspective-dominated foreshortening than usual, and bringing strongly to mind the feet of the Sebastian who represents the most Masaccesque saint in the whole of the *Misericordia Polyptych*.

Of the four Doctors of the Church, the two located where the undersurface of the arch meets the piers are certainly by Piero himself. These are *Saints Ambrose* and *Augustine*, both of the same rude family as the San Sepolcro *John the Baptist*. Ambrose, draped in white and pomegranate, brutally stretches out one hand in an illusionistic spatial foreshortening, while his head repeats a type already met with in one of the Adamites; but Augustine is delicate in his roughness, thanks to the pearly hues of his tunic and the white-lined green of his mantle. His head is perhaps the best-preserved passage in the entire Arezzo fresco cycle.

It is also customary to attribute all the figures on the pilasters to Piero; but such an opinion can in no way be accepted for the *Saint Louis*, whose execution seems to us to betray the hand of the untalented Lorentino, nor for the blindfolded *Cupid*, certainly the work of a very weak assistant, and in dreadful condition to boot. The only passages surely by the master in this zone are the *Saint Peter Martyr* in the decorative strip on the left and, on the right, the *Angel*, apparently meants as a representation of Divine Love (and thus as a counterpart to the Cupid). Although both figures are horribly mutilated, the few patches remaining show such a wealth of painterly ability and, thanks to this very "painterly" quality, such an utter annulment of any trace of the kind of preparatory drawing procedures whose material remains we have noted in other parts of the cycle—in the *Death of Adam*, for instance—as to lead one to believe that here, even more than in the *Victory of Constantine* or the *Defeat of Chosroes*, Piero's art has reached the latest and most extreme form it takes anywhere in the Arezzo cycle.

The magnificently cubical volumes of Saint Peter Martyr's head are, in effect, obtained more or less directly by an opposition of tones; it is not over-

stating the case to say that here we have already traveled farther down this particular artistic road than we will in the figure of the same saint painted by Giovanni Bellini for the town of Monopoli some twenty years later; with Piero's version, we have already reached the threshold of Giorgione and Titian.

The angel on the opposite side is also made more directly out of color than is usually the case. At the same time, he is more magically permeated with light than is, for example, the very beautiful prophet discussed above; and this difference leads us to date the prophet to the beginning of Piero's work at Arezzo.

These observations lead us back to the need to underscore the variety of handling manifest in the Arezzo frescoes, despite their superb "optical" unity. If we cautiously treat this variety with the reagents of historical circumstances, taking Piero's fundamental personality as a constant, we may, perhaps, succeed in discovering something about the evolution of the painter's artistic thinking during those years; and this, in turn, should suggest some ideas regarding the sequence in which the various parts of the work were executed.

At bottom, this is only a matter of making further use of certain observations that have already fallen naturally into place while we were looking at the individual pictures. For example, let us remember that if it is easier to detect certain distinctly Florentine ingredients in the draftsmanship of the two uppermost lunettes with the *Death of Adam* and the *Restitution of the Cross*, this is because, at the time Piero was painting these scenes, he was busy subjecting such elements to his own peculiar process of "purification," trying to reduce them from energetically vital signs to simple outlines delimiting divisions of the surface—which is, in fact, precisely what he was to succeed in achieving, bit by bit, in the subsequent frescoes. In the *Meeting of Solomon with the Queen of Sheba* and the *Invention of the Cross*, we find a greater fullness in the suture of the volumes, accompanied by a more broadly sweeping use of color. But even in these last-named scenes, there persists, here and there, an insistence upon dark and heavy tonalities, and we encounter some nodes of intensified chiaroscuro. All this still recalls Masaccio to some extent, to say nothing of the reminders of Brunelleschi and Alberti in the conception of the architectural settings. It is when we get to the lower register, with the *Victory of Constantine* and the *Defeat of Chosroes*, the *Dream of Constantine* and the *Annunciation*, that volumetric and chromatic tendencies are wholly merged in the "prospective synthesis."

Unless we are mistaken, portents of further developments are to be seen in the extreme left-hand portion of the *Defeat of Chosroes*, in the ferocious group of armored riders upon armored steeds: here we have greater freedom of arrangement and a more intense and particularized way of painting. The

light on the armor is mobile, bold, and wandering, as in Titian or Velázquez; while, in his method of scoring, the painter now seems to assign a few points less to the metrical strictness of the underlying structure. To return to our point of departure, the same observations also hold good for the *Saint Peter Martyr* and the *Angel of Divine Love*; and this shows us, more or less, the point where Piero finally lifted his brush from the wall at Arezzo.

Of course, when evaluating these observations we must constantly bear in mind, as well, our awareness of the collaboration, on more than one of the frescoes, especially among those on the left wall, of the assistants whose presence we have already noted. In other words, we must distinguish between the areas where the "drawn" or "coloristic" treatment reflects the master's intentions and others where the handling must be ascribed to an assistant. It will be readily understood that an assistant, when following in a literal manner an outline pounced by Piero, might tend to treat the latter's seemingly linear indications—meant by the master to denote, instead, an invisible suture—with too heavy a hand (as may be clearly seen, for instance, in several passages in the *Defeat of Chosroes*). Contrariwise, in following the master's coloristic indications, an assistant might interpret over-literally the manner in which Piero's hues lie "on the surface," and thus be led into changing their lightness into something like a primitive print closely resembling a playing card; this effect, too, is evident in certain parts of the *Defeat of Chosroes*.

Do not, dear Reader, mistake for shifts in Piero's own art the variations resulting from his followers' greater or smaller failures to match the master's own quality; it is, in fact, precisely through understanding variations of the latter sort that you will succeed in taking the true measure of changes expressing the master's own development.

Having pointed out, however summarily, the development traceable in the Arezzo frescoes, let us now, before leaving these works, return to our earlier statement regarding their overwhelming unity, even when viewed from afar. I refer to that broad vesture of color that makes them, above all else, a new world in comparison with the frescoes of Masaccio.

Since the aesthetic impact of color is, however, even less capable of being expressed in words than that of form, we shall confine ourselves to a few brief remarks, in the manner of a list; such remarks may be more confidently entrusted to the reader's discretion than any uselessly effortful metaphors vainly presuming to add more fuel to the fire already burning perennially in the vocabulary of color itself.

Putting matters briefly, one feels it necessary to leap back over many centuries in order to pose a question that arises at the outset. Should not a history of color begin with two possibly hidden sources? One is a Nilotic, high-noon color scale; the other, a nocturnal and lunar scale, belonging to the Asiatic East and visible even in the civilization of Mesopotamia. One might then go on to a consideration of the historical mediation between these two scales that began with Greek and Hellenistic culture, continuing, with infinite variations, down to the end of the Italian Trecento; although it seems clear that, as that century ended, the Oriental harmonies had the edge.

At this point, one would find most tempting the thesis that Piero, in some obscurely atavistic way, had revived the scale the ancient Egyptians had originally spread throughout the Mediterranean. But since real history calls for a far more perfectly developed system of joints and articulations than this, the most probable supposition must be that Piero's "return" in matters of color is, in reality, one more expression of his utter independence; the apparent "kinship" is actually, instead, the result of a similarity of sensibilities that also involves form. The "shape of color," as expressed in the perfect calibration of a hue's extension in relationship to contiguous zones, reveals itself to both Piero and the Egyptians as the natural result of their representation of bodies as "demonstrations of surfaces," in accordance with the laws of an uninterrupted production of volumes. In Piero's art, as in the Egyptians', color is thus enabled to "rest" gently upon continuously extended surface zones of equal importance.

We have already said that Piero's color tends to "quarter" itself heraldically upon its field. One might be tempted to suggest that the breadth of his fields of color is derived from some mysteriously learned school of heraldry, whose business it was to think out the most effective visual solutions for the vast coats of arms of whole nations, or families of the most ancient lineage. Probably, though, the reverse is true: it is Piero's spacious chromatic beauty that turns up, freed from even the most summary connection with volume, in the work of the artists who colored shields, caparisons, and coats-of-arms.

Let us return, however, to the history of painting and color in the period we are discussing. Ask anyone to tell you the color of the Brancacci Chapel, and you will be told: a single earthtone, a color as susceptible to modeling as clay, a monochromatic constant.

But who, at the moment of departure, can help turning around one more time, from far off at the beginning of the nave, to bathe once again in the harmonious serenity, already freed from any link with representation, that pours forth uninterruptedly from the colored walls of the presbytery at

Arezzo?

The vast, light-blue sky, gently warmed by the white of cloud-banks, in the *Death of Adam*; the flesh tones of the Adamites, faintly suffused with pink and then immediately veiled, as though viewed through some luminous and diaphanous gum; the quicklime of white hair and beards; the gleaming ebony of dark heads; the great black blotch of the Oceanian girl's mantle.

In the *Meeting of Solomon and the Queen of Sheba*, the enormous heraldic devices of trees against the azure field of the sky, and the quarterings of sable and vert mountainsides; to the right, the squarish occupation of space by variegated and ashen marbles, creating a diorama-like box for human figures who turn back their cloaks to show the linings, in a fine display of complementary colors. The youth in a green mantle offers us its rich red underside, in juxtaposition with an old man in porphyry. A pinkish elder puts in an appearance. Reds, whites, and blacks on triangulated buskins. Solomon in ivory and blue, with light-green markings. The Queen of Sheba in white. Her first lady-in-waiting in a grass-green robe; and then grays, pink, violet. Steeds and grooms are disposed in reversed colors, as though quartered on a coat of arms; then come sloping trains, in various shades of white, light turquoise, pomegranate, or earth green.

The *Victory of Constantine*: once again, the cloud-sashed blue sky, awash in pink and yellow banners boldly stamped with heraldic devices; the enchanted traceries of gray, white, pink, and black lances; the big horses, white as Parian marble, or amaranthine, or blue-black as swallows; saddles and cruppers of evergreen or cochineal red; cuirasses turned to silver by a bit of gray and a touch of lead white, or to gold by a little yellow; white lime sun-drenched in blue liquor or plunged in amber shade. Maxentius flees, in deep-blue sleeves, upon a pink-saddled bay horse; the white-garbed trumpeter is sashed in red. We mean that, *similia cum similibus*, these affinities are forever revealing themselves, stupendously, between the lightest and deepest hues alike: rose and bay, black and violet. And we think the credit goes to that moderately warm veil that covers them all impartially, like the unnoticed circulation of a gentle extract of sun.

Not far from the Arezzo frescoes there are several other wall paintings by Piero to be seen; these should, perhaps, be thought of as having been finished during the pauses that must naturally have occurred during the execution of so vast a project. In a certain sense, they confirm the opinion we have expressed regarding the sequence of developments visible in passing from one

register to another of the Arezzo cycle.

We refer to the *Madonna* at Monterchi, who seems to comment upon the most "draftsmanship-oriented" moment in the making of the frescoes; the *Saint Luke the Evangelist* in Santa Maria Maggiore at Rome, whose style seems to match the point reached in the second order at Arezzo; the *Resurrection* at San Sepolcro, which alludes to the artist's fully developed Arezzo manner—without, however, as is usually suggested, containing hints of things yet to come; the *Magdalene* in the Duomo at Arezzo, who seems to go just a little beyond the latest among the San Francesco pictures, or, more precisely, to start out from almost the very same, sumptuously "painterly" point at which we have left the *Saint Peter Martyr*.

We would exclude from this group, which may be assumed to cover the whole decade of the 1450s and bring us down to as late as 1465, the design of the *Saint Louis* now in the picture gallery at San Sepolcro; its original date of 1460 and generically Piero-like stylistic characteristics are insufficient reason for accepting an attribution to the master of a work that was always rather feeble, in the manner of Lorentino d'Arezzo, even before reaching its current state of ruin.

<center>*******</center>

In the *Madonna del Parto* [fig. 12], painted for a rural chapel in the fields near Monterchi, Piero devised a composition at once very simple and, in the way that pleases country folk, suggestive of noble courtly ceremony. How natural the rustics must have found the gesture of the two angels who draw apart the two panels of the curtain, a gesture in which Piero did not hesitate to turn one pounced angel into the other's echo by simply flipping over his cartoon! Yet there is an admirable purpose in the gesture's having been so conceived; in each angel, the lowered arm and falling curtain act as catheti to the hypotenuse of the other arm, raised to support the curtain and lift it "high as high can be!"

As for the Virgin, less Isis-like than the *Madonna of Misericordia*, less Junoesque than the annunciate Virgin at Arezzo, she puts to rest any doubts the peasants may feel about the reality of her pregnancy by appearing, no longer frontally, but in a three-quarter pose where the rounded curves of her full robe speak plainly enough. Majestic as a king's daughter beneath that ermine-lined pavilion, she is, nonetheless, as rustic as any mountain girl standing in the doorway of the woodshed.

The hand resting on her hip, and the other one pointing to her lap, both of a restrained and wooden stiffness, make gestures of a melancholy puri-

ty. The insistent contour of the weasel-like face lends the figure a subtle, disproportionate grace, touching a note unusual in Piero but not, perhaps, utterly unique: something like it has passed into the clever frescoes painted at Palazzo Schifanoia by the painters of Ferrara, where the sources for this note were, one presumes, Piero's now-lost works in that city.

The *Saint Luke*, the only figure still legible among the four Evangelists who once decorated the vaulting of a chapel in Santa Maria Maggiore at Rome, a space today reduced practically to the condition of a storage area, agrees perfectly, as we have said, with the style of the "second order" at Arezzo. To us it seems precious, in part because it helps us imagine how Piero might have ornamented the vault at Arezzo, had his patrons there only permitted him to replace the tired and clumsy Evangelists by Bicci di Lorenzo.

The ground is of the star-specked blue so dear to Roman taste, still under the sway of Fra Angelico's ultramarine, that hue constituting so sweet a mediator of Paradise; but here it already bears ornaments as beautiful as any on the most exalted Doric acroteria. Upon it appears Saint Luke, the earliest example of that grand art of synthesis that was to hold the field in Rome for a quarter of a century, until—to be precise—there arose a babel of figurative tongues amongst the decorators of the Chapel of Sixtus IV.

Seated solidly upon his chair of clouds, the figure of the Evangelist is draped in a tunic still smacking of *terraverde* and a mantle that—thrown back in the usual manner over the shoulder, so as to display the lining and form a measured passageway for the arm engaged in writing—falls in excellent folds about those legs so firmly poised on air. Here and there, where the color has fallen, the figure reveals the naked beauty of the preliminary drawing, which the artist seems to have limned, on this occasion, directly on the plaster, with no pouncing. The hands that once held open the inscribed scroll, now utterly vanished, are among the most beautifully constructed Piero has left us; the Evangelist's symbolic ox has the pale strictness of an Apis; the Saint's own head is as granitic as that of an Osiris; and, from the volume of his face, his eyes and eyebrows stab and pierce with the same astral cruelty of rotation in space later employed by Antonello da Messina in portraits such as the one in the Trivulzio Collection.

We think this the appropriate moment to recall, as well, the Borgo San

Sepolcro *Resurrection*; while usually dated later, perhaps because of the influence of a passage in Vasari, the work seems to us not only to match up well with Piero's mature Arezzo style, but even to precede it by a bit.

Here once again, Piero has been called upon to portray a scene—the most triumphal scene of them all—from the Christian myth; and he has apparently fulfilled his task without diverging much from the traditional staging. Nonetheless, the new wholeness of Piero's painted world and the hidden strictness of his spatial laws have necessarily led him to a triumph far different from any won, before or since, by all the more devoutly facile painters who have followed a similar scheme.

The scene is set between the barely suggested stage-wings formed by a marvelous architecture of Corinthian columns. Beyond these, upon a ground tender, brown, and mottled as though at some inclement transitional time of year, arises the Christ: a horrible, nearly bovine woodland creature who, standing at the rim of the Sepulchre, broodingly contemplates, like some grim Umbrian peasant, his own worldly acreage.

The erect rigidity of that Stoic effigy, impassive and ineluctable within the landscape's surpassing gentleness, succeeds in evoking, most naturally, all the other images the artist wished to call up. Even today a cultivated memory, faced with such an apparition, still returns spontaneously to the most solemn representations of the Pantocrator: from the one in Santi Cosma e Damiano in Rome to the one at Monreale in Sicily, and that other one by Cavallini at Santa Cecilia in Trastevere; until, after passing under the relentless stare of the "Ottonian" emperors, one arrives at the mitred God the Father reigning at Ghent.

Nonetheless, such vague resemblances of sentiment and outward iconographic affinities are—always, and above all here—as nothing to the differences created by the peculiarities of individual form. Piero's Christ is at once more immediately naturalistic and more profoundly abstract than all the others. Owing to altered emotional circumstances, this frowning, sunbaked farmer now finds himself involuntarily transformed into a symbol of salvation. But it is the new imaginative stance of Piero's genius toward rigorously formalistic representation that produces such a purification of the image as may turn rigidity into measure and art; only thus can that staring head become the horrible yet supremely appropriate culmination of a sublimely proportioned body whose live flesh, of the rarest ivory, is draped in a toga that, while undoubtedly Classical, is tinged with a fresh and rosy bloom such as ancient painting had never known.

We will not deny that this Christ, alone in some unrealistic space, would turn as grimly fetishistic as the *Madonna di Misericordia*. But how can

we ignore that pacification of the emotions brought on by the measured certainty of a painted depth that flows into every least curve and corner both of the surrounding spectacle of the landscape and of Christ Himself? The thing depicted becomes one with the painting. Now there appear, delighting our gaze, the wound in His side, precious and useless as a scarlet seal, and the amber sunbeams that play upon the bared torso, turning in the air like some great block of polished stone. One after another the manifold beauties of color's precious substance are displayed, in those winding hollows of violet shade that Christ's heavy fingers seem to dig out of the knee of His toga. Victims of illusion, we tremble at that risen foot resting so near us, and, in such a foreshortening, upon the Sepulchre's rim. And here are the four sleeping guards, smitten from the side by an invincible flood of sunlight that describes them with desperate clarity, like pit-orchestra players caught napping during a break in the music.

And if, at first glance, these four armored figures seem just to have dropped where they were at the moment of Christ's Resurrection, as though they were four sections of a piece of fruit, one quickly spots in them the same principle of stupendous metaphorical naturalness also apparent in certain passages at Arezzo. To be shown sleeping with one's face in one's hands, or resting on one's side, or lying on one's back, or clinging to a lance for support, is not, in itself, the same thing as expressing an invincible fit of agonized desperation, born of the hearing of secret things, nor yet a state of utter beatitude; these, however, are what Piero captures in the various sorts of sleep. Nor could this metaphorical naturalness have ever manifested itself in types, if not by means of this free synthesis of the colored spaces, where forms show themselves in perspective to our gaze.

Thus it is that the sleeping guard on the left offers an almost schematic profile motif in a simple relief that brings to mind the figures on the sides of the *Throne of Venus* (Ludovisi Throne). Volume is promptly restored, however, first by the precisely calibrated depth of the shadows cast by the folds and then, even more importantly, by the freedom of relationships through which this figure, so far from encountering matching rhythms on the opposite side, is instead put back into circulation, as it were, in a manner different from the other figures: it links itself abstractly in depth with the intervals formed by the variegated and white marbles of the sarcophagus. As an instance of sheer beauty in the intersection of colored shapes, note the play of the buskins at the center, which are like fragments of a puzzle. Their meaning becomes clear at the moment when, partly raised above the ground, they leave upon it their long footprints of shadow. One is uncertain whether the use of color by means of which all this is achieved is more "cultured" or "popular." A mantle of grass-

green turns to brick red; then come zones of red, green, and bay, as in pictures on tarot cards. Remember too that these simple relationships are quickly altered to other, more cultivated ones by the rosy reflections issuing forth from the figure of Christ and seeming to touch even the crocus-hued clouds in the sky.

In such chromatic solutions, too, the miracle seems to become a natural event; and yet, they present themselves to the viewer's mind only after having been tinged with Piero's new and singular formal refraction. So it is that, despite our initial suspicion that it is through mere artifice that Christ's Resurrection coincides with the breaking of dawn over the still night-dark Umbrian hills to which He brings His intensely rosy illumination, we are now, instead, calmed and satisfied by the multiform yet unified perfection of the style that Piero has so slowly and lovingly communicated to us by means of so many signs. We cannot tear our gaze from the view until we are sure of having read the visual message conveyed in every fold of this work.

In the fresco in the Cathedral at Arezzo, Piero was meant to set *Saint Mary Magdalene* before the adoring eyes of the faithful. What he did instead was offer us an imposing, tower-like form, whose structure and strict verticality are, so to speak, symbolized on a smaller scale in the simple shape of the alabaster jar the saint carries, in order that we may compare it with her own shape. This vase rests upon the base of her perspectively foreshortened hand in just the same solid manner in which the figure, so one senses, stands firmly upon the ground. The figure itself would, in fact, appear perfectly immured within its heavy cloak, with no variations in the integrity of its columnar volume, were it not for the way the garment is suddenly turned back over the shoulder. Yet the cleanly opened breach in the wall of the cloak (promptly closed up again, in part, by the hand lifting the hem below) allows the eye to enjoy both the arrangement of smaller volumes enclosed within greater ones—through the square opening, the viewer discerns the massive column-section of the body in its fluted robe—and the astonishing, unexpected, yet utterly calm display of colors. In accordance with a procedure we have observed in other instances, the calculated throwing back of the cloak here turns its white lining into a coloristic "outer surface." The figure as a whole thus takes on a veiled, three-toned appearance; viewed through the milky atmospheric mists, the pomegranate-red garment, with its white reverse, and green robe girded in a lighter hue give the figure the look of a pennant lowered by one-eighth from its masthead.

Our mention of the atmospheric veil surrounding the Magdalene already supplies us with a clue to the place this fresco occupies in the series of Piero's paintings. A closer view of the head quickly reveals that it is modeled almost entirely out of tones; we have already seen Piero using such an effect, if not quite this boldly, in the *Saint Peter Martyr* who forms a marginal note to the frescoed stories of the True Cross. Here the contrast produced by the juxtaposition of the white of the curved cheek with the black of the hair is so immediate that it comes close to producing a detachment between planes and dazzling the viewer's eye; the same immediacy of black on white recurs in the deep black locks of hair heavily brushing against the bare throat or standing out starkly against the sky. Our astonishment knows no bounds when, upon examining the pounced outlines of these locks, we discover that Piero has worked out, formally, even such niceties as these! Who would not have felt practically certain, at the outset, that these locks were no more than fanciful touches, suggested by a brush heavy-laden with black paint? Who will not marvel to discover that just the opposite is true and that the painter has only arrived at these touches of substantial, material beauty after careful reflection, employing them as a means to warm up the figure's formal strictness? Thus it happens that the cautious commentary embodied in these deft tonal notes detracts nothing from the beauty of the greater volumes.

It is worth noting how well this saint exemplifies the way in which Piero was able to bring the sentimental traditions tending to accrete around Christian legends within the framework of his art's stylistic necessities, thus avoiding any accommodating inclusion of human types other than those already identified, in a sense, with his painting. Sensuality and a sweet nostalgic longing for past sin are shut outside this Magdalene's walls; there is absolutely nothing to be recounted or reproved regarding the present and, it may be, even the past life of this pure monument to peasant nobility. There can be little doubt that were it not for the little alabaster jar constituting, in the Christian iconographic tradition, her identifying attribute, a Catholic viewer would immediately be disposed to call her a Saint Barbara. We would even venture to suggest that, had Piero ever been commissioned to transform the Magdalene into Barbara, he would have done no more than turn the little alabaster jar into a little round tower, leaving all the rest unchanged. You may draw for yourself the natural consequences of this proposition.

In closing, we wish to emphasize that the family relationships of this saint must be sought not in the realm of hagiography, but rather in that of form, which is itself a domain of the spirit. She is, indeed, because of her mass, the granddaughter of the Giottesque Magdalene at Assisi; and yet, less harsh and more tower-like than the latter, our Magdalene was herself born at

Heliopolis, and is therefore the ancestor of those generously shapely heroines among whom Palma's Vecchio's Saint Barbara will assume such an outstanding place fifty years later.

The *Hercules*, formerly at San Sepolcro in a house belonging to Piero, and now exiled to the Gardner Collection in Boston, seems to us too damaged to allow any deep scrutiny of the artist's intentions. Originally complete, this gigantic figure is now cut off above the ankles. The absence of the other, equally famous mythological personages who once accompanied it prevents us from learning whether it was only the single instance of the god of strength that here tempted Piero into exaggeration, as a result of his desire to differentiate the figure from the surrounding ones by expressing in it, as obviously as possible, the outward signs of an overwhelming physical energy.

We say this because, in its present state, the outline of the figure strikes us as unusually busy; although it is true that the powerful demand for modeling seemingly expressed by so forceful an outline is, to some extent, satisfied by the rare material, like Pentelic marble, of which the figure seems made. One is thus tempted to interpret the work in terms of a composite canon derived from Polycleitus and Lysippus; but perhaps it will be more useful to consider that the background, where a few broad horizontal bands are still to be made out, once served to re-establish the regular "grid" that would have kept this overly nervous giant within bounds. The latter hypothesis finds additional support in the beautifully thought out expansion of the Nemean lion skin into a nearly circular orbit in which the display of the skin's lighter-toned reverse dilates the field of the hero's thorax, giving rise to a single great roundel of relaxed brightness.

These variants of the "Arezzo style" were also, in part, prompted by a new figurative impulse, as becomes clear when we look attentively at Piero's last known group of works. This group covers about fifteen years, from 1460 to 1475; although we know that, as late as 1478, Piero painted a *Madonna of Misericordia* (a picture whose preciousness to us would be further enhanced by the possibility of comparing it with the artist's youthful treatment of the same subject), we possess no unquestionably authentic work dating from after the period discussed above.

Our knowledge of Piero's art in these late years is, in any event, ham-

pered by other, far more serious losses. Let us recall, for example, that around 1460 he was in Rome, possibly for the second time, in order to work on the [Vatican] frescoes that would later make way for those by Raphael; not a trace of these works of Piero's has come down to us.

So we must restrict ourselves to the few surviving works. After first turning our attention to the somewhat disfigured polyptych now in the picture gallery at Perugia, we shall continue, in chronological order, with the very famous diptych, now in the Uffizi, showing the ducal couple of Urbino; the *Sinigallia Madonna*; the *Nativity* now in London; and the votive altarpiece with the portrait of Federigo da Montefeltro now in the Brera in Milan.

In painting the *Perugia Polyptych*, perhaps during a pause in one of his journeys along the road from Borgo San Sepolcro to Rome, Piero once again—more than ever, in fact—found himself fettered by an excessive number of physical givens. The artist was certainly offered the panel only after it had already been mounted in its late-Gothic frame and gilded by some Umbrian artisan. It seems clear that the nuns of Sant' Antonio wanted a votive apparatus where the articulation into compartments was to be inspired by what Fra Angelico had done more than twenty years earlier in his polyptych for the Chapel of Saint Nicholas in San Domenico in the same city; they must even have urged our painter to dispose his saints in a scheme similar to Angelico's.

Furthermore, Piero was directed, for reasons involving the space where his handiwork was to be displayed, to top the tripartite panel with a large, cusped crowning element having a profile like that of a flight of stairs, where he was to paint the *Annunciation* [fig. X]; however, *superiorum permissu*, this part was to show, in place of the gold-leaf background, a fine painted setting in perspective. At first glance, this scene is so much at variance with the rest as to have led some people into thinking it was originally meant as a separate work and adapted only subsequently for use as a crowning element; however, both the unity of style and the way the scene's perspective center matches up with that of the polyptych below convince us that the contrary is the case.

So Piero set about working out the Perugia altarpiece as best he could, with a humility that would be less surprising had the painter been a Matteo da Gualdo or a Niccolò da Foligno. At any rate, we have already seen that, on an earlier occasion, he had not rejected the effective devotional symbolism of head-on symmetry and had willingly adapted himself to a gold-leaf background: I refer to the polyptych of the *Madonna di Misericordia*. Now, how-

ever, so many years later, he took a step forward, placing the saints at the sides deeper in space than he had done in the San Sepolcro polyptych, out of concern for the third dimension.

These saints look as though they belong to Piero's well-known family. Saint Anthony's and Saint Francis's cord belts still drop with the same white strictness as in the San Sepolcro polyptych; Saint Elizabeth, with her shoulders forming a dome, is of the same voluminous tribe as the Magdalene at Arezzo; and John the Baptist, with his vertical wand, his pointing index finger forming a right angle to it, and the invincible frontality of his head, expresses a conception similar to the one we have seen in the Risen Christ. And yet, when we look at these saints more closely, we see that they have already lost something of the supremely theorem-like beauty that revealed itself at its pinnacle in the second order of the Arezzo frescoes. It is as if color, having grown richer at various individual points within the borders of each zone, were here setting out to produce a greater variety of intimacies within the context of the forms.

For the first time, the feet and hands of these figures and the folds in their clothing show physiological or random irregularities. The whole of the Christ Child's body, for instance, is modulated less abstractly than usual, being treated to an affectionate patina that comes close to turning Him into a plumply Romanesque little boy; the Virgin's hands are more intimately prehensile; her robe falls to the ground in more complicated folds. Even the throne on which the divine group is seated makes a less imposing and perfect bit of architecture than the painted spaces at Arezzo; the new unction of light that falls upon the sculpted roses decorating the curved niche behind the throne (much as the light fell upon the cuirasses in the *Defeat of Chosroes*) and the patina of shadow upon the ornate armrests confer upon this throne the venerable familiarity of some bishop's seat, which the caressing hands of the faithful have, by now, reduced practically to the condition of a piece of household furniture.

Something similar may be said of the *Annunciation* [fig. X], where the bond between figures and architecture is less abstract and more elaborate than usual. Here the little ornamental intimacies we have watched insinuating themselves so tactfully into Piero's youthful works command the painter's attention to a greater degree and end up taking a narcissistic pleasure in themselves. Look, for example, at that slab of variegated marble set so preciously into the wall at the far end of the portico; as for the portico itself, the recession of the columns is a bit too much a game of "perspective solitaire," played only for gratuitous entertainment. The two figures, in fact, seem rather uncomfortably placed against such a background; and yet, the subtly chang-

Roberto Longhi

ing, shifting shades of violet in the angel's tunic, where it puffs itself out around his hips, indicate a more attentive observation, a scrutiny that inevitably has an effect on form as well.

Few conclusions can be drawn today from an examination of the three scenes of the predella, given their damaged state.

In the little picture of *Saint Francis Receiving the Stigmata*, Piero seems to have rethought the traditional Giottesque scheme for this subject while adding a greater truthfulness in the handling of light, the most exquisite aspects of which have surely been lost to us today. At least, this is what we believe may be deduced from a comparison with the other two scenes offering stories of Saint Anthony and Saint Elizabeth, respectively. If, in these, the simple little figures, resembling rude, freshly sawn tree trunks, go about the accomplishment of their predestined miracles with a certain paucity of gesture, there can still be no denying that they are immersed in an environment that is utterly new in its intimacy. Those short stretches of wall gather up, in their corners, a richly familiar and corporeal fabric of light and shade; within the cupboard set into a recess in the wall, this fabric of shadow thins itself out into grayish threads of light. Of course, we cannot expect Piero to take to heart that detail-laden and affectionate kind of interior decorating at which the Flemish painters of his day excelled; for him, a slender vial and a rustic little ceramic vase are enough to suggest, in the sumptuous poverty of an Italian setting, the secret intimacy he was seeking to express with a vocabulary of light and shade.

In part because they so easily lend themselves to comparison with the Saints Claire and Agatha flanking the predella, we think the two little panels from the Liechtenstein Collection [now in the Frick Collection] may be assigned to the same period as the *Perugia Polyptych*. Showing, at more than half-length, an Augustinian monk and a sainted nun, these companion pieces, while clearly displayed against their gold ground, are, at the same time, inimitably modulated in black; they are fierce, calm, and ancient, like figures by Antonello.

We may reasonably suppose that we are now approaching the moment when Piero della Francesca, back in Urbino once again, painted with such subtlety his triumphal diptych of the Duke and Duchess of Montefeltro: a work that may be dated, for various reasons, to 1465 or thereabouts. On one side of the two small matching panels, we see the couple's portraits facing each other; on the other, likewise facing each other, their individual *Triumphs*.

When inquiring as to why the artist has chosen to represent the ducal couple in profile, we should certainly bear in mind the concrete fact that Federigo da Montefeltro, Duke of Urbino, could not suitably be shown in any other view, given that he was missing one eye. At the same time, we must give even greater weight to another reason: namely, that the tradition of court and commemorative portraiture had but little tolerance for any view other than what I should call the "numismatic" profile. This courtly tradition had recently been reinforced by the tendency of Sienese art towards the use of profile in achieving the sort of near-botanical subtlety of delineation visible in works from [Simone Martini's] *Guidoriccio* to Pisanello's *Lionello d'Este*. Nor did the increasing energy and excitability of Florentine line offer any opposition to this tendency. The profile portrait, in fact, held its ground against competition from other modes of presentation throughout the whole of the Quattrocento, as may be seen in the various alternatives employed in Botticelli's portraits; it even reappeared at the height of the Cinquecento, as Pontormo's profile portraits demonstrate.

We trust that our numerous analyses of perspective's impact on art will already have clarified the reasons that perspective representation is precisely the type most apt to free itself from the tyranny of the profile and to seek in other poses, such as the three-quarter view, those means of suggesting natural information most useful for an ideally complex construction of volumes. It is almost superfluous to recall that one such experiment—perhaps the very first—was carried out by Paolo Uccello in the quadruple portrait in the Louvre, today as ruined as it is celebrated. And yet, not even these perspective images, destined as they were to lead, only shortly thereafter, to the triumphs of Antonello's portraits in a three-quarter pose, consistently manage to escape the iconographic necessities (or, if you prefer, the limitations) imposed by the profile. Instead, by treating these necessities as nothing more than a matter of fashion, these images succeed in making possible a different artistic treatment. This is what Paolo Uccello did in the profile in his Chambéry portrait; and this is also how we should understand the apparent profile in which Piero renders the Angel of the Annunciation in the San Sepolcro polyptych, the donor in the little panel in Venice, or the kneeling Malatesta in the Rimini fresco. As we have already said in our discussions of those works, Piero reinforces his effect by presenting the profiles with no insistence upon their linear outline; he shows them not as anything particularly sharp or pungent, but rather as the peaceful outcome of his treatment of the volume of the head as a whole. Instead of a sharply traced outline, we have the natural fruits of a carefully thought out distribution whereby the "lineaments" (a physiognomical term, like "profile" itself, seemingly derived from the specific traditions of a linear

art) are nothing more than the corners or borders of the volumes of the head itself, and hence of the adjoining volumes as well; these various volumes being conjoined, as is Piero's invariable practice, in the flat masonry of coloristic perspective.

We do not think that Piero's intentions in the Urbino diptych were substantially different.

If we look, for example, at the image of [Federigo's wife] Battista Sforza [fig. 33], we find that the fundamental intuition underlying its representation of form resides in the artist's recognition of the opportunity offered by a side view for presenting the head as a section: a vaguely hemispherical "half" inevitably suggesting its complement, in accordance with the natural requirement for symmetry. And in fact, once we have realized that the curve at the top of the head and the prominent portions of the profile coincide at some points with an enclosed circle, appearing, at others, as tangents to it, we shall better appreciate how this suggestion of a sphere is reinforced by the gradual rounding of the ivory temple; the heavy, nearly equine jaw; the ribbon, binding the head from above like a stave in an astrolabe and attracting to itself the precious satellite of the enormous piece of jewelry; and the very cautious suggestion of the planes hinting at the location in space of the eyes and nostrils. Now we can see that Battista's head is indeed, as a verse of Giovanni Santi's puts it, *di tutte virtù lucente sfera*, the "gleaming sphere of every merit." Resting on the black, gray, and gold base of the bodice, ornamented at the neck by a delicately polychromed border, this great vial of misted glass has been unexpectedly blown by the chromatic synthesis upon a ground of sky and earth.

After so careful an analysis, one hopes that the reader will fix a firm divide between, on the one hand, his pleasure in the elegant, Protogenes-like line enclosing the vital spirits of Pollaiuolo's young lady and etching them against the sky in the picture in [the Poldi-Pezzoli collection in] Milan, and, on the other, his understanding of the way in which, in the complex construction of the *Battista Sforza*, the faint traces of line have already been reabsorbed into substance, like ancient scars dating from the infancy of art; in the picture as a whole, whatever remains of line now belongs as much to the contiguous sky as to the face itself.

We shall forego any similar comparison between a profile portrait by Pisanello and the one representing Federigo that now appears before us, where the Duke and his hat are built as a single unit, like the keep of some impregnable castle standing high on the horizon. Or perhaps he is a good-natured Horus, a sort of tame falcon of the Montefeltro region. Piero's old spacious synthesis still reigns in the simple background of sky and landscape, in two

areas of a nearly tropical red in the hat and the tunic, in the sharp-cornered zone of the black-ivory hair, and in the brown fields linking the Duke's red costume with the white of the river.

What is ineffably new about these portraits in the development of Piero's art is that, while remaining true to his belief in a superb measurement of nearby and imminent form, here he plunges such form directly into the plenitude of the surrounding air. He thus achieves an immediate contiguity between these enormous nearby forms and those other ones in which distance makes Nature appear more indistinct, nebulous, and sketchy. And so it comes to pass that the two abstract, barely individualized structures of the Duke and Duchess of Urbino reign intimately over the landscape, with no mediation by curtains or windows, parapets or window ledges. Should it be objected that this also occurs in various Florentine portraits dating from only slightly afterwards, we should reply that there, this unmediated reign only *seems* to occur; the landscape really having, instead, a subordinate role, almost like a sort of musical accompaniment. This is the case, for example, in Botticelli; not to speak of the far-off backgrounds reduced to mere rhythmical frameworks in such portraits as those by Perugino, Francia, and early Raphael, or to romantic settings, as in those of Piero di Cosimo. But in the present case, we repeat that the connection is one of a perfect intimacy obtained through new pictorial refinements. Not the least of these innovations, we think, is the relationship of identity set up between even the most minute details; and it should be clearly understood that this relationship takes in foreground and far-off background alike. The intimacy with which minutiae are rendered makes it possible, for example, for the highlights on Battista's pearls and jewels—highlights deriving from the clear impression produced by nearby things—to have the same pictorial weight as the glittering swarm of highlights in the background, whose dazzle is due to the natural indistinctness conferred on things by distance [fig. 34]. The wens upon Federigo's face turn pearly in the light, just like the magnified slopes of the farthest hills. It is, in a word, just through such "small" things that the diaphanous glass ball of Battista and the castle keep of Federigo are linked, by way of the air itself, to the minor castles and country roads of their dominions; that the Duchess's jeweled pendant rests, not only upon her bosom, but upon the meadow below; that Federigo's tunic looms over his estates like the shadow cast by some familiar hill.

It is easy to believe—it has, in fact, frequently been suggested—that this new intimacy in the backgrounds is, in Piero's case as in others, specifically derived from Northern art. And it is certainly true that something of Van Eyck's humble magic seems to be reborn here; only it is as though it has been refined through a return to its own old Sienese sources.

Roberto Longhi

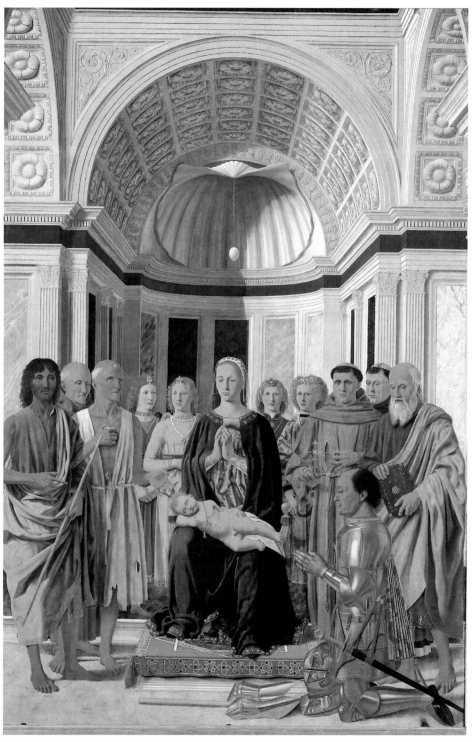

IX. The Brera Altarpiece. The Madonna and Child with Saints, Angels and the Duke Federigo of Montefeltro Praying. *Brera, Milan*

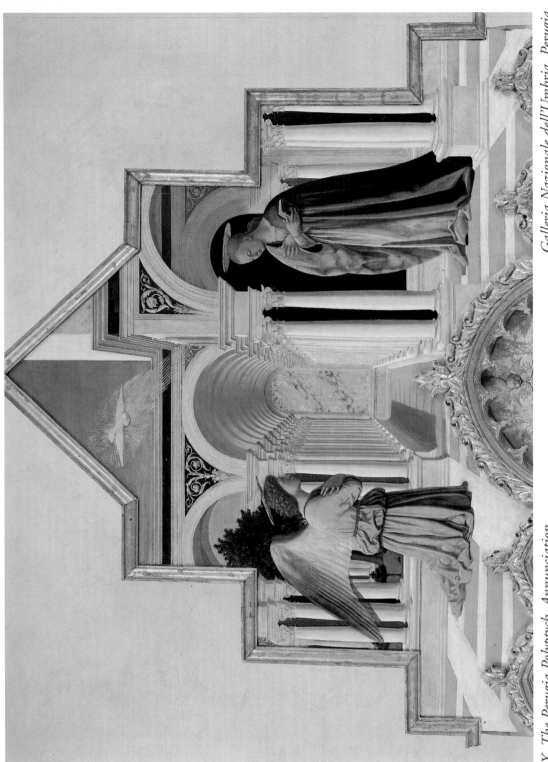

X. *The Perugia Polyptych. Annunciation.*

Galleria Nazionale dell'Umbria, Perugia

The busy, over-showy bustle to be seen in a background such as that of the *Madonna of Chancellor Rollin*, and suggested even by the roofs visible in the twilight through the Annunciate Virgin's little window at Ghent, here makes way for a certain mute solemnity, for that air of simultaneous cultivation and desolation so typical of the landscapes of Italy's heartland: an atmosphere incompatible with overt confidences or excessively visible dealings, one in which a man is either hidden in the ditches, or else lording it over the land from above, a tower-like proprietor or huntsman. The Flemings never achieved, nor even attempted, such a perfect adaptation of Man to the most majestic of panoramic settings. What is more, it is precisely at this moment of desperate adoration of the phenomenal world that Piero rediscovers an unnoticed and symbolic "unrealism" related, however distantly, to that of the old Sienese painters. Just when volumes seem to lose themselves in the distance, giving rise to languid and indistinct impressions, as though because of the eye's natural inability to reach so far; just when trees have become nothing more than spots sprayed along the roadside, and the fences in the field are but fleeting wrinkles like those on Federigo's face; just then, I say, there reappears, out of the mists hanging over Montefeltro, a certain idealized generalization of the terms of landscape, the effect of which is to bring back—thanks to the water's unfailing limpidity and the evenness with which those far-off low mountains emerge, as though from some imaginary three-dimensional model—the ethereal subtlety of Sassetta's distant scenes, here restored to us as after some Dantesque journey. And Piero seems to use this idealized generalization to transfer to these elect exemplars of Quattrocento aristocracy the very sense of dominion that the Trecento had reserved for supernatural beings. Thus it is that he has chosen the moment when the contrast between the divine and earthly dimensions is at its height: now the mighty of this world tower so high that their heads soar up into the rarefied air of Heaven like Trecento idols into the gold, looming over the distant little mountains like saints over the faithful. It almost seems that the painter means to declare explicitly that the mountains possessed by Federigo extend farther than the eye can see. This Duke obviously holds sway over both land and sea.

We may say the same of the reverse side of these panels, where a landholding nobility seems to celebrate its own triumph. Beyond a marble parapet inscribed with eloquent eulogies and crowned with a subtly wrought frieze, the scene is enacted upon the stage of Nature itself; downstage, where the ground falls away, the setting is bounded by a second frieze of natural stone. Slowly, along the ashen road, the two triumphal wagons of the ruler come to meet each other; the light seems to hold the spokes of their wheels locked in stillness. Now may one enjoy at leisure the preciousness of every

slightest touch of color. Who would not wish to remember forever the blue hubs of the wheels, the Duke in his cuirass barely touched with brown, the red mantle, the knobs of the chair gilded with varnish containing real gold, the small gold-and-crimson platforms? Or those Virtues, their white and yellow robes shimmering into purple and delicate violet, their feet shod in slippers like red, yellow, violet, and azure berries? Or the pumice-hued horses, shod in gray and decked with carmine trappings? Or the roan unicorns? And yet, these gem-like touches detract nothing from the scene as a whole; instead, they invest it with a sort of rustic bloom. Against the background of the gently rolling, three-dimensional geological model, with its numbered hills, and against the lake, upon which the reflected zone of pale sky confers the mild warmth of a pail of fresh milk, this triumph of the Ducal couple, surrounded by peasant Virtues, has the crisp and lazy tranquility of a return from the fields.

An identical harmony—or something much like it—between monumentality and intimacy, with the latter smoothing the former's overly sharp corners and lubricating them with the balm of new affection; a shift of attention from abstract decorative synthesis to minute observation of the way light strikes the most beautiful materials, and the notation of a certain sort of light's ability to change colors into tones; these are the qualities once again manifest, even more than in the diptych, in the group of works remaining to us as Piero's last testament: the *Sinigallia Madonna* now at Urbino, the London *Nativity*, and the votive altarpiece in the Brera.

In the *Sinigallia Madonna* [fig. 35-36], it would certainly not be possible (as it was, to some extent, in the case of the "priestesses" at Arezzo) to define in arithmetical terms the law of structural volumes Piero is applying; but we may remark that the artist has here softened his metrical strictness less out of a conviction that his earlier schematicism had lost its effectiveness than from an increasing subtle intellectual insight into the hidden secrets of a visibility no longer merely formal. This Madonna seems to have already assimilated the law of volumes, and to thrive upon it in greater freedom.

She is, in a word, monumental by nature, as are those miraculous specimens of the human race, the nurses of kings: women sought out on some distant farm, that they may silently minister—watched over by the ruler's enigmatical bodyguards in the palace's most secret chambers, far from profane eyes—to the everlasting perpetuation of the royal dynasty.

The present nurse's arms do, in fact, hold a most precious and unusu-

Roberto Longhi

al Child: one who, already hinted at by his predecessor in the Perugia altarpiece, reveals His true lineage more clearly here. Obese and lymphatic, like all contemplative Oriental founders of religions, and having that grimly proud childishness which, in Byzantine painting, looks just like old age, He has learned ceremonial gesture from the last of Cavallini's suburban Emperors; wrapped in the pure white toga of an ancient Roman aspirant to public office, he gravely confers his blessing. Amid so much gravity, his coral necklace and the rose in his hand suggest a more up-to-date sort of refined barbarism. If we would seek a legitimate brother to this imposing and world-weary child, we shall not find him in the works of Piero's contemporaries or predecessors in Florence, not excluding Masaccio. Instead, we must go back to the sublime and desolate interpretations of antiquity given by the late Middle Ages; to Nicola Pisano, even more than to Cavallini.

More singular still is the apparition of the two guardians—identifiable, after some hesitation, as a male and a female angel—standing, arms folded, behind the divine group. Their pose may be simple, but their vitality has the almost alarming intensity of some unknown hybrid plant. The left-hand figure, in particular [fig. 36], is of most doubtful stock, as we may see from his half-breed countenance, enameled with the tiny, almost squinting eyes of a sacred elephant; nonetheless, his function as a celestial Praetorian guard is vaguely indicated by the collar in red and gold brocade, by the light-beaded golden shoulder-plates against the pale violet robe, and also, perhaps, by the heraldic emblem of the linked gold necklace. At first glance, this last might perhaps be taken instead for a precious secretion, deposited by that colony of Rhizopods to which the serpentine mass of the figure's hair has been reduced by the subtle light shining on the scene.

To these sources of wonderment is added yet another, when we realize that this already sufficiently unusual cast is performing before a background that remains, even after all the delicate and meticulous experiments of the North, absolutely unique in the European art of the period. In the middle is a subtly gray wall; to the right, beneath an arched cornice, is a recess where a few simple domestic items are displayed on different shelves; but to the left, beyond a door whose jambs time has reduced to mere luminous lines, is an opening where the sunbeams, filtered though an invisible two-light window glazed with small round panes, enter suddenly and in the penumbra create the rarest play of light ever seen. On the ceiling to the right of the window, the light forms two triangular brackets; at the sides, two rhombuses embroidered with the round panes; a third rhombus is projected upon the wall, where it takes on a delicate milky color from the material thus struck by the sunbeams. One is staggered to see pure light distilled and collected in these simple

shapes; it almost seems as though, having already suggested to him the theorems of form and color, Piero's old sense of synthesis were now pointing the way to yet other theorems regarding the abstract shape of light: theorems that were destined, as is well known, to come to fruition in painting only much later. And last, when one notices how that rhombus of sunlight on the wall is conjoined with the light source by means of a pathway of dust particles floating in the area of shadow, one wonders whether Piero, in this near-reconciliation of the infinitesimal with volume, is not holding out his hand, across the generations, to those Dutchmen—De Hooch and Vermeer—who, two centuries after him, were to base their treatment of the problems of light on a sense of space learned from Italy.

What is certain is that here you would try in vain to hang the concave mirror of [Van Eyck's] Arnolfini and his bride against the gray wall in the background; it could never reflect a life like this one, so majestic and rich in subtleties.

<center>*******</center>

More complex in its presentation of those new tendencies, described above, that reveal correspondences with both the changing art of Florence and the Flemish love; a near-return, motivated by nostalgia, or perhaps by the natural wisdom of old age, to the refinements of Piero's one-time master Domenico Veneziano: this is how the London *Nativity* [fig. 37], a work of the same period, presents itself to our eyes.

In the dazzling, almost lunar light of noon, we find ourselves climbing toward a little patch of level ground ending in a vertical drop into a valley enclosed by a ring of mountains, the rockface of which is dotted with trees; at the edge of this clearing stands the stable, built of a few stubble-covered boards propped against the tottering ruins of an old tower. The ass and the ox have taken shelter there; as for the Child, He lies, in accordance with a humble Northern usage, upon a part of the kneeling Virgin's mantle that rests on the ground; a group of angelic musicians is lined up behind him. To the right, beyond the Virgin, Saint Joseph sits regally upon his pack-saddle; while two shepherds, partially blocking our view of a town a cross-bow's shot away, point out the star to each other.

The painter's insistence on the nearly episodic connections between the things represented seems to us to justify our lingering description of the picture's subject matter. Some people have gone so far as to discover humorous intentions in the work. If we cannot agree, it is nonetheless certain that the emotional bonds between the various figures—the unusually humble

Virgin, the Saint Joseph sitting on his pack-saddle and, despite himself, as rapt in thought as any monarch, the ass braying along with the chorus of very ornate angels—do indeed indicate the artist's willingness to savor the details of a new narrative language that by no means rejects episodic story-telling. Furthermore, this new naturalness is a perfect match for the new painting of small, expressive details that Piero had been working at ever since the *Perugia Polyptych*. In a word, here his poetry of minutiae continues to develop; still, there is no way we can ignore the limitations that the period itself imposed on such progress. For example, the arrogant Humanism surrounding the artist did not allow him to achieve, in the people he painted, the same liberation of detail that was possible for him in things: those selfsame things which the Florentines neglected, but which he, right from the start, had always been accustomed to relate to his human figures as part of his pursuit of synthesis. Thus it is that while he celebrates the triumph of the pure impression in such passages as the ass's silver-shot neck, the canteen leaning against the saddle, and the view of the the town, when it comes to the observation of the angels and the modulation of their hands, feet, or hair, he is incapable—for all the exquisite variety in the coloring of their garments—of imagining a treatment neither a touch overly anatomical nor too ornate. So these overdecorated, overdressed angels, with their strings of pearls, strike the viewer as nothing more than a variation, albeit a nobly ceremonious one, upon a "fancy dress" theme dating back to the beginning of the century; in much the same way, the careful classification of the angels' music-making into various specific kinds of singing and playing reminds us of Luca della Robbia's choir-loft and, in another sense, of the precious elegance of Agostino di Duccio's reliefs at Rimini.

As for the Child and the Virgin, their unaccustomed humility of sentiment has turned the former into a sad little wax model lying upon the lapis lazuli storage case formed by the cloak spread on the ground, and the latter into a pallid worshiper showing scarcely any kinship with the truly imperial Annunciate Virgins at Arezzo and San Sepolcro.

Our gaze therefore goes back with joy to the small details of the things rather than to those of the figures. That rotted, weather-beaten, crumbling wall—where the old theorems of "sweet perspective" hardly put in an appearance, except in the magpie indicating the inclination of the roof—is painted with a penetrating understanding of the secrets of form concealed within its disintegrating length such as might put Leonardo himself to shame; and it bathes in the sky-blue atmosphere with a ecstatic vibrancy that will recur only one more time in art, in certain passages by Vermeer.

And as for the roof—the thatching covering the roof beams, the

patches of mold, and, above all, the tuft of weedy grass are the consummate handiwork of a past master of every drop of wisdom that can be distilled from the hairs of a brush. The view of the town quivers in the light like the orchards and farmhouses of the greatest Lombard and Northern European landscape painters; on the ground before the stable, the patches of grass trod by the angels' mannered feet achieve a sublime level that still today, perhaps, remains unsurpassed in painting.

This ecstasy of tonal reduction is, so to speak, the most infallible key to the values of this work. It is a picture in which even the old, firmly joined spatial structure is reduced to a newer, freer one, indicated by subtle hints and practically intuitive relief effects: the perspective of the roof, barely inclined in relation to the ruined building; the way the ox is boxed in by a cubical foreshortening; the various directions taken by the groups of figures; the sudden glimpses into the distance. Precisely because of the very sparseness with which they are all tied together, all these spatial indicators are, as it were, enraptured by the light. The blazing sun creates large blotches of tonality that circulate freely through the picture, from the patches of grass on the ground to the mosses huddling on the roof of the stable. What purer quintessence of sunlight than the lion-tawny coloring of the ox alongside the dung-yellow of the shepherd?

Were we to extract every last bit of meaning from the stylistic affinities traceable in this strange admixture, we should find ourselves back at a point farther back than any easy Florentine and Flemish comparisons. We should return to that crucial moment in the very early Quattrocento when a handful of masters, active in various places somewhere midway between Flanders and Florence, set forth, after stealing the former's subtle intimacy and the latter's style, to create some of the century's greatest mysteries from both these elements: mysteries manifest in a vast area taking in Lombardy and Piedmont, Liguria and Provence, and even reaching as far as Tours and Moulins. Piero is thus kin, more than to Van Eyck or Van der Goes, to the Master of the Aix *Annunciation*, and to Fouquet, and to Charonton. It must be understood that Piero finds himself traveling down the same road once followed by these artists as a result of shared predispositions. In the same way, one must also recognize that in certain passages, the speculative maturity of his genius carries him far beyond all his contemporaries; even, perhaps, placing him outside every other period as well.

We have noted among the complex speculations embodied in the

Nativity certain contrasts originating in the intellect, and others deriving from sentiment. It is the intellect, for example, that prompts the artist to distinguish the degree of detail in his treatment of human figures from that to be seen in his handling of natural surroundings, as though painting must not recount an adolescent's foot in the same free verse it may adopt for a tuft of weedy grass or a mold stain. On the other hand, it is sentiment that suggests to him so exceedingly class-conscious a distribution of the ornaments human beings may be permitted to wear. Think, for example, of the vast difference in feeling—expressed as a difference in pictorial freedom—between the pointing shepherd, where the artist has concentrated upon nothing but the tobacco-brown hue of the tunic, even the pointing hand being modeled from little pockets of chiaroscuro—and the angels, upon whose pearl-laden overdecoration we have already commented.

This same twofold tendency in Piero's work of this period is equally in evidence in the two figures of *Saint Nicholas of Tolentino* and the *Archangel Michael*; although both certainly belong to a single, now dismembered work, they nonetheless reveal extraordinarily opposing intentions.

The *Saint Nicholas*, indeed, immediately declares his tonality, so visibly as to consume and dissolve any trace of the overstrict definition of shapes. One example is the immediacy of the contrast between the outer and inner surfaces of his leather belt, painted directly upon the tobacco tunic in the manner of Goya or Manet. The ideas at work in the *Archangel Michael*, however, are of an entirely different order. Meticulously garbed as a celestial Praetorian guard, decked out with precious shoulder-plates and baldrics, decorated with pearls and filigree even down to his buskins (which fill one with nostalgic longing for the simple, straightforward stockings worn by the Queen of Sheba's squires), this figure is burdened with a parade-ground Classicism; nor is his unpleasantness in any way reduced by the far-fetched idea of having him grasp the dragon by the protuberance on its head.

The slightest shift in dress, and thus in feeling, would suffice to link a hero like this with Carpaccio's saintly knights. As matters stand, though, the Classical get-up retains the same frigid stiffness it typically possesses in Central Italian painting; by and by, this fancy dress handed down by Piero will turn up again in Perugino's boring, if handsomely shod, classical-romantic warriors.

Limited as it is by the strictly votive purposes it was made for, the *Brera Altarpiece* [fig. IX]—a work datable, for a number of reasons, to some-

time between 1470 and 1475—is certainly no match for the *Nativity* as an all-round demonstration of Piero's artistic intentions in his final years. A comparison with the *Perugia Polyptych* or with the early *Misericordia* altarpiece—works showing the effects of numerous constraints—will nonetheless reveal quite clearly Piero's sublime capacity, when the constraints had been loosened a bit, to harmonize his "measured" style with the devotional aims inherent in a display of sacred personages to the gaze of the faithful. In its grandiose unity of conception, the *Brera Altarpiece* outshines the earlier ones.

With the subtlety demanded by the situation, Piero exploits the noble stage-blocking of the spatial relationship between, on the one hand, the ten figures disposed in a half-circle around the Virgin and, on the other, the architecture; the latter's piers, and its polished porphyry and colored-marble slabs, turn around the semicircular tribune in an oblique foreshortening centered upon the sacred egg hanging from the shell-shaped canopy, thus reiterating the very composition formed by the human figures. In the end, there is no knowing whether the architecture has determined the disposition of the human elements, or is not, instead, a consequence of the figures' arrangement; and this calculated coincidence gives rise to a ceremonious, ritual symbolism, the religious implications of which are so readily apparent as to obviate extended comment. More than a sacred conversation, it is thus a solemn, pre-ordained, most sorrowful assembly that is taking place in this Bramantesque hall, painted before Bramante had ever built such things.

But the freedom of potential movement we sense in this sublime illusion of a traversable space ample enough to accommodate all these figures is created both through measurement—since we feel ourselves to be spectators standing at the entrance to a semicircular *tempietto*—and through light: a cool, grayish stream of it tinges the various structures of flesh or marble a diaphanous blue. This freedom goes beyond anything in the Italian art of the time, surpassing Florentine art in particular. If anything, it accurately foretells the measured and sumptuous architectural depths into which the apses in Venetian painting will shortly receive their figures: from Antonello's San Cassiano altarpiece of just a few years later to the memorable series set off by Giovanni Bellini in his picture at Pesaro.

Here too, of course, we find, within this solemnly arranged composition, the same mysterious variants of Piero's style encountered in the other works of this period; as we have said, it is very difficult to pass any sort of definite judgment upon them.

As in the *Nativity*, we note here the ever more splendidly painterly—or rather, tonal—reliance upon a light that "sees" every aspect of local tonalities, sometimes emphasizing them, but more often reducing them, to the

point where certain of them—such as Saint Francis's gray, the Baptist's green, and, above all, the ashen hue of Saint Jerome—seem to have been obtained through a prolonged immersion in the atmosphere. Here again, as in the *Nativity*, we find—along with the artist's pursuit of this poetry of the phenomena of tones resembling those found in Greek temples—his complacent, ongoing enjoyment of the richness and material value of certain ornaments, to the point where they take on a terribly exclusive quality of aristocratic, courtly reserve. In the end, one comes to the conclusion that such jewels, such bindings, and even such hairstyles could exist only within the narrow walls of the Duke's own court: the only place where the sumptuary laws were not enforced. Even in the architecture, the ornaments reach inaccessible realms: inlays and chiseled motifs, carried out according to the personal wishes of a ruler whose limitless aesthetic demands regarding his own private chapel could never be satisfied. Sometimes it even happens that this refinement of ornamentation, brought to bear upon some inappropriate zone, loses its value as an illustration of an aristocratic circle (which is what it so stupendously was in those very elegant young attendants of both sexes whom we saw transformed into angels); when this refinement insists upon curling the white hair of a severe Apostle such as Saint Andrew and comes close to beading with gems the hem of a cloak belonging to an ascetic like the Baptist, it certainly oversteps the mark. Where, instead, it stays within bounds, we get such eminently appropriate, brilliantly colored passages as the Virgin's plum-and-gold brocade, or the marvelous decomposition of light in some of the precious stones in those one-of-a-kind bindings crafted by the ducal goldsmiths.

As for the structure of the bodies, this, too, reflects in varied ways the pursuit of things exceedingly minute and complex, which we first saw under way in the Perugia altarpiece: a pursuit entailing an admixture of anthropomorphic perils and of advantageous discoveries regarding "painterly moments." In all probability, this contrast had already been adumbrated in Domenico Veneziano's last works, from which it afterwards passed into the painting of the brothers Pollaiuolo, so singular for what we may term its "two-fold register."

The arthritic joints of Saint John's feet, and the detailed dwelling on the claw-like toenails of this wilderness-dweller; Saint Francis's almost neurotic hands, and the quite knotty modeling of the Virgin's; the slightly Verrocchio-like flavor in the structure of the Baptist, as in that of the Saint Jerome, with his prominent shoulder blades; the Child's distorted posture, captured with an understanding of the plasticity of infancy that almost demands to be called Leonardesque: all these tensely wound-up details demonstrate, at the very moment that they are so happily plunged into the

already glaucous liquor of "Piero the painter of light," the point beyond which the period would never have permitted any further exceptions to the dominant visual habits. They show that Piero continued to set himself many subtle, complex, and contradictory problems, rather as a result of the tirelessly ardent love of speculation that must have been a characteristic of his last years, than out of any certainty that he would be able to solve them. These problems arose out of the news reaching him regarding the general tendencies of art in the great center at Florence. More specifically, they grew out of the appearance at Urbino of such linear paradigms as the ones Botticelli was sending for Baccio Pontelli to translate into the wooden inlays of the Duke's *studiolo*; also from such Flemish examples as those by Justus [of Ghent], in which Piero would have seen an accumulation—even if at a qualitative level much deteriorated from that of the *Women Bathing* by Van Eyck, a picture Piero must have considered afresh in these years—of not unusable single observations, and of secrets regarding the depiction of material wealth.

But Piero's intention of keeping his pursuit of the latter topic within reasonable bounds is demonstrated (whether or not material circumstances also played a part) by the fact that, when it came to painting the hands of Duke Federigo, he was obliged to make way for the brush of a Northern-trained Spanish painter, Pedro Berruguete, who didn't bother his head about such abstractions as the tonal unity of a work, just as long as he could gorge himself on tiny surface truths that Piero would never have wished to achieve, not even if he had taken more than his few, very cautious steps (and here we come to the other tendency) down the anatomical road of the Florentines.

It is, in fact, in this very caution—as well as in the workings, innate in Piero, of the older, more immaterial values of *real* painting, values such as light and tone—that we become aware that the artist at work here could, perhaps, boast of having, as a lad, seen Masaccio up on the scaffolding of the Carmine, Domenico just in from Venice, Fouquet passing through on the way to Rome.

Thus it was that, in him, new problems were marked once again by the stigmata of things more remote and archaic; or, as generally happens in human affairs at a certain advanced stage of life, they displayed, at the least, a slight affectation of such antiquity. Compared with the moderns, our painter remained, invincibly, "Piero from San Sepolcro, who is older than they are."

As we end this prolonged scrutiny of the works we have watched lining themselves up over the thirty-year or so stretch from 1445 to around 1475, we feel that any detailed consideration of the historical importance of

Roberto Longhi

Piero della Francesca's art would be out of place, as it would be beyond the scope of our study.

Nonetheless, the inheritance an artist leaves to his successors is surely a matter possessing its own spiritual importance; it is so, at least, for people attempting to see beyond the kind of narrow-minded and fanatical "personality cult" that imagines artists to appear out of thin air. The subsequent development of an artist's inheritance means, in short, the widespread transfiguration of the personal side of art history into a figurative continuity; and only those who reject the very idea of the "spirit of forms" will take it upon themselves to deny the existence of such a continuity. So it will be appropriate if, at this point, we at least put out some signposts, pointing out the roads that study of the consequences of Piero's art—a study, in fact, already at quite an advanced point—will have to travel.

To indicate these roads is practically to go back over the ones that took Piero from Florence to Rimini, Urbino, Ferrara, Arezzo, Perugia, and Rome.

Let us begin, then, by looking as carefully as possible at the full historical significance of Piero's presence in Florence in around 1440; we may, perhaps, be led to conclude that it at least facilitated—if it did not actually set in motion—some extremely momentous events in the history of European painting. Even the appearance of both the great painting of Fouquet and that of the no-less-great Provençal school led by the genius who was Charonton is inexplicable unless we take into account the time Fouquet spent in Italy in the decade between the years 1440 and 1450; and the development of these kinds of art must, in fact, be brought into a precise historical relationship with the beginnings of "Pieresque" painting.

Among all the Madonnas of Mercy of the fifteenth century, that painted in 1452 by Charonton (now at Chantilly) is the one closest to Piero's *Madonna of Misericordia* of 1445, not so much for compositional reasons as for its intrinsic structure. The heavenly hues of Charonton's *Coronation of the Virgin* (now at Villeneuve-les-Avignon) were grown in the same coloristic flower bed where Domenico Veneziano had previously cultivated his *Saint Lucy Altarpiece*, and Piero his *Baptism of Christ*; the last-named work's diaphanous, glaucous-blond solar liquor flows once again in the Provençal picture. As an explanation of the Italian secret of such French works, the relationship that has long been proposed between Fouquet's art and Angelico's is, in a word, inadequate. This relationship is equally inadequate as a key to the "voluminous" grace of the Madonna in the Melun diptych, who is no relation of Angelico's Florentine *Linaiuoli* guild members; her true family is, instead, that of the peasants at Monterchi.

In these pages, we can do no more than point out the now nearly van-

ished traces of what was once a major thoroughfare. The rapid spread of the civilization of "perspective and light" to many shores of the Mediterranean—all the way from Provence to the lands of the King of Aragon, and thus, for historically obvious reasons, to Southern Italy as well—will appear all the more striking once we realize that it was, in all probability, this very spread that, shortly after the century's midpoint, offered Antonello da Messina a point of departure for the climb to the pinnacle of his own mysterious style: a mystery traditionally "solved," in overvague terms, by references to Magna Grecia on the one hand and to the painter's Flemish journey on the other. If some scholar were to succeed in reassembling the scattered bits of evidence regarding this fabulous story played out in the Mediterranean basin between 1440 and 1460, he would have have accomplished one of the most attractive and important tasks yet remaining to a historian of the fifteenth century. In pursuing his subject, he would also find it worthwhile to study how North and South reveal, in the century's last decades, an admirable capacity for reciprocal compensation. We find this capacity demonstrated in the works of various French and Spanish painters: Berruguete at Urbino, Juan de Borgoña, the Master of the Madonna of the Cavalier of Montesa, Juan de Flandes, the Master of Moulins. These painters also have relatives in Piedmont, Liguria, and Lombardy, as one sees in certain far-off backgrounds by Bergognone, or in Spanzotti's structure, or in the subtleties of [Carlo Braccesco] the Master of the Louvre Annunciation. In this connection, it would be very useful if we could place the materialistic version of the story's beginning, as given by Vasari—who speaks in passing of Antonello's trip to Flanders, and of his dealings with Domenico Veneziano—back to a more ideally abstract level; for, as is is well known, Vasari's way of putting the matter reduces the transmission of the greatest pictorial ideas of the fifteenth century to the repeated theft of a technical secret.

Before leaving Florence, we shall also point out—in the interests of history—the probable desirability of a reversal of the terms of a further question regarding Piero's youth.

We think that the dating to a period earlier than the decade between 1440 and 1450 of a certain group of works by Andrea del Castagno, a group that includes the Sant' Apollonia frescoes and those from Legnaia, is no longer tenable. Precisely because of their sun-filled style and the grandeur of their composition and figures, these works of Castagno's cannot constitute, as has usually been suggested, a precedent; they are, instead, a consequence of the work of Piero who—besides being a far greater genius than the Florentine—was, by that time, already accomplished in his art.

Even though the works in question look like nothing more than a par-

enthetical episode in the development of Andrea, who in later years yielded anew to the demon of his urge to create "characters," we think Piero's influence surfaces momentarily once again as a slight but easily detected "Pieresque" impulse in Alessio Baldovinetti's best pictures—such as the *Nativity* in the atrium at the Santissima Annunziata, or the *Madonna* in the Louvre—and in certain qualities of Giovanni di Francesco in works of his prime such as the Buonarotti predella panels, the Carrand triptych, the *Saint James* at Lyons, and the Dijon *Saint Roch*. Does not the simple affirmation that both Piero and Baldovinetti are directly descended from Domenico Veneziano—a claim that has been used to justify the erroneous attribution to Piero of Alessio's Louvre *Madonna*—seem too feeble nowadays, crying out for clarification in the light of our sense of the rising tide of the still-young Piero's predominant influence in Florence at the time? How can we possibly persuade ourselves that the Arezzo frescoes, executed during a decade when Florence had nothing equally imposing and lofty to set against them, left no trace in the work of the very artists who had been companions of the master from San Sepolcro in his youth? We are, instead, prepared to recognize that the "Pieresque" movement in Florence was quickly smothered: the chaotic performance of Florentine painting throughout the second half of the Quattrocento convinces us that this was the case.

This is not to say that all the qualities of the art promoted by the circle of Piero and Domenico utterly vanish; in fact, the aspects of such painting reflecting the Trecento inheritance of minute pictorial details and tiny observations—aspects certainly propagated by Domenico's last, worried speculations—turn up again, in what we have already called the "twofold" painting of the Pollaiuolo brothers. But in Piero's case, it is only after he has grown old that analogous explorations lead him to similar results; this is, however, a matter outside the purview of the present discussion.

At this point, having closed the Florentine episode, we must follow Piero's painting as it spreads: first, in terms of chronology, to the Marches and Emilia, where it arrives prior to 1450. We must nonetheless be aware that, generally speaking, the message could only be received at the price of oversubtle or excessively simple compromises with the still practically fourteenth-century culture of these regions. The inevitable result was the ripening, in the more cultivated centers, of such absolutely monstrous fruits as Ferrarese art, from Cosmè Tura down to Ercole [de' Roberti] da Ferrara; and, in less cultivated places, a sweet, near-Byzantine vegetation such as that of Girolamo di Giovanni da Camerino. As early as 1449, working in his hometown, this last-named artist had shown himself to be a good Pieresque follower: a year later, in the company of some Ferrarese painter, he perhaps brought the master's

gospel to the team frescoing the Eremitani at Padua. But afterwards, he preferred to spread a simpler, more devout translation of it around the Marches.

As for the monstrous and excellent fruits that ripened out of the grafting of Piero's works onto the Ferrarese orchard, tasting them one by one would mean having to rewrite the entire history of the local school. In so doing, we would have to insist upon the particularly Pieresque quality of the Ferrarese masters' light, not without pointing out the refractions it undergoes as it passes through matter conceived by these painters as a wondrous collection of minerals. Attractive though these byways be, we cannot linger in them.

Instead we shall mention, even if only in passing, those individual instances in which Piero's art has a more direct descendancy. These works include those cycles of poems on the subject of mute, uninhabited space that are still to be read in certain old cathedral choirs, inlaid in wood by the great masters from Lendinara; also such anonymous, utterly enigmatic works as the *Pietà* in the University of Ferrara, the admirable little portrait in the Museo Correr in Venice, and the Berlin *Autumn*. Despite the signature it bears, we would also add the unique, and sublime, *Pietà* painted by the Modenese artist Bonascia in 1485.

When Piero heads back home, we get a local offshoot of his style. This variant is rendered quite as enigmatic as the above-mentioned works by the fact that it has come down to us in just a single work: the *Madonna delle Grazie* painted for Città di Castello by Giovanni di Piemonte (a place name probably referring to Piemonte in Tuscany rather than to the region of Piedmont). This follower is anything but untalented: his rustic and luminous picture reveals a temperament similar to that seen in the work of Giovanni di Francesco in Florence or of Cossa at Ferrara. As we have already mentioned, there are grounds for believing Giovanni to have collaborated with Piero on some of the Arezzo frescoes.

At Arezzo itself, these years see the appearance—alongside the great cycle in San Francesco—of the popularized version of Piero's art offered by the ungifted but pleasing Lorentino. We have already observed how, in certain passages of the Arezzo frescoes, the instructions Piero gave his assistants with regard to coloring were immediately and rustically reinterpreted by these assistants as a call for the same flat and simple range of hues found in a deck of playing cards. This transformation—accompanied by the reduction of Piero's difficult metrics of form into the easy, flat cutout of popular marionettes—is, in fact, absolutely characteristic of Lorentino: a painter offering, in short, a magnificent demonstration and paradigm of the lofty origins of "rustic" art. To some extent, the stories of Saint Gaudentius and Saint Columatus in the predella of his Arezzo altarpiece can help us understand the Modernists' aston-

ishing insistence upon viewing Piero as, first and foremost, a forerunner of the Douanier Rousseau.

Still on the subject of the Arezzo frescoes, we have noted the way Piero's painting, unlike Masaccio's, was suited to (and even enhanced by) the sumptuous narration of the elaborate fables of arms and fancy dress so beloved of the lower- and middle-class imagination, which demanded such subjects on painted household furnishings. And so, just when Piero is working at Arezzo, we may observe the development of a type of painting frequently met with in the colorful representation of these fables on *cassone* chests; the survival at Arezzo of some traces of this art leads one to suspect that it may, indeed, have originated in that city. At times, such painting comes close to constituting a link between Piero and the last Sienese "unrealists"; it nonetheless rediscovers, by following in Piero's footsteps, so crisp a clarity in its far-off, sunlit backgrounds as to proclaim itself the work of real painters, especially in such works as the *Triumph of Chivalry* belonging to the New York Historical Society, or the celebrated *Adimari Wedding Chest* in Florence.

Around 1460, Piero was in Rome, perhaps for the second time; and his murals there quickly gave rise to a luminous and imposing kind of painting aiming at the recovery of certain solemn archaisms, as a means of drawing upon the symbolic and theurgic efficiency of the medieval Roman tradition. This tradition demanded judging, commanding Pantocrators, and Mothers of God towering over devout little prelates, and heavenly hosts forming vast semicircles; both Melozzo da Forlì and Antoniazzo Romano sacrificed more than once upon its altars. Despite all this—and even if we omit discussion of the highly personal variant, leading nowhere, proposed by the youthful Lorenzo da Viterbo—Antoniazzo is also capable of showing us such "off-center" scenes as the *Birth of the Baptist* at Tivoli; and in the dedicatory fresco of 1477 for the Sistine Library, Melozzo offers us a side-view where the composition, just as it stands, is ready to be clad in masses of color by the young Titian.

Shortly afterwards, Melozzo comes close to representing separately the perspective of his painted architecture, on the one hand, and that of the figures inhabiting it, on the other; this divergence is a result of his boundless enthusiasm for the problems posed by *sott'insù* views, where the entertainingly illusionistic possibilities of false cupolas allowed the painter the most complicated displays of skill. Melozzo thus opens the door to a *trompe l'oeil* architecture which may, indeed, be "optically" precise, but amidst which the figures will—alas—go flapping about in a manner inconsistent with the sort of poetic perspective that had formerly created the entire lovely fiction as a single, indissoluble piece. It is not in the Bramantesque space Piero invented for the

Brera Altarpiece, but rather in the complex artificialities of the cupolas at Loreto and Forlì, that we find the origins of the dangerous specialization which will later become *quadraturismo*, the perspectival transformation of real walls into a fictive architectural environment.

Once we are back at Urbino with Piero, in the period between 1470 and 1475, it will be more than sufficient for us to recall the comment already offered in the appropriate place regarding Piero's share in the formation of Laurana's supremely calm and voluminous architecture; as a demonstration of this close relationship, we need but cite the little panel paintings of lonely architectural views now in Urbino, Berlin, and Baltimore: works that must be situated, at one and the same time, in Piero's circle and in Laurana's, and that have, in fact, sometimes been attributed, far from improbably, to the latter artist.

We have also spoken of the interaction that certainly occurred at Urbino between Piero and the Spaniard Berruguete in the course of the 1470s. Since we have had occasion to include Berruguete among the foreign painters gifted with a singular capacity for balancing Northern and Southern elements, this seems the right place to specify that it must surely have been contact with Piero's wisdom that suggested to him the ideas needed to achieve the equilibrium apparent in works such as his portrait of Federigo now in the Barberini collection; in the most artful among the *Famous Men* formerly in the *studiolo* at Urbino; and, above all, in the series of the *Liberal Arts* painted for the ducal library there.

In the meantime, three noteworthy Italian painters also come close to Piero's style: Bartolomeo della Gatta, Luca Signorelli, and Perugino. We may briefly recount their well-known individual development here, even outside the particular terms of their affinities with Piero.

The first, skinny as a stylite when he first arrived in Florence, achieved, in the course of his isolation in the provincial countryside around Arezzo, such excellence as would have staggered even the cleverest among the city-dwellers; and this, thanks to his familiarity with the mature Piero. Bartolomeo's tonalities of lapis lazuli and old lacquer, lowered and, as it were, glazed beneath a veil of bottle green, are among the most fragile and attractive of Pieresque subspecies. His *Stigmata*, painted in 1487 at Castiglion Fiorentino, is an unexpected pinnacle of the Tuscan Quattrocento, a work in which we once again glimpse Venice and, almost, modern painting—the only problem being that, in his own time, Bartolomeo remained all alone up there on his lonely peak, as though invisible.

According to Vasari, the young Signorelli painted works that could barely be distinguished from those of the master. These early pictures have

been identified, probably correctly, with a group of Madonnas such as the ones in Boston, Oxford, and Casa Villamarina: works very close indeed to Piero, where it is nonetheless not impossible to spot advance warnings of the dangerous alliances the painter from Cortona was about to get himself involved in at Florence. For a certain time afterwards, these alliances did not stop him from keeping up his old friendship with Piero's antique solemnity, to which Luca imparts no more than a slight added hint of violence: in his Berlin picture, the friends of the great god Pan still reflect, to some extent, the grave innocence of the Adamites at Arezzo. Later on, however, Signorelli's spirits explode with a far bigger bang: at Orvieto the *End of the World*, dating from the very last years of the century, shows that tragic harshness which frequently casts its shadow over his forced juxtaposition of quite incompatible formal symbols.

As for Perugino, it would be overstating the case to say that he was ever Piero's faithful follower, even during his probable collaboration on the famous *Stories of Saint Bernardino*, where it is, above all, the peculiarly milky quality of the light that is derived from the master. As far as his much overpraised skill in the "composition of space," it seems to us that he winds up by artificially placing, at airily rhythmic intervals along the fixed lines of mute perspective, groups of figures no longer sharing any inherent qualities with the space itself, but standing out against it, who line themselves up for an utterly superficial parade; the far-off landscape is no more than a rhythmical setting, tinged with the feel of a waning afternoon.

This was to follow the opposite path from Piero's and to return, if anything, to the elegant Attic vase painting of Ghiberti and Luca della Robbia. Here that profound symmetry of volumes, only occasionally coinciding in Piero with the symbolic effectiveness of an accentuated center, reverts to a simple symmetry of continuously bilateral rhythms; and this may also help us to grasp the true level to which the youthful Raphael's dealings with Perugino were reduced.

The descent of the adolescent Raphael's still little-known *Madonna of Mercy* from Piero's version at San Sepolcro is obvious; and yet, there is no more typical example of the way the measured fullness of the latter artist's volumes gets sweetened into a simple rhythmical reduction. Add the frontal fixity apparent in certain youthful portraits painted by Raphael at Urbino, and the desire they reveal to imitate Piero's subtle links with Northern art, and you will have exhausted practically every aspect of the relationship between the two painters. The point is, in fact, that we must deny any descent, even a mediated one, of Cinquecento Classicism from Piero.

Classicism's calm willpower and its imperatively Catholic effectiveness

arise from what we may call the condensation of a rhythm transmitted from the early Quattrocento to Perugino and Fra Bartolomeo: to the dominant centrality of the figure groups there is added the "Platonic" idea of the pyramid or sphere, as a way of shutting in the rhythm. The sublimely normative sentiments and ideals expressed by such calm, stage-managed self-control are quite unlike the perceptible tranquility of everything in sight emanating from Piero's lovely spatial enthusiasm.

Faced with the *Vatican Stanze*, we cannot doubt the predominance in Raphael's spirit of the old sense of rhythm, condensed into groups enclosed each in its own envelope of controlled ideal beauty, within the centralized concavity of Bramantesque space. Nonetheless, Piero's art might seem to linger on in the more "painterly" and "coloristic" parts of Raphael's frescoes—not so much in the *Liberation of Saint Peter from Prison* as in the scenes of the *Pandects* and the *Decretals*, or in the right-hand portion of the *Mass at Bolsena*—were it not for the fact that these passages already proclaim themselves so clearly to be descended from Venetian painting.

Everywhere we look, then, we find the most unmistakable signs of the way history solved the problem of the continuation of Piero's art. Opposed on principle to Masaccio's style, Piero's "sweet new manner" (so well understood by Vasari) could never have led to the rhythmic Classicism of Central Italy. In fact, its continuous presentation of form by means of spatially measured "quantities" of color, along with its poetic devotion to the utterly immaterial events—light and shade, for instance—through which the world reveals itself and then hides itself anew, meant that Piero's art became the natural heritage, instead, of that other race of painters whose genealogy had ever been, *ab antiquo*, chromatic. Without Piero, this race would never have succeeded in coming to terms with the new Renaissance ideals—ideals born of a sense of "naturalistic analogy" quite unknown to the Middle Ages.

We once had occasion—and fully thirteen years have gone by since that time—to indicate in detail the styles and painters through which Piero's art manifests itself anew in Venice. We showed, first and foremost, how two famous events that had always been viewed as the most fundamental of all in the proclamation of the new Venetian art must, in fact, be understood as parallel results, both directly descended from Piero: we refer to Antonello da Messina's creation of the *San Cassiano Altarpiece* in 1475 and the appearance, at almost the same moment, of Giovanni Bellini's utterly new manner as revealed in the *Pesaro Altarpiece* and the Naples *Transfiguration*.

We trust that the lesson has, by now, been learned so well as to make it possible for us to read correctly the verses in which Boschini states that the cornerstones of the whole edifice of Venetian painting were laid by Giovanni

Bellini "upon the foundations of perspective." Our efforts, in the present study, have been directed toward understanding this selfsame perspective's boundlessly efficient capacity for embracing, in its poetic synthesis, the entire visible world.

So the inheritance Piero left to the Venetians was no mere series of "formal procedures"; it consisted, rather, of the very spirits inevitably embodied, and to the highest degree, in such forms.

In the works where Piero's intentions are displayed at their best—I refer to the frescoes at Arezzo—the broadly set forth spectacle of "appearances" is like some wondrous sweet, brought to the table by the intellectual workings—at first glance so abstruse—of perspective; and the events of this invincible feast day, grandly harmonized in an unending chain of chromatic octaves, afterwards came from the walls of Tuscany to merge themselves with the Veneto's ever more favorable seasons of color. The first of those seasons was to be seen, we believe, in Bellini's lost canvases of local epic and is still most certainly visible in the scenes from the *Golden Legend* painted by Carpaccio in the *scuole* of Sant' Orsola and San Giorgio degli Schiavoni; the second may be read in Titian's frescoes at Padua; the third, in those by Paolo Veronese at Maser.

And from there, Piero's art continues its journey, along more mediated routes; it is still at work in the greatest modern painting.

THE ART OF PIERO DELLA FRANCESCA: NOTES

First published in 1927, Longhi's monograph subsequently grew by a process of accretion. In the second and third editions of 1942 and 1962, the author added new notes to supplement those included in his first edition; these additions dealt with everything from afterthoughts and changes of mind to newly discovered pictures.

In the definitive Sansoni edition, Longhi's various sets of notes remain separated according to their year of publication. While this system does have the advantage of enabling the reader to follow the progress of scholarship over several decades, we have instead opted to serve the reader's convenience by bringing together, insofar as possible, all notes dealing with a common work or topic; the date of publication of each note is nonetheless clearly identified.

Editorial notes and interpolations by David Tabbat appear within square brackets.

Piero and Siena

Piero and Sienese fourteenth-century art (pp. 1-2). — Today my earlier, somewhat exaggerated view of Sienese art's glorious Europe-wide currency is tempered by my recognition of the many independent aspects and values present in fourteenth-century North Italian painting, and also of the subtle coloristic and atmospheric qualities of several Florentine painters of the time— in particular Stefano,[1] Giusto,[2] and Giottino[3]: painters who were neither Giottesques nor imitators of the Sienese school. For Giusto, see especially my article in [the journal] *Pinacotheca*, 1928, pp. 137-52; for Stefano and Giottino, see Note 1 to my essay *Fatti di Masolino and Masaccio* in [the journal] *La Critica d'Arte*, Florence, 1940.[4]

(1942)

1. [Giotto's grandson Stefano, born probably around 1306 and generally known as Stefano Fiorentino, was a famous painter in his own day, enthusiastically praised by his contemporary Villani for the rare naturalism of his figures; the painter is also the subject of one of Vasari's *Lives*. Identification of his work, however, remains hypothetical, even if the reconstruction Longhi proposed in a lecture in 1943 still carries some conviction. See R. Longhi, *Opere*

complete, Vol. VII (*"Giudizio sul Duecento" e ricerche sul Trecento nell' Italia centrale*), Florence, 1974, pp. 64-82. (D.T.)]

2. [Giusto de' Menabuoi, documented from 1363 on, died around 1393. This important Florentine artist seems to have arrived in Padua in around 1370, and his greatest work is the fresco cycle in the Baptistry there, painted approximately a decade later. This cycle unnervingly combines radical spatial manipulations and a lively chattiness in the narrative scenes on the walls with an archaic, hieratic, practically neo-Byzantine solemnity in the treatment of the vault. To come under the unyielding gaze of the Christ occupying the middle of the ceiling, and that of the other members of the court of Heaven who concentrically surround him, is one of the most personally chastening experiences that can befall a traveler in Italy. (D.T.)]

3. [Giottino is probably Giotto's great-grandson Giotto di Stefano, son of Stefano Fiorentino (but some authorities identify this great-grandson as Stefano di Stefano, documented in 1368 and 1369). Confusion has always reigned concerning Giottino's identity. Vasari's account mixes him up with another artist, the sculptor Tommaso di Stefano, further confounding the latter with the great painter Maso di Banco (in whose frescoes in Santa Croce Longhi recognized one of Piero's antecedants). The one work widely ascribed to the "real" Giottino—i.e., Giotto di Stefano—is a *Deposition* originally in the Florentine church of San Remigio and now in the Uffizi; this little panel is a towering achievement, unforgettably uniting monumental breadth of rhythm, exquiste delicacy of color and execution, and a heart-rending intensity of feeling. (D.T.)]

4. [The latter essay, now in Longhi's *Opere complete*, Vol. VIII/I (*"Fatti di Masolino e di Masaccio" e altri studi sul Quattrocento*), Florence, 1975, is one of Longhi's most important. It is available in English as "Masolino and Masaccio," trans. D. Tabbat and D. Jacobson, in the volume Roberto Longhi, *Three Studies*, New York, A Stanley Moss-Sheep Meadow Book, 1995. (D.T.)]

Piero and Sienese art (pp. 1-2). — For the possible precedent represented by Domenico di Bartolo's Madonna in Siena, upon which Toesca[1] has insisted, see my discussion in the new chapter added to my study of Piero's "critical fortune."[2]

(1962)

1. [Both Longhi and, later, the distinguished connoisseur Federico Zeri studied with the art historian Pietro Toesca (1877-1962), several of whose books still retain their usefulness. (On the Italian television program *Il laureato* a few years back, radical-chic host Chiambretti's opening gambit in an interview with Zeri was, "You studied with Professor Tosca [sic], didn't you?" To which the great connoisseur disdainfully replied, "I beg you not to speak of matters you do not understand.") (D.T.)]

2. "In the meantime, the first edition of my *Officina ferrarese* had appeared [in 1935]; it explored in some depth the relationship—already mentioned by me in 1927 [in *Piero della Francesca*]—between Piero and the great artists who worked for the d'Este court [of Ferrara], above all, with the great Lendinara school of wooden inlay work. But in his article on Piero (*Enciclopedia italiana*, vol. XXXV, 1935), Toesca paid no heed to the important following that had been attracted by the artist from Borgo. It was a piece of ill luck (here's another note from my personal file) that, at that time, my relationship with my revered master was having its ups and downs. Toesca refrained from accepting my conclusions, even failing to cite my essay of 1914 ["Piero dei Franceschi e la pittura veneziana"] in his bibliography. None of this, however, will keep me from acknowledging the consistently high level of the writing in his article and the excellence of certain of his observations. The most important of these regards the precedent represented by a Madonna painted by the Sienese Domenico di Bartolo at the very early date of 1433, well in advance of Piero. Nonetheless, Toesca's statement that the Sienese picture is already full of reflections of "the new Florentine art of Domenico Veneziano" startles even me; for it is only several years afterwards that we begin to hear of Domenico Veneziano. Now, I myself have always tended to emphasize Domenico Veneziano's importance as a precedent for Piero. But Toesca's claim [regarding Domenico Veneziano's influence upon Domenico di Bartolo] would call for a more thoroughly grounded demonstration—especially since it still remains to be seen why Domenico di Bartolo, already so far ahead in 1433, is penitentially ready to forget all his newfangled Florentine traits in his *Perugia Polyptych*, painted in 1437, which is to say, several years before Piero and Domenico Veneziano began working together in Florence. Here lies, probably, the historical secret of a problem which I have attempted to illuminate in my essay of 1954 on the Master of Pratovecchio." [The above passage, from Longhi's study of Piero's *fortuna storica*, first published in the 1927 edition of *Piero della Francesca* and updated to 1962 in the third edition of the monograph, appears in R. Longhi, *Opere complete*, vol. III (*Piero della Francesca*), Florence, 1962, p. 158. Longhi's "Il Maestro di Pratovecchio" is now in the

Opere complete, vol. VIII/I (*"Fatti di Masolino e di Masaccio" e altri studi sul Quattrocento*), Florence, 1975, pp. 99-122. (D.T.)]

Piero and Sassetta[1] (pp. 2-4). — For a more correct evaluation of the affinities between Masolino and Masaccio and of their common ancestry, see my above-mentioned *Fatti di Masolino e di Masaccio*. Sassetta's connections with the new Florentine art of the Quattrocento now appear to me closer and more recurrent than my earlier discussion of a single isolated instance might suggest; on this topic, see also my *Ricerche su Giovanni di Francesco*[2] in *Pinacotheca*, 1928, pp. 37-38,[3] offering some hints later developed by Pope-Hennessy in his book on Sienese painting.[4]

(1942)

1. [In the most recent major monograph on Piero, Calvesi expresses the opinion that, since Sassetta's *Saint Francis Altarpiece*—as recent research has revealed—was not installed at Sansepolcro until 1444, it cannot have been as important an influence on the young Piero as believed by Longhi and other historians. At the same time, however, he emphasizes the work's specific influence on Piero's *Baptism* and *Misericordia Altarpiece*, both of which he dates far later than Longhi did. Cf. Maurizio Calvesi, *Piero della Francesca*, Milan, 1998, pp. 15 and 37. (D.T.)]

2. [The minor painter Giovanni di Francesco may turn out to have a crucial role in making possible a more precise dating of Piero's Arezzo cycle. Or, then again, he may not. In 1990, the connoisseur Luciano Bellosi published an argument that can be expressed as a syllogism: *a)* a predella by Giovanni di Francesco now in the Casa Buonarroti in Florence depends upon the battle scenes in the bottom register of the Arezzo cycle, the one which would have been painted last; *b)* Giovanni di Francesco died in 1459; therefore *c)* Piero's cycle was complete by that date, as Longhi always maintained. (L. Bellosi, *Pittura di luce: Giovanni di Francesco e l'arte fiorentina di metà Quattrocento*, Milan, 1990, p. 42.) However, the brilliant *frondeur* Carlo Ginzburg has complicated matters afresh by arguing that there are two separate Giovannis di Francesco involved. (C. Ginzburg, *Indagini su Piero*, new 3rd. ed., Turin, 1994, pp. 115-123.) Taking a more radical approach to the problem, Calvesi (op. cit., p. 41) denies the predella's dependence upon the Arezzo cycle. (D.T.)]

3. [Now in R. Longhi, *Opere complete*, vol. IV (*"Me pinxit" e quesiti caraveg-*

geschi), Florence 1968. (D.T.)]

4. [John Pope-Hennessy's books on Sienese painting include *Giovanni di Paolo, 1403-1483*, London and New York, 1937; *Sassetta*, London, 1939; and *Sienese Quattrocento Painting*, London and New York, 1947. (D.T.)]

Piero and Florence

Piero and the Giottesque painters (pp. 4-5). — Today I would no longer repeat the parallel I drew here between Maso di Banco and Pietro Lorenzetti. I was led into it by the old writers, who habitually gave disproportionate weight to the dealings between Siena and Florence. These interactions now strike me as far less significant, especially for the development of Florentine painting.

(1942)

Piero and Paolo Uccello (pp. 10-12). — Despite the fact that the necessary documentation was available even back then, in those oddly prehistoric days it had not yet occurred to anyone to reconsider the chronological significance of Uccello's very late development. Today this painter seems to me quite unimportant to Piero's art.[1] In this connection, see my *Fatti di Masolino e di Masaccio*.

(1942)

1. [Calvesi adduces interesting arguments for Piero's battle scenes having been conceived and executed after 1456, the year of the twin Christian victories over the Turks along the Danube. Since Uccello's three famous panels of the *Battle of San Romano* were presumably painted slightly earlier than that date, Calvesi revives the old theory—rejected by Longhi—of the dependence of Piero's scenes upon Uccello's. (M. Calvesi, op. cit., p. 48.) (D.T.)]

Piero and Andrea del Castagno (p. 13). — My hypothesis that it was Andrea del Castagno who came within Piero's gravitational field, rather than the other way around, has since been amply confirmed by new documents that have occasioned an enormous shift in Castagno's chronology. The artist was born in 1423, around a quarter of a century later than used to be thought.

(1942)

Piero and Fra Angelico (pp. 13-15). — I did not yet have an adequate grasp of Angelico's far-reaching impact as the first mediator between the ideas of Masaccio and Brunelleschi and the artists of the following generations, Piero among them. Perhaps reacting against the piously bigoted defenses of Angelico current at the time, I assigned him a lower rank than I now think he deserves. For the various stages of my subsequent study of the artist, see: "Un dipinto dell' Angelico a Livorno" in *Pinacotheca*, 1928, and the previously cited *Fatti di Masolino e di Masaccio*.

(1942)

The Baptism of Christ

[London, National Gallery]

Painted for the Priory of San Giovanni Battista at San Sepolcro. Moved to the Duomo in the same town in 1807 at the time of the [Napoleonic] suppressions [of many ecclesiastical and monastic institutions]. Sold in 1857 by the Cathedral chapter to one Robinson; resold by the latter to Uzielli; purchased by the National Gallery, London, at the Uzielli sale in 1861.

Given its obvious affinities with the circles of Masolino and Domenico Veneziano, this must be considered Piero's first known work, painted around 1440-45. The only admissible doubts as to the date are the ones aroused by the two saints on the left in the *Misericordia Polyptych*. Powerfully reminiscent of Masaccio, these two figures may perhaps be even earlier than the present *Baptism*; if so, our picture would have been painted slightly after the time frame proposed here. But we reject outright the attempt[1] to date it to around 1465 on the basis of a comparison with the panels by Matteo di Giovanni that once surrounded it. Working around 1465, Matteo made no effort to harmonize his contribution with Piero's main panel, and this frank discrepancy suffices to suggest that the *Baptism* was of an altogether earlier period; as we have seen, the stylistic evidence identifies this period as Piero's earliest one.[2]

(1927)

1. M. Logan, "Due dipinti inediti di Matteo da Siena" in *Rassegna d'Arte*, 1905, pp. 49-53.

2. [The very early dating Longhi proposed for the *Baptism* remains one of the more controversial aspects of his Piero chronology, although it has won its adherents. Like Logan in 1905, several modern scholars have ascribed the work to the latter part of the artist's career: Parronchi places it in 1465 ca., while Creighton Gilbert dates it around 1460: a period, he believes, when Piero was returning to the Arezzo cycle after his Roman sojourn. (Cf. A. Parronchi in G. Rositi, ed., *Legenda di Piero della Francesca*, Florence, 1992; and C. Gilbert in *Change in Piero della Francesca*, Locust Valley, New York, 1968). But Kenneth Clark (*Piero della Francesca*, London, 1951) found it difficult to place the *Baptism* earlier than the left-hand saints and the *Crucifixion* from the *Misericordia Altarpiece*, and—noting a similarity with the river landscape in the *Victory of Constantine* in the Arezzo cycle—suggested a date of 1450-55. Several scholars have accepted Clark's position. Others, however, have underscored the *Baptism*'s deep indebtedness to the art of Domenico Veneziano, with whom Piero worked early in his career, accordingly proposing a date in the closing years of the 1440s. (Cf. H. Wohl, *The Paintings of Domenico Veneziano, ca. 1410-1460. A Study in Florentine Art of the Early Renaissance*, New York and London, 1980, and P. De Vecchi in *L'opera completa di Piero della Francesca*, Milan, 1967). Today the *Baptism* is often dated to the period 1448-52, an hypothesis taking into account both its affinities with the style of Domenico and its closeness to Piero's own idiom in parts of the cycle at Arezzo; but there is still no real consensus on the issue, especially as the chronology of the fresco cycle itself still awaits definitive clarification. In support of Longhi's very early dating, Angelini has associated the work with Piero's documented presence at Borgo San Sepolcro in 1442; while Hendy adduces, as further circumstantial evidence for an early date, the fact that this work, unlike others among Piero's panel paintings, is entirely in tempera. (Cf. A. Angelini, *Piero della Francesca*, Florence, 1985, and P. Hendy, *Piero della Francesca and the Early Renaissance*, London, 1968.) Bellosi also thinks the picture Piero's earliest, in account of its "geometrization" of forms. (L. Bellosi, *Una scuola per Piero. Luce, colore e prospettiva nella formazione fiorentina di Piero della Francesca*, Florence, 1993.) Like Clark, Calvesi (*Piero della Francesca,* Milan, 1998) relates the still, centralized monumentality of the Christ to the example of Sassetta's now-dispersed *Saint Francis Altarpiece*, once at San Sepolcro; however, given that a document discovered after Longhi wrote his book shows that this Sienese painting was not installed before 1444, Calvesi argues that the *Baptism*—which he dates, in any event, to the middle of the following decade—could in no case have been painted before that year. (M. Calvesi, op. cit., pp. 37 and 144-46. (D.T.)]

The Misericordia Altarpiece

Misericordia Polyptych
[San Sepolcro, Pinacoteca Comunale]

Ordered from Piero on July 11, 1445 by the Compagnia della Misericordia of San Sepolcro. While the contract[1] committed the artist to deliver the altarpiece by 1448, stylistic evidence proves that he finished it much later.[2] Beginning with the still-Masaccesque figures of Saints Sebastian and John the Baptist on the left, we may follow Piero's work as it progresses first through the right-hand saints and the small panels composing the crowning element, then on to the central panel representing the Madonna of Mercy. In this last panel, where greater artistic maturity is apparent, the portraits of the worshipping donors are particularly close to the complex grandeur of the Uffizi portrait diptych of 1465-66. It therefore seems likely that this polyptych is still the subject of the 1462 document[3] recording a partial payment to Piero's brother for a panel the master had painted for the Compagnia della Misericordia. Work on the project may thus have been protracted over many years.

Further support for this hypothesis comes from the inclusion of Saint Bernardine of Siena among the saints depicted. Not canonized until 1450, he is rarely found (with a few natural exceptions) prior to that date. Even in Sienese painting, he does not appear with any real frequency until several years after his canonization, from around 1460 onwards.

We have deliberately excluded from our illustrations all the figures of saints on the various lateral pilasters and predella panels of the polyptych. As our main text makes clear, these are certainly by some other painter. Probably Florentine, this artist, who must have been working practically independently, made only slight concessions to Piero's style in the interests of harmonization.

There is no basis for the occasional suggestions[4] that the elderly worshipper shown in profile is the same man seen praying before Saint Jerome in the picture in Venice.

Equally ill-founded are the repeated attempts to discover Piero's own features in those of another among of the faithful, through comparison with the similarly foreshortened face of the sleeping guard in the *Resurrection*. Inspired by local civic-booster sources of quite recent date, such claims have been yet more wildly expanded by a writer[5] who, after spotting every member

of the Franceschi family among the devout, goes on to find two further self-portraits by Piero: one among Solomon's attendants in the *Reception* at Arezzo, the other in the *Hercules* in the Gardner Collection.

(1927)

1. G. Milanesi, publication of documents in the journal *Buonarroti*, 1885-87.

2. [In 1971, Battisti published a document unknown to Longhi, dated (in accordance with the Florentine calendar) January 14th, 1454; it is an injunction to Piero, demanding that he return to Borgo San Sepolcro within forty days to finish the altarpiece. (E. Battisti, *Piero della Francesca*, Milan, 1971, p. 221, doc. xxxiv.; but for the correct reading of the date [1455] and the probable significance of the document's wording, see also J.H. Beck, "Una data per Piero della Francesca" in *Prospettiva* 25, 1978, p. 53.) In his recent effort to date all painted portions of the polyptych to after 1454, M. Calvesi (op. cit., p. 19) makes much of this document. He also recalls the discovery—based on study of the grain—that the four principal saints were painted on wood that had grown contiguously, since he believes that this shows all four figures to have been painted in a shorter lapse of time than previously thought (op. cit., p. 200). Calvesi further draws attention to another new document dated Apil 29th, 1450, recording a partial payment for "tabule construende in oratorio Sancte Marie de Misercordia." (First published by James R. Banker in "The Altarpiece of the Confraternity of Santa Maria della Misericordia" in *Piero della Francesca and His Legacy*, Marilyn Aronberg Lavin, ed., Washington, D.C., 1995, pp. 21-36.)

Faced with the obvious stylistic discrepancies within Piero's contributions to the polyptych, already well delineated by Longhi, Calvesi writes: "Art historians base their chronologies on stylistic developments, which sometimes aren't really stylistic developments at all, but rather the result of different means used as a function of different contents." (op. cit., p. 32; my translation.) One may, perhaps, take this as a response to the outlook expressed in Longhi's more theoretically oriented assertion that "all the formal elements, observantly examined in the relationships between one work and another, inevitably dispose themselves in an historically developing series." (R. Longhi, review of Petraccone's *Luca Giordano* in the journal *Arte*, 1920; now in *Opere complete*, vol. I (*Scritti giovanili*), Florence, 1980, p. 43; my translation).

What is certainly true is that, in the *Misericordia Altarpiece*, Piero faced the challenge of fitting new ways of representing bodies in space into the context of an older format and icononography. (In this regard, Bertelli has

rightly drawn attention to the simple expedient whereby the painter dispenses the viewer's eye from the impossible task of attempting to fit all the figures on the central register into a continuous fictive space and scale: Piero places the four saints upon a light-colored marble dais and the Virgin with her minuscule flock upon a dais of black marble. Cf. C. Bertelli, *Piero della Francesca*, London, New York, Sydney and Toronto, 1992, pp. 30-31.)

Scholars continue to disagree over the polyptych's chronology. Despite the new documents, many still believe that parts were painted in the late 1440s, however sporadic and slow the subsequent progress of the polyptych's execution and installation—delays which, in fact, Longhi never doubted. The polyptych does not seem to have been fully completed until 1460 or even later. Bertelli suggests (op. cit., p. 31) that the urgent demand in 1455 that Piero come back and finish the work may be connected with the recasting of the saints on the right demanded by Bernardine of Siena's canonization in 1450. (D.T.)]

3. In G. Gronau, "Piero della Francesca oder Piero dei Franceschi" in *Rep. f. Kstw.*, 1900, pp. 393-94.

4. C. Ricci, *Piero della Francesca*, Anderson, Rome, 1910.

5. A. Del Vita, "Il volto di Pier della Francesca" in *Rassegna d'Arte*, 1920, p. 109.

The *Misericordia Polyptych*: **Piero's collaborator** (pp. 19-20). — Professor [Mario] Salmi has proposed (in *Rivista d'Arte*, 1942) that the artist who collaborated with Piero on the predella and pilasters of the altarpiece be identified as Giuliano Amedei, basing this suggestion upon a comparison with that Camaldolite painter and illuminator's signed triptych at Caprese. The idea is a plausible one.[1]

(1942)

1. [Salmi's identification of Piero's collaborator as Amedei—sometimes spelled Amadei—is generally accepted. (D.T.)]

The *Misericordia Polyptych* and **Masaccio** (pp. 22-23). Regarding the comparison—involving both affinities and contrasts—between the crucified Christ and the two sorrowing figures in the *Misericordia Polyptych* and the ones in the analogous little panel by Masaccio that originally was part of the

Pisa Altarpiece, I should like to point out, as I do not think has been done hitherto, that the most unorthodox figure in Masaccio's panel, the famous Magdalene with raised arms, was added by the artist at a late stage of the execution, as we may see from the fact that this figure's halo (not demanded by the usual iconography of this scene) had not been prepared for in advance by the artisan who, when readying the gold-leaf ground, had anticipated the position of the other figures' haloes.

For a curiously low opinion of Piero's admirable little panel, see Toesca in the *Enciclopedia italiana*, XXVII, p. 209.

(1962)

The *Misericordia Polyptych* (p. 21)

The first saint to the right of the central panel is usually said to be Saint Andrew; but in the light of Millard Meiss's[1] observations concerning the similar—and analogously placed—figure in the *Saint Augustine Polyptych*, it is possible that this one is also a Saint John the Evangelist.[2] The later was especially venerated at San Sepolcro, where the cathedral had been dedicated to him since earliest times.

(1962)

1. [M. Meiss, "A Documented Altarpiece by Piero della Francesca" in *The Art Bulletin*, March 1941 (D.T.)]

2. [Both identifications are to be met with in the more recent monographs on Piero. (D.T.)]

The Venice *Saint Jerome*

Saint Jerome with a Donor
[Venice, Gallerie dell'Accademia]

This painting's history is unknown prior to 1850, when it entered the Accademia in Venice as part of the Hellmann-Renier bequest.

It seems reasonable to connect it with Vasari's mention of the numerous pictures with small figures painted by Piero at Urbino and later dispersed as a result of that little state's political misfortunes.

We believe that it must be dated much earlier than it generally has been,[1] since its style is still closely related to Domenico Veneziano's, especial-

ly in the figure of the saint, and also very near that of Piero's own *Baptism*, notably in the handling of the background.

The authenticity of the inscription referring to the donor, *Hier. Amadi. Aug. F.*, has been challenged, but on no very specific paleographic grounds. On the other hand, it is also true that Cavalcaselle's efforts to identify the hometown of this Gerolamo Amadi led nowhere in particular.

(1927)

1. C. Ricci, op. cit.

The Venice *Saint Jerome* (p. 25). — As regards the hometown of the "Hier. Amadi." who commissioned the little painting, Cavalcaselle himself already noted, in the Italian edition of his history, that Piero's patron belonged to the same family as the Venetian who had ordered pictures from Niccolò di Pietro [Gerini] and Gentile da Fabriano; nonetheless, doubting the authenticity of the inscription and finding no Veneto traits in the landscape or the donor's clothing, Cavalcaselle declined to draw any conclusions. We, on the other hand, do think that the inscription supports, however tenuously, the idea that the work was commissioned by a Venetian, and that Piero made a trip to Venice in around 1450. From Ferrara, where he was working at the time, the road was not a long one.[1]

(1942)

1. [Piero's relationship with Venetian art was a crucial issue for Longhi. As readers of the present volume will discover, the art historian returned repeatedly to the idea that Piero's approach to the relationship between form, color, illusionistic space, and the picture plane was to receive its most significant later development in Venetian painting (and in Venetian art's offspring throughout Europe) rather than in the painting of Piero's native Central Italy. As early as 1914, in "Piero dei Franceschi e lo sviluppo della pittura veneziana" (now in R. Longhi, *Opere complete*, vol. I (*Scritti giovanili*), Florence, 1980, pp. 61-106), Longhi argued that Giovanni Bellini and Antonello da Messina had been, in a sense, Piero's truest heirs and continuators (the peripatetic Sicilian Antonello being rightly and reasonably considered, for the purposes of the argument, a key figure in the history of painting in Venice). Given the absence of any direct evidence linking Piero to Venice, Longhi not unnaturally welcomes the present opportunity to suggest one point at which direct contact between Piero and artistic Venetian circles might have been possible.

(D.T.)]

On the *Saint Jerome with a Donor* (p. 25)

In the note I added to the second edition, I set forth the reasons for supposing this little painting to have been executed by Piero in the course of a trip to Venice; the most plausible date for such a trip—one quite compatible with the style—would be during the artist's sojourn at Ferrara in 1449. It is true that attempts have been made to identify the city in the background as San Sepolcro. But the identity of the towns in Italian paintings, except in cases where there is some unmistakable, absolutely specific characteristic, must always be approached with caution. Let it be clear that I would not even dream of identifying the place in the present picture as Venice! But I have long been aware of a distinctive regional trait in the painting that no one else seems to have noticed: the little city's roofs are crowded with those tower- or chalice-shaped chimneys that are to be found exclusively in Venice, or at least in the Veneto. There are, in all, thirty-five of them; a young friend has gone and counted them at my request. Outside Venetian painting, where such chimneys abound in the works of the Bellini and, even more, in those of Carpaccio, I can find no examples except for the wooden inlays by the Lendinara in Modena. But the Lendinara were from the Veneto, too; nor does it hurt my argument any that they were friends of Piero's and made good use of his cartoons. It therefore seems to me that the presence of all those chimneys strongly suggests that the little painting was commissioned for Venice; and this, in turn, would make Piero's trip there a near certainty. For this reason, I have added an enlarged illustration of a detail in which the architectural peculiarity is particularly evident.

(1962)

The Urbino Flagellation

The Flagellation of Christ
[Urbino, Galleria Nazionale delle Marche]

Formerly in the sacristy of the cathedral at Urbino; now in the Galleria Nazionale delle Marche in the same city.

This is probably another among the small panels with little figures mentioned by Vasari.

From the eighteenth century to our own day, there has been endless debate regarding the interpretation of the three mysterious figures on the

right, outside the atrium. The most probable of the numerous theories is based, in part, upon an old inscription[1] beneath the three figures; no longer legible today, the text read: *Convenerunt in unum* ["They came together as one," in the sense of "agreed" or "plotted together"], as in the psalm alluding to Christ's martyrdom.[2] According to this interpretation, the blond youth is a portrait of Oddantonio da Montefeltro, flanked by Manfredo dei Pio and Tommaso dell'Agnello. The bad advice of these two evil ministers occasioned popular anger that exploded in the Serafini conspiracy, leading to the young ruler's death [and to that of his ministers as well (ed.)]. The year 1444, when these tragic events took place, may thus serve as an approximate date for the painting,[3] since [Oddantonio's successor] Count Federigo presumably did not wait too long before having an image made to commemorate his half-brother's death.[4]

Moreover, the style likewise points to a period earlier than that of the frescoes at Arezzo. The architectural setting has its marvelously Classical passages, but is nonetheless more slender than that produced by the "divine measurement"[5] manifest in the Arezzo frescoes; the colors have a practically miniature-like purity, while the snake-like coils of Oddantonio's hair recall the hair of the angels in the *Baptism*. Even the sense of almost exaggerated mathematical demonstration[6] that underlies the picture as a whole—exaggerated, that is, even by comparison with the general trend of fifteenth-century Italian painting—is typical of the beginnings of Piero's artistic development. It seems absurd to place the London *Nativity* or the *Sinigallia Madonna*, both painted around 1470, alongside such a rigorously "perspectival" work as this; twenty years of evolution hardly seem too many to arrive at those late works, starting from such a point of departure as the *Flagellation*.

(1927)

1. [The inscription was published by the German historian J.D. Passavant in his monograph *Rafael von Urbino und sein Vater Giovanni Santi*, Leipzig, 1839. Passavant's description suggests that the words must have appeared in the foreground near or below (*dabei*) the three mysterious figures at the right. Since an inventory of 1754 describes the picture—then in the sacristy of the Duomo at Urbino—as possessing an "entirely gilded frame" that has subsequently vanished, some scholars (including C. Gilbert and C. Ginzburg) have hypothesized that the inscription—whether or not it went back to Piero's time—may have appeared on the frame rather than on the panel itself. Other writers, however, insist that the words must have been painted on the panel itself: perhaps on the pavement, within the prominent white band passing

beneath the feet of the bearded figure and intersecting with the picture plane. If so, the text was removed in the course of a misguided cleaning sometime between 1839 and 1864, when it was no longer visible. (Cf. R. Lightbown, *Piero della Francesca*, New York, 1992, p. 65.) (D.T.)]

2. [It is obvious that, for simple reasons of chronology, no psalm can "allude" to Christ's Passion. But there was, of course, a long tradition whereby, in an erudite and ingenious display of concordances, Old Testament texts were interpreted as *prefiguring* events and ideas recounted in the New Testament. (The process is memorably made visible, for example, in the stained glass windows in the transept at Chartres.) The words *convenerunt in unum* occur in Psalm 2, verse 2 of the Vulgate Latin translation of the Bible; the passage is rendered in the King James version as "the rulers take counsel together against the Lord and against His annointed." The psalm is, in fact, quoted in the *Acts of the Apostles* (4:26-27), with specific reference to the conspiracy against Christ. As has occasionally been noted in the literature on Piero, the words *convenerunt in unum* are part of the Good Friday liturgy, and are thus particularly appropriate to a subject taken from the Passion. (D.T.)]

3. [Longhi's early dating for the work has not always found favor. In his lucid and influential monograph, Kenneth Clark (op. cit., pp. 19-21) observed that certain details of the architectural setting are apparently dependent upon the works of L.B. Alberti and—given the chronology of that Florentine architect and theoretician's career—would thus appear to support a date no earlier than 1455-60: a period coherent with Clark's association of the work's iconography with the Council of Mantua of 1459, or at any rate with one or another of the councils held in the aftermath of the fall of Byzantium to the Turks in 1453. (See following Editorial Note.) More recently, Marilyn Aronberg Lavin has dated the *Flagellation* after 1457, likewise on the basis of detailed comparisons with Alberti's architecture. (Cf. M. A. Lavin, *Piero della Francesca: The Flagellation*, London, 1972.) Using different arguments, Carlo Ginzburg (*Indagini su Piero*, new 3rd. ed., Turin, 1994, pp. 73-74) arrives at similar conclusions: the Italian scholar claims that numerous features of Piero's setting depend upon the antiquities and relics, some brought from the Holy Land, that Piero would have studied in and around the Lateran complex in the course of his documented Roman sojourn of 1458-59. Maurizio Calvesi (op. cit., pp. 154-5) believes that this work and the Arezzo cycle share common references to specific events in contemporary military struggle against the Turks along the Danube; partly on the basis of these external events, he dates the *Flagellation* to 1463-64 (as does, for other reasons, Creighton Gilbert, op.

cit.). But Ronald Lightbown, who for stylistic reasons (related, in part, to the lettering in Piero's signature in the painting) prefers a date around the end of the 1440s, finds that Piero could easily have derived his architectural language from monuments that were visible in Ferrara as early as 1449, and from other models in Florence. (R. Lightbown, op. cit., p. 56). The great nineteenth-century connoisseur Cavalcaselle, followed by Berenson, thought the *Flagellation* a late work of around 1469. Longhi's own last word on the subject was published in a note appended to the third, 1962 edition of the present monograph (and translated elsewhere in this volume). While accepting that his initial dating of 1444 or shortly thereafter might have been too early by a very few years, he remained convinced that the work predated the cycle at Arezzo, where Piero—according to Longhi—began work in 1452 or thereabouts. (D.T.)]

4. [The iconography of Piero's *Flagellation* remains one of art history's great unanswered riddles. Recent scholarship has tended to reject the traditional interpretation recorded by Dennistoun and published by him in 1851. In reality, the local tradition identifying the blond, barefoot youth in the group at the right as Oddantonio goes back at least to the mid-eighteenth century: an inventory of 1744 describes the three figures as Oddantonio and two of his kinsmen. There is even inconclusive evidence that Montaigne may have been shown the picture as an image of Oddantonio when he visited Urbino in 1580. (Cf. C. Bertelli, *Piero della Francesca*, London, New York, Sydney and Toronto, 1992, p. 125 and p. 139, note 44.) Still, there is no question that the romantic—and, in fact, typically Romantic—reading accepted by Longhi raises major logical and iconographical difficulties.

Numerous alternative explanations for the work's mysterious iconography have been proposed. Only John Pope-Hennessy has gone so far as to deny that the subject is the *Flagellation of Christ*, seeing instead a depiction of the *Dream of Saint Jerome*; according to the late connoisseur, Jerome is here being chastised for having loved his books more than the human souls in his cure. (Cf. J. Pope-Hennessy, "Whose Flagellation?" in *Apollo* 124 (1986), pp. 162-165 and in *The Piero della Francesca Trail*, London, 1991).

According to the great critic and historian Ernst Gombrich, the group in the foreground may represent the penitent Judas returning the payment for his treachery to the members of the Sanhedrin. But, as Gombrich himself was the first to admit, one difficulty with this idea is that no purse or coins are in evidence anywhere in the scene. (Cf. E.H. Gombrich, "The Repentance of Judas is Piero della Francesca's 'Flagellation of Christ'" in *Journal of the Warburg and Courtauld Institutes*, XXII (1959), pp. 105-107, now in *Reflections on the History of Art*, R. Woodfield, ed., Berkeley and Los Angeles,

1987).

A number of scholars, in fact, have seen the iconography in a context of anti-Semitism. De Tolnay, for example, thought that the three figures on the left were personifications of Judaism and heresy. (Ch. de Tolnay, "Conceptions religieuses dans la peinture de Piero della Francesca" in the journal *Arte antica e moderna* 23, 1963, pp. 205-41). According to Joseph Hoffmann, the painting commemorates a sermon of the Franciscan Saint John Capistrano, "scourge of the Jews"—who played an important role in the battles against the Turks at Belgrade: an event that Calvesi sees as relevant to the topical theme of the Arezzo cycle. (J. Hoffman, "Piero della Francesca's 'Flagellation': A Reading from Jewish History" in *Zeitschrift für Kunstgeschichte* XLIV, 1981, pp. 340-257; M. Calvesi, op. cit., p. 41). Follini sees the three figures at the right as Jewish persecuters of Christ. (F. Follini, "Una possibile connotazione antiebraica della 'Flagellazione' di Piero della Francesca" in *Bollettino d'Arte*, n. 65, 1991, pp. 1-28); but one cannot help observing that, especially where the blond, barefoot figure is concerned, this would be an extreme instance of "casting against type"!

Most recent interpretations recognize that the three figures in the foreground, so far from being mere bystanders at Christ's flagellation, are separated from the event in both space and time. Apparently figures of Piero's own day, the three men at the right seem to comment and reflect upon Christ's Passion, a matter which probably has, in turn, some specific symbolic bearing upon their own situation.

Taking up a suggestion already put forward by Felix Witting as early as 1898 (in his *Piero dei Franceschi: Ein Kunsthistorische Studie*), Kenneth Clark hypothesized a connection with the sufferings of the Christians of the Greek Church at the hands of the Turks during the 1450s; as mentioned above, Clark thought that the picture commemorated a plea for Western help, delivered by the bearded Eastern emissary who cites the cruel scourging being inflicted upon Christ. Clark believed it likely that the picture was associated with the Council of Mantua, called by Pope Pius II Piccolomini in 1459 to promote an alliance of Christian rulers against the Turks. Subsequent variations upon the idea that the work reflects the Turkish threat to Christianity in the East—almost certainly, in its basic outline, the correct hypothesis—have been far too numerous and complex to recount in detail here. Let us briefly note that the bearded foreground figure (who, it seems, is doing the talking) has often been tentatively identified as the Eastern monarch John VIII Palaeologus or else as the great churchman Bessarion: in short, as a representative of Byzantine Christendom, who has come to Italy to bear witness and to exhort the West to action in defense of Christ's tormented body, the

Christian community.

Many identities have been proposed for the foreign emissary's intent, blue-robed listener: a very incomplete list includes the Milanese Duke Francesco Sforza; Ludovico Gonzaga, *marchese* of Mantua; a member of the Malatesta family of Rimini; and Giovanni Bacci, of the family that offered Piero its patronage in the church at Arezzo. (For interesting arguments in favor of the latter, see C. Ginzburg, op. cit., esp. pp. 65-68.) The beautiful barefoot youth—not taking part in the conversation but gazing into the distance beyond the picture plane—is, if anything, yet more reluctant to yield up his secrets, lacking as he is in the kind of specific social and ethnic attributes displayed by his companions. Some have seen him as an angelic messenger, or else as an "athlete of virtue" being exhorted by the Greek to struggle against the Turks. The numerous other highly conjectural identifications—more historically specific and therefore, as we have seen, less convincing, given the figure's lack of any truly individual characteristics—have included Federigo da Montefeltro's beloved son Buonconte, or the son of Ludovico Gonzaga—both of whom died young—or else the young Hungarian king Matthias Corvinus, who took part in the war against the Turks.

A new interpretation unconnected with the travails of Eastern Christendom has been offered by Marilyn A. Lavin. She reads the picture as a conversation between Ludovico Gonzaga and his courtier Ottaviano Ubaldini della Carda; the latter is exhorting his master to Christian resignation in the face of the illness and physical suffering that has recently befallen youths of both men's houses. (M. A. Lavin, "Piero della Francesca's *Flagellation*: The Triumph of Christian Glory" in *The Art Bulletin* 50 (1968), pp. 321-42; with additions, in the same author's *Piero della Francesca: The Flagellation*, cit.)

Another anomalous proposal has been very cautiously set forth by Bruce Cole, who thinks it just possible that the panel—seemingly too small for an independent altarpiece, too large for a predella, and hard to imagine as part of a conventional polyptych—may have been painted for one of the period's many lay confraternities of flagellants. (B. Cole, *Piero della Francesca: Tradition and Innovation in Renaissance Art*, New York, 1991, p. 66.)

After this exhausting but far from exhaustive *tour d'horizon*, the reader may be forgiven for wondering if Longhi's uncritical acceptance of the traditional interpretation did not perhaps bespeak a certain easygoing wisdom. (D.T.)]

5. [*Divinamente misurate* is Vasari's description of the Corinthian columns in Piero's Arezzo fresco of *Solomon Receiving the Queen of Sheba*. As is his allusive—and, at times, irritating—wont, Longhi employs a brief quotation with-

out identifying its source. (D.T.)]

6. [In a famous article, Wittkower and Carter identified the mathematical module—the basic unit of measurement—upon which the architecture seen in the *Flagellation* is based, offering architectural drawings of the setting in plan and elevation. Cf. R. Wittkower and B. A. R. Carter, "The Perspective of Piero della Francesca's 'Flagellation'" in *Journal of the Warburg and Courtauld Institutes*, no. 16 (1953), pp. 292-302. (D.T.)]

The Urbino *Flagellation* (p. 26). — Toesca[1] has recently made a strenuous effort to date this panel later than I proposed to do; he ascribes it to the period of the Arezzo frescoes or even later, rejecting the traditional connection with the story of Oddantonio da Montefeltro and calling the picture "a work distinguished by the artist's sovereign indifference to the principal subject." His logic is faulty: aside from the fact that one could never encounter such indifference in an artist of the fifteenth century, it is clear that the main subject here is embodied not in Christ's flagellation, but rather, precisely, in those three mysterious figures in the foreground. It is in them that we must find the significance and subject expressed by means of the transparently allusive and symbolic *Flagellation*, here placed in a subordinate position. Since the work was intended for Urbino, the mysterious modern topic must likewise have beeen connected with that city. This is why the traditional local interpretation of the picture is so plausible.[2] The dating it would suggest is entirely compatible with this work's style, still close to that of the early works; the picture is a clear prediction, rather than a consequence, of the Arezzo frescoes.

(1942)

1. *Enciclopedia italiana*, XXVII, pp. 209-212. [The important art historian Pietro Toesca had overseen the young Longhi's studies at the University of Turin. Despite the blunt tone of the present note, his brilliant charge—who in later years likened him to a "gentle medieval monk"—always retained a high regard for him. (D.T.)]

2. [A propos of Longhi's espousal of this untenable interpretation, Carlo Ginzburg has rightly written: "It is clear that Longhi would never have dreamed of accepting acritically an attribution which had turned up in the local tradition a hundred years, let alone three hundred years, after the fact. But when it came to iconography, he was infinitely less demanding." (C. Ginzburg, op. cit., p. XVIII; my translation.) For an analysis of Longhi's gen-

eral outlook and conception of art-historical inquiry, which frequently induced him to concentrate on stylistic considerations to the virtual exclusion of iconological and socio-economic factors, see David Tabbat, "The Eloquent Eye: Roberto Longhi and the Historical Criticism of Art" in Roberto Longhi, *Three Studies*, Riverdale-on-Hudson, A Stanley Moss-Sheep Meadow Book, 1995, pp. ix-xxx; now also in the journal *Paragone Arte* XLVII (nos. 557-559-561), Florence, 1998, pp. 3-27 and (in Spanish) in the catalogue *Pasión por la pintura: la Colección Longhi*, Madrid, Fundación la Caixa, 1998, pp. 40-57. (D.T.)]

On the Urbino *Flagellation* (p. 26)

Regarding the approximate date of this picture, which some scholars think later than I proposed, I too am now inclined to put it a few years later—but still in a phase preceeding the Arezzo frescoes.[1]

(1962)

1. [Longhi's initial dating of 1444 or shortly thereafter had depended, in part, upon the fact that Oddantonio da Montefeltro had been assassinated in that year. Longhi initially accepted the traditional connection of this work's mysterious iconography with Oddantonio's death; but his subsequent observations in the 1942 and 1962 (pub. '63) editions may, perhaps, be read as— among other things—a tacit retreat from his earlier confident position regarding the iconography. (D.T.)]

The Rimini Fresco

Saint Sigismund and Sigismondo Malatesta
[Rimini, Tempio Malatestiano]

The fresco is signed and dated: *Petri de Burgo opus MCCCCLI*. The date has occasionally been questioned, but wrongly, probably as a consequence of its being confused with the date 1446 in the inscription on the medallion surrounding the depiction of the Rocca Malatestiana fortress, built in that year. (For the history of this error, see the relevant passage in my study[1] of Piero's "critical fortune.") The date 1451 has recently been confirmed by Ricci's research[2] regarding the date on which the Chapel of the Relics, where the fresco is located, was dedicated.

Sigismondo's profile has frequently been compared with Matteo de'

Pasti's portrayal of the ruler on a medal of earlier date; but it should be borne in mind that Piero could have drawn on this medal only for iconographical purposes. Everywhere in the fresco, the style is already that of the Arezzo cycle; the Rimini work thus offers extremely valuable evidence as to the only slightly later moment when work at Arezzo began.

There is no basis whatsoever for Witting's claim that Saint Sigismund's face and various other aspects of the fresco reveal a relationship with a work by Rogier van der Weyden. The same critic's observation that the composition has affinities with an early work by Titian now in Antwerp is more to the point; such affinities, however, must not be understood as the result of any specific derivation. They bespeak, instead, Piero's wide-ranging anticipation of Venetian styles down to Titian and beyond. Witting failed to catch any glimpse of this truth.[3]

(1927)

1. [R. Longhi, "Fortuna storica di Piero della Francesca" in *Piero della Francesca*, Rome, 1927; now in *Piero della Francesca*, Florence, 1963, pp. 115-169. (D.T.)]

2. C. Ricci, *Il Tempio Malatestiano*, Milan, 1925.

3. F. Witting, *Piero dei Franceschi*, Strasbourg, 1898.

The Rimini fresco (p. 29). — Several years ago, at a moment when some conservative maintenance was being carried out, I had a chance to study the fresco at close hand. I observed that, in the area between the piers, the painted ground against which the lord of Rimini appears had not always been a space open at the back to the sky, as the coarse seventeenth-century restoration had made it appear; originally, it represented a smooth surface of variegated marble against which the figure stood out, light against dark. On the right, the apparent ambiguity of the Castellum Sigismundum seen through the oculus window—an apparition of which I wrote that "there is no telling whether it be more a graphic symbol or an optical reality"—has now been revealed as being solely the latter; it is as though the only aperture in the darkly gleaming marble ground had magically come to frame the far-off castle.

(1942)

The Legend of the Wood of the Cross

[Arezzo, Church of San Francesco]

A series of frescoes forming the greater part of the painted decoration in the choir of the church of San Francesco at Arezzo. Bicci di Lorenzo had begun the painting of the choir; when he died in 1452, he had already frescoed the choir vaulting and underarches, as well as the piers marking the entrance to this part of the church. There is no reason to believe that much time had elapsed after Bicci's death before Piero took the work in hand—especially since the stylistic kinship with the Rimini fresco of 1451 is so immediate.[1]

The only portions by Piero's hand omitted from the illustrations [in the 1927 edition of this monograph, ed.] are the representations on the entrance underarch of two sainted Doctors of the Church, Ambrose and Augustine, for which no photographs were available. On the other hand, the exclusion of other portions, such as the *Saint Louis* and the *Blindfolded Cupid* on the pilaster strip at the left, is deliberate, since it is our opinion that these are the work of followers.

For detailed information regarding the role of assistants, see the notes regarding the individual scenes.

Almost forgotten after the end of the sixteenth century, the frescoes have suffered much at the hands of men and time; contrary to what Cavalcaselle thought, however, they do not seem ever to have been plastered over. In 1860, Dr. Gaetano Bianchi was entrusted with a first restoration. A few years ago, a new restoration by Professor Domenico Fiscali definitively[2] consolidated the frescoes, even making possible the removal of the metal clamps that formerly traversed the entire width of the two scenes of *The Meeting of Solomon and the Queen of Sheba* and *The Restitution of the Cross to Jerusalem.*

For information on the legend of the True Cross, see: F. Kampers, *Mittelalteriche Sagen vom Paradiese u. vom Holze des Kreutzes Christi*, Cologne, 1897; P. Mazzoni, *La Storia della Croce nell'arte italiana*, Florence, 1911; G. Battelli, *Leggende Cristiane*, Milan, 1924; Jacobus de Voragine, *Leggenda aurea*, fourteenth-century Italian trans., A. Levasti, ed., Florence, 1924; Honorius Augusodonensis, *Speculum Ecclesiae* (Migne, *Patrologia*, T. CLXXII, p. 208, 1002, "De exaltatione sanctae Crucis").[3]

(1927)

1. [There is no consensus regarding either the dates marking the beginning and end of Piero's work at Arezzo or the sequence in which the scenes were painted. Some scholars (e.g. Pope-Hennessy and Bertelli) have suggested that Piero may have actually taken over the project from an ailing Bicci di Lorenzo as early as 1448. As readers of the present volume will be aware, Longhi thought, on stylistic grounds, that Piero probably took over the project around 1452—shortly after his dated Rimini fresco of 1451—and essentially saw it through to completion prior to his documented Roman sojourn in 1459. (Despite replacement of Helena by Heraclius as the principal actor, the lunette with the *Exaltation of the Cross*—called by Longhi *Heraclius Returning the Cross to Jerusalem*—is so close to Agnolo Gaddi's analogous scene at Santa Croce that one may wonder whether Piero did not, perhaps, largely accept an extant design by Bicci, based on the illustrious Florentine model: an element of continuity suggesting, perhaps, that not much time elapsed between Bicci's departure and the start of Piero's work—although Piero himself obviously studied Agnolo's work carefully, too.)

Longhi believed that Piero and his assistants worked on both walls from a single scaffolding, proceeding downwards, register by register, from the level of the lunettes, with Piero leaving a larger share of autograph work on the right wall while supervising his helpers across the scaffolding. As will be readily apparent, Longhi's chronology recognizes a stylistic shift over the course of the cycle: from a certain residue of typically Florentine linear elements in the lunettes to a more perfect fusion of three-dimensional form and broad areas of surface color in the lower registers. Longhi's dating—although not his reconstruction of the manner in which the work was performed, which seems absolutely coherent with the visual evidence—encounters a certain potential difficulty over Piero's fresco of *Saint Luke* in Rome, where Piero is not reliably documented before 1459; for Longhi himself regarded the Roman work as stylistically coherent with the *middle* years (around 1455) of Piero's task at Arezzo.

Kenneth Clark (in *Piero della Francesca*, London, 1951) offered an alternative, "separate scaffolds" chronology, according to which Piero would have worked his way first down one wall and then down the other, with the Rome trip marking the hiatus between the two phases. Work would thus have continued well after 1459.

A solution combining features of the two mentioned above was proposed by Creighton Gilbert in 1968 in his *Change in Piero della Francesca*. Gilbert believes that Piero began work on both walls simultaneously, but that the stylistic differences between the top and middle registers—including a

shift in the direction of a greater architectonic monumentality—reflect the impact of the artist's Roman sojourn and of his contacts with Humanist circles there. According to Gilbert, even if work had begun in the early 1450s, a good part of it must thus have been executed in the first half of the 1460s, but still prior to 1466, when a document refers to the frescoes as already complete. Maurizio Calvesi (whose various publications on the subject are summarized in his *Piero della Francesca*, Milan, 1998) connects the battle scenes with the Christian victories over the Turks near Belgrade in 1456, deducing that the program must have been revised after that date. He further suggests that the central role assigned to Heraclius in the lunette with the *Exaltation of the Cross*—where in essence the Emperor takes over the role played by Helena in such earlier representations as Agnolo Gaddi's at Santa Croce—may be an allusion to John Hunyadi's victory at Belgrade. Perhaps overstating his case, Calvesi therefore believes that the year of the twin battles along the Danube should be taken as a *terminus ante quem non* for Piero's cycle as a whole. Like Gilbert, he thinks that most of the cycle dates to the first part of the 1460s, after Piero's return from Rome.

Several other chronologies have been offered, however; and various elements have been adduced as having some bearing on the problem. For example, the signed Città di Castello altarpiece of 1456 by Giovanni di Piemonte—whom Longhi brilliantly recognized as Piero's assistant in two of the scenes at Arezzo—already reveals a thorough acquaintance with Piero's style. (D.T.)]

2. [Longhi's optimism was misplaced. Fiscali's restoration of 1915 was followed by another in 1959-65 under the direction of Leonetto Tintori, who found that, while the condition of the *intonaco* (the painted layer of plaster) appeared relatively stable, there had nonetheless been a significant acceleration in the process of microscopic color loss; as Kenneth Clark had previously noted, the colors seemed to be losing their intensity. Tintori's restoration aimed to consolidate the frescoes and make them less vulnerable to the water permeating the walls, and also removed the tinted wash with which Fiscali had covered over the lacunae. Longhi and the noted restorer Pellicioli, among others, were critical of both Tintori's aesthetic results—the colors were widely thought to have become too bright and cold as a result of overcleaning—and of certain of his technical decisions; Tintori replied that the safety and reversibility of the substances he had used had been tested under the supervision of the Consiglio Superiore delle Belle Arti, the Institute of Fine Arts of New York University, and the Mellon Institute. Tintori nonetheless acknowledged that the condition of the support—i.e., the adhesion of the *intonaco* to

the wall—remained a source of concern. (Cf. P. De Vecchi in *L'opera comple-
ta di Piero della Francesca*, Milan, Rizzoli, 1967, p. 92; Anna Maria Maetzke,
*Piero della Francesca: les chef d'oevres retouvés à Arezzo. Estampille. L'objet d'art
1999*, no. 338, juillet-août, pp. 66-73; Rossella Lorenzi, *Cross examination,
Art News*, 2000, v. 99, no. 3, March, p. 74.) It is still too early to evaluate the
results of the current restoration campaign—the fourth major intervention in
little more than a century. Piero della Francesca, *La leggenda della vera croce in
San Francesco ad Arezzo*, Milan, 2001. (D.T.)]

3. [Passages from Jacobus de Voragine's *Leggenda aurea* relevant to the Arezzo
cycle are conveniently quoted, in William Caxton's attractive English transla-
tion of 1483, in P. Hendy, op. cit., pp. 81-88. For various reasons, the stories
of the True Cross had become a favored subject for fresco cycles in Franciscan
churches such as the one at Arezzo. As we have seen, it has also been suggest-
ed that these stories of the defense of the Cross against its enemies—a popu-
larly-flavored theme that some, including Longhi, have judged oddly "old-
fashioned" in an age of increasingly Humanist taste—may have actually taken
on a new urgency and relevance at a time when Christianity faced a major
challenge from the Turks. But it is also true that the last large *True Cross* cycles
had been painted as recently as 1410 (Cenni di Francesco in San Francesco at
Volterra) and 1424 (Masolino in Santo Stefano at Empoli); and so the under-
lying theme was still essentially a current one that would have required no spe-
cial justification, whatever the topical adjustments encountered in Piero's ver-
sion. (D.T.)]

Two Prophets

Their identification is uncertain. Naturally, it has been sought among
those figures who in some way alluded to the Cross or events from its story;
the names of Jeremiah, Daniel, and Jonah have been proposed, as has that of
Saint John the Evangelist.

In one of the figures, Schmarsow[1] and Witting[2] saw contributions by
Melozzo da Forlì. This opinion seems to us untenable, all the more so since
the date both proposed for the Arezzo frescoes—i.e., after 1460—is easily
confuted. While we do not deny the evidence that Piero had a collaborator on
this figure, we suggest that the hand is that of a painter close to the one who
worked on the predella of the Misericordia altarpiece.

1. A. Schmarsow, *Melozzo da Forlì*, Berlin, 1885.
2. F. Witting, op. cit.

The Death of Adam

Here begins the depiction of the legend of the wood of the Cross, wood said to have grown from the seed of redemption placed under the tongue of the dead Adam by his son Seth. More precisely, the lunette shows several moments connected with the death of the first progenitor. At the right: Adam, sensing that he is about to die, begs Seth to go to the angel guarding the lost Garden of Paradise, in order to obtain from him the oil of salvation promised so long ago. Surrounding Adam are two youthful great-grandsons and the decrepit Eve. In the background at the left: Seth converses with the angel, who—so the legend recounts—will give him, in place of the oil, three seeds to be placed under the tongue of his father, whom he will find dead upon his return. It is from these seeds that there will later spring the tree through which mankind will be redeemed. To the left of the tree, Seth carries out the angel's command as Adam lies dead upon the ground. All around are mourners, ranging from old men to adolescents: representatives of the various generations descended from Adam. The large tree in the middle of the composition may perhaps stand for a later stage of the story, when the wood has already grown from the seed of redemption; to me, this seems the best explanation for the tree's dominant, symbolic centrality.

The Meeting of Solomon and the Queen of Sheba[1]

Saved by mysterious impediments from use in the construction of the Temple, the wood—as a passage in the *Leggenda aurea* tells us—has been placed across a stream in Shiloh to form a bridge. The Queen of Sheba falls to her knees in adoration of it, having been struck by a sudden revelation regarding the wood's future while on her way to Jerusalem.

This is the moment shown in the left-hand part of the fresco. At the right, within a Corinthian atrium, the queen is received by Solomon and shares her revelation with him.

As previously stated, there is no basis for the claims that the black-hatted member of Solomon's entourage, seen practically full-face, is Piero's self-portrait.

1. [It has been convincingly suggested that this scene carries an allegorical allusion to the reconciliation of the Eastern and Western Churches pursued at the Council of Ferrara and Florence of 1431-1443. (Cf. R. Krautheimer, *Lorenzo Ghiberti*, Princeton, 1956, pp. 184-86, with reference to the analogous scene

in Ghiberti's second set of doors for the Baptistry in Florence; extended to Piero's fresco in E. Battisti, *Piero della Francesca*, Milan, 1971 vol. I, pp. 107-108 and accepted by several subsequent writers.) The episode is absent from the *True Cross* cycles by Agnolo Gaddi, Cenni di Francesco, and Masolino da Panicale, all painted prior to the Council. (D.T.)]

The Removal of the Wood of the Cross

In the opinion of some, this fresco shows the wood being laid down to form a bridge, as Solomon has ordered. We, however, think it more likely that the scene represented is a subsequent one: troubled by the Queen of Sheba's revelation regarding the destiny of the holy wood, Solomon has demanded that the latter be removed from its position over the stream and buried deep in the earth. By implication, the scene also alludes to the much later rediscovery of the wood at the time of Christ.

Here again, Schmarsow and Witting claim to recognize the contribution of Melozzo; for reasons already set forth, this view is unacceptable.

If we had to suggest the name of a collaborator, it would be that of the little-known Giovanni di Piemonte. With the exception of Girolamo di Giovanni, this artist is the follower most closely associated with the master, and the one having the longest-standing connection with him. In Giovanni di Piemonte's signed fresco of 1456 at Città di Castello, dating from the same period as the Arezzo frescoes, we encounter certain details—for instance, the treatment of the curls, looking almost like wood shavings—that recur in the present fresco, as well as in the closely related scene of the *Torture of the Jew*.

The Annunciation

The relatively indirect nature of the connection between the scene represented and the legend of the Cross induced Springer[1] and others who have followed his lead to state that the recipient of this angelic annunciation is not Mary, but the Empress Helena; in this view, the angel is entrusting Constantine's mother with the mission of seeking the holy wood. Some have even gone so far as to see the object in the angel's hand as a cross instead of as the symbolic lily. But the iconography is clearly that of the annunciation to Mary; this event enables Piero to allude elliptically to all the others that were to follow from it but which, given the limitations of space, could not be shown in the cycle.

We find it impossible to accept, even partially, the suggestion[2] that this fresco is the work of assistants.

1. A. Springer, "Über die Quellen der Kunstdarstellungen in Mittelalter" in *Berichte über die Verhandlungen d. Kgl. Sachs. Gesell. d. Wissensch.*, 1880, I, p.6, note 1.

2. A. Venturi, *Storia dell'Arte*, vol. VII, Milan, 1911.

The Dream of Constantine[1]

The Emperor Constantine sleeps on the night before his battle against Maxentius, the invader who is laying claim to all the Imperial lands, even the westernmost ones. An angel appears to Constantine and shows him a small, shining cross as the symbol of victory.

The handling of the light has led several scholars to claim that Raphael's *Liberation of Saint Peter* [in the Vatican Stanze] is descended from this *Dream*. But Raphael's work reveals a generalized assimilation of so many different historical stylistic sources as to nullify the assignment of any very precise significance to such a derivation.

The drawing now in the British Museum believed by Cavalcaselle, among others, to be a study for this fresco—and published by Ottley,[2] before Cavalcaselle's time, as the work of Giorgione—is really a much later reworking of Piero's painting. Of a later date than believed even by Witting, who attributed it to the school of sixteenth-century Parma, it is an imitation of no particular merit.

1. [Calvesi, who argues that the battle scenes commemorate the victories over the Turks at Belgrade in 1456, has linked the sleeping Constantine's vision of the Cross—accompanied by the words "In hoc signo vinces" ("By this sign shalt thou conquer")—with the Franciscan Saint John Capistrano's vision, before his victory at Belgrade, of a falling arrow bearing the words, "Este constans Joannes" ("Be constant, John"). Cf. M. Calvesi, op. cit., p. 86. (D.T.)]

2. W. Ottley, *The Italian Schools of Design*, London, 1823, p. 58.

Constantine's Victory over Maxentius

On the day after his vision, Constantine advances against Maxentius, holding in his hand a little ivory cross; seeing it, Maxentius and his army clamber back up the riverbank in disarray and flee without giving battle.

While revealing the finest quality of execution of any scene in the cycle, this fresco is also, unfortunately, the most damaged of all. Sometime between 1816 and 1842, when it was still in better condition, the German

painter J. A. Ramboux made a watercolor copy of it now in the museum in Düsseldorf; while not so faithful as believed by the scholar who first published it,[1] this copy is nevertheless quite precious, in part because it helps us to grasp the significance of the commentary by Vasari, who devotes particular attention to the portion of the scene that has now practically vanished.

1. A. Warburg, "Piero della Francesca Costantinschlacht in der Aquarellkopie des Johann Anton Ramboux" in *Atti del X Congresso Internazionale di Storia dell'Arte di Roma* [1912], Rome, 1922, pp. 326-27.

An Angel

One of the remaining fragments of the decoration on the piers at the entrance to the choir. Certainly from Piero's own hand. The angel is probably meant to represent Divine Love, inasmuch as it counterbalances the figure of Cupid [symbolizing Profane Love, ed.]; however, we believe the latter to be by another hand.

The Torture of the Jew

The episode is drawn from the story of Saint Helena's laborious efforts to rediscover the Cross. Judas, the only Jew who knows where the Cross was buried following Christ's death, is undergoing torture intended to persuade him to share his knowledge. The fresco shows the moment when Judas, just hauled up from the well where he has been imprisoned, is about to face interrogation by the judge, who has already seized his hair.

Invention and Trial of the True Cross

Forced to confess, Judas has pointed out the spot where the three crosses are buried. The left-hand portion of the fresco shows them being dug up, with Saint Helena in attendance; on the right is the test that singles out the True Cross from among the three. At its touch, in fact, a dead youth is miraculously resuscitated, as Saint Helena and her retinue kneel at the sight.

The execution of the fresco is, at least in great part, by Piero himself.

The Defeat of Chosroes

Thirty years after the rediscovery of the Cross, the Persian king Chosroes has carried it off from Jerusalem and incorporated it into a strange throne also decorated with other symbols of the Passion. The Emperor Heraclius, head of the eastern Empire, has declared war on the infidel. The fresco shows the moment when the Persian forces led by Chosroes's son suc-

cumb to the Christian army. As for Chosroes himself, seen at the extreme right, he has refused conversion and is about to be decapitated as Heraclius looks on. According to Vasari, the bystanders at this scene include—along with other important personages of the Arezzo of Piero's day—several members of the Bacci family, who had commissioned the fresco cycle.

For the contribution of assistants, see the main text. It is likely that Lorentino d'Andrea took a hand in the "translation" of Piero's cartoon into fresco.

Restitution of the Cross to Jerusalem[1]

According to the legend, when Heraclius carried the recaptured Cross back to Jerusalem in great pomp the city gates, having miraculously shut themselves, refused him entry. In Piero's fresco we see the emperor, barefoot and wearing no insignia of rank, bearing the extremely heavy Cross himself after receiving an angelic admonition to approach afresh in a spirit of humility. He is followed by a procession of Greek priests; some townspeople who have come out to greet him kneel in veneration of the holy wood.

The execution is not entirely by the master's own hand. Here once again, Schmarsow and Witting fancied that they could spot the work of Melozzo.

1 [Recent scholarship generally prefers to designate the subject as the *Exaltation of the Cross*. The distinction is not a trivial one, when we consider Laurie Schneider's observation that the invention (finding) of the Cross, its exaltation, and Constantine's vision were all celebrated on the same date, September 14th. Schneider suggests that the cycle as a whole was meant to honor the little cross of crystal given to Constantine by his mother Helena before the battle; a precious relic conserved in the Franciscan church at Cortona, not far from Arezzo. (L. Schneider, "The Iconography of Piero della Francesca's Frescoes Illustrating the Legend of the True Cross in the Church of San Francesco in Arezzo" in *Art Quarterly* 32 (1969), pp. 23-48.) In connection with the Arezzo cycle, Carlo Ginzburg has called attention to another reliquary, this one containing a fragment of the True Cross. (This quite spectacular reliquary is now in the Accademia in Venice.) Once the property of the Palaeologi, Emperors of the East, and brought to Italy in 1451, in 1459 it passed into the hands of Cardinal Bessarion. This Greek prelate was appointed Protector of the Franciscan Order—in whose church at Arezzo the cycle is located—in 1458. According to Ginzburg, he was in close contact with Giovanni Bacci, of the family that underwrote the frescoes in the apse of

San Francesco. (C. Ginzburg, op. cit., new 3rd. ed., 1994, pp. 38-39.)

In Longhi's main text, the inspired jest about the figure in this scene who cannot find his spatially ambiguous hat is a case of a gifted writer's having let his pen run away with him; surely the hat's two- and three-dimensional ambivalence must be the result of paint loss, and not Piero's intentional meditation on the nature and limits of illusionism. (D.T.)]

Two Busts of Angels

To the left of the lunette with the *Death of Adam*, near the point from which one of the vault-ribs springs. Together with the Doctors of the Church Saints Ambrose and Augustine on the entrance under-arch, these are the only parts of the decoration where Piero completed work begun and then brusquely abandoned by Bicci di Lorenzo.

Constantine's Victory over Maxentius (p. 40-42). — For reasons already set forth above in the note [regarding the relationship between Piero's art and that of Uccello], I now doubt that John Hawkwood's stallion[1] sired the ones painted by Piero at Arezzo. Uccello repainted[2] Hawkwood's steed a first time in 1436; as we see it today, however, it is compatible only with Uccello's style of around 1455. So I have no difficulty in believing that Uccello repainted it once more around that date, wishing to harmonize it with the [illusionistic equestrian] monument of Niccolò da Tolentino, painted by Andrea del Castagno in 1456.

(1942)

1. [Longhi is referring to the horse ridden by the English *condottiere* John Hawkwood in the *trompe l'oeil* equestrian monument frescoed by Uccello in the Florentine cathedral church of Santa Maria del Fiore, where it was subsequently joined by Castagno's similarly illusionistic mock-monument to Niccolò da Tolentino, the general who led the Florentines to victory over the Sienese at the battle of San Romano in 1432—a triumph commemorated in Uccello's three celebrated battle pictures. Castagno's man of arms is not the same person as the identically-named hermit saint Niccolò da Tolentino (1245-1305) who turns up in Piero della Francesca's dismembered polyptych painted for the Augustinians of San Sepolcro. (D.T.)]

2. [Hawkwood, known to the Italians as Giovanni Acuto, had died in 1394; Uccello's fresco replaced an earlier version of the Englishman's painted monument. (D.T.)]

The Trial of the True Cross (pp. 44-46). — My most recent views concerning the *Resurrection of Tabitha* and the *Healing of the Possessed Woman* are those set forth in the previously cited *Fatti di Masolino e di Masaccio*.

(1942)

The Madonna del Parto

[Monterchi (Arezzo), Cappella del Cimitero]
The fresco is first mentioned in 1887 by the Aretine writer Commendatore Vincenzo Funghini,[1] although it was apparently already known to various scholars in Città di Castello.[2] Detached from the wall of the little church adjacent to the cemetery at Monterchi in 1911 and restored by Professor D. Fiscali, it was kept in the Museo Civico at Borgo San Sepolcro during the years 1919-25; today it is once again *in situ* at Monterchi.

In his catalogue, Berenson ascribes the execution to Loretino d'Andrea; but, as is now generally recognized, the greater part of the work is certainly from Piero's own hand.[3]

The uncharacteristically dry, sharp character of the outlines makes it difficult to date the picture.[4] Were it not for the most "calligraphic" passages in the Arezzo cycle, one would be at a loss to find anything comparable in Piero's work. It follows that the most probable date is somewhere between 1450 and 1455.

(1927)

1. V. Funghini, "Scoperta di un pregievole dipinto" in La Provincia di Arezzo for January 13, 1887; reprinted in *Arte a Storia*, 1887, pp. 205.

2. Cf. G. Magherini-Graziani, *L'arte a Città di Castello*, Città di Castello, 1897.

3. [Calvesi writes: "The contribution of an assistant is perhaps detectable in the actual painting of the angels, but not in the idea of using the same cartoon for both of them, which is meant to produce a mirror-image." (op. cit.; p. 162; my translation). Like Longhi, Clark has drawn attention to the important role in Piero's art of the symmetrical reversals and repetitions of form and color field typical of heraldry. (K. Clark, *Piero della Francesca*, 2nd. ed.,

London and New York, p. 46.) Although no works of Antonio d'Anghiari, with whom Piero worked at the outset of his career, have yet been identified, the most recent research has vastly increased the available documentation on him; he seems to have been much in demand as a painter of such typical heraldic forms as coats-of-arms and banners. Cf. J. Banker, "Piero della Francesca as assistant to Antonio d'Anghiari" in *The Burlington Magazine*, CXXXV, I (1993), pp. 16-21 and F. Dabell, "Antonio d'Anghiari e gli inizi di Piero della Francesca" in *Paragone* 318 (1984), pp. 74-94. (D.T.)]

4. The *Madonna del Parto* is among the works by Piero that have provoked the most widely disparate views regarding dating, significance and collaboration.

Saint Luke the Evangelist

[Rome, Basilica of Santa Maria Maggiore]
This is the only remaining legible fragment from the frescoes in the former chapel—today reduced to a storage area—of Saint Michael and Saint Peter in Chains in Santa Maria Maggiore in Rome.
Vasari ascribes the chapel's decoration to Benozzo [Gozzoli], perhaps as a result of the usual confusion of the latter with Melozzo [da Forlì]. It is, in fact, not impossible that Melozzo later continued this fresco scheme, perhaps on those portions of the walls where no frescoes have survived; what is certain is that in this Saint Luke both the draftsmanship and the execution—the latter, unfortunately, still partially obscured by restorations—reveal the hand of Piero himself. It is harder to propose any very precise date. However, the moment in the artist's stylistic development matches that in the second order of frescoes at Arezzo; if we grant that Piero had reached that point in the Arezzo cycle by 1455 or thereabouts, then we may suggest that the Santa Maria Maggiore fresco was executed during an interruption in the work on the larger project, sometime around those same years. This date would, in turn, prove the correctness of Vasari's firm assertion that Piero had turned up in Rome as early as the pontificate of Nicholas V.[1] But we are not altogether convinced that this subtle chronological reasoning of ours is right, since current knowledge does not permit the establishment of a calendar-year-by-calendar-year chronology for the work at Arezzo. We shall therefore restrict ourselves to observing that, should our hypothesis be incorrect, then the alternative one is that Piero might have painted the Saint Luke in 1459, when we certainly do find him in Rome.[2]

Recent scholarship has either blindly followed the Vasarian tradition,[3] or else got back on the right track by attributing the fresco to a Roman follower of Piero's—while also finding in it, however, an undemonstrable relationship with Lorenzo da Viterbo.[4]

(1927)

1. [There is considerably more at stake here for Longhi's chronology as a whole than first meets the eye. Piero's only surviving dated work is the Rimini fresco of 1451; on stylistic grounds as well as others, Longhi believed that Piero must have begun work at Arezzo shortly after finishing the picture in the Tempio Malatestiano, and that he had virtually completed his great Aretine cycle by some time in 1459. However, the only near-certainty we have regarding the conclusion of the Arezzo cycle is that a document of 1466 describes the frescoes in San Francesco as finished. Since Longhi's conjectural chronology has to allow time for the changes the critic perceived in Piero's style in the years following the Arezzo cycle, it is clear that a fresco executed as late as 1459—but still in what Longhi considered the "middle-period" Arezzo style of around 1455—could have caused trouble all down the rest of the the line. Understandably, Longhi preferred to hope that Vasari had been right about Piero's otherwise undocumented first trip to Rome. Cf. C. Ginzburg, op. cit., p. 25. (D.T.)]

2. G. Zippel, "Piero della Francesca a Roma" in *Rassegna d'Arte*, 1919, p. 87 et seq.

3. G. Biassotti, "Affreschi di Pier della Francesca in Ferrara" in *Bollettino d'Arte*, 1913, pp. 76-89.

4. G. Galassi, "Appunti sulla scuola pittorica Romana del '400" in *L'Arte*, 1913, pp. 107-112; also E. Lavagnino and V. Moschini, *Santa Maria Maggiore* in the series *Le Chiese di Roma illustrate*, Rome, n.d., p. 94.

The Resurrection of Christ

[San Sepolcro, Pinacoteca Comunale]
 In the Palazzo Comunale (town hall) at San Sepolcro. Cited by Vasari as Piero's finest work.[1] In the same style as the Arezzo frescoes; not later, as

generally claimed. Conceived as an illusionistic scene visible beyond a frame of painted Corinthian columns.

Plastered over for many years in the eighteenth and nineteenth centuries. Lanzi, writing in 1790, did not know the work; Rosini,[2] in 1839, did, but ascribed it to Signorelli.

(1927)

1. [John Pope-Hennessy noted that Aldous Huxley, in a book of 1925 called *Along the Road*, had designated the *Resurrection* "the most beautiful painting," thereby turning it into an obligatory shrine for generations of culturally ambitious British tourists. Pope-Hennessy sardonically drew attention to Huxley's heroic exaggeration of Borgo San Sepolcro's out-of-the-wayness and of the time and trouble required to get there from Urbino, wondering how Huxley had contrived to make the bus trip last seven hours when he himself had always managed it in three. Cf. J. Pope-Hennessy, *The Piero della Francesca Trail*, London, 1991. (D.T.)]

2. G. Rosini, *Storia della pittura italiana*, Pisa, 1837-41; vol. III.

Saint Mary Magdalene

[Arezzo, Duomo]
Fresco near the entrance to the sacristy in the cathedral at Arezzo. The lower portion badly damaged by restorations.

In Piero's most mature "Arezzo style." Comparable, for instance, to the Saint Peter Martyr on one of the piers.

(1927)

Hercules

[Boston, Isabella Stewart Gardner Museum]
Initially in a building [at Borgo San Sepolcro] belonging to Piero, afterwards the property of the Graziani family; the house was ceded by them to Senator Collacchioni, who had the fresco detached from the wall and moved first to a country villa and then back into town. Exiled to the Gardner Collection in Boston in 1906.

Originally a full-length figure. Probably once belonged to one of those series of "famous men" already popular in the Gothic period: the most celebrated example from Piero's time is the famous group of frescoes by Andrea del Castagno at Legnaia [now in the Uffizi, ed.].

<div align="right">(1927)</div>

Madonna and Child with Saints Anthony of Padua, John the Baptist, Francis, and Elizabeth

Crowning element: **The Annunciation**
[Perugia, Galleria Nazionale dell'Umbria]

Polyptych formerly in Sant' Antonio delle Monache in Perugia; in the local picture gallery since 1810.

Certainly later than the Arezzo frescoes. Several details, in fact, link it with the group of late works. It nonetheless has an archaic look deriving from its late-Gothic frame and gold-leaf ground (both surely imposed by Piero's patrons).

As Weisbach[1] and Aubert[2] have shown, it is impossible to accept Witting's[3] hypothesis that the *Annunciation* in the crowning element once constituted an independent work, the predella of which would have included the two figures of *Saint Agatha* and *Saint Rose*, as well as an *Adoration of the Shepherds* once in the collection of Lord Dennistoun.

Although the polyptych may perhaps shows signs of collaboration, we nonetheless think that its relatively unpleasing appearance is due, above all, to the serious deterioration in its quality brought on by the ravages of time. The worst damage is visible in the predella.

<div align="right">(1927)</div>

1. W. Weisbach, review of Witting's book in *Repertorium f. Kstw.*, 1889, pp. 72-77; also in *Das Museum*, VII, 1901, p. 53.

2. A. Aubert, "Bemerkungen über das Altarwerk des P. d. Fr. in Perugia" in *Zeitschr. f. bild. Kunst*, N.F., X, 1898-99, pp. 263-66.

3. Witting, op. cit.

On the two-tiered Perugia Altarpiece (pp. 63-64). — Several observations

may be added to my over-hasty discussion of this work in the first edition, reproduced without revision in the second. It may surprise us that Piero should have been willing to take on an altarpiece whose forms and structure had obviously been readied for a painter of more archaic tastes; but we must accept the matter as it stands. It is likely that Piero also accepted the demand that he place the panel with the *Annunciation* atop all that Gothic carpentry, probably in order to correct the "Gothic" impression made by the altarpiece below. The alignment of the perspective axis in the *Annunciation* with the central cusp of the Gothic triptych leaves no room for doubt on this score. It should be added, however, that the uppermost panel must originally have been rectangular, and was later cut down to its present "staircase" shape (without Piero's approval) in order to make it match the Gothic appearance of the whole. The way it has been cut arbitarily interrupts the porticoed architecture framing the scene; if, in the mind's eye, one were to restore the missing portions, there would be room on either side for two vertical landscape passages, providing an appropriate continuation of the portion of sky with the dove on high and the tree in the porticoed passageway behind the angel. Out of respect for what is left of the painting, I shall refrain from supplying even a schematic drawing that attempts to show the work as it originally appeared, preferring to leave the task to the imagination of my sufficiently well-equipped readers.

(1962)

The Uffizi Portraits

Portrait Diptych of the Rulers of Urbino
[Florence, Uffizi]

Research by Cinquini[1] has established the date as sometime around 1465.[2]

When the ducal family of Urbino died out in 1631, the work went to Florence with the della Rovere legacy; today it is in the Uffizi.

Coated in the nineteenth century with a thick yellow varnish that radically altered the tonality, originally much colder, as may be seen from a surviving unvarnished strip along the edges. Displayed in a horrendous mock-Renaissance frame. Deserving of renewed curatorial attention,[3] the panels should also be hung close together so as to reveal the intended unity of the two landscape backgrounds.

On the left-hand part of the reverse, Count [later Duke, ed.] Federigo displays—unusually—the side of his face that was, in reality, disfigured; a winged victory crowns him as he sits on a metal faldstool. The Cardinal

Virtues sit at the front of the cart as an *amorino*—a *putto* personifying love—guides the horses by the power of his voice alone.

To the right, on the facing panel, two roan unicorns, likewise directed by an *amorino*, draw the matching cart where Battista Sforza sits reading a Book of Hours. Before and behind her ride the Theological Virtues and other variously identified figures.

(1927)

1. A. Cinquini, "Piero della Francesca a Urbino e i ritratti degli Uffizi" in *L'Arte*, 1906, p. 56.

2. [The work almost certainly dates from no earlier than 1472, the year of Battista Sforza's death. Gilbert (op. cit., 1968) insisted on the late date for several reasons, including Piero's use for the portrait of Federigo of the same cartoon employed for the late *Brera Altarpiece*. He also drew attention to the presence of the pelican in the lap of the figure of Charity in Battista's *Triumph*; believed in the middle ages to nourish its young with its own blood, the pelican—which frequently appears at the top of painted crucifixes as a eucharistic symbol of Christ's sacrifice—is here meant as an evident allusion to the fact that the duchess had died giving birth to her son Guidobaldo. What is more, philological study of the inscriptions accompanying the *Triumphs* has demonstrated conclusively that Battista was dead at the time when the texts were written. For a summary of the recent philological research, see Calvesi, op. cit., 1998, p. 168. (D.T.)]

3. [Restored in 1986. (D.T.)]

The Uffizi Portrait Diptych (pp. 65-66). — It is now my opinion that, so far from having anything to do with Paolo Uccello as stated in my monograph, the Louvre's famous quadruple portrait is a mere late-fifteenth-century assemblage of quotations from various works; it is perhaps derived from Masaccesque portraits such as those that once appeared in [Masaccio's] now-lost *Sagra*[1] at Santa Maria del Carmine. It should be remembered that, in the first edition of the *Lives*, Vasari ascribed the Louvre's picture to Masaccio. I should like to add here that the first person to suggest to me orally that the work was of the late fifteenth century was my much-mourned friend Jëno Lányi, who expressed this opinion around 1935.

(1942)

1. [Formerly in the cloister at the church of the Carmine, this *chiaroscuro* fresco, executed in *terraverde*, represented the solemn procession marking the church's consecration in 1422. Vasari tells us that it contained portraits of "an infinite number" of citizens, including Brunelleschi, Donatello, and Masolino. The fresco is praised by such early Florentine writers as Manetti, Albertini, Billi, and the so-called Anonimo Magliabechiano. The work was destroyed in 1598-1600. Drawings copied from parts of it survive in the Uffizi and the Casa Buonarroti in Florence and in the Albertina in Vienna. (D.T.)]

The Madonna of Sinigallia

[Urbino, Galleria Nazionale delle Marche]

Formerly in Santa Maria delle Grazie at Sinigallia; now in the gallery at Urbino. Significantly altered by poor restorations, especially in the Virgin's head covering and face.[1]

Pungileoni[2] incorrectly identified the work as a "sketch" for the large altarpiece in the Brera, to which it bears no relationship save for general stylistic affinities and the use of the same models for the two angels. With no justification, the same writer identifies these angels as portraits of members of the ducal family.

(1927)

1. G. B. Cavalcaselle and G. Morelli, "Catalogo delle opere d'arte nelle Marche e nell'Umbria" in *Le gallerie nazionali italiane*, II, 1896, pp. 237-261. Cf. the information on the condition of the picture published in *Arch. Stor. d. Arte*, 1892, p. 362.

2. L. Pungileoni, *Elogio storico di Giovanni Santi*, Urbino, 1822.

The Nativity

[London, National Gallery]

In the house of the painter's family since early times. Later in Florence in the collection of the Cavalier Baldi, who sold it to Barker in 1861.

Purchased for the National Gallery, London, at the Barker sale in 1874. Clearly part of a stylistic "group" that also includes the *Madonna of Sinigallia* and the *Brera Altarpiece*.

It has been suggested[1] that the town in the background may represent San Sepolcro.

(1927)

1. Evelyn Marini-Franceschi, *Piero della Francesca*, Città di Castello, 1912.

The Augustinian Altarpiece

Saint Nicholas of Tolentino and the Archangel Saint Michael
[Milan, Museo Poldi-Pezzoli; London, National Gallery]

Lateral panels from a now-dismembered polyptych. The *Saint Nicholas of Tolentino* is in the Museo Poldi-Pezzoli in Milan. Once likewise in Milan, in the hands of one Fidanza, the *Saint Michael* entered the collection of Eastlake, who in 1867 ceded it to the National Gallery, London.

On the basis of the last word of the inscription (*Angelus Potentia Dei Lucha*) appearing on Saint Michael's belt,[1] Cavalcaselle cautiously advanced the hypothesis that Luca Signorelli might have had a hand in the figure. Berenson's recent proposal[2] of a group of works to be assigned to the early period of this painter from Cortona may offer an opportunity to reconsider the great Italian historian's old idea.

(1927)

1. [Restoration and radiological study have found that the last word in the inscription may perhaps have read *MICHA.*, not *LUCHA.* as was long believed. (D.T.)]

2. B. Berenson, "An Early Signorelli in Boston" in *Art in America*, April 1926, pp. 105-117.

Saint Nicholas of Tolentino and the *Archangel Michael* (p. 75). — For a better clarification of the contrasting stylistic intentions in these two saints, see my comments[1] regarding the Saint Nicholas, where I suggest that both figures may once have belonged to the Sant' Agostino Polyptych at San Sepolcro.

1. [In the 1942 "Notes on Works Illustrated for the First Time in the Second Edition," translated in the present volume. (D.T.)]

An Apostle (Saint Andrew?[1])

The Frick Collection, New York

Identified, I believe, by Suida, while in a collection in Vienna. Given its similar dimensions and the identical marble parapet, it clearly belongs to the same series as the *Sainted Monk* [*Saint Nicholas of Tolentino*, ed.] in the Museo Poldi-Pezzoli in Milan and the London *Saint Michael*. Here, the fragment of a step that partly covers the saint's right foot indicates the presence of a throne (the Virgin's?) in the now-lost central panel, telling us that the saints occupying the lateral panels numbered at least four. So one saint still remains to be found,[2] along with the central panel.

At first glance, the figure's violent illusionism recalls Piero's youthful period: for instance, the earliest figures in the *Misericordia Polyptych*, begun in 1445. But the saint's head, with its rustic white hairs against scorched flesh, depends upon the type already used for God the Father in the Arezzo *Annunciation*; the hands, rendered in a penumbra filled with reflected light that I should call almost Velázquez-like, reveal a pictorial maturity approaching that of the "Manet-like" saint in the Poldi-Pezzoli; the filigreed border of the garment already displays ornamental embellishments similar to those of the London *Saint Michael*, and the bony feet anticipate the anatomical refinements of the late *Brera Altarpiece*.

On the basis of these observations, it seems that the three Saints that have come down to us from a now-dismembered larger work must have been executed over a period encompassing several years of Piero's artistic development: the present *Apostle* comes first, followed by the Poldi-Pezzoli *Sainted Monk* and then by the London *Saint Michael*. Now, it happens that there survives the memory of a polyptych by the master, the execution of which was protracted over many years: according to the documents, from 1454 through 1469. This was the work ordered by the Augustinian brothers of Borgo San Sepolocro for their high altar. Might our three figures have belonged to it, as we have already suggested is the case with the little panels in the Liechtenstein, Lehman, and Rockefeller collections?[3] The strongest support for this new hypothesis[4] comes from a careful reading of the iconography of the Poldi-Pezzoli *Sainted Monk*: an interpretation already proposed by Berenson in his "lists" in 1932[5] and accepted by Toesca in his article[6] of 1935, but without

their having drawn the probable conclusions. Historians up to and including Van Marle (1929) used to call the figure Saint Thomas of Aquinas; but here once again, the habit tells us that this is an Augustianian monk, not a Dominican; and the symbolic sun in the upper left-hand portion securely identifies him as Saint Nicholas of Tolentino, a glory of the Augustinans who could not fail to appear in the altarpiece of a church dedicated to the founder of the order. The polyptych was thus comprised of a central panel and four lateral ones. In the center was probably a *Virgin Enthroned*.[7] In the two panels at the left, a *Saint Augustine* (still missing)[8] and the London *Saint Michael*; on the right, the Frick Collection's *Saint Andrew* and the Poldi-Pezzoli *Saint Nicolas of Tolentino*. Of course, there is no ruling out that the central panel portrayed, instead, Saint Augustine *in cathedra* [i.e., enthroned upon the traditional teacher's chair, as befits a Doctor of the Church, ed.]; should this be the case, then the still missing left-hand panel would have shown some other saint. But those who accept my attempted reconstruction of the predella, with the Rockefeller *Crucifixion* as its central panel, will find it more in keeping with usual iconographical practice to imagine the latter subject placed below the enthroned Madonna, rather than at the feet of Saint Augustine.

It is thus quite likely that the reconstruction of Piero's now dismembered polyptych for the Augustinian monks of San Sepolcro has begun—and we have high hopes that it may continue! The delays in the work's execution, surely occasioned by Piero's deep involvement in the vast Arezzo project until 1460 or thereabouts, help explain the artist's considerable stylistic development over the course of the three surviving panels, apparently painted at intervals between about 1460 and 1469, the year when he received the final payment for his long and frequently interrupted labors on it.

(1942)

1. [Variously identified by more recent writers as St. John the Evangelist or St. Simon Zelotes. (D.T.)]

2. [The missing panel, representing Saint Augustine, was identified in 1947 by Kenneth Clark (*Burlington Magazine*, 1947) in the Museu Nacional de Arte Antiga in Lisbon, where it had been displayed since its acquisition in 1936 as a work by the Veneto master Cima da Conegliano. Clark considered the execution to be largely the work of an assistant; this opinion was shared by Bianconi and Mario Salmi, the latter (*Rivista d'arte*, 1953) going so far as to identify Piero's otherwise unfamiliar collaborator as the young Luca Signorelli. Both Longhi, in the third edition of the present monograph (1962)

and John Pope-Hennessy (*The Piero della Francesca Trail*, 1991) have argued vigorously for the panel's entirely autograph character. (D.T..)]

3. [Now respectively in the Frick Collection (the two little *Saints* from the Liechtenstein Gallery in Vienna), the National Gallery in Washington (the Lehman *St. Apollonia*) and, once again, in the Frick (the *Crucifixion*). (D.T.)]

4. [Longhi's basic thesis has been universally accepted, although numerous specific reconstructions of the polyptych, of varying degrees of elaborateness, have been proposed. (D.T.)]

5. B. Berenson, *Italian Pictures of the Renaissance. A List.* Oxford, 1932.

6. P. Toesca, "Piero della Francesca" in *Enciclopedia italiana*, vol. XXVII, 1935, pp. 208-213.

7. [But for a very influential, closely argued alternative hypothesis, according to which the missing central panel would have depicted the *Coronation of the Virgin*, see also M. Levi D'Ancona, *Supplement* to the *Catalogue of the Frick Collection*, New York, 1955, pp. 63 ff. (D.T.)]

8. See note 2, above.

Crucifixion
[Formerly] New York, John D. Rockefeller Collection
[Now Frick Collection, New York, ed.]
Wood panel, 35.5 x 40.5 cm

In the first edition, I mentioned this little panel only in the catalogue of recently attributed works, noting that in some passages the quality appeared slightly inferior to that of the master himself. Today I wish to clarify matters, recognizing that the entire work was originally autograph and that its present uneven quality is due to the restoration that the picture, already touched up in early times, underwent in 1910-15 when it was on the market in Florence. Anyone wanting to see it with the old repainting, but prior to its last, deceptive restoration, has only to consult the photograph (Reali, no. 248) in the archives of the German art-historical institute in Florence. Let us concede that several passages, such as John the Evangelist's draperies and several heads near the edges of the panel, are now illegible; the grandeur of the whole, the subtle placement of the group of the Maries, and the noble scale of the foreshortened steeds are still there to confirm that the painting is Piero's original.

Having therefore included the work among those illustrated in this new edition, we ask our readers to make the necessary allowances when studying the picture.

Valentiner ascribed it to the master's early period; so did Lionello Venturi,[1] even going so far as to base this opinion on the passages painted with but little vitality—a defect, however, never signifying youth (and, in this case, resulting from restoration). In my opinion, the panel dates from around 1460 or later—i.e., shortly before the Perugia altarpiece. The small scale suggests that the work may have originally formed part of a predella. Given that the gold-leaf ground, where still original, is cracked and abraded in ways closely resembling what is observable in the panels in the Liechtenstein Gallery and the Lehman Collection [now respectively in the Frick Collection and the and National Gallery, Washington, ed.], I would suggest that it must once have belonged, together with these other panels, to a polyptych dismembered quite early on. I can go even further, adding that, if I am correct in linking these works with one another and with the quotation from Mancini cited above, then the polyptych must be the one commissioned from the master for the high altar of the church of Sant' Agostino at Borgo San Sepolcro in 1454, but for which final payment was only made in 1469. The church later passed into the hands of the nuns of Saint Clare who, while dismembering the altarpiece and, perhaps disposing of its principal parts, may well have retained some minor fragments, keeping them in the choir where Mancini was to see them. More careful study of the two little Liechtenstein saints bears out my thesis. Venturi published them as Saints Clare and Dominic; I, in the first edition of this book, as a sainted nun and Dominic. But it now strikes me as more probable that this old, scroll-bearing woman of religion is [Saint Augustine's mother] Saint Monica, whose presence in an Augustinian altarpiece is practically obligatory; while the male saint whose brown habit is belted with leather, not rope, must likewise be an Augustinian, rather than any Dominican or Franciscan.

1. A. Venturi, "Frammenti di polittico di Piero della Francesca nella Galleria Liechtenstein" in *L'Arte*, 1921, IV.

Saint Augustine
Lisbon, Museum
[These photographs of the *Saint Augustine* discovered[1] in Lisbon in 1947 appeared for the first time in Longhi's third (1962) edition. (D.T.)]

1. [The panel was recognized in 1947 by Kenneth Clark (*Burlington Magazine*, 1947) in the Museu Nacional de Arte Antiga in Lisbon, where it had been displayed as a work by Cima da Conegliano. (D.T.)]

The Lisbon Saint Augustine

Discovered in 1947 and published by Clark and shown in Florence in 1954, this panel from the Augustinian altarpiece is making its first appearance in my book. In the illustrations I have chosen to reproduce, above all, the details of the figures from the fictive figural embroideries on the mitre and the borders of the cope, so as to convince the reader that—contrary to Clark's hypothesis—these parts are not from the hand of a collaborator but are, instead, Piero's exquisitely autograph work.[1] Piero here faced the very subtle challenge of rendering the optical effect that his little scenes would have produced when translated into embroidery and subjected to the pulling and twisting of the moving woven fabric. He here achieves "impressionistic" effects—startling for their time—which can only be compared with the *croquetons* of Seurat. Note the trees in the *Agony in the Garden* and the *Flight into Egypt*, the thatched roof in the *Nativity*, the silky look of the *Presentation in the Temple*, the sparkling chalice in the *Christ Pouring Blood*. Similar effects are to be found only in the Perugia predella panels: above all in the admirable nocturne of *Saint Francis Receiving the Stigmata* painted at around the same time.

(1962)

1. [In his informal little study *The Piero della Francesca Trail* (London, 1991), the great connoisseur John Pope-Hennessy argues much the same point, for analogous reasons. (D.T.)]

Proposed reconstruction of the Augustinian Altarpiece from Borgo San Sepolcro
See fig. 39
[Appeared for the first time in Longhi's third (1962) edition. (D.T.)]

The Small Perugian Panels

Saint Monica and an Augustinian Saint
[New York, Frick Collection]

From the same period and of the same quality as the altarpiece in Perugia. The gold-leaf ground is ruined.

Perhaps to be identified with the two small panels seen by Cavalcaselle in the Franceschi household; also with those Mancini[1] recorded, even earlier, as forming part of the altar frontal in the nuns' choir at Santa Chiara in San Sepolcro.

(1927)

1. G. Mancini, *Istruzione storico-pittorica per visitare le chiese e i palazzi di Città di Castello*, vol. II, with an *Appendice . . . delle più eccellenti tavole di San Sepolcro*, pp. 268-279, Perugia, 1832.

Saint Apollonia
[Formerly] New York, Philip Lehman Collection
[Since 1943 in the Samuel H. Kress Collection, with which, in 1952, it entered the National Gallery in Washington, D.C, where it is catalogued as being by an "assistant of Piero della Francesca." (D.T.)]
Wood panel, 41 x 27 cm

First published by R. Lehman in the Lehman Collection catalogue; also published by L. Venturi as Plate 205 of his *Italian Paintings in America*.

The thought processes behind the construction of the figure are related to those underlying the fresco of the *Magdalene* in the Duomo at Arezzo; the present figure, later than the fresco, is close to the figures in the predella of the altarpiece in Perugia. The figure clearly forms part of a series with the Liechtenstein Gallery's two little panels [now in the Frick Collection, New York, ed.]; like them, it probably comes from the parapet surrounding the nuns' choir at Santa Chiara in San Sepolcro where, as late as 1832, Mancini noted "several little panel paintings, some seemingly by the hand of Piero della Francesca." But for further conclusions, see the discussions of the [Frick Collection's panels with the] *Crucifixion* and an *Apostle (St. Andrew?)*.

(1942)

On the *Saint Apollonia* from the Lehman Collection, New York
[Now Samuel H. Kress Collection, National Gallery, Washington, D.C. (ed.)]

In my comments on the works illustrated for the first time in the second edition, I expressed my confidence, based on similarities of style and size, that this panel was part of the same series as the little "Augustinian" panels in the Liechtenstein Collection in Vienna and that, like them, it must once have been part of the Sant' Agostino altarpiece in Borgo San Sepolcro. But today,

in the new chapter added to my account of Piero's "critical fortune," I offer proof that this work cannot be connected with that altarpiece.[1]

(1962)

1. "As for the panels with half-length figures in the Liechtenstein and Lehman collections, which both I and [Millard Meiss independently] suspected to be parts of the same altarpiece, today I should observe that the hypothesis still stands for the two Liechtenstein panels (and, in my opinion, also for the Rockefeller *Crucifixion*, not mentioned by Meiss), but that it is no longer valid for the Lehman *Saint Apollonia*, for the incontrovertible reason that the fictive illumination is coming from the other side with respect to the light source in all the other figures in both the predella and in the larger panels. Considering the similar dimensions of the three little panels and their probable common provenance, we may nonetheless suppose that the *Saint Apollonia* appeared in another altarpiece—or at least another predella—in the same church, but placed so that the [real] light fell in the opposite direction. No other explanation is possible, since we have no right to think that Piero suffered such a lapse of attention while executing a project that, as is clear, would not tolerate the slightest deviation from the principle of the 'unity of the the work.'" R. Longhi, *Opere complete*, vol. III (*Piero della Francesca*), Florence, 1963, p. 159. [The Liechtenstein and Rockefeller panels are now in the Frick Collection, New York. (For Meiss, op. cit.) It was the usual practice in Piero's time, when paintings were often executed for specific locations in which there was no artificial light, for the fictive light source to coincide with the real one, so as to enhance the effectiveness of the illusion. (D.T.)]

The Brera Altarpiece

The Madonna and Child with Saints, Angels, and Duke Federigo da Montefeltro Praying[1]
[Milan, Pinacoteca di Brera]

The saints are: at the left John the Baptist, Bernardine of Siena, and Jerome; at the right Francis, Saint Peter Martyr, and Saint Andrew.

In the church of San Bernardino near Urbino since at least the eighteenth century, the work was traditionally ascribed to Fra Carnevale—the result of confusion that eludes easy explanation. Ricci suggested that the altarpiece was the one the Confraternity of Corpus Domini had initially ordered

from Fra Carnevale before giving the commission to Piero in 1469. One might also think that this is the same picture ascribed to Fra Carnevale by Vasari, who says that Bramante studied from it. We think that this must be what Berenson meant when, in his catalogue of Piero's works, he suggested that the architecture[2] might be by Fra Carnevale.

As matters stand today, there is no known certain work by Fra Carnevale; we may thus usefully assume that he was no very outstanding painter. The *Brera Altarpiece*, on the other hand, is now universally accepted as a late work of Piero's. Whether or not this is the picture ordered in 1469 by the Confraternity of Corpus Domini, it seems clear that it was finished quite a bit later than that. Duke Federigo[3] appears decidedly older than in the portrait diptych of 1465, while the portrait of Pacioli (whom Ricci rightly recognized in the Saint Peter Martyr), born around 1445 and here looking over thirty years of age, pushes the dating to some time around 1475.[4] Further support for this date comes from the fact that Duke Federigo's hands are not Piero's work, but rather that of the same Italo-Flemish artist who painted the majority of the *Famous Men* formerly in Federigo's studio, the *Liberal Arts* once in the ducal library, and the portrait of the Duke now in the Barberini gallery in Rome.

However, this Italo-Flemish master is not, as is still generally believed, Justus of Ghent. As I had occasion to determine on purely stylistic grounds in the course of my travels in Spain in 1920, he should, instead, be identified with the Spaniard Pedro Berruguete. My learned friend Juan Allende-Salazar has more recently informed me that this stylistic conclusion is, perhaps, borne out by some words of Pablo de Céspedes, as well as by a document dug up as early as 1821 by Pungileoni, recording the presence of one "Pietro spagnolo" [Spanish Peter] in Urbino.

(1927)

1. For the critical historiography of the altarpiece, see: Lazari, *Delle Chiese di Urbino e delle pitture in esse esistenti*, Urbino, 1801; L. Pungileoni, op. cit.; V. Marchese, *Memorie dei più insigne pittori . . . domenicani*, Florence, 1845, I, p. 358 et seq.; F. Madiai, "Dei quadri tolti a Urbino sotto il Regno italico" in *Nuova Rivista Misena*, Arcevia, 1895, p. 84 et seq.; B. Berenson, *Central Italian Painters*, 2nd. ed., London, 1909; G. B. Cavalcaselle and J. A. Crowe, *Storia delle pittura in Italia . . .*, Florence, 1898, vol. VIII, pp. 188-259; Witting, op. cit.; F. Malaguzzi-Valeri, *Catalogo della Reale Pinacoteca di Brera*, Bergamo, 1908, pp. 325-27; C. Ricci, op. cit.; A. Venturi, *Storia dell'Arte*, vol. VII, 2nd. ed., Milan, 1913; A. Venturi, *Piero della Francesca*, Florence, 1922.

2. [Bertelli has published evidence that one-ninth of the painted surface has been lost at the bottom of the field. In accordance with a system common in the Adriatic area (although rare in Florence), the altarpiece was painted on a series of horizontally arranged planks clamped together—in this case, nine of them. The work's removal from its original frame led to the destruction of the plank at the bottom. (C. Bertelli, "La Pala di S. Bernardino e il suo restauro" in *Notizie di Palazzo Albani* 11, nos. 1-2, 1982, pp. 13-20.) The extent of reductions along the other edges is still a matter of disagreement and conjecture. In any event, the disappearance of what must have been the fictive step originally appearing at the bottom, and of the frame, has made it more difficult for viewers to measure the apparent distance separating them from the figures and the architectural elements, resulting in a certain loss of spatial clarity; as has often been noted, the figures are actually placed farther forward in relation to the apse than is immediately apparent. (D.T.)]

3. [Observations and measurements by Battisti have confirmed John Shearman's intuition that Piero used the same cartoon for Federigo da Montefeltro's portrait here that he had previously employed in the diptych now in the Uffizi. Cf. E. Battisti, *Piero della Francesca*, Milan, 1971, vol. I, p. 356. (D.T.)]

4. [For information regarding dating and iconography, see Author's Note appended to 3rd. (1962) edition, translated in the present volume. (D.T.)]

The altarpiece from Urbino in the Brera (pp. 75-78). — Meiss's subtle iconographic considerations,[1] intended to support a date between 1472 and 1474,[2] are discussed by me in the chapter added to the history of Piero's "critical fortune."[3]

I should add here—since I don't believe I've ever said it before—that the portion painted by Pedro Berruguete includes not only Federigo da Montefeltro's hands, but also his helmet, which he has placed on the ground in front of him while he prays.[4]

(1962)

1. M. Meiss, "*Ovum Struthionis*. Symbol and Allusion in Piero della Francesca's Montefeltro Altarpiece" in *Studies in Art and Literature for Belle da Costa Greene*, Princeton, 1954, pp. 92-101; and "Addendum ovologicum," *The Art Bulletin* 36 (1954), pp. 221-22. [An *ovum struthionis* is an ostrich egg;

for Longhi's discussion of Meiss's "considerations," see below, Note 3. (D.T.)]

2. [While a late dating is generally accepted, there is no precise consensus. Obviously, the date and the precise iconographic significance of the work are, to some extent, interdependent. Battisti (op. cit., 1971) has connected the picture with a victory won by Federigo at Volterra in 1472. Bertelli (op. cit., 1992, p. 136) has made the interesting observation that elements of the Saint Francis from the picture recur in Giovanni Bellini's great *San Giobbe Altarpiece* in Venice, and that Bellini must have seen Piero's work on his journey though the Marches in 1472-73 in conjunction with his execution of the *Pesaro Altarpiece*. Noting the prominence of the helmet and a subtle insistence on blood and wounds in the iconography, Bertelli connects Piero's altarpiece with Federigo's disfigurement in a tournament, the consequence of an incautious bit of amorous gallantry: the Duke wore a twig in his visor, so that a certain lady might recognize him, and lost an eye and part of his nose in the ensuing mishap. (Ibid., p. 135.) Marilyn A. Lavin has suggested that the absence of the orders of knighthood conferred upon Federigo—honors validated by the College of Cardinals in August 1474—may reflect the work's private and personal character (M. A. Lavin, "Piero della Francesca's Montefeltro Altarpiece: A Pledge of Fidelity" in *The Art Bulletin*, LI, 1969, pp. 367-71); Lavin thus implicitly challenges the relevance of Meiss's argument that the absence of these insignia shows the work to have been painted prior to that date. (See below, Note 3.) Emphasizing, as have others, the work's funerary character, Lightbown (op. cit., 1992, pp. 252-53) interprets the ostrich egg as a symbol of the resurrection after death to which Federigo aspires, recalling its long-established role in funerary art. The egg is, in fact, a symbol of hope and resurrection, on account of the "manner in which the small chick breaks from the [tomb-like, ed.] egg at birth." (G. Ferguson, *Signs and Symbols in Christian Art*, London, Oxford and New York, 1954, p. 18.) In what must be the most unpalatably hard-boiled conclusion ever reached by an art historian, David Brisson has asserted that the egg in question was not laid by an ostrich, but by a chicken. (Cf. D. W. Brisson, "Piero della Francesca's Egg Again" in *The Art Bulletin* LXII, 1980, pp. 284-286.) (D.T.)]

3. "More important for academic studies [than the 1954 show of early Renaissance painting held in Florence] was Millard Meiss's extremely erudite essay, bearing a title smacking of some mysterious cult: '*Ovum Struthionis*. Symbol and Allusion in Piero della Francesca's Montefeltro Altarpiece.' In my book, I had already spoken of that object suspended over the Virgin's head as a "sacred egg," but without going more deeply into the implications that this

symbolic choice might have had regarding the picture's subject and precise dating. Meiss suggests, on the basis of minute observations that need not be repeated here, that the altarpiece must allude to the birth of [Federigo's son] Guidobaldo in 1472, the year that also saw the death of Guidobaldo's mother, Battista Sforza. As for the *terminus ante quem*, Meiss deduces that the work must date from no later than 1474, since Federigo is not yet wearing the Order of the Garter conferred upon him at that time, which he displays in the portrait at Windsor, where we see him together with the little child Guidobaldo. Meiss also quotes several documents regarding the presence of ostrich's eggs in Italian churches, where they were often hung as counterweights to lamps; but unless I am mistaken, he leaves out the oldest among the few surviving examples—the one hanging over the enthroned Virgin from the aedicula containing the fresco on the Fissiraga tomb at Lodi, dated 1327 and already published by Toesca fifty years ago. This observation of mine will round out the valuable additions to his article that Meiss published later in the same year, in his special 'Addendum Ovologicum.'

As a matter of fact, Meiss's precious study did not change by much the dates usually proposed for the Urbino altarpiece; nonetheless, it did narrow them down and sharpen them up. I think it may also serve to show that the Duke's hands, which were painted by Pedro Berruguete, imply that the Spanish painter may have arrived in Urbino considerably earlier than 1477, when he is finally documented there." (R. Longhi, *Opere complete*, vol. III, cit., p. 167.)

4. [Some historians, troubled by Longhi's attribution of these passages to Berruguete so many years before the painter's documented presence in Urbino, have preferred to ascribe them to Joos van Wassenhove, called Justus of Ghent. Bertelli (op. cit., p. 137) observes that, while that the hands have been repainted (by Berruguete, in his opinion), the helmet has not been. (D.T.)]

Piero, Fouquet, and Charonton

(p. 79). — The issue of the circulation of a "Mediterranean" artistic culture in the period 1440-1460, here cited by me as one of the most fascinating questions in fifteenth-century history, has yet to be decisively clarified. The attempt by Aru (followed by Demonts) to identify the Neapolitan painter Colantonio as the Master of the Aix-en-Provence *Annunciate Virgin* has failed

to achieve its desired outcome and remains a mere bit of intelligent myth-making. I have managed to identify only one of the last representatives of that culture: the subtle Master of the Louvre *Annunciation*. He is the Milanese Carlo Braccesco, active in Liguria between 1478 and 1501. See my study of him, published in 1942 by the Sezione Lombarda of the Istituto Nazionale di Studi sul Rinascimento.[1]

(1942)

1. [Longhi's masterly reconstruction *Carlo Braccesco* is available in an English translation by David Tabbat in the volume: Roberto Longhi, *Three Studies*, Riverdale-on-Hudson, A Stanley Moss-Sheep Meadow Book, 1995. The original is now in R. Longhi, *Opere complete*, vol. VI (*Lavori in Valpadana*), Florence, 1973, pp. 267-85. (D.T.)]

The "Pieresques" in Florence

(p. 81). — I afterwards had the opportunity to publish[1] illustrations of the works by Giovanni di Francesco mentioned here. It is a pity that I jumbled these works together with others that by rights belonged, as I was to recognize shortly afterwards, to Paolo Uccello in person. On this point, see the relevant passage in the already cited *Fatti di Masolino e di Masaccio*.

(1942)

1. In my "Ricerche su Giovanni di Francesco" in *Pinacotheca*, 1928. [Now RL, *Opere complete*, IV.]

Offshoots at Ferrara and in the Marches

(pp. 81-82). — A propos of the direct descent from Piero apparent in the works in intarsia of the Lendinara brothers, I have subsequently had cause to suppose that the best among these wood inlays are, in fact, directly based upon cartoons by Piero.[1] As for the "enigmatic" paintings by unknown hands, today they are a bit less so: the *Pietà* in the University of Ferrara is probably by Pelosio, while the little portrait in the Museo Civico [Correr] at Venice is almost certainly by Baldassare d'Este.[2]

1. See my *Officina ferrarese*, Rome, 1934, pp. 31-33. [Now in R. Longhi, *Opere complete*, vol. V (*Officina ferrarese*), Florence, 1980.]

2. Idem, p. 29, and the *Ampliamenti* to the same book, Florence, 1940, pp. 13 and 14. [Now in R. Longhi, *Opere complete*, vol. V, cit., Florence, 1980.]

Followers at Arezzo: the Master of the Adimari Wedding Chest

(p. 83) — For a more complete study of this painter (probably from Arezzo) and his possible identification[1] as Lazzaro Vasari, see my *Fatti di Masolino e di Masaccio*, p. 187, n. 24.

1. [There is little evidence to support Giorgio Vasari's claim that his ancestor Lazzaro was a painter. Luciano Bellosi has proposed to identify the Master of the Adimari Cassone as Masaccio's less gifted but much longer-lived brother Giovanni di Ser Giovanni, a painter from San Giovanni Valdarno often known by the nickname "lo Scheggia." See Laura Cavazzini, *Il fratello di Masaccio. Giovanni di Ser Giovanni detto lo Scheggia,* exhibition catalogue, Florence, 1999; L. Bellosi, M. Haines, *Lo Scheggia*, Florence-Siena, 1999. (D.T.)]

Piero and Bartolomeo della Gatta

(pp. 84-85) — If we are seeking a better understanding of Bartolomeo della Gatta's stylistic traits and their relationship to the precedent Piero had set, then we naturally must restrict ourselves to the handful of works that are certainly his, while excluding a number of pictures frequently attributed to him. One of the latter is the *Assumption of the Virgin* in San Domenico at Cortona: a picture more reminiscent of Perugino at the start of his career than of Bartolomeo.

Piero and Signorelli

(p. 84) — Berenson's hypothesis regarding the works ascribable to Signorelli's earliest years, when the artist was still a close follower of Piero's, struck me as attractive back in 1927. Today I find it less persuasive; and the Madonnas in Boston, Oxford, and Villa Valmarina—even if all by a single hand—have returned to a condition of noble anonymity. There is certainly no denying their connection with the bits and pieces of the youthful Signorelli still surviving at Città di Castello, datable to 1474; but I think that the identity of the painter of the Madonnas with Signorelli remains to be proved.

(1942)

A fourteenth-century Sienese polyptych at Borgo San Sepolcro

It is my opinion that this handsome Sienese polyptych, formerly in Santa Chiara at San Sepolcro and now in the Galleria Comunale there, is the masterwork of Niccolò di Segna.

(1942)

The Barberini panels[1]

Now in America,[2] the fascinating Barberini panels were ascribed to Piero by Dennistoun; by others to Fra Carnevale, [Luciano] Laurana, or Francesco di Giorgio; by Berenson to Giovanni di Francesco; by Offner to a mid-fifteenth-century Florentine follower of Filippo Lippi. It is my opinion that they may be by the Umbrian Bartolomeo Caporali.

(1942)

1. [In 1942 Longhi appended to his "Fortuna storica di Piero della Francesca" the following four notes: "The Barberini panels," "Cavalcaselle and Piero della Francesca," "The copies in Paris of Piero's frescoes," "Piero criticism in the late nineteenth century." The "Fortuna storica . . .," a mordant and lengthy survey of writings on Piero from the fifteenth century down to 1927 (later updated to 1961), was first published in 1927 as part of Longhi's book on Piero; it has been translated in the present volume as "Piero's Reputation over the Centuries." (D.T.)]

2. [But not, alas, united in a single American collection: these striking and problematic works are now in the Museum of Fine Arts, Boston (the *Presentation*); the Metropolitan Museum, New York (the *Visitation*); and the National Gallery, Washington (the *Annunciation*). For their attribution, see following note. (D.T.)]

On the Barberini panels — Given that Dennistoun had attributed these works to Piero about a century ago, I advanced the hypothesis, in a note to my second edition, that they might be by the Umbrian painter Bartolomeo Caporali. This still seems to me the most reasonable proposal, even after the recent suggestions of Federico Zeri, who opted for Giovanni Angelo da Camerino—by whom no sure work is known—and of Alessandro Parronchi, who ascribes the panels to L.B. Alberti—a theory likewise, in my opinion, undemonstrable.[1]

(1962)

1. [The panels are today most generally given to Fra Carnevale. Cf. K. Christiansen, "For Fra Carnevale" in *Apollo* CIX, March 1979, pp. 198-201. (D.T.)]

Cavalcaselle and Piero della Francesca[1]

I have always been eager to seize every opportunity to do justice to our great art historian's[2] insights. Today I can add that, having come into possession some time back of a study copy of the *History* once in the library of Cavalcaselle's collaborator Crowe and filled with manuscript annotations for a never-published revised edition, I had the pleasure of discovering an inter- polated page about Antonello da Messina's *Saint Sebastian* in Dresden that included the following important passage [in English]: "The influence of the Bellini, of Carpaccio and of Mantegna [is] no doubt apparent. . . . But the sol- diers to the right, the sleeping man to the left reveal the deep study of *Piero's masterpiece*." (My italics; in the manuscript annotation, these last two words have been crossed out and replaced with the words "Piero and Mantegna.") Unfortunately, the manuscript passage then goes on to confuse Piero and Mantegna to the latter's advantage, comparing the Dresden work with [Mantegna's fresco of the] *Martyrdom of Saint Christopher* in the [Paduan

church of the] Eremitani and concluding that Antonello's picture is a free "adaptation of principles laid down by Mantegna and Piero della Francesca, which became the property and *Gemeingut* of the painters who succeeded him." Despite these failings, it thus appears that Cavalcaselle had, in his last years, a confused intuition that Piero had been crucial to Antonello da Messina's formation.[3]

(1942)

1. [Note appended by Longhi in 1942 to his "Fortuna storica di Piero della Francesca" of 1927. (D.T.)]

2. [Originally published in English, J. A. Crowe and G. B. Cavalcaselle's *A New History of Painting in Italy* (London, 1864-66) was the earliest survey to embody a rigorously critical approach to problems of attribution. This monumental work was the joint effort of an English writer and one of the first great Italian connoisseurs. Working without the aid of photographs, armed only with his own notes and sketches and with a prodigious eye and memory, Giovan Battista Cavalcaselle studied pictures throughout Italy. The conclusions set forth in "Crowe and Cavalcaselle" are primarily his own. (D.T.)]

3. [For a detailed exposition of Longhi's views regarding Piero's legacy to Antonello, see R. Longhi, "Piero dei Franceschi e lo sviluppo della pittura veneziana" (an essay of 1914, now in R. Longhi, *Opere complete*, vol. I (*Scritti giovanili*), Florence, 1980, pp. 61-106). (D.T.)]

The copies in Paris of Piero's frescoes

Regarding the copies of the Arezzo frescoes executed around 1880 by the painter Loyeux[1] at the instigation of Charles Blanc,[2] which are presumably still in the chapel of the Ecole des Beaux-Arts, it would be extremely useful to find out whether the youthful Seurat—who spent a lot of time in the classrooms of that academy—did not, perhaps, reflect upon them. We might thus find that Neo-Impressionism and Synthetism had a far loftier source than the works of Puvis de Chavannes.[3] While Seurat's genius would lose nothing by this discovery, Gauguin's mediocre South Pacific would risk being shown up—as might be expected—as no more than a shortcut back from the countryside around Arezzo.

Notes

1. [Loyeux's copies record the frescoes' appearance in the half-century following the restoration by Gaetano Bianchi in 1860. The works had already suffered the total loss of significant areas of the painted *intonaco*: a process brought on, in part, by the insertion into the painted walls of anchors for the metal tie bars used to stabilize the old building. Bianchi—also remembered for his work on Giotto's frescoes at Santa Croce in Florence—chose to repaint the missing areas, quite arbitrarily in some instances. His additions were removed by Fiscali in 1915. (D.T.)]

2. [Blanc was an indefatigable popularizer, the animating spirit behind the monumental *Histoire des peintres de toutes les écoles*, in which the volume devoted to the *Ecole ombrienne et romaine* (Paris, 1870) devoted considerable attention to Piero at a time when such an interest was not to be taken for granted. These attentions were renewed in Blanc's posthumously published *Histoire de l'art pendant la Renaissance* (Paris, 1889). According to Longhi, Blanc "does indeed reveal great enthusiasm for our artist; but it is an enthusiasm so disorganized that it can alternate the most sweeping praise with the most terrible condemnations." (R. Longhi, "Fortuna storica di Piero della Francesca" (1927), now in *Opere complete*, vol. III (*Piero della Francesca*), Florence, 1980, pp. 117-152.) (D.T.)]

3. [Pierre Cécile Puvis de Chavannes, 1824-98, a prolific painter of rather enervated, pallid mythological scenes tinged—often on a grand scale—with a nostalgic idealism. In their broad, calm, generally horizontal distribution of academic figures and softly luminous hues across the picture plane, his works reveal a debt to the fresco painters of Central Italy, including Piero. A comparison of *Seurat's Bathers at Asnières* of 1883-84 (London, National Gallery) with Puvis' *Pastoral* of 1882 (Yale University Gallery) offers easily recognizable evidence of Puvis's direct influence on the younger painter's work. (D.T.)]

Piero criticism in the late nineteenth century[1]

I am told that, towards the end of the nineteenth century, there appeared in the little magazine *The Golden Urn*, edited by the young Berenson, a precious reference to the Arezzo frescoes as a destination deserving of a pilgrimage; but

the publication is so extremely rare that I have never succeeded in laying eyes upon a copy. I have therefore been unable to cite it among my bibliographic references, as I should very much have liked to do.[2]

(1942)

1. [Note appended by Longhi in 1942 to his "Fortuna storica di Piero della Francesca" of 1927. (D.T.)]

2. [This apparently anodyne expression of regret takes on a more interesting flavor in the context of the prolonged trench warfare between the Berenson and Longhi camps. Hostilities began over the breakdown of plans to have the still unknown younger scholar translate Berenson's *Italian Painters of the Renaissance* into Italian—fittingly enough, during the years of the First World War. Over the ensuing decades of competition for hegemony in the connoisseurship of Italian painting, it was Longhi who did most of the sniping; things even reached such a pass that Ellis Waterhouse, reviewing Longhi's book *Officina ferrarese* in the *Burlington Magazine* (LXVIII, 1936, pp. 150-51), felt moved to write: "His two principal aims appear to be establish as rigorous a chronology as possible, and to be as rude to Mr. Berenson as the large vocabulary of the Italian language allows." (It is amusing, if only marginally relevant, that the irrepressible Longhi afterwards repaid Waterhouse's observation by mockingly referring to the British scholar, in print, as "il Casalacqua.") The correspondence between Longhi and Berenson has been published as B. Berenson and R. Longhi, *Lettere e scartafacci* 1912-1957, C. Garboli, ed., Milan, 1993. (D.T.)]

Works by Piero First Discussed in the Second and Third Editions
(1942 and 1962)

Madonna and Child

Florence, Contini Bonacossi Collection
Wood panel, 53 x 41 cm

This painting must already have been highly regarded centuries ago: according to an inscription added on the back in 1655, when the Florentine painter Alessandro Rosi retouched the work, it was thought to be by Leonardo da Vinci. The retouching has been removed and the painting, despite its badly abraded surface, is now clearly legible.

There is no doubt that this is the earliest of the master's works to have come down to us,[1] preceding even the *Baptism* and the first parts of the *Misericordia Polyptych*, and thus dating from around 1440, when Piero was still working with Domenico Veneziano. The present picture is closely related to Domenico's style, both in the softness of the transitions (for example, in the delicate shadow cast upon the flesh tone by the Child's necklace) and in the burnt-earth hues of the tree-spotted landscape that resembles the one in the *Baptism*. But the exploration of perspective is already intense; and this was, in fact, just the period when Florentine artistic circles were obsessed by the topic. It is worth noting that Piero's problem here was how to fit the holy group into the very carefully calculated interval between two vertical planes. The first of these planes is defined by the window jamb and the ledge against which the Virgin's blue-gray mantle breaks into its concluding fold; the second, farther back, by the wall where the window displays its subtly foreshortened, red-brown impost. The spatial definition is further accentuated by the Virgin's foreshortened nimbus, just grazing the top of the opening.

The same intense involvement in problem-solving recurs on the reverse of the panel, although in a form no longer figurative, but abstract and inanimate. The puzzle the artist has set himself here is the placement, within the measured interval between two analogous vertical planes, of a wooden vase made up of studiously curved slats. Even in its color-scheme, limited to various shades of brown, the result is a perfect model for the future wood inlays of the Lendinara brothers.

(1942)

1. [Longhi's attribution of this intriguing little picture to Piero has not won for it a secure place in the artist's *corpus*. Salmi, Bellosi, and Lightbown have accepted Longhi's ascription (but Lightbown, having discussed it in the text of his 1992 monograph, nonetheless omits it from his catalogue). Several subsequent writers on Piero (Bianconi, Hendy, Calvesi) have either cautiously published it as an attributed work or else (Clark, Bertelli) passed over it in silence, with Battisti openly expressing the opinion that it may be a fake. (D.T.)]

The Penitent Saint Jerome in a Landscape

The Penitent Saint Jerome in a Landscape
Berlin, Staatliche Museen
Wood panel, 51 x 38 cm

Although the work was published in the *Jahrbuch der Preussischen Kunstsammlungen* as long ago as 1924 by [the great scholar and museum director Wilhelm von] Bode, who had obtained it for his museum in Berlin, I refrained from discussing it in the first edition of this book, as I did not know what to say about it before examining it for myself. Van Marle criticized me for this omission, but failed to provide any convincing analysis of the painting;[1] while Toesca[2] decisively rejected the picture, calling it "very weak." But above and beyond the observation—in itself insufficient—that the inscription *Petri de Burgo Opus MCCCCL*, rediscovered in the course of cleaning, is in a believable style of lettering, the picture itself really must be read with more care. In my opinion, the basic composition and certain portions of the execution are by Piero, while another, unidentifiable artist completed the work and applied the finishing touches to it, probably at the very end of the fifteenth century. The two different hands are clearly distinguishable. Piero's contributions include not only (as Berenson noted) the extremely beautiful figure of the saint, but also the little bench with the elegantly bound volumes; the smooth rock from which a little storage area, containing more books and a suspended inkwell, has been carved; on the left, the outline of the unfinished lion and the shining roadway with its gleaming pebbles; in the middle distance, behind the rock, some tufty little trees; and, farther off to the left, a bright little clearing. To the anonymous artist who completed the work must be attributed almost the whole of the middle ground, where the coarse trees

display their oddly mannered and mechanical foliage; the distant mountains; the sky, too dense like the trees; and some added clumps of weeds in the foreground. It would be worth restoring this picture to its "first state," although the result might be an unfinished work; even as matters stand, the precious autograph passages give it the right to be included in the great master's *corpus*.

(1942)

1. R. van Marle, *The Development of the Italian Schools of Painting*, vol. XI, p. 16, The Hague, 1929.

2. P. Toesca, in *Enciclopedia italiana*, vol. XXVII, p. 212.

On the Berlin Saint Jerome — In his *Enciclopedia italiana* article of 1935, Toesca expressed his extremely low opinion of this work—a painting that I had accepted as Piero's in my second edition. Toesca was also in disagreement with Berenson, who had included the work in his 1932 *Lists*. Having had an opportunity to re-examine the panel in the exhibition in Florence in 1954 [*Mostra di quattro maestri del primo Rinascimento* at the Palazzo Strozzi, ed.], I find that Berenson was quite right to suspend judgment regarding the illegible date. I would also observe that, if we maintain our approximate date of around 1450 for the Venice *Saint Jerome with a Donor*, then this Berlin picture—which has, by comparison, several more archaic traits, if we ignore the finishing touches added later on—should be placed at a moment several years earlier in the course of the 1440s: perhaps even at the time when the artist was working with Domenico Veneziano.

(1962)

The Louvre Portrait

Portrait of Sigismondo Pandolfo Malatesta
[Formerly] Florence, Collection of Senator Contini Bonacossi
[Paris, Louvre since 1978, ed.]
Wood panels, 44.5 x 34.5 cm
 Certainly from 1451, since it is precisely related, even in its dimensions, to the portrait of Malatesta in the fresco at Rimini. Just as the present originally served as a model, now it may help us gain a more precise idea of the profile, fudged and altered in the fresco by restoration. The observation[1]

that in the wall painting the head originally stood out brightly against a dark background explains why here, too, the painter has chosen the dark ground typical of the Gothic tradition—if you like, the tradition associated with Pisanello. But against that ground the head, rising over the fullness of the brocaded cloak, expresses depth, sailing forever through space on an unchanging course and once at sublimating and negating the choice of the profile view, dictated by decorum and common usage.

(1942)

1. See author's "Notes appended to the text" from the second edition (1942), included in the present volume.

On the Portrait of Sigismondo Pandolfo Malatesta
[Formerly] Florence, Contini Bonacossi Collection
[Now Louvre, Paris (ed.)]

As I have already stated[1] in the chapter added to the account of Piero's "critical fortune," the correspondence between [the connoisseurs] Richter and Morelli offers proof that the portrait, brought to Milan in 1889 by Morelli's Russian follower Delaroff, is the same one that, after entering the D'Ancona Collection in Milan, later went (by way of the Florentine art dealer Luigi Grassi) to the Contini Bonacossi Collection,[2] of which it still forms part. Having been previously reproduced and discussed in my second [1942] edition, the picture was shown in the "Exhibition of Four Masters of the Early Renaissance" held at Palazzo Strozzi in Florence in 1954, where it was described as an "attributed work."[3]

(1962)

1. "In 1960 a German publisher brought out, perhaps unnecessarily, the late-nineteenth-century correspondence of the two famous critics Giovanni Morelli and J. P. Richter (*Italienische Malerei der Renaissance* . . ., ed. I. and G. Richter, Baden-Baden, 1960, p. 547.) If nothing else, the book proved useful for the references it contained to the numerous works resurfacing around the time of its publication. I was lucky enough to discover in it—I use the term 'discover' advisedly, for there is no trace of the picture in the index—a mention of a portrait of Sigismondo Malatesta that had been brought to Milan from St. Petersburg in 1889 by Morelli's Russian disciple Delaroff; Morelli immediately recognized it as an autograph work by Piero, an artist about whom he had never had much good to say. As I said in a review written in

1961, I had no trouble recognizing the picture—undergoing restoration in Milan at the time—as the same one that had left the D'Ancona Collection in Milan around 1930 to enter the Contini Bonacossi Collection in Florence, where it is still to be found; it was part of that collection when I reproduced it in the second edition of my book." (R. Longhi, *Opere complete*, vol. III (*Piero della Francesca*), Florence, 1963, p. 158.)

2. [Longhi's 1942 note, marking the picture's first appearance in the literature, was published while the picture was in the possession of Longhi's patron Contini Bonacossi. The painting's subsequent emigration to Stanley Moss in the United States in 1974, and then to the Louvre in 1977, with its permits in order despite stringent Italian laws restricting the exportation of works important to the nation's cultural heritage, provoked intense debate and many accusations. (D.T.)]

3. [Several scholars have accepted this work—of which there is no trace prior to the late nineteenth century—without serious reservations. Some have doubted that it is an autograph work (P. Bianconi, *Tutta la pittura di Piero della Francesca*, Milano, 1957; U. Baldini in *Mostra di quattro maestri del primo Rinascimento*, Florence, 1954). Others have implicitly rejected it by passing over it in silence (Clark, Hendy, Cole). However, after the painting was cleaned by Moss in 1976, Kenneth Clark and Federico Zeri became believers, and Clark, as a trustee to the Louvre, supported the purchase. Calvesi (op. cit., p. 195), noting a certain over-cautious quality in the execution, thinks that it may have been painted by an assistant. The most radical opposition has been expressed by G. Briganti (*La Repubblica*, Feb. 24, 1978) and E. Battisti, both of whom considered it a possible fake; Battisti (op. cit., II) thought that it perhaps dated from around 1820. According to Michel Laclotte of the Louvre, laboratory analysis and study of the work in conjunction with its acquisition by the Louvre have clarified the attribution. Laclotte considered it the proudest acquisition of his tenure as curator and director. (M. Laclotte et. al, *Piero della Francesca*, exhibition catalogue, Paris, Louvre, 1978). (D.T.)]

Virgin and Child with Four Attending Angels

[Formerly] Paris, private collection
[Now Sterling and Francine Clark Art Institute, Williamstown,

Massachusetts, ed.]
Wood panel, 42 x 31 cm

Sold by the dealer Knoedler, fifteen or twenty years ago, to an American collector, resident in Paris, who cannot be more precisely identified at present.[1] As early as 1930, Gnoli[2] published the work with a few lines of commentary, adding that it "is unknown to everyone and, what is worse, will remain invisible to everyone for many years to come," since "the lucky and jealous owner has no intention of letting others enjoy it." In the history of the artist's "critical fortune," this episode may stand as an extreme instance of Piero-worship! In his article on Piero in the *Enciclopedia italiana*, Toesca includes Gnoli's article in his bibliography but makes no mention of the work in his main text. And since I have repeatedly heard noisy claims from all quarters to the effect that the painting is a modern fake, let me hasten to declare that even a photograph is more than sufficient to put paid to all such doubts.

The work is by Piero—and it is one of Piero's masterpieces.[3] The regal interpretation of the subject immediately proclaims the work to have been painted for a court, probably Piero's beloved court of Urbino. The bond between the figures and the architecture is, perhaps, the subtlest and most pregnant that the master ever gave us; and the great surprise lies in the off-center treatment of the hall. Rather than composing itself into a Bramantesque or classicizing space surrounding the group of figures who have come together for the sacred ceremony, the architecture makes an angular turn at the right while, at the left, it spreads itself out on a straight course that seems to continue beyond the picture; the result is an intense asymmetry.

Throughout the entire fifteenth century, such freedom of thought in composition is rare; but it is not unprecedented in Piero himself. Indeed, it is quite consonant with the observations in which—while denying Piero's direct paternity with respect to the centralized, domed, pyramidal classicism of Bramante, Leonardo, and Raphael—I have credited him with the invention of an even more profound type of free perspectival synthesis, one not to be pursued further until the sixteenth century in Venice. Only in such a very late work as the *Brera Altarpiece* does Piero employ a frankly centralized plan; and this observation is among those leading me to believe that Gnoli's proposed dating of this new panel to around 1470 is too late. The astonishing freedom of conception of the setting is also, I think, reflected in the idea—a profoundly speculative one, however fully resolved as an image—of placing the "divinely measured" Corinthian column at the back off-center, so as to leave the painting's mathematical center to the nearby head of the Virgin, but in such a way as to obtain from this calculated contiguity a supreme comparison between the human head and the capital—quite literally the "head" (*capitel-*

lo)—of the column. The master had already sketched out this speculative idea in the Annunciate Virgin in the Arezzo frescoes; at a date nearer that of the present picture it recurs, with less force, in the Angel of the *Annunciation* in Perugia.

We leave the viewer to reflect further on the lofty silence of this enchanted scene: one that hangs, as it were, upon the gentle interplay of the Virgin, who proffers the rose with delicate fingers; the Child, holding out his arms for it; and the angel on the right, raising his hand to point, while his companions are not to be deflected from their worshipful immobility. The reader will surely not fail to notice the angels' belts, subtly combining to form an illusionistic ring about the central group; nor the refined, space-articulating festoons impressed upon the dark marble slabs in the background, giving us a better idea of the effect the Rimini fresco originally made, before it was altered; nor the slow, varied immersion of the forms in the glaucous light that once again creates—in the contrast between the deep, cavernous folds in the garment of the angel in back and the knobs of the burnished, back-lit faldstool—passages worthy of Vermeer. The transparent shadow of the angel in profile on the left grazes the marble podium carved with rosettes so yielding and fleshy as to recall a fragment of Greek sculpture of the fifth century B.C.

It is not difficult to place the work somewhere between 1460 and 1470—meaning, in a general sort of way, that it comes after the Arezzo frescoes but before the *Brera Altarpiece* and the other late things. Should we wish to narrow down this frame a bit more, we might add that, among Piero's small-scale paintings, this one seems closer to the Uffizi portrait diptych than to either the *Flagellation* (which precedes the Uffizi work) or the *Madonna of Sinigallia* (which follows it). And it is true that the somewhat Northern European modeling of the Child and the heart-shaped or lanceolate necklines of the angel's robes are already typical of Piero's later years; but on the whole, these superhuman attendants at the threshold are less bejeweled and "dressed to kill" than the figures in the picture from Sinigallia, or in the works now in London and Milan. The architecture of their feet—powerful in its floor-plan and triangular in elevation—is, in fact, a sincerely Aretine trait. For these reasons, and others I should have difficulty in articulating (although the inadequacy is, of course, mine alone), I think it decidedly safer to date the work to 1460-65, rather than 1465-70.

The picture appears to be in a good, even if not perfect, state of conservation. One detects a few uncertainties—resulting, I believe, from minor restorations—in the somewhat dulled folds of the Virgin's robe, and perhaps in her face as well. All the rest may be read with absolute confidence; and I hope that everyone will eventually have the opportunity to give this master-

work the unstinting admiration it deserves.

(1942)

1. [M. Calvesi (op. cit., 1998, p. 226) gives a detailed account of the work's ownership history in the nineteenth and twentieth centuries, about which a great deal of deliberately misleading information has been put about in the past. The Clark family (American collectors unrelated to the late Sir Kenneth) bought the painting as early as 1913—but in New York, not Paris. (This detail incidentally explains how it happened that Longhi, who never crossed the Atlantic, never saw the picture and discussed it only on the basis of a photograph.) Although Longhi does not say so, the work is, according to Calvesi, cited as autograph in Felix Witting's monograph of 1898. (D.T.)]

2. U. Gnoli, "Una tavola sconosciuta di Piero della Francesca" in *Dedalo*, August 1930, p. 133.

3. [Longhi's appreciation, translated above, was decisive in winning for this painting wide acceptance as a work by Piero; dissenting opinions—generally acknowledging the work's high quality and regarding it as, at any rate, "close to" Piero—include those of Berenson, Meiss, Creighton Gilbert, Cole, Bertelli, and Calvesi. The picture's modern history has been reconstructed by Battisti, who traces it as far back as a Christie's sale in 1869, when its provenance was given as the "Gherardi house" in San Sepolcro; Battisti further notes that a painting attributed to Piero is recorded in 1583 as belonging to one Jacomo di Bernardino Gherardi in that town. Cf. E. Battisti, *Piero della Francesca*, Milan, 1971, p. 64. (D.T.)]

On the fragment showing a young male saint, San Sepolcro, former church of Sant' Agostino

[Now Pinacoteca Comunale, San Sepolcro, ed.]
 This fresco fragment, discovered on December 24th, 1954, was presented by Mario Salmi with some reservations that strike me as unnecessary. In my opinion, there is no question that this is a work by Piero in his "Arezzo period": i.e., before 1460. Salmi's hypothesis that this is Saint Julian seems acceptable, since the mantle, thrown back over the shoulder in such a way as to reveal the lining, appears to denote a young, "knightly" saint, while the sor-

rowful expression of the eyes, with their arched lids and eyebrows,[1] is quite appropriate to the legend of Julian and his horrendous unintentional crime.[2]

(1962)

1. [This may be the first recorded instance in which a worried expression has been adduced as evidence of a person's identity. (D.T.)]

2. [As Catholics, art historians, and readers of Flaubert's *Trois contes* will know, Saint Julian the Hospitator found his parents sleeping in his wife's bed and, imagining himself to be the victim of marital betrayal, stabbed them to death in a fit of jealous rage before discovering their identities. (D.T.)]

Saint Julian (?)

Fresco formerly in Sant' Agostino at San Sepolcro. These reproductions of the mutilated fresco, rediscovered[1] in December 1954, appear for the first time in this third edition.

1. [In the apse of the former church of Sant' Agostino, subsequently rededicated to Santa Chiara. Published in 1955, first by R. Papini and then by M. Salmi, the work is now in the Pinacoteca Comunale at San Sepolcro. (D.T.)]

PIERO IN AREZZO
(1950)

Architecture and painting rarely evolve at the same pace, because economic considerations condition the former art much more powerfully. Thus it happened that, years after the architect Brunelleschi's invention of perspective, painters exploiting this brilliant innovation (the greatest single artistic idea of the Renaissance) were still fitting their pictures into spaces built in "Gothic" times; even if it is also true that Italian Gothic architectural space was, in general, broader and calmer than the variants encountered elsewhere.

Masolino and Masaccio had to come to grips with such a situation during the years 1424-27, in their frescoes in the Brancacci Chapel in Florence; and so had Piero della Francesca when, sometime around 1452, he was offered the opportunity to continue the mural decorations begun a few years earlier by the mediocre Florentine *retardataire* Bicci di Lorenzo in the fourteenth-century church of San Francesco at Arezzo. I mean that the predominantly vertical axis of the walls there did not permit the unified conception and effect that would have been attainable in a chapel built in the new style, or in a Brunelleschian room. (One might note in passing that, in any event, Brunelleschi was most reluctant to admit painted wall decorations into his own architectural works, rightly regarding his buildings as quite sufficiently "figurative" in their own right.)

Thus Piero had to arrive at some sort of accommodation to his space. He did not try his hand, however, at the sort of overly intellectualized solution Mantegna was attempting, at just this same period, in his famous frescoes in the Paduan church of the Eremitani:[1] a solution that, on the wall's uppermost register, ends up rendering the figurative decoration so ineffectual as practically to abolish it outright. Instead, Piero adhered to the practice of Masaccio and of Giotto before him: the wall is divided vertically into large rectangles having proportions vaguely determined by the golden section; these rectangles are placed one above the other so that the spectator's eye may travel upward or downward from one scene to another according to the narrative sequence.

In order to understand the Arezzo frescoes the viewer, no less than the painter himself, must bear in mind the constraints regarding the cycle's distribution over the wall; he must remember that these same scenes would make a far more coherent overall effect if only, rather than being stacked one above the other, they could be lined up single file, in the manner made possible by the new architecture. It is sad to reflect that, in those same years or very short-

ly afterward, the earliest commissions for the pictorial decoration of modern architectural spaces were being awarded to far lesser artists than Piero: Andrea del Castagno at Legnaia near Florence, Benozzo Gozzoli in the Palazzo Medici chapel in the city itself.

Another preliminary observation concerns the cycle's subject matter. Here is a further constraint to which any figurative artist must necessarily devote a great deal of thought if he hopes to harmonize his subject matter, as discreetly as possible, with his innermost inclinations regarding form. In the present case, it would be most useful to know whether or not the belated medievalist Bicci di Lorenzo had already agreed to the theme of the *Stories of the True Cross* prior to his acceptance of the initial commission in 1447. To judge by the popularity of this lushly embellished narrative among pictorial storytellers of the late Trecento, from Agnolo Gaddi at Santa Croce in Florence through Cenni di Francesco at Volterra, we might think that such an agreement had indeed been reached. If so, then it is all the more significant that so advanced and modern a painter as Piero della Francesca should have been willing to execute this pre-determined project. It may be illuminating to observe that—unlike Masaccio who, when dealing twenty-five years earlier with a series of Apostolic events, had drawn upon his thunderous chiaroscuro as a means of intensifying the dramatic complexity—Piero is quite content just to illustrate, in the choir of the church at Arezzo, the long and adventure-packed romance that the late Middle Ages had written in the margins of the pages of Holy Scripture. His interpretation reveals no sign of ambivalent after-thought concerning his initial acceptance of the subject matter.

In fact, no sooner have we listed the various scenes in narrative sequence—the *Death of Adam*, the *Meeting of Solomon and the Queen of Sheba*, the *Removal of the Bridge*, the *Annunciation, Constantine's Dream, Constantine's Victory over Maxentius*, the *Torture of the Jew*, the *Invention and Trial of the True Cross*, the *Defeat of Chosroes*, the *Restitution of the Cross to Jerusalem*—than we make an important discovery. If we attempt to free the frescoes of their strictly illustrative function, reading them with no further reference to any mental "captions" drawn from the Golden Legend, we find that their appearance refers only minimally to the "religious" core buried within each scene. Instead, we have what looks very much like an extensive epic of secular, profane life. *Solomon Receiving the Queen of Sheba* and the *Restitution of the Cross* are a pair of royal ceremonies; the *Removal of the Bridge* and the *Invention of the Cross* boil down to two scenes of humble, everyday labor; the *Torture of the Jew* is a picture of contemporary judicial practice; the *Dream* is a treatment of the effect of moonlight shining upon an Imperial encampment; and Constantine's and Heraclius' two battles are showy display scenes out of the

Roberto Longhi

tournaments of Piero's day.

Here, then, we seem to find a revelation of Piero's basic inclination: his tendency to see and represent the world as an endlessly unfolding spectacle. Unlike Masaccio's dramatically condensed world, where a close-knit little band of tremendously energetic men enact the basic gestures of the active life upon a stage caught between light and shadow, Piero's world unfurls as lucidly as some colored banner. It unfolds a calmer, more indifferent vision of the ineluctability of passing events: here are the hours of morning and afternoon, here is the moonlit night. Under this eternal protection, every episode is set forth in tones of natural solemnity; for all its air of gravity, this placid display of forms, set forth within a shifting setting of buildings and figures and mountains and clouds and coats of arms, is always clad in color.

Here, then, is a majestic spectacle, carefully measured out and controlled by a style. If we are to comprehend this spectacle, we must first briefly review how such a figure as Piero della Francesca could have developed within the figurative culture of the Quattrocento.

He was born around 1410 at Borgo San Sepolcro in the upper reaches of the Tiber Valley, on the border between Tuscany and Umbria. There can be no doubt that the boy derived his earliest artistic impressions from Sienese work of the fourteenth century; during the Trecento, in fact, Sienese painting had made its way up the valley from the Valdichiana to Arezzo and Borgo. The finest picture in Piero's native town—an image that was always to remain a vivid presence for him—was Niccolò di Segna's dazzlingly resplendent altarpiece of the *Resurrection of Christ* (a subject constituting, in a town named for the Holy Sepulchre, a sort of civic emblem). And when the youthful Piero went to Arezzo, the little regional capital, the best picture he might see there was, once again, Sienese: Pietro Lorenzetti's polyptych in the church of the Badia. So deeply rooted was this regional cultural tradition that while Piero was already off studying his art more deeply in Florence the most important pictorial commission in Borgo San Sepolcro was awarded (1437-44) to yet another Sienese artist: Sassetta.

Apart from these childhood memories, most useful to the kind of critic interested, first and foremost, in "ancestors," Piero's true destiny was nonetheless shaped by his having reached intellectual maturity in Florence in the years 1435-40. There he might savor quite a different quality of food for thought, in the already old, but still lofty and weighty events of the local Trecento; and he had to make up his mind regarding the new developments brought about by Brunelleschi, Masaccio, Angelico, and Domenico Veneziano. So far as the older works went, he surely meditated deeply not only on Giotto, but even more on Maso di Banco, whose style, with its sovereign

capacity to transform the mature Giotto's limited but firm mass and space into calm expanses of color, constitutes a fourteenth-century prophecy of Piero's own work.

As for more recent events (these being always, for a young artist, the most decisive of all), nobody went more deeply than Piero into every aspect, including the theoretical ones, of Brunelleschi's new manner of structuring space: the youth thought about the "harmonic proportion" posited by the architect and about how all these matters might be absorbed into the mysteries of painted perspective. Masaccio had already given it a try: in his work, space had functioned as a stage for ongoing action of unparalled vigor; and something similar was occurring in the sculpture of Donatello. The beauty of Trecento coloring would thus have seemed a paradise on the brink of being lost, had it not been for the splendid conviction of Alberti who—while holding fast to the new space and to the "intersection of the visual pyramid"— nonetheless insisted upon the possibility of that "friendship among colors" of which splendid exemplars were already to be seen in the work of Fra Angelico and Domenico Veneziano. The former painter was reviving the blaze of Trecento color, but in a spatial context expressive of a new depth; the latter was carefully observing, with an attention worthy of Van Eyck but in a more firmly constructed spatial setting, the way colors change when played upon by the new rays of a light no longer transcendental but instead natural, physical, and happiest in the springtime. It is thus a far from negligible fact that when Piero makes his first appearance in 1439, he is in the company of Domenico Veneziano. Right from the outset, though, Piero is meditating on issues of broader scope as well. Although many years will pass before he comes to write his treatise *De quinque corporibus regularibus*, there is already taking shape, in his mind's eye, the poetic vision of a crystalline harmony of regular volumes, with everything bound together by perspective and set forth in a smoothly flowing display of broad, calm color.

When Piero received his first commissions from his fellow-townsmen of San Sepolcro, in the period around 1445, he was already on the brink of being able to express his own true artistic personality. The *Misericordia* altarpiece was commissioned in 1445; but work on it proceeded slowly over the period 1445-62, so that the altarpiece reveals the successive stages of Piero's development. The Baptist and the Saint Sebastian are still coarsened by a Masaccesque violence in the modeling. They are followed, however, by other figures, whose greater serenity of form and richer coloring have analogies with Piero's *Baptism of Christ*, now in London; in his Urbino *Flagellation*; and in his Venice *Saint Jerome*, where passages of crisp, close-up realism worthy of Van Eyck's supreme miniaturism fade away, in the far background, into effects

of such freedom that they might have been painted by some modern-day post-Impressionist.

If, seeking an artist for the Arezzo frescoes in 1447, the Bacci family had to settle for poor old Bicci di Lorenzo, their choice is likely to have had less to do with any lack of reputation on Piero's part than with his probable absence from the region. Perhaps he was already at Urbino. We know for a fact that he was at Ferrara in 1449 and at Rimini in 1451; and it is significant that this was also Alberti's itinerary in those same years. There is nothing to be gained by belaboring the point that Piero's Ferrara frescoes, now lost, were certainly among the underpinnings of the achievements of the great local painters, from Bona through Tura through Cossa down to Ercole de' Roberti. As for Piero's votive fresco in the Tempio Malatestiano at Rimini, it shows, as early as 1451, the enormously "secular" freedom our painter allows himself in his handling of a religious subject. A youthful autocrat kneels before his patron saint, but without allowing himself to be parted, for so much as a moment, from his faithful hunting dogs; and the saint receives his devotee in a palace, not a church. The breadth of the design, freed from any obedience to a central compositional point; the vastness of the fictive space; above all, the majestically festive coloring: all this is quite similar to what we shall encounter, not long afterward, in the Arezzo frescoes.

Every time we enter the choir of the church of San Francesco at Arezzo, we are plunged afresh into the same river of contentment that flowed round us at our first encounter with this indescribable array of rich, clear, light-loving colors. In Piero, hues seem to be born for the very first time, like elements in the invention of the world. One might go so far as to say that, in that authentic rebirth of the visual world that was early fifteenth-century Tuscan painting, Masaccio gives us the poetic sensation of active forms, engaged in a process of plastic growth; while Piero restores our awareness of the tints Nature must have taken as it was being touched, for the very first time, by the rays of the newly created Sun. Therefore his hues are elementary, like the colors in a rainbow or the inevitable vowels of some perfect lyric poem.

But when, at a second reading, the forms likewise set themselves forth, clear and majestic, then we understand better that those colors are "quantities": measured expanses of a deep, complete Nature, unfolding in the natural light. The secret of Piero's poetics, in fact, lies in his carefully calculated conjoining of the areas of color corresponding to these forms. He achieves this fusion through a "perspective synthesis," first developing a group of simple shapes three-dimensionally, and then putting them back up against the two-dimensional picture plane as a "chromatic façade." Piero's poetics grew out of

his rethinking, and applying even to the human figure, the selfsame laws Brunelleschi had derived from his measurement of ancient buildings. Grave, measured, modular, Euclidian, in a word, "regular," Piero's shapes are at long last freed from the tensions of the sharply drawn line: tensions to which form had been subject in Brunelleschi's creations and even in Masaccio's fermenting light and shade. This is why Piero's figures and things possess, in place of Masaccio's desperate urgency, a gravity of stance, a sovereign indifference, and a ritual air that would put us strongly in mind of Egyptian or archaic Greek low reliefs, were it not for the way his shapes occupy the dimension of depth and the way they bathe themselves in light; for both these traits were unknown to ancient art. Or, to leave the past for the far-off future, Piero might seem to have predicted and fully achieved the sense of Cézanne's famous motto, "*Quand la couleur est à sa richesse, la forme est à sa plenitude*" ["When color is at its richest, form is at its fullest"]: words incomprehensible and esoteric only for those who adore nothing save relief and the all-conquering line.

The Arezzo fresco cycle, painted over many years, does show signs of a certain evolution, even within the context of its overall stylistic unity. (For example, in the two lunettes of the *Death of Adam* and the *Restitution of the Cross*, both certainly painted at the outset, we find linear outlines having a distinctly Florentine cast; whereas, in the scenes painted later on, such hard-edged outlines vanish in the seamless conjoining of areas of color as such.) We may nonetheless state that the cycle as a whole contains not one passage that does not satisfy the demands of a measured synthesis between the two fundamental aspects of visual experience: color and form.

As an example, let us now turn our attention to the first large scene, representing two distinct events: *The Queen of Sheba at the Bridge* and the *Reception in Solomon's Palace*. We may clearly note the way the big rectangle is divided equally between the architecture on the right and the landscape on the left, where two conical trees offer us a resting-place on our way to the mountainous horizon. Here what is far away and what is nearby are, in fact, conjoined by Piero's new poetics. Every interval between the figures is filled to the brim with intense colors that embrace alike the most distant hillside and the bright-hued, nearby wall of Solomon's great hall.

The same is true of the details. On the left, the Queen's squires are looking after the horses. "Ah, but that's mere byplay," you might feel tempted to say; and yet, in the spectacle as a whole, the episode is fully as important as the activities of the leading actors. The squires and horses demonstrate no particular interest in any very precise placement in space; the rhymed poses of the two squires are answered by the rhymed poses of the horses; and this reversal

of shapes finds a further echo in the inversion of the order in which colors appear, as in the quarterings of a coat of arms. Blue coat against red coat; red hose against gray hose; two white horses, two sorrel ones; a brown saddle, a blue saddle. But this carefully set forth chessboard of alternating colors would not exist had not shapes already been rotated in space to the positions where they can display their proportions in the most elementary way: frontally, or from the back, or in profile. No more could this design exist, had not the elimination of plastic chiaroscuro modeling made possible a calm division into transparent hues that shows off the coloristic effect with no watering down. Like a stream flush with its banks, the greens and grays of grassy fields and sloping hills flow freely around fetlocks, shins, horse heads; an equine mouth gapes open like some enormous red-lipped fruit with white teeth for seeds. Every seemingly isolated interval and every least detail brings us back to the broader context.

In the passage where the Queen kneels before the little bridge over the Shiloh, the court ladies form a sort of apse around her. Enclosed in the stream of those pink and green and white mantles, gleaming glacier-like in the sunlight, these ladies define the apse-like space with their girdles; their unselfconsciously ritual gestures; their slow, graceful, majestic necks; and their foreheads that seem to have germinated, like gigantic flower-bulbs, against the gray background of the hills.

In the right-hand portion showing *Solomon Receiving the Queen* it is, instead, the architecture, with its large slabs of variegated marble, that fills up the intervals in the half-circle formed by the figures. There is no trace of drama here, nothing more than a scene of royal ceremony—a bow, two hands conjoined. And yet the tranquil gravity of the persons in attendance generates the sense that this is indeed an event of the utmost importance. Surrounding the main figures, spectators of both sexes, looking like bright, self-propelled statues, are enclosed in the elementary capsules of their garments: triangular hose in red, black, or white; massive robes fluted like antique columns; lined cloaks in two-toned color schemes where one garment is the inversion of another; for the men's heads, circular *mazzocchi* and cylindrical hats; for the women, long-trained tunics draped from the girdle in measured rhythms, conferring upon their wearers the majestic grace of ancient *amphorae* crowned by heads in soft, luminous earth tones.

On the other hand, the *Annunciation*—painted, remember, long after Fra Angelico had settled down to the bland humility of his various Annunciate Virgins at San Marco—speaks, instead, in tones of such lofty nobility as to have suggested to more than one writer that the scene must really represent the delivery of a divine message to the Empress Helena. If we are

to judge by the numerous recollections of Tuscan line complicating various passages of the work, then Piero may well have painted this scene prior to that of the royal *Reception*. Nonetheless, everything here is already consonant with Piero's vast new poetics: the Angel's peplum, in crystallized pink above the vivid red of his stockings; the Virgin's mantle, forming an open cupola for her body; her head, resting atop the cylindrical neck in just the same manner that the Corinthian capital sits on the nearby column; the beaded light, tranforming the folds of her veil into shimmering harp strings; and the articulation of the atrium where the action takes place into great zones of color.

On the same register of the wall, the *Dream of Constantine* has long been famous as the first nocturne in Quattrocento painting. There is, of course, no denying that a love of fables set at eventide or nighttime had existed as early as the "Gothic" period, from the red-and-purple stained glass of the cathedrals down to the work of the Burgundian miniaturists and the brothers Van Eyck. What *is* entirely new here, however, is the way Piero makes the miracle occur within Nature, as if he were asking: What could ever be more miraculous than a moonlit night in Umbria?

The secret sense of the supernatural occurrence is, I mean, shut away forever behind the sealed lips and closed eyelids of the sleeping, dreaming Emperor. For the guards, who do not lift their heads, and for us spectators, too, the event becomes superbly material at the moment when, further whitening the already pale servant and bleaching the bronze armor of the two impassible sentries, it manifests itself as a powder of light, spreading through the interior of the Imperial tent. From Jan Van Eyck through the *Maître du coeur d'amour épris* and Fouquet, from Raphael down to Caravaggio, Rembrandt, and Seurat, this may well be the most "natural" nocturne ever painted. And that is precisely what makes it, perhaps, the most magical one of all.

After this unsurpassed scene, which might almost be entitled *A Full Moon Shining over the Encampment*, Piero returns, by way of contrast, to the broadest daylight, or more accurately, to the very quintessence of sunshine, with *Constantine's Victory over Maxentius*. (In the narrative as well, this is the episode immediately following the *Dream*.)

The partial destruction of the right side of this fresco surely constitutes the most serious single loss ever sustained by early Italian painting. Still, enough is left to let us perceive the supremely spectacular appearance of this warlike procession as, parading across the timelessly beautiful landscape of rustic Italy, it composes itself into a scene captured by the artist at the very apex of its splendor.

This is, in fact, the moment when, seemingly propelled forward by the

bright sunlight itself, Constantine's cavalry reaches the bank of the Tiber. Once there, it reins in its wondrous steeds, while the Emperor pledges victory by holding his little white Cross up against the blue sky. Hooves delicate as wild plants pave the way for their own passage by breathing out delicate shadows; atop the crisscrossing equine legs, white, gray, or brown, there blossom the tall, arched masses of horses' bodies: Euclidian theorems. In their triangulated gait, triangles are fixed forever; in their round rumps is an everlasting roundness, irrefutably demonstrated by compasses in the form of red and turquoise cruppers. On these noble mounts there arise castles of ineffably civilized, yet quite inhuman, limbs, clad in Imperial armor and belonging to shining, monstrous warriors. The formidable array of helmets pierces the air. The yellow and red Imperial standard is a sail, billowing against the masts and spars of lances traced in green, pink, and white upon the blue page of a sky where clouds of light delimit the altitude.

Thanks to a mediocre but precious watercolor, painted by Ramboux over a century ago and now in the collection of drawings in Düsseldorf, we may accurately reconstruct the way this part of the fresco was originally related to the now-ruined right-hand portion, where Maxentius's fleeing cavalry clambered up the opposite bank of the Tiber. Back when Ramboux made his copy, a bend in the Tiber still gleamed at the center of the fresco, limpidly reflecting some little rustic houses, as if in some Provençal scene by Cézanne. Even those few traces of the interval of sun-struck landscape left to us today suffice to show the fluid, "impressionistic" vagueness Piero had achieved—in utter contrast to the sedulous meticulousness exhibited by the painters of Northern Europe—in his treatment of distant backgrounds. Modern *plein-air* painting, in fact, has never got beyond Piero.

On the opposite wall, facing the scene of *Solomon Receiving the Queen of Sheba*, Piero decided to show two stories of the Empress Helena: the *Invention* and *Trial* of the True Cross. His meditations on these new subjects led him to the conclusion that, for all the lofty status of his leading lady, the action could still be appropriately set in the open air, whether the events took place in the countryside or the city. For example, the digging up of the three crosses could become an excavation in the fields just outside the lower town; and it is just outside the city gates that, on the right, the miraculous trial of the True Cross could afterward be conducted, quite as simply as any everyday weighing up of goods at a toll barrier. Piero does not fail to mark the central axis separating these two successive actions. The division is denoted by the cornice—so foreshortened that it resembles a closed fan—of the little polychrome temple. This building is placed in the middle distance; unlike Solomon's hall in the *Reception*, it does not enclose the figures. The painter

thus leaves himself the freedom to wander at will. At the left, he climbs over the ploughed fields toward the red-and-white, sun-bleached upper town. At the right, he reminds us of what it is like, even today, to enter an old Italian provincial town: those streets, dark and gloomy but with sunlit intersections; those squarish red towers; and the big white dome that, glimpsed from afar, immediately induces you to ask the first person you meet which, among all these streets, is the one that gets you to the Duomo.

This is not to suggest that the events recounted in such a manner lose anything of their dignity and importance; rather, in Piero's work, dignity and importance look so natural as to seem an everyday affair. In the digging scene on the left, people are working, pointing, watching, listening, taking a break. The Empress's dwarf, in whom a Gothic painter would have seen a pretext for an entertainingly irrelevant bit of comic relief, has here become an integral part of the whole, so intent is he (just like everybody else) on what is happening. Nearby, the hands of the Empress and her chamberlain unfold like roses; calm arms carry such things as are best suited to pass through pictorial space: the two crosses, the spare pickax slung over the peasant's shoulder. Even in his depiction of the most humble gestures, the artist selects the ones possessed of a gravely natural air, as Vasari had already recognized when he mentioned the digger "who listens so attentively to Saint Helena's words that there could be no improving on him." And there is an extreme purity of draughtsmanship in the sun-dried Umbrian farmer, leaning on a shovel that practically takes the place of one of his feet, in a gesture so expressive of the harmony between the man and his rural implements as to constitute—as is Piero's wont—a kind of near-symbolism.

The scene of the miracle at the right similarly unites architecture, things, and figures in a single, harmonious whole, imbued with a sort of grave freedom. There will be, at this point, no need to insist upon the weight and measure of the Cross: in the aftermath of the miracle, it almost seems to be transferring a quantity of space from the kneeling to the standing group. Nor need we linger over an explanation of the abstract constellation formed by the multicolored temple's arches, circles, and stripes as a frame for the figures intent upon their "geometric prayer." Let no one claim, either, that this is sham architecture, only suitable for use by painters; it is, instead, built in accordance with that Albertian taste which was shortly thereafter to pass by way of Rimini into Venice, at nearly the same moment that Piero's painting was to make its first appearance there.

We have already mentioned the probable sequence in which the Arezzo frescoes were painted. At first glance, this scene of the miracle may look slightly earlier than the *Reception* facing it; for the torso of the resuscitat-

ed youth seems the sign of a return to archaic Greek art (somewhere between the Olympia sculptures and the works of Myron). But we must be cautious in drawing our conclusions. The painter's apparent insistence on linear definition may well be the result of problems connected with Piero's use of assistants rather than an expression of any archaizing tendencies; in the same fresco there are, in fact, other passages where a slightly inferior quality similarly suggests the involvement of collaborators. It is obvious that—especially in an art such as Piero's, where the seams are invisible, the syntax at once perfect and delicate—any "transcription" must immediately degenerate into a "translation" entailing all the limitations inherent in the latter concept, in literature as in art.

Thus it will be useful to state unequivocally that the only fully autograph portions of the Arezzo frescoes are the *Death of Adam*, the *Reception*, the *Annunciation*, the *Dream of Constantine*, and the *Victory over Maxentius*. In all the remaining scenes, "translators" of the master's cartoons have played a greater or lesser part: lesser in the *Invention of the True Cross* and the subsequent *Trial*; greater in the *Battle of Heraclius and Chosroes* located beneath these last-named events on the wall, and following hard upon them in the narrative sequence.

Alerted by now to the constant superiority of the autograph passages, the viewer must make an effort to restore in his mind's eye the ideal "text" of the *Battle of Heraclius* as it was conceived—but, alas, executed only in small part—by Piero della Francesca himself. We have a duty toward Piero to make this effort, for only thus can we recognize the baselessness of the frequently heard claim that the scene's relative failure stems from its subject matter (which would still make it, in the final analysis, a failure of the artist). We shall, in fact, be led by our imaginative reconstruction to a diametrically opposed conclusion: for it is only because of the "translation" that Italian painting has here missed producing a worthy rival to the celebrated *Battle of Alexander* of antiquity.

What is true is that on this wall, opposite the dazzling cavalry parade of Constantine's victory (won without a single blow's being struck), the master has sought to show, by way of contrast, a battle raging at its highest pitch. Comparison of the two battle scenes has led superfical observers to deduce that the artist's impassible style was unsuited to the depiction of "motion." But is not the real problem quite a different one? Our true task here will be to understand what appearance such an "action-packed" scene as this one might have taken on in Piero's meditations. He had always believed painting to be incapable of representing full-blown action. Instead, his style captures and freezes movement during those momentary pauses which, paradoxically,

reveal action at its most intense; it thus brings the process of "becoming" to an end. We see Chosroes's son falling over backwards, just a fraction of a second after his throat has been slit; and this instant will remain immobile forever. A lance sails across the sky; if we are to see it, however, we must take our aim at it with the perspective needles of other lances, following other trajectories and seemingly exploding within the white cloud at the very apex of their flight. At this same instant, yet another lance is breaking; in an example of careful forethought, its triangular, broken line coincides to the millimeter with the central axis of the entire scene.

We are, in short, at the antipodes from Antonio Pollaiuolo's famous print, the *Battle of Nude Men*, where everything is in frenzied motion. Piero's scene, described by Vasari as "an almost unbelievable massacre of the wounded, the fallen, and the dead" (but actually involving, if you bother to count, no more than forty participants), has already "happened," once and for all. To put things differently, the battle is already "over" at the moment that best represents, on Piero's stylistic terms, its dynamic culmination. It becomes a sort of colored anagram, created from the continuous intersection and conjoining of interlocking things: sky, clouds, earth; weapons, coats of arms, human figures. It is, in fact, a sort of "battle under glass," viewed with a cruel clarity. After the clarity of simplicity manifest in the *Victory of Constantine*, here Piero achieves a clarity of multiplicity; but the process and its outcome remain the same. Try saying to yourself: "from top to bottom" or "from bottom to top;" "from left to right" or "from right to left." All these expressions will turn out to have no bearing whatsoever on this polychromed structure, this brightly colored marquetry, locked in before our gaze like some freshly materialized abstraction. It takes a while to pronounce the names of the things we see: clouds; coats of arms; weapons held high against the blue backdrop of the sky; the sky itself, filling the gap in the torn banner; the complicated tangles of combat; one-on-one duels; warriors' dark heads, standing out against the bright rumps of warhorses; white, green, or blue helmets; costumes and shields in the colors of noble houses; wounds, sporting their blood like coral trinkets Ah, but it's too slow a business, for no verbal repetition can duplicate the instantaneous flash of this single moment of unified multiplicity, clarified by Piero at its language-defying peak.

The above commentary applies only to the ideal, autograph version of the fresco, however; in the real one, alas, too much has been "lost in translation." A demanding eye will be troubled by the distortions of Piero's ideas, both in this scene and in the concluding one of *Heraclius Returning the Cross to Jerusalem*. This same eye will, however, be better satisfied upon turning to another, supremely autograph fresco painted by Piero during the same years,

Roberto Longhi

perhaps just as his untalented assistants were struggling with their translations of the Arezzo cartoons; the picture I am referring to is the Borgo San Sepolocro *Resurrection of Christ.*

It is deplorable that so many reproductions of this work omit the fictive Corinthian columns at the sides, a grandly theatrical framing element. Opening in the middle to reveal yet another of Piero's spectacles of symbolic natural magic, this "frame" further enhances the scene's illusionistic effectiveness.

Given that the subject is the most transcendent one in all religious art, the artist would have been silly not to observe a strict, practically liturgical centrality: after all, the risen Christ is the very axis of the Christian faith itself. But how Piero succeeds in imbuing this tremendous, immobile certainty with natural tenderness! Like the sun, reborn in an April dawn after a long winter, Christ's mantle gives off a rosy glow. It is as though a peach tree had come into blossom, suddenly, silently, secretly, during the first night of spring. The guards stationed at the sepulchre sleep on, knowing nothing as yet of what has happened; but their sleep unconsciously takes the form of agony, ectasy, vulnerable happiness, attention to hidden things. The dawning light raptly shortens the shadows beneath the soldiers' brightly colored leggings, reddens the shade cast by a short green cloak, gently touches a leathern jacket; flowing forth from Christ's mantle, it produces crocus-colored streaks on the clouds above the encircling mountains, while the mountains themselves make ready to receive their full measure of light. And the Christ—a horrendous, nearly bovine woodland creature—is a grim Umbrian peasant, up before daybreak. Resting one foot on the edge of the sarcophagus, as though on a hillock at the boundary of a field, He looks out sadly over the shining acres of this, His melancholy world.

Thus it is that, without losing anything of its arcane symbolic effectiveness, the most lofty and austere of Christian subjects also becomes, in the artist's mind, a meditation on the way the reborn sun shines once again over the Italian landscape at the season's turning.

Piero was never to surpass the autograph portions of the Arezzo fresco cycle and the San Sepolcro *Resurrection*, a work contemporaneous with it.

His later works, which take us down to around 1480, fall outside the scope of the present essay. They include the fresco of the *Magdalene* in the cathedral at Arezzo; the *Hercules* in the Gardner Museum in Boston; the Uffizi's celebrated portrait diptych of the *Duke and Duchess of Montefeltro*; the

numerous, now-scattered surviving fragments of the polyptych painted for the Augustinians of Borgo San Sepolcro; the *Urbino Altarpiece* in the Brera in Milan; the *Sinigallia Madonna* now at Urbino; and the *Nativity* in the National Gallery in London.

While these later works do show a great meditative mind's unflagging ability to work out endless variations on a theme, they add nothing fundamental to Piero's initial, magnificent poetic invention at Arezzo. We must therefore go back to the decade between 1450 and 1460, when Piero was painting the Arezzo frescoes and the San Sepolcro *Resurrection*, if we would seek out the best vantage point from which to look out over time and space in order to survey, however summarily, the subsequent offshoots and fruits of his poetics.

Let us reflect on the fate of painting in fifteenth-century Tuscany following Piero's departure and the death of Domenico Veneziano. When we remember that the best the Florentine school has to show for itself in those years is Castagno's and Baldovinetti's frescoes, or those by Filippo Lippi at Prato, or those by Benozzo Gozzoli in Florence itself and at Montefalco in Umbria, then the least we can say is that Florence was on a downward slope, leading to an overly linear formalism. The consequences of Piero's absence were so serious that, despite the undeniable and varied attainments of Pollaiuolo, Botticelli, and the young Leonardo during the years from 1470 to 1480, the traditionally high value set on certain aspects of Florentine art during this period still needs to be reconsidered.

The far-reaching, ongoing influence of Piero's art on the future of Venetian painting—which is to say, on painting *par excellence*—is another matter entirely. The isolated episode of Mantegna's archaeological, academic wrong turning after 1460 does not alter the fundamental harmony, from shortly before 1475 on, between Piero's vision and that of the great painters of Venice. It was, in fact, Piero's discovery of a harmony between form and color based on perspective that facilitated the birth of the famous "Venetian sense of color," paving the way for the warm and spacious epic manner of Giovanni Bellini, Antonello da Messina, and Carpaccio; and their achievements led in turn to the joyful painting of the young Titian and of Veronese.

Only much later, after the lengthy interruption known by the generic names of "the Baroque" and "Romanticism," is Piero's lofty pursuit of a balance between form and color resumed. Moving along complex, yet-to-be-charted pathways, it manifests itself in the work of artists taking part in the "reconstruction" running parallel with, and following hard upon, the tender poetry of Impressionism: painters like Cézanne, Seurat, and—in certain regards—the "Synthetists." Herein lies the secret, partly unconscious story of

our temporary return to Piero della Francesca: for those who have gone back to him include not only the critics (who don't matter all that much), but also the artists themselves.

1. [The celebrated frescoes by Mantegna and his school in the Paduan church of the Eremitani were very severely damaged in the Second World War. In them, there was an increasing degree of foreshortening in each register, so that painted figures and objects high up on the wall were seen in a most distorted fashion. Longhi here contrasts Mantegna's system with the one Piero adopted at Arezzo, where all scenes, regardless of the position they occupy upon the wall, are treated as though they were essentially at eye level. (D.T.)]

THE LIFE OF PIERO DELLA FRANCESCA

The life of Piero dei Franceschi—usually known, since early times, as Piero della Francesca—is almost devoid of such turbulent events as have inescapably formed the stuff of all biographies of illustrious men, from Plutarch's day to our own. Instead, it flows by with the same everyday calm you would sense today, were some peasant farmer from Borgo San Sepolcro to tell you about himself while standing at the edge of his field—perhaps with one foot resting on his hoe, in the very pose of the digger taking a break in Piero's fresco at Arezzo.

Not even Vasari, so skilled in seasoning biography with anecdote, is able to find much in Piero's life that does not bear directly on the latter's scientific or artistic undertakings; almost the lone exceptions are the fable[1] at the beginning about the origin of the name "della Francesca," offered in an attempt to enliven the account, and the episode towards the end in which [Piero's assistant] Lorentino receives a hog in payment for a painting.

As for the rare and laconic documents, they, too, are concerned almost exclusively with art.

The story of Piero's life therefore arouses emotion only in the sense that, steeped as we are in the spiritual meaning of his work, we cannot help being moved by the happy accident that has linked events so natural and peaceful with the appearance of so great an art.

We shall not find our painter getting involved, as did Jacopo Bellini, in the squabbles of the young artists of Florence; nor shall we see him becoming entangled in litigation with his patrons, or pushing himself forward in an unseemly fashion. In fact, he once goes so far as to make a public confession that he has acted presumptuously out of "excessive zeal" for "the glory of the art of our day." His life runs tranquilly from its beginning to its natural end, like that of any good citizen of Borgo; only once is he cited for lateness in the payment of a municipal tax. Piero, who might have lived at the court of difficult or good-natured princes—from Sigismondo Malatesta to the Duke of Urbino or the Pope—set a higher value upon the enjoyment of a wise and tranquil life in his minuscule homeland [of Borgo San Sepolcro] than on the unmannerly competition of the capital cities of artistic patronage.

After every trip to a major town he returned home, content to work for the hooded Brothers of the Confraternity of the Misericordia and to promise the Mother Superior of the local convent, in hushed tones, through the little grate in the convent door, that that her painting would be ready by mid-September. During the frequent times of plague, he carried his picture off

to some tiny village in the Apennines; and when he had finished painting it, he sometimes preferred to present it to the peasants in the fields of Monterchi, who would praise it in their untutored voices, rather than expose it to the irritating buzz of the half-baked urban aesthetes with their windy dissertations.

<center>*******</center>

The little that we know about Piero's life is recounted here; it has been gleaned from surviving documents, contemporary references, and the earliest biographies, whether directly or through a process of deduction.

Piero dei Franceschi, better known as "della Francesca," was born at Borgo San Sepolcro [near Arezzo in southern Tuscany] in the period 1410-1420 or thereabouts. He was the first child of one Benedetto, a cobbler and tanner, and of Romana di Perino da Monterchi.[2]

Nothing more is known about his boyhood and adolescence. We ought not to believe Vasari when he tells us that Piero applied himself at a precocious age to the study of mathematics, if only because it is difficult to discover anyone, in his native San Sepolcro at least, who could have taken him much beyond a rudimentary use of the abacus. Furthermore, since Piero was a painter by inclination, it would seem likely that he arrived at mathematics—in which he saw hidden the key to the mystery of perspective—through the study of painting, and not the other way around.

So for his first encounters with the pictures visible in his native town while he was still little more than a child, we can only imagine what is most probable; as we have remarked elsewhere, these probabilities do not strike us as capable of shedding much light on the origins of Piero's painting.

When we nonetheless attempt to imagine the sights that offered themselves to the young Piero, it seems not impossible that the daily spectacle of the upper Tiber Valley—the singular pictorial qualities of which had been well described by Pliny the Younger in his letter to Apollinaris—may have been even more important than the equally familiar aspect of the fine fourteenth-century Sienese polyptych then to be seen in the local church of Santa Chiara. We do not think it worthwhile to pursue this rather captious line of inquiry any further.

Taking a slightly less primitive approach to historical reasoning, we may suppose that Piero was aware of the contract signed in 1430 by the painter Maestro Antonio d'Anghiari and the overseers of the church of San Francesco at Borgo San Sepolcro; its subject was the execution of an altarpiece for the church's high altar. We have no secure work by Antonio d'Anghiari; but the fact that we later find him painting town banners, first alongside

Roberto Longhi

Ottaviano Nelli and later by himself in "the little house at the bridge over the Tiber," leads us to believe that he was little more than a minor Gothic-influenced *retardataire* whose work cannot have been of the least interest in Piero's eyes.[3] Nor would this judgment change, even were we one day to discover that, as a boy, Piero had ground Antonio's pigments for him.

In 1437 the commission for the imposing San Francesco altarpiece was taken away from the insignificant painter from Anghiari and given to the great Sassetta; we do not know whether Antonio was simply taking too long to meet his commitment, or whether he had proven himself incompetent. The fact that the citizens of Borgo San Sepolcro did not decide, on that occasion, to entrust the work to their young and promising local talent leads us to think that by 1437, if not some years earlier, Piero had already left home. We cannot imagine that he was anywhere but Florence, the nearest center in which it was possible to study painting and perspective and, in a word, to make progress in one's art. If it is true that, as we are told [by Vasari], at around fifteen years of age, Piero was "put on the path to becoming a painter," then we cannot think that this took place elsewhere than in Florence. Since we are told, as well, that he took early to the study of mathematics—which we should take to mean the mathematical aspects of painting—we may well believe that this, too, occurred in that Florentine circle in which Brunelleschi had worked out the best practical ways of applying optics to painting, while Leon Battista Alberti and Toscanelli were busy defining the accompanying theory. It would thus seem that, for some years between 1430 and 1440, Piero must have been busy learning his art in Florence. If Alberti, in the famous preface to his first treatise, written in 1435, mentions only Brunelleschi, Donatello, Nanni di Banco, Luca della Robbia, and Masaccio, then it would seem evident that not even Paolo Uccello, Domenico Veneziano, and Andrea del Castagno had got very far as yet in their art—not to speak of our Piero who, if he was indeed already in Florence, must have been no more than a pupil attending to the lessons taught by his elders.

It is certainly in Florence that we encounter him on September 7, 1439. A document from the archives of the hospital of Santa Maria Nuova there, bearing that date and recording payments to Domenico Veneziano for his paintings in the choir of the church of Sant' Egidio, contains the following invaluable marginal note: "Pietro di Benedetto dal Borgo a San Sepolcro is with him."[4] Matters would thus appear to have gone for the best; for Piero could have had no better companion than the most "painterly" among all the painters working in the Florence of those days. Domenico was a painter of clear light and precious substances; what is more, he had a certain enthusiasm for the perspective definition of space, as we may see in the Berlin *tondo* of

the *Adoration of the Magi* (which was probably painted slightly earlier than the Sant' Egidio frescoes). But—for how long had Domenico's dangerous assistant from San Sepolocro been "with him?"

Vasari gives us confused but important information regarding a collaboration between Domenico and Piero in the sacristy at Loreto; and Domenico's passage through Umbria in 1438 is documented in his famous letter to Cosimo de' Medici, written from Perugia and promising miracles of painting, if only Cosimo will entrust him with a certain great task. It would thus appear that Domenico was already known in Florence. This, in turn, suggests that Piero, having taken up residence in Domenico's Florentine lodgings as an apprentice sometime around 1435, afterwards accompanied the older painter in his journeys through the Marches and Umbria, eventually returning with him to the great Tuscan city in order to work on the Sant' Egidio cycle. In the year 1439, however, Piero had not yet been declared a master [by the guild]; nor do Alberti's early theoretical works, written at around the same time, mention Piero's presence in Florence. We must therefore conclude that Piero's Florentine apprenticeship had begun not many years earlier and that he was still quite young. At any rate, Piero was still a member of Domenico's circle when he executed what may be the very earliest among his works: the *Baptism of Christ*.

The *Baptism* may date from the period when Piero was a member of the town council—as we learn from a document[5] of 1442—at Borgo San Sepolcro. In 1445, the year after Sassetta had delivered his radiant *Saint Francis Polyptych* to San Sepolcro, the Brothers of the Confraternity of the Misericordia there commissioned their fellow-townsman Piero (who had by that time already been declared a master, although this fact is not mentioned in the document[6]) to paint for them the large altarpiece now reassembled, to the extent practicable, in the local picture gallery. The contract committed Piero to two rather unusual conditions, the first being that he would be obligated to repair the work in the event that, within ten years after its completion, any "defects" were to appear in it, whether because of flaws in the wooden support or through errors on the part of the painter himself. (We may guess that the patrons were worried about the durability of the oil-paint medium that Piero may have been proposing to use.) The second stipulation was that *nullus alius pictor possit poner manum de penello preter ipsum pictorem*, "no other painter may set his brush-hand to this picture."

As we shall see, matters were not to go according to the contractual obligations. While the painter had promised to deliver the finished polyptych within three years, its various parts show themselves to have been painted at far wider intervals than that; and if he guaranteed that the entire work would

be autograph, the predella and pilasters nonetheless reveal the hand of an assistant. We are thus led to wonder whether a document[7] of 1462, recording the Confraternity's payment to Marco di Benedetto of "fifteen *scudi* for part of the picture that his brother Piero has painted," does not refer to some balance due on the altarpiece commissioned back in 1445.

The road that took Piero from San Sepolcro to Ferrara passed through the Montefeltro region [in the Marches]. We cannot state for a fact that Piero had already had occasion to journey to Federigo's court at Urbino during the period when he was an assistant to Domenico Veneziano. But the information reported by Vasari, confused though it be, suggests that Piero's dealings with the court date from quite early on; what is more, as early as 1449 the work of Gerolamo di Giovanni at Camerino [in the Marches, not far from Urbino] reflects the revelation that was Piero's painting. We may thus believe that Piero, having left Florence for Borgo San Sepolcro, soon began looking to the northeast for an outlet for his brand-new style of painting, rather than gazing back over his shoulder at the artistic capital of Tuscany. Incredibly, even after the Arezzo frescoes had made Piero famous throughout Italy, Florence—that dry teacher of drawing—continued to shut him out. Unlike Gentile da Fabriano before him and Perugino after him, Piero appears never to have received a commission for a single altarpiece to be set up there. The silence on this score of Albertini's *Memoriale*[8] is, in fact, decisive evidence that no public work of Piero's was ever displayed in Florence.

As for Piero's first dealings with the court of Urbino, we may note that he himself was to declare in his later years that he owed his fame as an artist to Federigo's early benevolence towards him—even if, as late as 1442, the only famous painters cited by Ottaviano Ubaldini as being active at Urbino are Allegretto [Nuzi], Gentile, and Pisanello, all names that attest to the persistence there of the medieval taste. [The mathematician Luca] Pacioli,[9] writing at the end of the fifteenth century, also says that Piero was a familiar in the ducal household. We may therefore conclude that Piero began spending time at Urbino as early as the 1440s. If, as seems probable, the mysterious little panel with the *Flagellation of Christ* alludes to the violent death in 1444 of Duke Oddantonio da Montefeltro,[10] then we may well believe that Federigo would not have waited very long before commissioning a work commemorating the fact; and this picture does, in fact, display stylistic links with the *Baptism*. Another work in the same style is the little *Saint Jerome with a Donor* now in Venice, which we are accordingly tempted to regard as one of the numerous small pictures that—so Vasari tells us—Piero painted for the court of Urbino.

Having examined the earliest evidence for Piero's intimate dealings

with the ruler of Montefeltro, we may now reasonably ask ourselves whether he was not the first truly "Renaissance" artist to have appeared at the court of the Montefeltro, and whether he did not have a hand in Federigo's decision—dating from the same period—to transform his residence at Urbino from a spacious and Italianate but still Gothic building into a great Renaissance palace composed of clearly articulated volumes. When we realize that Piero's movements in those years were pretty much the same as Alberti's, it is easy for us to imagine the crucial role played by intense late-night discussions at Urbino in 1445-50 or thereabouts. It seems to us that there are precise connections between the very Albertian aspects of Piero's little *Flagellation*; [the architect] Luciano Laurana's[11] conversion during the same period from Gothic syncopation to Renaissance order and clarity; and Alberti's plans, matured in these same years, to dedicate his treatise on architecture to Federigo da Montefeltro and, above all, to make a most unusual use of color in his architecture at Rimini.[12]

The most subtle (even if the most imaginary) of the conversations we might reconstruct from this period would regard the painting of *Women Bathing* by Jan van Eyck which, according to Facio, Federigo da Montefeltro may already have owned in those years. Let us suppose that the ruler had asked his three artists to express their opinion of it; Piero's reply is to be found in the *Flagellation*, in the gold and blue damask cloak worn by one of Oddantonio's councillors, rendered with an attention to every slightest detail worthy of the Flemish master, but governed, at the same time, by Italianate mathematical measurement of the overall space. *"Brugensis-Burgensis!"*—"Of Bruges and Borgo!"—some clever, prissy courtier of Federigo's may well have exclaimed.

The road taken by Alberti was the same one followed by Piero; it led from the Montefeltro region to Ferrara and to nearby Rimini.

Alberti's dealings with Lionello d'Este [of Ferrara] between 1440 and 1450 are well known; and [Adolfo] Venturi's demonstration of Piero's activity prior to 1450 strikes us as unexceptionable. It was around 1449 that Piero—who had, perhaps, just arrived from Urbino—received the commission for his frescoes in the Este castle at Ferrara, which are now lost, as are his other ones in the church of Sant' Agostino in the same city.

We may dispense with imagining a second conversational episode dealing with the dialogues between Piero and the Este ruler of Ferrara in the presence of Galasso, Mantegna, Tura, the very young Cossa, and "Maestro Lorenzo Canozo da Lendinara who was as dear [to Piero] as a brother."[13] Even without reconstructing any talks, it is obvious that Piero's now-vanished frescoes in Ferrara were a decisive training-ground for the local artists. The influ-

ence of Piero's lost works is, in fact, perceptible as far away as Padua; it was brought to that city both by one or another Ferrarese convert to Piero's manner and by Girolamo di Giovanni,[14] whose movements in these years would seem to parallel those of the master himself.

So it was that, practically on Alberti's heels, Piero turned up in Rimini around 1451. Here, in the Chapel of the Relics—which was about to be consecrated—in the Tempio Malatestiano,[15] he painted the only part of the church's decoration truly appropriate to those architectural elements contributed by Alberti. This is the fresco showing the terrible Sigismondo Pandolfo Malatesta kneeling in adoration of his good-natured patron saint, the holy King Sigismund, without batting an eyelash and without foregoing the company of his two beloved greyhounds (however distressing pious art historians of the Romantic period may later have found the dogs' presence), and carefully protecting his own back by the inclusion of his own menacing military architecture, labeled *Castellum Sismundum Ariminense*, "Sigismondo's Riminese castle."

We do not know whether it was in these same years that Piero also put in appearances at Ancona, Pesaro, and Bologna: towns that Vasari, Pacioli, or both mention—along with Urbino, Ferrara, San Sepolcro, and Arezzo—as ones where he worked. As for Piero's sojourn in Bologna, it is, on the face of it, very strange that Vasari, who was extremely well informed about the affairs of that city, does not tell us anything about it. We are nonetheless inclined to believe that Pacioli—who had, by the way, no vested interest in amplifying the scope of Piero's influence[16]—was correctly informed regarding the matter; for [Marco] Zoppo's[17] most Pieresque work is his triptych in the Bolognese Collegio di Spagna, while the impact of Piero's direct example is also visible in the territory of nearby Modena. There is more certainty about Piero's presence in Ancona, since Vasari even tells us that the picture Piero painted in the church of San Ciriaco there was a *Marriage of the Virgin*. The work was probably a fresco, and its early disappearance was probably the result of the city's salt-laden maritime environment.[18] Whatever the precise dates of these journeys, it is certain that Piero soon turned back towards his hometown and Tuscany; for our painter most probably took over the task of frescoing the choir of San Francesco at Arezzo almost immediately after Bicci di Lorenzo's death in 1452. When he died, Bicci had practically finished decorating the vault; and the Bacci family, patrons of the project, were eager to see the work completed. We may deduce the brevity of the interval between Bicci's death and Piero's arrival from the fact that, had the work come to any very prolonged halt, it would have been simple for the Bacci family to come up with some other painter as good as Bicci di Lorenzo in order to fill in the few gaps

left by the latter in the vault and the entrance under-arch, and even to undertake the rest of the cycle; in fact, though, even the tiny lacunae in the vaulting were to be filled with work from Piero's own hand. Further confirmation for this chronology comes from the Rimini fresco: dated 1451, it reveals the same mature breadth and capacity for synthesis apparent in the Arezzo frescoes.

Begun in 1452 and destined to confer a reflected immortality even upon Bicci di Lorenzo's feeble efforts, Piero's work in San Francesco went on, we believe, until 1459; during this period, the master returned at intervals to Borgo San Sepolcro and also, perhaps, made his first trip to Rome. In a contract dated 1454, the chapter of the church of Sant' Agostino at Borgo entrusts to Piero, "*pictori presenti*"—i.e., with the painter in attendance[19]—the execution of a polyptych for the high altar, to be delivered complete within eight years. The artist clearly wanted to assure himself of enough time to finish the Arezzo frescoes. But it was probably the summons to Rome in 1459 that prevented him from keeping his part of the bargain; only much later, in 1469, did he receive final payment for the altarpiece, whose parts are today lost or scattered.

Our reference to a possible earlier stay in Rome is based on Vasari's statement that Piero had gone there under Pope Nicholas V, which is to say, prior to 1455. We would not set much store by Vasari's information, were it not for some fragments of mural painting in Santa Maria Maggiore there—first reclaimed for Piero by the present writer—that match up well with the "first period" of the Arezzo frescoes.

But let us return to the Arezzo cycle itself, which shows us the flowering of Piero's style: Vasari is, perhaps, referring to this process of maturation when he says that Piero's works date from "around 1458."

Piero arrived in Arezzo practically simultaneously with the death of Spinello Aretino's son Parri [Spinelli],[20] the most elegant and specious local representative of the "international style"[21]: a manner which, in Parri's interpretation of it, takes on a particularly intense Sienese flavor, owing to the works by the Lorenzetti and their school that he had constantly before him. The artists who were to gather around Piero at Arezzo include Lazzaro Vasari; and the anonymous master whom we may provisionally call (unless, by some miracle, evidence turns up showing him to be Lazzaro himself) the "Master of the Adimari Wedding Chest" and who, in his best work, soaks up as much of Piero as his fundamentally Gothic idiom allows him to do; and the weak but likable Lorentino, who perhaps began working with Piero in 1458, and whose popular language combines fourteenth-century characteristics and perspective, carefully thought-out chromatic relationships derived from Piero and the

Roberto Longhi

punchy hues of shop-signs and banners; and Giovanni di Piemonte, known to us through a fine Madonna at Città di Castello, painted in 1456, that strikes us as containing evidence for his collaboration on certain passages in the frescoes at Arezzo.[22] It is unlikely that Melozzo [da Forlì][23]—unlike the artists we have just named—played any part in the execution of the San Francesco cycle; while Melozzo's earliest Roman works, in the church of San Marco, were painted later than Piero's Arezzo cycle, they are nonetheless derived from more archaic models; so it would appear that Melozzo only became acquainted with Piero several years later, in Rome itself.

A document[24] of 1466 refers to the Arezzo cycle as a work already completed, and one that brings glory to Piero's name; and the Urbino diptych [now in the Uffizi, showing the portraits and triumphs of Federigo da Montefeltro and his wife], painted around 1465, shows Piero at a point in his stylistic development antedating by several years the most mature among the Arezzo frescoes. For these reasons, we believe that when Piero went to Rome in 1459, perhaps for the second time, he had already essentially completed his great task. The Arezzo cycle soon became famous as "one of the worthiest works in Italy."[25]

Other works that must be dated to the same decade as the frescoes at Arezzo, and which constitute a sort of record of the artist's shuttling back and forth between that city and his hometown, are the *Madonna del Parto* or Pregnant Madonna in a country chapel near Monterchi [along the road connecting the two places], and the *Resurrection of Christ* in the town hall at Borgo San Sepolcro which [so Vasari tells us] "is held to be the best work in the city and the finest among all his works."

As for Piero's works in Rome, it is anything but easy to establish the truth. We have already noted Vasari's assertion that Piero had already painted there at the time of Nicholas V; but the only things left there today that could possibly be ascribed to that stage of his career are the surviving fresco fragments in Santa Maria Maggiore.

In any event, there survives in the Papal archives a document[26] dated April 12, 1459, ordering a payment to Piero of 150 *fiorini di camera* ("chamber florins") for "part of his work in the chamber of His Holiness Our Lord the Pope": proof that Piero worked that year in the Vatican for Pius II. Vasari has him painting in the "*Stanze,*" rooms that we do not think can be the apartments decorated by Pius II; what is more, Vasari, in his *Life of Raphael*, says that the *Stanze* contained [at the time Raphael embarked upon their decoration] only one completed scene by Piero. So the question grows complicated. It is not easy even to determine whether this Roman sojourn of Piero's ever had a sequel. We surely ought not to trust (as did Zippel) certain documents

bearing the date 1475; these were apparently falsified in an effort to bolster the groundless tradition ascribing to Piero, rather than to Melozzo, the celebrated fresco commemorating the opening of the Library of Sixtus IV. All we know with certainty is that Piero turned up in Rome alongside Benozzo [Gozzoli] and the mysterious Spanish wall decorator Salvatore da Valencia, and that he left behind him, in the Vatican, some works quite possibly located, according to a confused but persistent tradition, in the same spaces where, fifty years later, Raphael was to paint his own very famous frescoes. But nothing remains of these works; and there is no point in bending over backward to spot Piero's hand in the second-rate, decidedly Florentine frescoes in the Vatican's former Greek Library.[27]

By the time Piero left Rome, perhaps shortly after 1460, he had certainly laid the foundations for a new local painting there, leaving behind him several majestic models that were to be drawn upon by Melozzo in his conception of such freely monumental scenes as the *Inauguration of the Vatican Library* or his frescoes in the apse of the church of the Santissimi Apostoli; by Antoniazzo [Romano] in his splendid frescoes at Tivoli; and by Lorenzo [da Viterbo] in his famous paintings at Viterbo.[28] Piero's route home led him through Umbria; and it was perhaps in the course of this journey that he stopped at Perugia to paint the polyptych—of still-uncertain date—for the nuns of Sant' Antonio. When he returned to Borgo San Sepolcro, it was probably not in order to paint the fresco of *Saint Louis of Toulouse* there, dated 1460 but unsigned; for this work, while certainly Pieresque, is so mediocre that we are led to give it to Lorentino or some other follower. Instead, Piero probably had other tasks awaiting him: perhaps even the completion of the *Misericordia Altarpiece*, in which the central panel strikes us as belonging— especially in the portraits of the worshippers—to more or less this period in Piero's development.

We have already seen that there is, in fact, a document of 1462 from the archives of the Confraternity of the Misericordia that apparently refers to the completion of this very altarpiece: this is the record of the payment to Marco di Benedetto of "fifteen *scudi* for part of the picture that his brother Piero has painted." It looks as though the artist was absent from Borgo, but had left the town quite recently; even the choice of the verb tense in the words "has painted" [*a depincto*] suggests that the work had been completed only shortly before.

There is little doubt that in the period between 1460 and 1470, Piero lived sometimes in his hometown, sometimes at Urbino, sometimes at Arezzo. These were the years during which he had occasion to teach mathematics to the young Pacioli at Borgo,[29] and to devote himself not only to his studies but

also to the building and decoration of his own houses. A surviving architectural fragment, still conserving some shadow of its original nobility of proportion, may be seen in the Via delle Aggiunte at Borgo San Sepolcro; and a bit of its pictorial decoration has come down to us in the [detached fresco of] *Hercules* now in the Isabella Stewart Gardner collection in Boston.

As for the spread of Piero's fame throughout Italy, it is worth noting that, in a book on architecture written at this time, Filarete[30] includes a list of painters worthy of an invitation to decorate the imaginary city of Sforzinda; and he does not fail to mention "one Piero dal Borgho."[31]

It was around 1465, at Urbino, that Piero painted the very famous diptych now in the Uffizi, with the portraits and triumphs of Federigo da Montefeltro and his consort Battista Sforza: another summit of his career, and a precious testimonial to his spiritual development. We may usefully recall that he was thus in Urbino at the very moment that the transformation and enlargement of the ducal palace there was getting started, under the direction of Luciano Laurana. The imaginings aroused in a biographer by the thought of Piero's probable frequentation of the great Dalmatian architect cannot properly be given the weighty dignity of official historiography, precisely because they are merely imaginary. Nonetheless, we may discreetly point out—encouraged, in part, by Laurana's possible authorship of the well-known little panel paintings in Urbino, Berlin, and Baltimore showing architectural views [of "ideal cities"] in perspective—that the halls, windows, and spaces then taking shape on the site were measured out in accordance with the very same aesthetic that dictated to Piero his painted human figures and buildings.

In 1466, Piero was back in Arezzo. The [fresco of the] *Magdalene* [in the Duomo] dates from an earlier moment, perhaps shortly after the completion of the paintings in San Francesco; but we may reasonably assign to this period the numerous other works—today all lost—that Vasari tells us were once to be found in other churches around the city. Furthermore, in a document[32] of December 20, 1466, in which Piero del Borgo is cited as the celebrated author of the *True Cross* cycle [in San Francesco], the lay Brothers of the Compagnia della Nunziata, requiring "a good and adequate master," entrust the painter with the execution of a banner representing the Annunciation since, "having worked in Florence and here," he is the only one capable of "making the work as beautiful as can be." Apparently neither Lazzaro Vasari nor Loretino could be considered a good and adequate master, while it was still too soon to turn to Bartolomeo della Gatta, Signorelli, or Perugino.[33] One breathes an ineffably fourteenth-century atmosphere in the Brothers' instructions to the painter that "the heads of Our Lady and the Angel are to be refined and beauteous, with angelic countenances."

In 1469, we once again catch a fleeting glimpse of Piero at Urbino, where his host was none other than [the painter] Giovanni Santi, Raphael's father. On April 8 of that year, in fact, the Confraternity of Corpus Domini refused[34] to reimburse Giovanni the ten *bolognini* coins he had advanced "for the expenses of Maestro Piero dal Borgo, who had come to see the panel in order to do it."

It is not clear what panel is meant here. It has been proposed[35] that the document refers to the large votive altarpiece now in the Brera in Milan. But given that the work was commissioned by the Company of Christ's Body, we find more plausible the alternative suggestion[36] according to which the picture in question is the large altarpiece of the *Eucharist* for which Paolo Uccello, or some pupil of his, had already painted the predella in 1467, in the laziest possible manner. The project was later to be entrusted to Justus of Ghent in 1474, eventually giving rise to a lawsuit by the Confraternity because the painter "did not do his duty." For whatever reason, Piero did not feel like taking on the commission, and went back to Borgo without having agreed to anything at all.

For the untalented Giovanni Santi, the presence of the already elderly master, well known at Urbino for almost thirty years, must have taken on a fearfully arcane and incomprehensible aspect. This man whose expenses he was paying in *bolognini* was the very one who had made the miraculous diptych of the rulers of Urbino! It may even be be that Piero smiled ironically at the works of his host, that poor fellow from Colbordolo. And this may be why, when Giovanni Santi later got stuck for inspiration while penning his *Cronica Rimata*[37]—that "Rhyming Chronicle" in which, bad though the verses are, Santi still comes close to showing himself a better poet than painter—he settled for mentioning Piero (whether out of spite or because of the difficulty of coming up with a decent rhyme) in a line that says nothing at all:

> *Masaccio e l'Andrein, Paolo Occelli—*
> *Antonio e Pier sì gran dissegnatori—*
> *Piero del Borgo antico più di quelli.*

> Masaccio and Andrea [del Castagno]—
> Antonio e Pier [Pollaiuolo], such great draftsmen—
> Piero del Borgo, older than the others.[38]

From this time onwards, it becomes easier to ascertain that Piero remained at home in Borgo, making, every now and then, a brief visit to Urbino. He seems to have been ever less interested in urban competitiveness,

ever more deeply rooted in his native soil. Well off by this time and, as it were, ennobled[39] by his fame, Piero had attained to a happy destiny that rarely befalls a wise man: he had become a prophet in his own country. Besides attending to the building and decoration of his houses, he supervised the farms offered him as a recompense for his work—payments in kind accepted with the same glad graciousness displayed by Piero's feeble creature Lorentino when he received a hog in exchange for a Saint Lawrence. Piero certainly trained new pupils; this is probably the period during which Perugino and Signorelli studied with him. He planned and wrote his almost purely mathematical treatise *De prospectiva pingendi*, "On Perspective in Painting," dedicated to Federigo da Montefeltro. In November of 1469, the monks of Sant' Agostino in Borgo San Sepolcro paid Piero[40] for his completion of the altarpiece for their high altar: a work perhaps already lost[41] and replaced with another by the time of Vasari, who discusses it in the past tense, saying that it "was a highly praised thing." In 1471, Piero is cited[42] among those who are late in paying a municipal tax. In 1473, a document[43] attests to Piero's use of a power of attorney on behalf of his brother, thereby confirming his presence in Borgo, where he was probably painting the frescoes in the chapel of the Madonna di Badia for which he was to receive final payment[44] on April 12, 1474—works now lost, as are the two saints painted in the church of the Pieve, mentioned by Vasari as "an extremely beautiful thing."

Piero's fame was kept alive at the courts of Italy by his final sojourns at Urbino in the decade between 1470 and 1480. (This is the period when Nicolò Testa Cillenio praises him as "*Borgho mio divino*," "My divine [Piero dal] Borgo," in a bad sonnet[45] written at Ferrara.) We are tempted to concentrate the great master's last stays at Urbino primarily in the four years 1474-78, during which there is no mention of him in the documents at Borgo San Sepolcro. It was probably at this time that Piero brought the precious gift of his treatise on perspective in painting to Federigo. Certainly this is the period to which we must assign—for their embodiment of a mature spirit of intellectual inquiry and of new pictorial subtleties—the *Madonna of Sinigallia* and the [Montefeltro] altarpiece formerly in San Bernardino [just outside Urbino] and now in the Brera. In the latter work, the painted architecture closely foretells the real architecture of Bramante[46]—itself, in the words of Fra Sabbia Castiglione, "perspective on a grand scale, such as was created by Piero del Borgo."[47]

Ten years or so had gone by between the execution of the famous triumphal diptych and the time when Federigo, at around sixty years of age, posed[48] once more for his great household intimate from San Sepolcro. The old painter noted that his patron's tastes had grown more refined, but also

more precious. Luciano Laurana was no longer the ducal architect; or, even if he was, he was about to be replaced by the delicately decorative and non-architectonically-minded Sienese Francesco di Giorgio. The inlays being installed as decoration for the palace doors were no longer, as Piero and Laurana would have wished, the work of Canozi; instead, they had been designed in part by the Sienese architect and painter [Francesco di Giorgio] himself, and principally by Sandro Botticelli, who sent from Florence designs for the two doors of the Room of the Angels and for the whole of the duke's *studiolo* or study. On the wall above Sandro's inlays[49] there was growing, picture after picture, the series of panels representing the most famous ancient and modern philosophers and scholars. Specifically for this project, Federigo had brought from Flanders a "very lofty master," or someone who was, at least, advertising himself as such; but once he turned his hand to the *Corpus Domini Altarpiece*, the lofty master proved himself worthless. Almost all his works in Federigo's study were soon replaced by those of another foreign artist: the Spaniard Pedro Berruguete.[50]

There is little doubt that Berruguete and Piero were on good terms, as may be deduced, in part, from the strong interest in structure and space evinced by several of the Spaniard's figures [painted for the *studiolo*] of *Liberal Arts* and *Famous Men*; what is more, we may observe that Piero handed over the brush to Pedro when it came time to paint the hands of Duke Federigo in his *San Bernardino Altarpiece*, probably because the sitter wished them to be illusionistically recognizable as his own—a result attainable only by a foreigner with a Northern training, not by such a synthesizer and simplifier of forms as Piero. Nor do we think it impossible to detect a more sublimated expression of the two artists' reciprocal influence in the extraordinary painting Piero made for Sinigallia in which, setting out to measure himself against the Flemings, he ended up creating a preamble to Vermeer.

Following this singular and refined intermezzo in Urbino, Piero returned to his hometown, where in 1478 he frescoed a now-lost Madonna—which Corazzini mistakenly believed himself to have rediscovered[51] in 1875—upon a wall "between the Church and the Hospital" for the Brothers of that same Confraternity of the Misericordia that had commissioned an altarpiece from him at the outset of his career. Two years later we find Piero, a good Catholic, beginning a two-year term as head of the Priors of the Confraternity of San Bartolomeo;[52] for his fellow-citizens held him in the highest esteem. In 1480, the town authorities allocated money for the restoration of the wall "where Piero had [sic] painted the Resurrection."[53]

The last known journey of Borgo's great citizen was in 1482. At nearly seventy years of age, he went to Rimini where, on April 22, he rented[54] a

house from the well-born lady Giacosa, widow of Ganimede Borelli: a house with the use of a garden and a well, which suggests that he was planning a rather long stay in connection with a task of some importance. Alas, we can learn nothing more about this project from the local historians; for this and other reasons, we must believe that it was never carried out.

The heavy silence of the documents over the following years is like a presage of impending death. It was probably after his return to Borgo that Piero—whose eyesight was, perhaps, already failing but whose mind had not been dimmed into inactivity—turned his hand to the writing of his second treatise, the one on the [perspectival treatment of the] "five regular bodies," *De quinque corporibus regularibus*.[55] Piero's book ends with a humble, affectionate, but deeply serious dedication to [Federigo da Montefeltro's son and heir] Duke Guidobaldo,[56] exhorting him to preserve the treatise as part of the precious library inherited from his father. We believe, in fact, that it was in the ducal library that Luca Pacioli—who, throughout his own lifetime, continued to sing the praises of Piero as the king of painting and of the science of perspective—secretly studied and copied the book that he was later to print as his own work, several years after the artist's death. On July 5, 1487, Piero—now, in Vasari's words, a "good old man"—went to see the notary Ser Lionardo di Ser Mario Fedeli. Having reached what might be "counted the outer limits of his age" ["extremo aetatis suae calculo"], but still "sound in mind, understanding, and body," Piero instructed the notary to draw up for him a last will and testament, basing it upon some notes that Piero himself had written down upon a sheet of paper.[57]

That sheet of paper—rediscovered by Mancini[58] and now in the State Archives in Florence—bears, in Piero's own handwriting, the following simple words:

> La sepultura mia voglo che sia in badia nella sepultura nostra.
> lascio alopera de badia lire dieci
> et lascio al corpo de cristo lire dieci
> et ala madonna delabadia lire dieci
> et lire dieci ala madonna de lareghia
> et il resto del mio nelascio la meta ad Antonio mio fratello e murendo
> prima di me Antonio ai suoi figliuoli maschi et l'altra ne lascio alerede
> de marco cioe francesco bastiano et girolamo et murendo uno pervenga
> de l'uno a l'altro.

["I want to be buried in our family burial place / I leave ten lire to the church of the Badia / and ten lire to the Corpus Domini / and to the Madonna of the

Badia ten lire / and ten lire to the Madonna of the Reghia / and of the rest I leave half to my brother Antonio and if he dies before me to his male children and the other half to Marco's heir that is Francesco and Bastiano and Girolamo and if one dies it is to go from one to the other."]

Having thus carefully prepared to die, Piero lived on for a good long time afterwards. Blind at the last but sound in body, he was still to be met with for several years more, being led about by the hand by some small boy or other through the sunlit, empty streets of San Sepolcro and looking like a dazzled seer. In 1556, in fact, sixty-six years after the master's death, one Marco di Longaro, an elderly maker of "lanterns for going about," recounted a childhood memory to Berto degli Alberti, who set it down as follows in his own little book of recollections: "When he was little, the said Marco used to lead about by the hand Mastro Piero dila Francesca, an outstanding painter who had gone blind; this is what he told me."[59]

In the third "book of the dead" of the Confraternity of San Bartolomeo del Borgo, covering the years 1460 to 1519 and now displayed, open at the appropriate page, in the civic museum at San Sepolcro, we may read: "M. Piero di Benedetto de' Franceschi famous painter on October 12 1492; buried in the Badia."

Vasari adds that Piero's fellow-townsmen buried him "with honors"; but it is not our purpose here to try to imagine what class of provincial funeral Piero may have received. Along with "a very handsome fortune and several houses that he had built for himself," he probably left his heirs a number of pictures such as, for example, the *Nativity* now in the National Gallery in London and the little self-portrait that Vasari is said[60] to have used as the basis for the engraving of Piero in the second edition of the *Lives*. The little panel that, well into the nineteenth century, used to be shown to visitors to the Franceschi house as the original self-portrait instead struck [the great connoisseur] Cavalcaselle as a copy of the original upon which Vasari must have drawn; today, even this probable copy has vanished.

It is nearly impossible for us today to learn anything at all about Piero's appearance from the little woodcut printed in the Giuntine Vasari,[61] executed in the generically nervous line of routine sixteenth-century Maniera.[62] A local tradition at Borgo San Sepolcro, one that is probably not very old, spots a self-portrait of Piero's in the figure of the lay Brother who lifts his foreshortened face beneath the protective mantle of the Virgin [in the *Misericordia Altarpiece*], and another one in the guard sleeping with his head thrown back at the foot of Christ's tomb [in the *Resurrection*]; but we do not see any reason to put much faith in a tradition more plausibly accounted for in terms of the natural civic desire to seem well up on the local glories.[63] The occasional

attempts to find the painter among the bystanders in one or another of the Arezzo frescoes strike us as equally pointless. The large canvas attributed to Santi di Tito and belonging to the Marini-Franceschi, descendants of Piero's family, is a mere commemorative icon making no claims to historical accuracy; it shows a Piero who—engulfed in a vast cloak and sporting a ridiculous little mustache—is about to unleash a serious lecture about perspective upon his harmless and unsuspecting fellow citizens. When we call to mind the various stolid mugs from which certain historians have hoped to draw such conclusions as have eluded them when contemplating the painter's actual works in all their essential spirituality, then we cannot regret overmuch the fact that Piero's face remains hidden from us.

NOTES

Roberto Longhi's bibliographical references are given unbracketed. David Tabbat's editorial notes appear in square brackets.

1. [Vasari claimed that the sobriquet "della Francesca" arose from Piero's having been raised from an early age by his widowed mother (who, having married into the Franceschi family, might have been known as La Francesca). Numerous art historians, including several more recent than Longhi, have essentially accepted Vasari's account; Longhi, however, calls the sixteenth-century writer's version a "fable," thus revealing a well-founded suspicion that the historical truth was otherwise. Subsequent research has proved Longhi right: a document of 1390 refers to Piero's grandfather as Piero di Benedetto de la Francesca, demonstrating that the variant surname was already in occasional use before Piero's day. What is more, Piero's father lived until 1464, while Piero's mother had died earlier, in 1459, and thus was never widowed. Cf. Ronald Lightbown, *Piero della Francesca*, New York, 1992, pp. 11-12. (D.T.)]

2. G. Vasari, *Le Vite* . . . with notes by G. Milanesi, Florence, 1878, pp. 487-503; G. Mancini, "L'opera *De corporibus regularibus* di Piero Franceschi detto della Francesca," in *Atti della R. Accademia dei Lincei - Memorie della classe di Scienze Morali Storiche e Filologiche*, Series V, vol. XIV, pp. 446-487, Rome, 1915; G. Mancini, Vasari: *Vite cinque, annotate*, Firenze, 1917. [Research has yet to reveal the year of Piero's birth, generally placed by recent scholarship anywhere between 1406—based on the age Vasari gives for Piero at his death—and "some time after 1413" (M. A. Lavin, *Piero della Francesca: San Francesco, Arezzo*, New York, 1994, p. 30). At the time of Piero's birth, his father Benedetto was indeed a tanner and bootmaker; but neither Benedetto nor his wife was poorly off, and both Benedetto and the family as a whole would soon rise notably in the social scale. (Cf. Lightbown, op. cit., p. 12.) It seems likely that Piero's continuing interest in his family's commercial affairs was a factor in the ongoing attachment to Borgo San Sepolcro emphasized by Longhi in the initial pages of the present essay. (D.T.)]

3. [Recent research has brought to light documentation regarding Antonio d'Anghiari that was not available in Longhi's day. Cf. J. Banker, "Piero della Francesca as Assistant to Antonio d'Anghiari" in *The Burlington Magazine*. CXXXV, I (1993), pp. 16-21 and F. Dabell, "Antonio d'Anghiari e gli inizi di Piero della Francesca" in *Paragone* 318 (1984), pp. 74-94. (D.T.)]

4. E. Harzen, "Über der Maler Piero dei Franceschi und seinem ver-meintlichen Plagiarus, den Franziskanermönch Luca Pacioli" in *Archiv f. die zeichnenden Künste*, Leipzig, 1856, pp. 231-244; G. B. Cavalcaselle and J. A. Crowe, *Storia della pittura in Italia dal sec. II al sec. XVI*, Florence, 1898, vol. VIII, pp. 188-259 [the revised and enlarged Italian version of Crowe and Cavalcaselle's groundbreaking *A History of Painting in Italy from the Second through the Sixteenth Century*, London, 1864-66, ed.]. [Not much is known about Domenico Veneziano's early life and training. Most of this brilliant painter's work has been lost; his most important surviving work is the *St. Lucy Altarpiece* now in the Uffizi in Florence. (Cf. The Dictionary of Art entry; *Pittura in Italia, Il Quattrocento,* Electa, 1987; John F. Moffett, *Domenico Veneziano's altarpiece* (New York, New York), 1997, v. 16 no. 4 Summer, pp. 14-24; H. Wohl, The paintings of Domenico Veneziano, ca. 1410-1461: a study in Florentine Art of the early Renaissance.) (D.T.)]

5. A. Venturi, "Gli affreschi del Palazzo di Schifanoja in Ferrara" in *Atti e Memorie della R. Deputazione di Storia Patria per le provincie di Romagna etc.,* Series III, vol. III, Bologna, 1885.

6. G. Milanesi, publication of documents regarding the *Madonna della Misericordia*, the *Assumption* in Sant' Agostino at San Sepolcro, and Piero's will in the magazine *Buonarroti*, 1885 [various nos. and pp.]

7. G. Gronau, "Piero della Francesca oder Piero dei Franceschi" in *Rep. f. Kstw.*, 1900, pp. 393-94.

8. [Published in 1510, Francesco Albertini's *Memoria di Florentia* is a funda-mental source for our knowledge of "what works were where" in the Tuscan capital. (D.T.)]

9. [Born at San Sepolcro around 1445-50, the Franciscan Fra Luca Pacioli was a famous mathematician. In his book *Summa de arithmetica, geometria, proportione et proportionalitate*, published at Venice two years after Piero's death, he calls the latter, who was his fellow townsman, the "prince" of mod-ern artists. Nonetheless, Vasari opens his *Life of Piero della Francesca* with a blast of justified outrage at Pacioli's wholesale and unacknowledged incorpo-ration of Piero's manuscript treatise *De quinque corporibus regularibus* into his own *De Divina Proportione* (Venice, 1509). On the basis of Vasari's statement

that Pacioli was a pupil of Piero's, scholars—including Longhi, toward the end of the present essay—have suggested that the elderly painter must have instructed Pacioli in the principles of mathematically constructed perspectival representation; it has been hypothesized that Pacioli helped Piero draft his book, and thus remained in possession of a manuscript. (Cf. *Luca Paccoli e la matematica del Rinascimento, Atti del convegno internazionale di studi, (San Sepolcro, 13-16 April, 1994)*, Citta di Castello, 1998; *Piero della Francesca tra arte e scienze, Atti del convegno internazionale di studi, (Arezzo 8-11 Ottobre, 1992, a cura di Marisa Dalai Emiliani)*, Venice, 1996; Philip Hendy, *Piero della Francesca and the Early Renaissance*, New York, 1968, p.155. Hendy [idem., p. 154] follows Longhi in identifying the figure of St. Peter Martyr in Piero's late *San Bernardino Altarpiece* as a portrait of Pacioli.) Be that as it may, Pacioli's well informed remarks in the *Summa* remain, as Longhi suggests, a useful source for the reconstruction of Piero's career. (D.T.)]

10. [Longhi is inclined to accept the local tradition—first recorded by James Dennistoun in 1851 in his *Memoirs of the Dukes of Urbino*—that the Urbino *Flagellation* refers to the death in 1444 of Oddantonio da Montefeltro at the hands of conspirators. This explanation of the picture's mysterious iconography is, however, almost certainly untenable. It follows that the historical event of Oddantonio's assassination cannot be used as an element in ascertaining the picture's date. For a summary of the numerous theories that have been advanced regarding the painting's subject matter, see the editorial note regarding the *Flagellation*, appended to Longhi's essay "The Art of Piero della Francesca," included in the present volume. (D.T.)]

11. [The Dalmatian architect Luciano Laurana perhaps worked for Alfonso of Aragon in Naples before arriving around 1465-66 in Urbino, where Federigo da Montefeltro put him in charge of the Renaissance transformation of the Gothic palace: "Federicus, Montis Feretri, Urbini etc. . . . We have searched everywhere, and especially in Tuscany (which is the fountainhead of architects) without finding a really skilled man, learned in the said mystery; but we at last learned of the reputation—which has been confirmed by experience—of the excellent Master Lutiano [sic], bearer of this patent. . . . We have appointed the said Lutiano as Overseer and Head of all the masters. . . . 20 June 1468." (This translation of the document is taken from Peter Murray, *The Architecture of the Italian Renaissance*, New York, 1963.) Luciano Laurana died at Pesaro in 1479. He was the brother of the sculptor Francesco Laurana. For Laurana and other architects see F. P. Fiore, ed., *Storia dell'architectura italiana. Il Quattrocento,* Milan, 1998. Laurana has traditionally been regarded as

the possible painter of the celebrated view of *An Ideal City* in the Ducal Palace at Urbino (an attribution that Longhi found plausible but not definitive). The painting is one of three similar panels, probably all by the same hand, now dispersed between Urbino, Berlin, and Baltimore. See *Rinascimento. Capolavori dei musei italiani*, Tokyo-Rome, 2001, Geneva-Milan, 2001 (where the Urbino panel is attributed to Laurana or to Fra Carnevale). See also *Ricerche e studi sui signori del Montefeltro di Piero della Francesca e sulla Città Ideale*, exhibition catalogue, Florence-Urbino, 2001. (D.T.)]

12. [Born into an important but temporarily exiled Florentine family, Leon Battista Alberti (1404-1472) worked at numerous courts in northern and central Italy, as well as in Florence. He was the most important humanist and artistic theoretician of the early Renaissance, and a practicing architect as well as a painter. In his writings he stresses the importance of artisanship in combination with a humanist preparation, and he gave great importance to the artist as a cultivated man, one who knows literature, both Latin and vulgar, optical sciences and the related laws of perspective. One of the primary concerns reflected in his books is the role of clearly defined mathematical relationships in the visual arts: both in painting (where mathematics controls the perspectival diminution of forms as they recede into the distance) and in architecture (where, in accordance with rediscovered ancient Roman practice, buildings were be rendered harmonious through the use of a *modulus* or basic unit of measurement, from which all other dimensions might be derived). Alberti's recommendations owe much to the work of Filippo Brunelleschi, who was both the most important architect of the day and the inventor of the Renaissance system of perspective. As Longhi suggests, Alberti's outlook had much in common with Piero della Francesca's; it has even been suggested that Piero intended numerous aspects of his painting—from his perspective to his coloristic relationships, from the poses of his figures to the Classicizing architecture he represents—as conscious responses to the ideas Alberti had set forth in his treatise on painting. (Cf. Hendy, op. cit., esp. p. 65; and John Pope-Hennessy, *The Piero della Francesca Trail*, London, 1991.) Alberti was also a practicing architect, important examples of whose work are still to be seen in Florence and Mantua. Beginning in 1446, he undertook a radical remodeling of the Gothic church of San Francesco at Rimini on behalf of Sigismondo Malatesta, ruler of the city. Alberti encased the building—which contains Piero's fresco of Sigismondo kneeling before his patron saint, dated 1451—in a weighty, convincingly Classical shell incorporating elements derived from such ancient models as the Arch of Constantine in Rome and the Arch of Augustus at Rimini; the air of antiquity conferred upon the church by Alberti,

Agostino di Duccio and other fifteenth century artists has earned it its familiar name of Tempio Malatestiano (Malatesta Temple). Longhi's observation regarding Alberti's "unusual use of color" alludes to the manner in which the architect has attenuated the severity of his new exterior through an imaginative, geometrically rigorous deployment of polychrome materials. (D.T.)]

13. [The artists Longhi lists here were all active at the court of Ferrara. In a brief biography in the first edition of Vasari's *Lives*, the mysterious Galasso is described as a successful painter much inspired by Piero; but Vasari omits Galasso's biography from the definitive Giuntine edition of 1568. The corpus of works once ascribed to this artist has by now been dismembered by scholars and given to an assortment of other masters; Longhi, in his *Officina ferrarese* (1934), entertains the possibility that two surviving paintings may be his, but thinks them more likely to be by Antonio Maccagnino. There are documented payments by the Ferrarese ruling house of Este to Galasso in 1450-53; in 1455 he is recorded as painting a portrait of the Greek Cardinal Bessarion.

The style of Cosmè Tura (c. 1430-1495) was crucial to the peculiar artistic evolution of fifteenth-century Ferrara. Like Andrea Mantegna and many other important North Italian painters, Tura was deeply influenced by the dry and meticulously detailed "Paduan" manner promoted in the workshop of the painter and antiquarian Squarcione: a manner called "mineralogical" by Longhi, who amply and beautifully discusses Tura's work in *Officina ferrarese*, Rome, 1934 (new edition Florence, 1980). (Cf. S. Campbell, *Cosmè Tura of Ferrara. Style, Politcs and the Renaissance City, 1450-1495,* New Haven and London, 1998; M. Molenti, *Cosmè Tura,* Milan, 1999.)

Francesco del Cossa (c. 1436-1478) may well have been trained by Tura. The frescoes of around 1470 at Palazzo Schifanoia in Ferrara, frequently attributed to him, show the influence of Piero della Francesca along with that of the Paduan school and of Andrea Mantegna, who was working in nearby Mantua. Although Vasari writes about Cossa; he is constantly confounding him with another Ferrarese painter, Lorenzo Costa, further worsening matters by confusing the latter with Ercole de' Roberti (who was called by Longhi the "genius number three" of Ferrarese painting, coming as he did after Tura and Cossa).

Lorenzo Canozzi da Lendinara and his brother Cristoforo were celebrated masters of intarsia or inlaid work; Pacioli (see note 8, above) tells us of Piero's friendship with them. (Cf. G. Fiocco in *L'Arte*, 1913, 327.) In *Officina ferrarese*, p. 22, Longhi suggests that Piero provided Lorenzo with cartoons that the latter eventually used for his work in the sacristy of the Duomo at

Modena; but modern scholarship has tended to reject this idea. (D.T.)]

14. [For the Squarcionesque painter Girolamo di Giovanni, see R. Longhi, *Officina ferrarese*, pp. 27, 102. (D.T.)]

15. [See note 12, above. (D.T.)]

16. [Longhi is probably drawing a gently ironic contrast here between Pacioli's lack of any "vested interest" and Vasari's notorious tendency to aggrandize local phenomena having to do with Arezzo and such nearby places as San Sepolcro. (D.T.)]

17. [Marco di Ruggero (1433-c. 1478), called Lo Zoppo or "the Lame One." Born at Cento near Bologna but trained under Squarcione in Padua; his style reflects developments in the Veneto including the work of Mantegna and Bartolomeo Vivarini. (D.T.)]

18. A. Ricci, *Memorie storiche delle arti e degli artisti nella Marca di Ancona*, Macerata, 1818, vol. I, p. 182. For Piero's lost work in Ancona: C. Posti, in the journal *Le Marche*, anno VII, N.S. II, 1907, p. 127.

19. For documentation regarding the *Madonna della Misericordia*, the lost *Assumption* from Sant' Agostino at San Sepolcro, and Piero's will: various publications by G. Milanesi in the journal *Buonarroti*, 1885-87.

20. [Parri Spinelli (c. 1387-1453) was the son and pupil of the important Aretine painter Spinello Aretino. As Vasari tells us, Parri was powerfully influenced by Lorenzo Monaco, a Sienese painter who became a leading figure in early fifteenth century Florentine art. Parri's work is nonetheless highly personal and even eccentric, characterized by a mannered elaboration of line and by human figures of startlingly elongated proportions. Vasari notes that, while other painters made their figures "at most ten heads high, he made them eleven and sometimes twelve; nor did this make them graceless, as they were very slender, and always curved like a bow, whether to the right or to the left" (my translation). (D.T.)]

21. [The so-called International Style spread throughout Europe of the great trade routes from the late fourteenth century onwards. Predominant in courtly and bourgeois circles alike until well into the fifteenth century, the International taste is generally characterized by elaborate and decorative work-

manship; careful, naturalististic rendering of details; elongated, delicate, consciously "graceful" forms; an involved but entirely empirical spatial construction that rarely troubles to establish a credibly continous spatial context; a certain doll-like, weightless quality in the luxuriously dressed and draped figures portrayed; sinuous line; brilliantly luminous yet subtle coloring. Among the best of the many Italian practioners of the style were Pisanello and Gentile da Fabriano. (D.T.)]

22. [In his *Lives of the Artists* . . ., Giorgio Vasari lays claim to an ancestor by the name of Lazzaro Vasari, who was, he tells us, a painter active in Arezzo. The surviving documentation, however, shows Lazzaro to have been a saddler by trade (although it may well have been a family tradition family that he had done a little painting on the side—he couldn't have done much without belonging to the appropriate guild). Piero's Aretine assistant and follower Lorentino di Andrea (not d'Angelo, as Vasari calls him) is documented from 1465 until his death in 1506. His own surviving works, closely dependent upon Piero's example, include an altarpiece of 1482 and a fresco of the Virgin and Child from 1483. Lorentino is the hapless and humble protagonist of Vasari's anecdote, cited by Longhi at the beginning of the present essay, about a payment in kind. Despite the implications of his name, Piero's more gifted assistant Giovanni di Piemonte was Tuscan, not Piedmontese; the proper form of his name is, in fact, Giovanni da Piamonte, from the town in the Val di Sieve where he was probably born. Giovanni is known as an independent artist only from one picture at Città di Castello in Umbria, near the Tuscan border. On the basis of a visual comparison, Longhi recognized the Città di Castello picture's author as Piero's principal assistant on the Arezzo fresco cycle: a brilliant identification subsequently confirmed by the discovery of a graffito signed by "Giani Pimt" and dated "1487/86" [sic] on the painted *dado* beneath the Arezzo frescoes, recording some sort of maintenance work on them. For the text of the inscription, see Lightbown, op. cit., p. 287. (D.T.)]

23. [Melozzo da Forlì (1438-1494), from Forlì near Bologna, was an immensely gifted and appealing painter much influenced by Piero. The Vatican picture gallery contains both his detached fresco commemorating the inauguration of Sixtus IV's library in the Vatican and several *Angel Musicians*; the latter are fragments of his lost fresco of the *Ascension* from the apse of the church of the SS. Apostoli in Rome. (The showily foreshortened figure of Christ from this work is now in the Quirinale, Italy's presidential palace.) In Melozzo's mature work, a love of illusionistic and decorative detail tends to

push the calm, broad areas of color typical of Piero's frescoes in the direction of a sort of grandly pretty illustration. (C. Gilbert, "Melozzo: his status, his drawings" in A. Cadei, ed., *Arte d'Occidente: temi e metodi,* Rome, 1999, pp. 1043-1050.) (D.T.)]

24. Published by G. Milanesi in *Giornale storico degli Archivi toscani*, vol. VI, Florence, 1862, pp. 10-15.

25. Luca Pacioli, *De Divina Proportione* (first ed. Venezia, 1509), Vienna, 1889, pp. 123, 160.

26. Published by G. Zippel, "Piero della Prancesca a Roma" in *Rassegna d'Arte*, 1919, pp. 87 et seq.

27. Ibid. See also A. Venturi, *Piero della Francesca* in the series *I grandi maestri dell' arte italiana*, Florence, 1922.

28. [Antoniazzo di Benedetto Aquili, called Antoniazzo Romano, was an important Roman painter who is documented from 1452 onwards and who died sometime between 1508 and 1512. His work tends to combine, not always comfortably, up-to-date "Renaissance" elements with more archaic ones. The fresco cycle in San Giovanni at Tivoli near Rome has been attributed to him by Longhi and other connoisseurs. Lorenzo da Viterbo (c. 1444-c. 1472) left a fine fresco cycle of the *Life of the Virgin* in the church of Santa Maria della Verità in his native town of Viterbo near Rome. For Melozzo, see note 23. (D.T.)]

29. [See note 9.]

30. [Antonio Averlino (c. 1400-c. 1469), Florentine sculptor, architect, and theoretician who called himself Filarete, a Greek coinage meaning, roughly, "lover of excellence." In the early 1460s, while working for the ruling Sforza family in Milan, he wrote a mystical, essentially medieval farrago in which he urges the elimination of all remnants of the "barbarous modern style"—i.e., the Gothic—in favor of a return to pure Classicism. The book contains a detailed description of a centrally planned imaginary city called Sforzinda, in honor of his Milanese patrons. (M. Beltramini, "Francesco Filelfo: nuovo contributo alla storia dell'amicizia fra il letterato e l'architetto della Milano sforzesca" in *Studi in onore del Kunsthistorisches Institut in Florenz per il suo centenario 1897-1997. Annali della Scuola Normale Supriore di Pisa. Classe di*

Lettere e Filosofia, Pisa, 1996, 1-2 pp. 119-125.) (D.T.)]

31. Antonio Averlino, *Trattato dell' Architettura,* W. v. Oettingen, ed., in the series *Quellenschriften für Kunstgeschichte,* vol. 3, p. 302, Vienna, 1890.

32. Published by G. Milanesi in *Giornale storico degli Archivi toscani,* vol. VI, pp. 10-15, Florence, 1862; see also G. Milanesi, *Scritti vari sulla Storia dell'Arte Toscana,* Siena, 1873, pp. 299-302.

33. [The little-known Bartolommeo della Gatta, a Florentine monk of the Camaldolite order who lived in Arezzo from 1470 until his death in 1502, was probably the finest of Piero's local followers. His large *Stigmatization of St. Francis,* painted in 1487 and now in the picture gallery of Castiglion Fiorentino, owes much to Piero's example, but nonetheless expresses a distinctively individual sensibility.

Luca Signorelli (c. 1441-d. 1523), a native of Cortona near the border between Umbria and Tuscany, is reliably reported by his contemporary Pacioli to have been a pupil of Piero's. Details of Signorelli's painting of the *Flagellation,* dating from the 1470s and now in the Brera in Milan, presumably depend upon a now-lost drawing by Piero for his own version of the subject, which is now in the Ducal Palace at Urbino. This circumstantial evidence for the role of drawing in Piero's studio practice is especially precious given that Piero's drawings, of which there must once have been a considerable corpus, have apparently vanished. (See Lightbown, op. cit, p. 17; there are comparative illustrations of Signorelli's and Piero's versions of the *Flagellation* in James Beck, *Italian Renaissance Painting,* New York, 1981, pp. 276-77, and in Carlo Bertelli, *Piero della Francesca,* London, 1992, pp. 120-21.) Signorelli worked chiefly at Cortona, Arezzo, Florence, Rome, Monte Oliveto near Siena, and Orvieto. His most important works are the intensely dramatic frescoes in the Brizio Chapel in the Duomo at Orvieto, showing such subjects as the *End of the World,* the *Resurrection of the Dead,* and the *Damned.* Widely held to have influenced Michelangelo, this heroic cycle fuses Piero's broad areas of color with a quite un-Pieresque strenuousness of line derived from such Florentines as Antonio Pollaiuolo and Verrocchio.

There is no documentary evidence for the occasional suggestions by Longhi and others that the Umbrian painter Pietro Vannucci, called Perugino (1452?-1523) may have studied with Piero. But it is obvious that the broad, calm spaciousness of Piero's landscapes, like the utter stillness of many of his figures, exercised a great fascination on the very successful younger artist, and contributed greatly to the formation of his style—although Perugino was to

offer increasingly dull and stereotyped interpretations of these elements as his career went on. (V. Garabaldi, *Perugino, Catalogo Completo*, 1999.) (D.T.)]

34. L. Pungileoni, *Elogio Storico di Giovanni Santi*, Urbino, 1822, pp. 12 and 75; A. Schmarsow, *Melozzo da Forlì*, Berlin, 1885.

35. C. Ricci, *Piero della Francesca* in the series *L'opera dei grandi artisti italiani*, Rome, 1910.

36. A. Venturi, *Storia dell' Arte*, Milan, 1911, VII, I, pp. 434-486.

37. [Raphael's father, the painter Giovanni Santi (c. 1440-1494), active at Urbino, was the author of a history of Federigo da Montefeltro written in twenty-four thousand lines of verse, using the Dantesque scheme of *terza rima*. (Cf. G. Santi, *Federigo da Montefeltro, Duca di Urbino*, ed. Heinrich Holzinger [from Vat. Ottob. 1305], Stuttgart, 1893.) Like Vasari, who was later to view the teleology of art history as moving towards the supreme pinnacle of Michelangelo, Giovanni, too, had his hero, whom he viewed as infinitely superior to all others: this was Andrea Mantegna. (D.T.)]

38. [In the present biographical essay, Longhi interprets Santi's line about Piero in the most straightforward manner possible, taking it as a simple reference to the painter's chronological age. He thus seems to agree with the interpretation offered by James Dennistoun, who first brought Giovanni's epic to the attention of scholars in his *Memoirs of the Dukes of Urbino*, London, 1851. (Dennistoun translates the relevant passages of the poem in his vol. II, pp. 456-60.) However, in the essay "The Art of Piero della Francesca," also included in the present volume, Longhi proposes a quite different reading of the same line, finding in it the implication that Piero's work was considered more *old-fashioned* than that of the other painters mentioned. Just to complicate matters further, Philip Hendy, in his frequently admirable monograph on Piero (op. cit., p. 144), offers what seems to the present writer a forced interpretation of this second reading of Longhi's, claiming that the Italian critic saw in the verse an appreciation of the antique—i.e., Classical—essence of Piero's art. (D.T.)]

39. [In the sixteenth century, the steady accumulation of wealth on the part of Piero's family was, in fact, to lead to the literal attainment of noble status. Cf. Lightbown, op. cit., p. 12. (D.T.)]

40. G. Milanesi, publication of documents regarding the *Madonna della Misericordia*, the *Assumption* in Sant' Agostino at San Sepolcro, and Piero's will in the magazine *Buonarroti*, 1885 [various nos. and pp.]

41. [Since Longhi published the first edition of his monograph on Piero in 1927, additional dispersed elements of the *Sant' Agostino Altarpiece* have been identified, thanks in no small part to Longhi's own efforts. (For a brief summary of this process of accretion, see Bertelli, op. cit., p. 202.) The central panel, however, continues to elude capture, and may well have been lost within a few decades of its completion, as Longhi suggests; the late John Pope-Hennessy was apparently alone in his unshakable faith that, sooner or later, this key element would turn up. (J. Pope-Hennessy, *The Piero della Francesca Trail*, London, 1991; Italian trans., *Sulle tracce di Piero della Francesca*, Turin, 1992, p. 8). "The Pope" was less isolated in his conviction (ibid.) that the missing panel must have shown a *Madonna and Child*; but many scholars have accepted, instead, the thesis argued by Mirella Levi d'Ancona, according to whom the subject was almost certainly the *Coronation of the Virgin*. (Cf. M. Levi d'Ancona, *Supplement to the Catalogue of the Frick Collection*, New York, 1955, pp. 61 ff.) (D.T.)]

42. Published by Evelyn Marini-Franceschi, "Alcune notizie inedite su Piero della Francesca" in *L'Arte*, 1913, pp. 471-73.

43. Published by G. Gronau in his article entitled "Piero della Francesca" in *Thieme-Beckers Künstlerlexikon*, XII (1916), pp. 289-94.

44. Ibid.

45. Nicolò Testa Cillenio, *Sonetto*, c. 1470-75. Published by Ricci ("Un sonetto artistico del Sec. XV") in *Arte e Storia*, 1897, p. 27.

46. [Far and away the most important architect of his generation, Donato Bramante (b. nr. Urbino c. 1444) started out as a gifted painter. By the time his artistic activity is first documented, in the 1470s, he had left his native region for such Lombard cities as Bergamo and, especially, Milan: centers where aspects of the late-Gothic taste still flourished. The "Renaissance" language of the paintings and buildings Bramante was already creating in his early career in Lombardy nonetheless shows his Central Italian training; without such a background, he could probably not have achieved such Classical *gravitas* and authority in the works predating his departure for Rome in 1499.

It has sometimes been hypothesized that Bramante studied with Piero della Francesca. Certainly, Piero was often at Urbino during the younger artist's formative years; at the very least, Bramante would have had ample opportunity to study Piero's works there.

Bramante's earliest known architectural undertaking was the remodeling of the small ninth-century Milanese church of Santa Maria presso San Satiro, probably carried out in the late 1470s and well into the 1480s. (There exists a relevant document from 1486.) Since the presence of a narrow street outside running behind the apse, parallel to the transept, made it impossible for Bramante to build a presbytery of normal depth, he opted for an illusionistic solution, using relief detailing in perspective on the wall behind the crossing to simulate the presence of a deep, rhythmically articulated space that isn't really there. Reminiscent though this unusual project may be of many a later Baroque trompe-l'oeil stunt, Bramante's language here is—in detailing and spatial construction alike—of an ideally Classicizing, mathematically rational sobriety closely recalling the fictive architecture in Piero's paintings. Specifically, Bramante's crossing and illusionistic presbytery, complete with pilaster strips and coffered barrel vault, put one very much in mind of the fictive setting in Piero's *Montefeltro Altarpiece*, now in the Brera. In any consideration of the apparent dependence of Bramante's solution at San Satiro upon the *Montefeltro Altarpiece*, it should nonetheless be noted that there is little agreement about the dating of the latter work, assigned by Longhi to the years 1474-78. (While Shearman, finding in the altarpiece analogies with the Arezzo frescoes, thinks it must have been painted prior to 1466, both Hendy and Clough have held that it should be dated to some time after Federigo da Montefeltro's death in 1482. Cf. John Shearman, "The Logic and Realism of Piero della Francesca," in *Festschrift Ulrich Middeldorf*, ed. A. Kosegarten and P. Tigler, Berlin, 1968, pp. 180-86; P. Hendy, op. cit., pp. 147-55; Cecil H. Clough, "Piero della Francesca: Some Problems of his Art and Chronology," in *Apollo* no. 91, 1970, pp. 278-89.)

The powerful influence of the spatial articulation and measurement, the detailing, and the atmosphere of Piero's fictive architecture in general is, in any event, readily apparent in many of Bramante's designs, from San Satiro and the Tribune at Santa Maria delle Grazie in Milan to Saint Peter's in Rome (where something of Bramante's original conception survives, especially in the crossing, despite the subsequent interventions of other architects such as Antonio Sangallo the Younger and Michelangelo). As Peter Murray has acutely observed, Bramante was "deeply influenced by his training as a painter and above all by the architectural ideals of Piero della Francesca. This feeling for architectural space as a series of planes and voids, like those in a painting,

rather than as a series of three-dimensional solids, distinguishes Bramante from Brunelleschi and from most of the Florentine architects of his own generation." (P. Murray, op. cit., p. 106.) See also H. A. Millon and V. Magnago Lampugnani, eds. *The Renaissance from Brunelleschi to Michelangelo. The Representation of Architecture*, catalogue of the exhibition held at Palazzo Grassi Venice, Milan, 1994. (D.T.)]

47. Fra Sabba da Castiglione, *Ricordi overo Ammaestramenti*, Venice, 1549, "Ricordi" nos. 109-110.

48. [Longhi's language here may lead us to take for granted that Federigo "sat for his portrait" in the manner familiar to us from more recent experience. While this may in fact have been the case, it is worth noting that there are also other plausible hypotheses consistent with the artistic practice of the time. In discussing Piero's frescoed portrait of Sigismondo Malatesta at Rimini, for example, Lightbown (op. cit., p. 100) suggests that, despite his subject's probable availability to him, the artist may have drawn primarily upon a portrait medal by Matteo de' Pasti.

　　In the case of the Uffizi diptych portraying Federigo and his wife Battista, many scholars have believed the work to date from some time after the latter's premature death in 1472; the Latin inscriptions on the reverses of the two panels speak of Federigo in the present tense, but of Battista in the past tense, in terms drawn from the epitaph of the ancient Roman poet Ennius. It has been variously suggested that Piero's portrait of Battista may have been based upon a death-mask, upon the very elegant and subtle relief portrait now at Pesaro (probably the work of Francesco Laurana, brother of Federigo's court architect), upon some now-lost portrait medal, or other sources. It has likewise been suggested that the portrait of Federigo himself from the same diptych may be based on any of a number of medals bearing the ruler's bust-length likeness in what Longhi once wittily called "numismatic profile" (a view, however, very popular in painted portraiture of the time as well as for medals); the parallels with a medal by Sperandio of Mantua dated 1474 are particularly close—although there is no ruling out the opposite possibility, i.e., that Sperandio himself based his own work upon Piero's panel.

　　Bruce Cole has put the basic case succinctly: "Our modern ideas about the need for extensive sittings to capture something of the subtlety of the sitter's mind would have made little sense to a Renaissance artist working about 1450 in the service of a commanding ruler. What was wanted . . . was a symbol of power and authority. Accordingly, Piero's faces are so formalized and abstracted that many direct sittings would have hindered rather than

　　　　　　　　　　　　　　　　　　　　　　　　　　　Roberto Longhi

enhanced his images; Piero was after reductive form, not realistic representation." (B. Cole, *Piero della Francesca: Tradition and Innovation in Renaissance Art*, New York, 1991, p. 132). Longhi himself suggested that, if Federigo chose to have his own hands in the Piero's *Montefeltro Altarpiece* portrayed by some Northern-European-trained artist (who may have been Berruguete, as Longhi thought, or perhaps Justus of Ghent), it must have been because he wanted them to be "illusionistically recognizable as his own"—a result Longhi judged to be outside the scope of Piero's "synthesizing" art. This is not to say, of course, that Piero was utterly uninterested in small accidents of surface; the little growths on the skin of Federigo's cheek and neck in the Uffizi portrait bear sufficient witness to the contrary. But he would have been well acquainted with such aspects of Federigo's appearance in any event, even without specific sittings, being as he was a familiar of the Urbino court.

It does seem to the present writer that the powerfully directional lighting in the Uffizi portrait may indeed testify to "sittings" in the modern sense, rather than to any derivation from a previous work. As for the sittings mentioned in passing by Longhi in conjunction with the *Montefeltro Altarpiece*, it should be recalled that some recent scholars—not the majority—have believed the entire picture to date from after Federigo's death. (See note 46). (D.T.)]

49. [While undocumented, the design for the intarsia in the Sala degli Angeli in the Ducal Palace at Urbino is generally considered to be based on a now-lost drawing by Botticelli, who also contributed designs for some of the work in the *studiolo* or study in the same building. (D.T.)]

50. [The Spaniard Pedro Berruguete (1450-1504), who worked for Federigo da Montefeltro, is not to be confused with his younger compatriot Alonso Berruguete (1480/86-1561), also active in Italy. (D.T.)]

51. F. Corazzini, *Appunti storici e filologici su la valle Tiberina*, San Sepolcro, 1875, pp. 57-63.

52. Evelyn Marini-Franceschi, "Alcune notizie inedite su Piero della Francesca" in *L'Arte*, 1913, pp. 471-73.

53. Evelyn Marini-Franceschi, *Piero della Francesca*, Città di Castello, 1912.

54. G. degli Azzi, "L'inventario d'archivi di San Sepolcro," in *Archivi della Storia d'Italia*, Rocca San Casciano, 1914, IV, 128.

55. [While only two of these are directly germane to his work as a painter, all three bear witness to his strong interest in mathematics; Vasari, in fact, tells us that Piero started out as a local prodigy in the latter field. Piero's *Trattato del abaco* or "Treatise on the Abacus," probably written in the early 1450s, is preserved in a codex in the Laurentian Library in Florence. It is a series of exercises in commercial accounting, testifying to Piero's familiarity with such disciplines as algebra and trigonometry as well as with Euclidian geometry, and also to his ongoing sympathy with the mercantile world of his family. (As Longhi repeatedly observes, our painter had little in common with the modern figure of the "alienated artist.") *De prospectiva pingendi* ("On Perspective in Painting"), of which a number of old manuscript copies survive, is an illustrated manual for the construction of three-dimensional objects' appearances in three-dimensional space, with space and objects alike projected onto a two-dimensional pictorial surface. Presented as a series of numbered theorems, it provides a mathematically precise but pragmatic methodology for putting "profiles and contours . . . proportionately in their places" upon a *termine* or "assigned end plane" marking the intersection between the viewer's vision and the objects portrayed. The treatise owes much to the ideas of Alberti (cf. note 11, above) as expressed in the *Della pittura* of 1436, the Italian version of the Florentine writer's *De pictura*; and Alberti was himself deeply indebted to Filippo Brunelleschi where matters of perspective were concerned. This second book may have been completed sometime around 1469-70, as the date of the dedication to Federigo da Montefeltro suggests; but it was undoubtedly a long time in the making. Piero's last book, *De quinque corporibus regularibus,* was the one plagiarized by Luca Pacioli (cf. note 9). Sometime in the years following Federigo da Montefeltro's death in 1482, Piero dedicated this work to Federigo's son and successor Guidobaldo, presumably in order to assure the continuity of his longstanding close relationship with the ducal family of Urbino. As the title "On the Five Regular Bodies" implies, the book—surviving in a manuscript in the Vatican—provides further important insights into the geometric underpinnings of Piero's art. Although only the Latin versions of Piero's two most important books have come down to us, the artist does not appear to have known the ancient language especially well, and undoubtedly received help from Humanist circles in turning his Italian draft versions into suitably Classical prose. For bibliographical details of modern publications of Piero's writings, see Lightbown, op. cit., pp. 236-237. See also, for Leon Battista Alberti, Giovanni Bellini, Donatello, and Piero, *Il potere, le arte, la guerra. Lo splendore dei Malatesta,* catalogue of the exhibition in Rimini, Milano, 2001.) (D.T.)]

56. [See note 55 above. Guidobaldo will be familiar to readers of Baldassare Castiglione's famous *Libro del Cortigiano* or "Book of the Courtier" as a sort of constant off-stage presence; the edifying conversations of the Duchess of Urbino and her circle of learned friends take place after the Duke has retired to his chamber. (D.T.)]

57. G. Milanesi, publication of documents regarding the *Madonna della Misericordia*, the *Assumption* in Sant' Agostino at San Sepolcro, and Piero's will in the magazine *Buonarroti*, 1885 [various nos. and pp.].

58. Gerolamo Mancini, "L'opera 'De corporibus regularibus' di Piero Franceschi detto della Francesca," in *Atti della Reale Accademia dei Lincei— Memorie della classe di Scienze Morali Storiche e Filologiche*, Serie V, vol. XIV, pp. 446-487, Rome, 1915.

59. Berto degli Alberti, "Codicetto di memorie, con citazione relativa a Piero," extract published by G. degli Azzi in *Archivi della Storia d'Italia*, IV, Rocca San Casciano, 1915.

60. J. Guiffrey, in a note on the attribution to Piero della Francesca of a Madonna by Alessio Baldovinetti in the Louvre, in *L'Arte*, 1898, p. 46.

61. [The Aretine painter and architect Giorgio Vasari (1511-1574) published the first version of his *Le vite de' più eccellenti pittori, scultori ed architettori*— the famous and indispensable "Lives of the Artists"—in 1550. In 1568 he brought out a vastly enlarged and more ambitious second version; this is the "Giuntine" edition to which Longhi refers. The term derives from the new edition's having been printed and published at the famous Giuntine press, founded by the Florentine typographer Filippo Giunta in the fifteenth century and still being run by his family two centuries later. As Longhi notes, Vasari adorned the Giuntine edition with a series of woodcut portraits of artists, varying in accuracy from eyewitness reliability to outright fantasy. (D.T.)]

62. [Longhi never approved of the widespread use of the term "Mannerism" to denote the sinuous and attenuated, willfully irrational, elaborately glamourous style that came into vogue in Italy and throughout Europe in the latter part of the Renaissance. Late in his career he wrote, "This is one of those many abstract terms that, spread by Germanic philosophizing, have come to populate history in general and art history in particular ever since the nine-

teenth century; before that, however, it never existed. Vasari, himself a member of the Mannerist cohort, restricted himself to saying '*la maniera*' or '*la maniera moderna*'—'the style' or 'the modern style.'" (R. Longhi, "Ricordo dei Manieristi," in *L'Approdo*, II, I 1953; now in R. Longhi, *Cinquecento classico e Cinquecento manieristico*, Florence, 1976, p. 82; my translation.) Longhi's objection to the word Mannerism was based upon his perception that the term misleadingly implied some sort of organized, programmatic movement—in short, an "ism." (D.T.)]

63. [Surprisingly, the various local traditions according to which Piero is said to have painted his own self-portrait in various of his works—the *Misericordia Altarpiece*, the *Invention of the True Cross* at Arezzo, the San Sepolcro *Resurrection*—are still accepted in some of the modern scholarly literature. Cf. Carlo Bertelli, *Piero della Francesca*, trans. Edward Farrelly, London, 1992, p. 198 and esp. p. 26. (D.T.)]

[Bibliographical note. Full texts of practically all the documents on Piero della Francesca mentioned by Longhi, available in the latter's day only in a scattered array of often elusive journals and other publications, are now conveniently accessible in the second volume of Eugenio Battisti, *Piero della Francesca*, Milan, 1971. (D.T.)]

Editorial notes by David S. Tabbat

PIERO'S REPUTATION OVER THE CENTURIES
(1927)

There is no doubt that Piero's reputation or "fortune" in the history of taste—or, at least, in such a portion of that history as has been handed down by criticism—has been far less favorable than the artist's qualities deserved; it has, in fact, been almost malign.

Think, for example, of the fundamental fact of Piero's historical impact: by way of Rimini and Pesaro and Forlì, whether directly or indirectly, through greater or lesser events such as the painting of Melozzo da Forlì and Marco Palmezzano, his art provided the basis for nothing less than the new Venetian painting. It joined north and south and created a deep, almost national unity that is reflected in the coloristic classicism of Bellini, the young Titian, and even Veronese. And yet, the scarcity of the master's panel paintings outside Urbino and the little town of San Sepolcro (Michiel doesn't mention a single one in the rich Venetian collections of the first quarter of the sixteenth century), the remoteness of his works in Arezzo, and other related reasons make it difficult to perceive clearly the historical link with Piero that enabled Bellini to become the father of Venetian painting. Moreover, one must realize that the criticism and history of art were not, back then, things habitually written down; instead, they were transmitted, rather imprecisely, through the act of painting itself. To us it seems certain, for example, that in the lessons in perspective given by Malatini to Giovanni Bellini, there must have been such references to Piero as would be precious for us, could we evoke them. Today we have to settle for recognizing that when Boschini tried, much later, to set forth the problem of Bellini's style, he saw quite well that it was based on perspective, even if he did not mean by this that the suture between Bellini and perspective had occurred at Rimini and Pesaro; i.e., in places where Piero had been active.

This is not to suggest that at the end of the fifteenth and the beginning of the sixteenth centuries, long before Vasari wrote his *Lives*, one does not find the master from San Sepolcro mentioned. But the references to Piero's art are only hearsay, and writers preferred to discuss his scientific and theoretical activities.

In the biography, we have already recalled the mentions by the artist's contemporaries AVERLINO, FERABÒ, TESTA CILLENIO, and SANTI. Far more important are the numerous references that turn up shortly afterwards in the works of LUCA PACIOLI, whom we have already cited as Piero's fellow-countryman, and as his pupil around 1460. Writing in his hieroglyphic style,

Pacioli took it upon himself to spread Piero's fame before and after the master's death. He first wrote about him, in precious detail, in his *Summa Arithmetichae*, which nonetheless appeared when Piero was already two years dead; later, in 1509, he repeated his praise in *De Divina Proportione*, at the very moment when he was literally plagiarizing Piero's treatise on the five regular bodies, which lay buried in the library at Urbino.

The coarsely metaphysical and astrological-Platonic complication that Piero's principles undergo in the practical-minded encyclopedism of the popularizing Fra Luca, who seems to be attempting to turn the genius from Borgo into a magus and holy man along the lines of Leonardo, makes way for a much clearer, if oddly anonymous, treatment by the period's writers on artistic theory. Just as the essence of Piero's perspectival theory and practice pass directly but namelessly into the Venetian art of Bellini and his followers, so they do into the work of foreign theoreticians. For example, Panofsky has convincingly demonstrated the precise relationship between Piero's theories and those of Dürer; and yet Piero's name is never mentioned in the writings of the great German artist. It is even more surprising that Piero's name is not to be found in the international catalogue of artists that JEAN PÉLERIN (Viator) placed as a preface in 1505 to his *De artificiali Perspectiva* where, in elaborate verse, he addresses himself to the "bons amis trespassez et vivans—grans esperiz Zeusins Apelliens—decorans France Almaigne et Italie" [good friends departed and living—great spirits in the manner of (the ancient Greek artists) Zeuxis and Apelles—decorating France, Germany, and Italy]. This is surprising, I say, in a work on the science, an auxilliary to painting, of which Piero had been practically the inventor and, even better than the inventor, the poet.

In Italy, in the first years of the sixteenth century, MAFFEI, a writer from Volterra who was acquainted with Melozzo, said that the "nobilis pictor" Piero had held forth "in quodam volumine," copiously, on perspective in painting; we may conclude from this that ideas regarding the regular bodies were already less clear. But Maffei doesn't restrict himself to citing Piero's importance as a theorist of pictorial optics. Piero's name recurs in the *Commentariorum Urbanorum libri*, in the part devoted to *Anthropologia Pictorum*; and it appears immediately after Giotto's, in the company of a very few other fifteenth-century painters.

CAMILLO LEONARDI from Pesaro, also called Leonardo Pesarese, would seem to have been in a privileged position when it came to understanding Piero's importance, given that he came from an area where the latter had worked; and yet in his *Speculum lapidum* he limits himself, under Pacioli's influence, to the question: "Nam in pictoria arte quis praestantior fuit Petro Burgensi?" And he replies to this rhetorical question: in perspectival painting.

The usefulness of perspective theory to architecture ensures that there is no lack of references to Piero in the treatises regarding this discipline. In the commentary on his translation of Vitruvius of Como (1521), CESARIANO still considers Piero to be one of "our moderns," grouping him with Melozzo and the Modenese artist Francesco Magagnolo. Vitruvius's other commentator, the Perugian G. B. CAPORALI, says essentially the same thing in 1536.

Toward the midpoint of the century, we find what seem to us more important references to Piero in the *Ricordi* of FRA SABBA DA CASTIGLIONE, one of the most informative books of the century. It will be enough to say that Fra Sabba anticipates Vasari's fable about Bramante having studied perspective from a panel of Fra Carnevale's, since, in Ricordo CX, Bramante is, instead, explicitly said to be "a great perspectivist, as created by Piero del Borgo." This statement has habitually been omitted or misinterpreted by writers on Bramante and Piero. Elsewhere (Ricordo CIX), Castiglione gives us a fairly precise sense of the detachment that sixteenth-century Humanistic classicism already felt vis-à-vis the "primitive" classicism of the inventors of perspective. For him, the fifteenth century's incisiveness is already "diligence," shortly to become, for the seventeenth century, "hardness and dryness." As for perspective—and, let us understand, he means precisely the perspective of Piero and Melozzo, since he is writing in Faenza, the very point from which Pieresque art flows northward—he confesses that "the works of Pietro del Borgo or of Melozzo da Forlì" are "perhaps more pleasing to connoisseurs, on account of their perspective and secrets of art . . . than attractive to the eyes of those with less understanding." The smugness of the antiquarian with his élite culture that emerges from these words seems almost to echo the contemptuous judgment regarding the common people that Giotto's work had once elicited from Petrarch. At the same time, however, it carries an unconscious warning that taste is moving away from these works.

After Piero's death, Florence seems to have imposed on itself a strict silence regarding the artist. One might almost say that the city was aware of how greatly Piero's style might have deflected it from that which it was preparing to become. As we have said, there was a certain renewal of the ardor for perspective, and perhaps a slight reinforcement of Piero's influence, in a certain phase of Andrea del Castagno and, later, in Baldovinetti and Giovanni di Francesco; but for the greater part of Florentine art, Piero remains an alien. There is no mention of him in the accounts of Neri di Bicci who, having worked in the region around Arezzo, would have had occasion to meet him. Nor is he referred to in the accounts of Baldovinetti, who was nevertheless the Florentine artist whose manner was closest to Piero's, and the only one in whom, around 1460, Florentine painting appeared to hesitate in its resolu-

tions. At the beginning of the fifteenth century, Albertini's desciption of the city's art is silent regarding Piero. Silent, too, are Vasari's various anonoymous sources, all walled up in the strictest Florentinism and all apparently demonstrating, at any rate, that Piero no longer worked in Florence after about 1440—or that if he came back, it was only occasionally and fleetingly.

And now there appeared in Florence, in 1550, the first biography of Piero, included in the first edition of VASARI's *Lives*.

We owe it to Vasari's Aretine origins, and also to the fact that a great-grandfather of Giorgio's, one Lazzaro, had had contact with the Master of Borgo during his stay in Arezzo, that the *Life* of Piero della Francesca is so rich in precise information regarding his works. It is scarcely necessary to say that Vasari's text reveals a direct knowledge not only of the Arezzo paintings, but also of those at Borgo San Sepolcro; and in this regard, it is useful to bear in mind that Vasari may also have drawn for information about Piero's activities in his home town upon the memories of G.B. Cungi and Cristoforo Gherardi, both of whom were Vasari's faithful assistants and both of whom came from San Sepolcro. It is worth noting that there are no errors of attribution in Vasari's precious catalogue of Piero's works, while there are, instead, many errors and imprecisions in his biographical information; we cannot recognize as valid even Vasari's statement that Piero flourished around 1458, which seems to us to allude to the period of the Arezzo frescoes. All things considered, even Vasari's few and confused biographical details nonetheless reveal themselves to be of strictly local, not Florentine, origin; and this applies even to the information on Piero's dealings with Domenico Veneziano. One thing is clear, in fact, even at a first reading: Vasari does not know that the master studied in Florence, and does not even seem to presume so; Piero's name is not mentioned in the lofty list of those who have studied in the Brancacci Chapel. This silence strikes us as highly revealing of the non-Florentine significance that Vasari senses, in a confused fashion, in Piero's personality. In his mind, in short, Piero is a child of Central Italy, trained at home and possibly in Urbino, and somehow connected with Domenico Veneziano. When we think of the symbolic meaning of the fables created by Vasari regarding Domenico's relationship to Antonello da Messina, the matter takes on greater importance: even more so when we connect it with the very high rank he assigns the works of the Master of Borgo.

After Masaccio—and yet, with no reference to Masaccio—Piero is the artist whom Vasari praises most highly, and at only slightly lesser length, above all for his importance as a precursor and initiator. Among all the early masters, Masaccio is the most modern ever seen; all the celebrated painters who have come after him have become excellent and have attained clarity of style;

Masaccio is the one who, in his mastery, produced order in the beautiful style of our day. Nonetheless, Vasari praises Piero's "sweet and new style"; in Piero, after having cited the "nocturne" in the *Dream of Constantine*, he notes that, having shown in that darkness "how important it is to imitate real things and to take them from reality . . . he has given the moderns reason to follow him, and to reach that lofty level that we see things have reached in our time."

One might ask whether Vasari's evaluation of Piero does not reveal a greater degree of "relativity" than does his estimate of Masaccio, but I believe that one would have to answer in the negative. It is quite well known that this relativity is natural in Vasari's approach to all the artists of the fifteenth century, since the writer was a believer in "progress." Even in his remarks on Masaccio, we find that it has left a significant residue, where he calls him "*of all the old masters* the most modern," and again where he adds, "it is not mere opinion, but the firm belief of many, that he would have produced much greater fruit in art, had not death . . . taken him so early on." As for Piero, an analogous relativism is quite perceptible when Vasari writes that the foreshortened horses in the *Flight of Maxentius* are "so marvelously handled that, *considering the period*, they can be called extremely fine and excellent."

As for perspective, Vasari does not view this singular inclination of Piero's as having a purely scientific significance; he keeps the master's theoretical and painterly qualities quite distinct from each other. While he feels Paolo Uccello's perspective to be capricious, in Piero's he notes a "more modern style and draftsmanship," and even "grace." It should be understood that Vasari places heavy emphasis upon the importance of Piero's work as a theoretician; but even after this insistence, he does not forget to say that Piero's books have made his name immortal "above and beyond his fame as a painter." We therefore believe—in contradiction to Olschki's opinion, which is distorted by an imprecise understanding of Piero's art—that Vasari achieves a well-balanced view of this Janus of painting and science, just as Piero himself achieved a perfect equilibrium in this double activity.

In this regard, some further observations on Vasari's interpretation of Piero will not come amiss; it is, naturally, a matter of reading discreetly between the lines, without expecting of him—as is a common vice among many of today's art commentators—a way of thinking or, more precisely, a way of expressing his own thoughts, such as would come naturally to a modern critic.

Still concerning the interpretation of Masaccio, it does not seem pointless to note, for example, that when he speaks of this artist, Vasari insists on a certain quality of true, natural relief, on the enormous *terribilità*, on the realism, on the beautiful poses, movements, and proud attitude of the figures,

who are endowed with the qualities of life and alertness. If, in Masaccio, Vasari views perspective as a simple graphic auxilliary to plasticity, to the point where he says that the *Trinity* fresco in Santa Maria Novella "seems to pierce the wall," when he speaks of Piero he insists upon the "divine measurement," and not upon the illusion of relief, in the columns in the *Meeting of Solomon and the Queen of Sheba*. He insists upon the "grace" of Piero's perspective, on his "sweet and new style," finding superior to "every other consideration of invention and art" the artist's "having painted the night . . . with very great discretion . . . " and praising very highly his "having imitated in fresco the gleam of armor . . . "

From these passages we may gather that Vasari intuited, however confusedly, that the preponderance of Piero's merits lay in a pictorial totality distinct from the plastic intention. And while Vasari's judgments are usually based upon naturalistic illusion, this standard is corrected by his passing references to relief in the case of Masaccio, and to pictorial and coloristic effects in that of Piero.

Let us content ourselves with this, even if Vasari did not see the historical importance of this barely-sketched-out stylistic distinction; if he did not manage to imagine, alongside the historically documented procession of the many artists who, over a period of a century, had settled for studying the Brancacci Chapel, that other procession—which is, if less well documented, nonetheless a certainty in our thoughts—of artists who made an equally decisive pictorial pilgrimage to the frescoes in the church of San Francesco at Arezzo, "one of the highly worthy works of Italy, and praised by all." Vasari saw none but Perugino, Signorelli, and his great-grandfather Lazzaro looking up at those walls; today we can add not only Melozzo and Bramante, but also Antonello and Bellini, which is to say all of Venetian and modern painting.

After Vasari, the general historical trends of Italian art and, as we have said, the geographical remoteness of Piero's most important works, led to his fame's being increasingly restricted to his isolated province, that heartland of Italy which has always remained apart from the highways traveled by fame. His reknown as a writer of treatises held out rather longer, at least for a time, thanks to the books' great usefulness to theorists of architecture. His treatises, still in the library at Urbino, were studied by scholars, whether directly or from copies. In his *Practica della prospettiva* [the Venetian aristocrat and amateur architect] DANIELE BARBARO, while denigrating Piero as out-of-date, borrows geometrical demonstrations from him; and through Barbaro, certain principles are passed on to [the architect] Vignola. EGNAZIO DANTI, writing the preface to Barozzi's *Due regole* in 1583, mentions Piero and even shows that he is aware of the extent of Pacioli's plagiarism.

We have deliberately excluded from this study considerations specifi-
cally regarding Piero's activity as a theorist. But since the long-debated ques-
tion of Pacioli's plagiarism bears, in part, on the basis of Piero's critical fortune,
we will here provide a brief account of this debate.

Vasari was the first to denounce publicly Pacioli's theft from Piero; but
the denunciation was not a detailed one, and seemed to refer to "all the efforts
of that good old man." As we have just said, precise information was provid-
ed in 1583 by Egnazio Danti in his preface to Vignola's *Due regole della
prospettiva practica*. Danti cites the Nuremberg theoretician Jamnitzer, "who
has put the regular bodies in perspective, and other composite ones," adding,
"just as did Piero del Borgo, although Fra Luca printed his work under anoth-
er name." So in the last decades of the sixteenth century there were not only
people who still had a precise notion of Piero's works (as Barbaro's book also
shows), but also those who knew the exact extent of Fra Luca's plagiarism. To
this precise truth, dating from 1583, no one returned until 1880, in the after-
math of much pedantic wrangling; and the credit for re-establishing it goes to
Jordan. It is a shame that the pedants of the late eighteenth century, and those
of the entire nineteenth century, did not take a careful look at that passage in
Danti. They might have spared themselves many wasted words for and against
Pacioli, for the passage indicated the most natural way to discover the truth
about the old accusation: by going and finding (a not over-difficult task)
Piero's little codex *De quinque corporibus*, which had passed directly from
Urbino into the Vatican Library, and seeing whether, and up to what point, it
matched the treatment of the same subject offered by Pacioli in an appendix
to his *De Divina Proportione*. Scholars continued, instead, to scratch their
heads over the interpretation of Vasari's generic accusation, until, as has been
said, Jordan clarified matters through a simple comparison in 1880, publish-
ing the two texts in two facing columns. It is a grave matter to have to state
that, despite this, certain Italian scholars amused themselves by continued to
pursue the long dispute, twice rediscovering, after Jordan, the Vatican codex
that had already been well known to [the historian of Urbino] Dennistoun,
and pointlessly repeating the proof of plagiarism, or pointlessly denying it.

To return to the sixteenth century, it must be said that even the theo-
retical interest in geometrical research regarding regular bodies—suggested to
Piero by his predilection for clearly geometrical forms and to Pacioli by his
need to find everywhere symbolic correspondences in keeping with his astro-
logical-Platonic lucubrations—was slowly dying out. Composing his *Idea del-
l'architettura ideale* towards the end of the century, Scamozzi declares that he
believes that discussions about regular bodies were no more than an artifice to
"sharpen scholars' minds," thus showing that he no longer understands their

original esthetic significance.

At the same time GRAZIANI, another prelate who was a native of San Sepolcro, in his *Scriptis invita Minerva*, shows that there no longer existed a precise tradition regarding Piero's works even in the artist's hometown; the writer limits himself to paraphrasing a passage from Vasari. One may even suspect that his apparent correction of Vasari regarding the duration of Piero's life—eighty years instead of the eighty-six claimed by Vasari—is nothing more than the result of a hasty reading of Vasari's *Life*. The only noteworthy, and probably deliberate, divergence from that text is the passage where Graziani, calling Piero "suprema senecta, captus oculis," seems to be correcting Vasari, who claimed that Piero had gone blind at sixty; but Graziani complicates his correction by adding that Piero, during his blindness, dictated his works to an amaneunsis, something which the documents exclude. The only information taken, not from Vasari but from the local tradition, regards the house designed by Piero himself, in Via delle Aggiunte: having become the property of the Graziani family and having been ruined by a fire, it was, so we are told, restored by a brother of the bishop and author to its original state.

A local product of the period, not unimportant in the local context of Piero's hometown, was the school of painters specializing in *quadrature* (trompe-l'oeil architectural settings) and headed by the Alberti family. We mention them here because, more than an outgrowth of the art of Piero—who would surely have disapproved of such an arbitary separation between the various branches of the painter's art—they seem to us to belong to the story of Piero's historical fortune: in a certain sense, they represent one of the more special forms that his theoretical teachings, when misunderstood, took on in later Italian painting. *Quadrature* was the name given to those perspectival-architectural illusions, spatial fictions created within formerly almost bare buildings which were soon filled, not with the *uomo quadrato*, the "squared" or "measured man" of Aristotle and Piero, but with the shouts and agitation of the most mannered and least architectural humanity imaginable. ROMANO ALBERTI, the brother of the founder of this group of *quadraturisti*, wrote in 1585 in his *Nobiltà della pittura* that "the never-sufficiently-praised Piero della Francesca . . . was very excellent in perspective and the greatest geometrist of his time, as is shown by his books, which are mostly in the library of Federigo the Second, Duke of Urbino." This rhetotical statement, lifted from Vasari's *Life*, does not reveal any particular understanding of Piero's art on the part of his local descendants, who learned of his principles from Vignola, in an already distorted form.

For Italian writers and travelers of the period, Piero's image was growing ever fainter and more distant, on account of the reasons already set forth

Roberto Longhi

regarding the earliest period, to which must be added the transformation of esthetic ideals in the seventeenth century; the growing provincialism, if not of art itself, at least of artistic culture outside the major centers; the increasingly unfavorable view of the fifteenth century that was the consequence of this provincialism; and the specialization of painters into branches or genres, leading to an ever more narrow and exclusive interest in perspective as nothing but a ready-made system for the use of the *quadraturisti*.

It is nonetheless true that the always lively interest in the dispute between Florence and Venice would have identified the Master of Borgo as the fundamental point of unity between the two, had that point been sought. But only a sense of history typical of far more recent times would have made that possible—a sense lacking, as we have seen, in Vasari, and also in his opponents, the defenders of Venetian art.

In the sixteenth century, RIDOLFI (1648) and BOSCHINI (1660-64), both of whom had a far deeper understanding than Vasari of earlier Venetian painting, wrote in powerful opposition to the latter's entirely false judgment on Bellini, who, Vasari says, "because he had not studied antique things, was very much in the habit, or rather, did nothing else than portray whatever he painted from life, but in a dry, crude, effortful manner." Ridolfi recognizes that Giovanni possessed an "exquisite and sweet style," a "certain delicacy and sweetness"; while Boschini, even more acutely, notes Bellini's "good grounding in perspective" and, in the effect made by the painter's work, a "flowering springtime" that seems the distant prelude to the "deep garden" that the decadent writer Gabriele d'Annunzio was to see in the Arezzo frescoes. Nonetheless, they do not think of trying to get back to the first moment of unity between the two schools; if anything, they return to the naturalistic explanation of Vasari, with his fables about Antonello's having stolen the secrets of oil painting from Van Eyck, and Domenico Veneziano from Antonello. They fail to understand that behind this apparent explanation, poised between black magic and materialism and based on the "great secret" of "oil," they have missed the true explanation of the moment when fifteenth-century Italian painting reached, in Piero della Francesca, its classical apex— the moment at which Venetian and modern painting discovered its best foundations.

Such an explanation is not forthcoming from them, nor from the other historian who set out to recapitulate, in an ample treatise, the lives of all the painters: I am referring to BALDINUCCI, who is silent regarding Piero and so many other great fifteenth-century painters. It would be equally useless to seek such an explanation in BELLORI, the pretentious theorist of academicism; if he mentions Piero among the "painters called by Pope Julius II to paint the

rooms on the upper floor [in the Vatican]"—thus adding another chronological error to those of Vasari—he can do no better than to place him among those early painters who, "although they had made much progress, still had not dissipated the shadows," etc. It would be equally vain to seek new illumination from the provincial historians of the period, even if we might have hoped for something from SCANNELLI who, being from Forlì, had a certain local affection for Melozzo. Nor can we find anything in the first guidebooks which, in Rome, manage to confuse Piero with Melozzo, and thence with Benozzo [Gozzoli], while the guides to Bologna and Ferrara seem to have lost even the faintest trace of the painter from Borgo. We do not know whether the loss of the manuscript of Gioseffo Montani, written around 1660, represents a grave loss for the study of Piero's reputation at the time; referring as it does to the painters of the state of Urbino, it may, perhaps, have contained some memories of our painter's activity.

The only seventeenth-century compiler who, unlike Baldinucci, does not forget the great master is the German SANDRART. Naturally, he relies upon Vasari; but it is noteworthy—and, perhaps, explicable on the basis of his specialization in "nocturnes"—that he puts his finger on the painter's best work when he begins his life of "Petrus Franciscae de Castello S. Sepulchri" as follows: "Operibus nocturnis celebris erat et scenographicis." Unfortunately, matters end here, since it is hard to imagine that the phrase "imagines autem iconicas ad vivum dextre repaesentavit" is more than a disguised version of Vasari's mention of the portraits of the Bacci and other Aretine personages included in Piero's Arezzo frescoes. It is true that the portrait diptych of the Duke and Duchess of Arezzo had passed to Florence around 1631, following the death of Francesco Maria II, right at the time of Sandrart's Italian journey (1630-35); but it does not strike us as likely that he had had the opportunity to see and identify it. Sandrart's brief *Life* is also important as the source of the few bits of information to be found in foreign artistic reference books of the eighteenth century, for instance, that of LACOMBE.

The mention of Piero inserted by FILIPPO BUONARROTI into his *Osservazioni istoriche sopra alcuni medaglioni antichi* of 1698 sounds quite cursory. It refers to Piero's importance as the founder of the theory of perspective, and—as Mariotti also believed to be the case—the source must certainly have been Danti. Buonarroti in turn becomes, we believe, the source of that passage, in PASCOLI's introduction to the biography of the "architectural" painter Pier Francesco Garoli, where Piero is remembered as the patriarch of perspective. Buonarroti takes the opportunity to propose a chronology of Piero's life, basing his arguments upon the references in Pacioli. His conclusions, nearly the same as those reached by Harzen in 1856, were shown to be incorrect only

fifty years ago, when Corazzini rediscovered Piero's death certificate of 1492.

More noteworthy is the attention devoted by BARUFFALDI, at the end of the seventeenth century, to Vasari's words in the first edition of the *Lives* regarding Piero's importance for the Ferrarese school. He tries to go more deeply into the matter, but with rather unhappy results. We see him claiming that Piero was called to the city under Borso d'Este, and identifying Schifanoia as the palace where the artist drew certain things that he did not finish, "on account of a great trembling that came on him in his hands (perhaps provoked by his having spent too much time with his brushes in hand on the plaster of the wall)." Baruffaldi thinks that the work was then taken over by Tura. As we shall see, this misinformation was still being seriously discussed by many nineteenth-century scholars, who attributed several of the Schifanoia frescoes to Piero, until a better opinion came back into favor.

The second half of the seventeenth century had been the period when Italian painters traveled much; their taste, however, had strayed so far from the events of the fifteenth century that it would be pointless to seek memories of Piero in Scaramuccia or Barri. The eighteenth century is, instead, the period of the elegant voyages of the cultivated and rich English "antiquarians" and the very presumptuous French painters; but Borgo San Sepolcro, like Arezzo, was off the coach routes of the time, as well as being far from its tastes. For example, in the *Nouveau Voyage d'Italie* (published at Lyons in 1691), among the few and erroneous mentions of primitive works in Rimini, there is no reference to Piero's fresco. And even though people are used to attributing the rediscovery of the primitives to these English travelers, and to Richardson in particular—it would be worth expressing some reservations on this point—it is certain that no such credit can be granted them when it comes to Piero della Francesca. If Piero's name, which had completely vanished from the little lists appended to the quite noteworthy writings of M. de Piles, reappears in the *Historical and Chronological Series of the Principal Professors of Painting* appended to RICHARDSON's *Works*, this is because Piero was said by Vasari, in the Giuntine edition, to have been the teacher of Signorelli, whose fame still lived on; and every good Englishman, before coming to Italy, consulted his Vasari. It is well known what widespread use the Anglo-Saxons still make of such genealogical tables of the history of painting even today, although they now look for relationships between painters that go rather deeper than the ones they used to derive back then from the simple status of teacher and pupil.

And let us not forget that there was, in reality, nothing to rediscover, because Vasari was readily available and one visited Florence under the guidance of Cinelli, as Richardson himself does not fail to note. These factors, along with the English interest in collections of drawings and prints (an inter-

est that also existed in Italy, as the typical example of Padre Resta shows) seem to us to explain, among other things, the references to Baldovinetti and Pollaiuolo in Florence.

The prevailing taste, both among the English and in Italy, was nonetheless the one set by the most cultivated literary tradition, as established by Bellori and Félibien. Ancient statues and Raphael came first, then Correggio and the Venetians, and you can just imagine what they made of the fifteenth-century painters. If Richardson mentions Melozzo's work in the church of the Santi Apostoli, he does so on account of Luti's having told him that Correggio had drawn inspiration from it when painting the cupola of the Duomo in Parma. With Joshua Reynolds (1749-52) things get, if anything, even worse. It is true that, as a thoroughly grounded and traditional artist, he did not omit the obligatory visit to the Brancacci Chapel in the church of the Carmine; as for the rest, however, all the other primitives, so abundantly cited by Richardson, vanish completely from his field of vision; Reynold's outing to Arezzo was the result of his love of Baroccio, and not of any interest in Piero's frescoes. In the painter Cochin (1758), indifference to the fifteenth century reaches a kind of sorry perfection, which remains scarcely less perfect in the very famous travel book by Lalande (1765-66).

Credit for the slow rediscovery of Piero goes to local Italian historians and to the industrious erudition of commentators on Vasari, who brought together the material for the excellent evaluation of Piero which Lanzi was later to provide, in contrast with the superficial information offered by Padre ORLANDI who—in his sadly famous *Abbecedario* of 1704—devotes just a few lines to Piero. In some of these lines, which are full of mistakes, he discusses Piero's theoretical works and the plagiarism issue, while the few others which he devotes to the paintings are nearly incredible: "He painted fine and bizarre stories."

In 1754, MARCHESELLI offers the first information regarding the Rimini fresco, although the inscription and the date are incorrectly transcribed—an error which was to be repeated by Oretti, Lanzi, and even some modern writers. In 1756, in his biography of Signorelli, MANNI finds numerous opportunities to mention the Master of Borgo, and even to exaggerate the meaning of Vasari's text. Where Vasari had said that Luca Signorelli "did [Piero] more honor than did all the others," and that "in his youth he studied very hard in order to imitate the master, and even to surpass him," Manni—who was evidently not very familiar with Piero's works—concludes: "What is certain is that Luca far surpassed him, especially in the painting of the nude." In his Roman edition of Vasari (Pagliarini, 1759), BOTTARI adds some good commentaries, proposing, among other things, an intuitive identification of

Roberto Longhi

Pietro Perugino as the Piero da Castel della Pieve mentioned by Vasari as one of Piero della Francesca's disciples—an intuition far from obvious at the time, and never before set forth. Bottari's notes are taken over and expanded in the Livornese edition of Vasari in 1767 and again by GIUSEPPE PIACENZA in 1770, who republishes Vasari's text as a complement to his new edition of Baldinucci. It is true that Piacenza complicates the issue of Piero's sojourn in Ferrara by introducing new errors of chronology; but he also offers some not unimportant information regarding the current state of certain works by the painter. The frescoes in San Francesco at Arezzo are largely ruined, he says; the *Prayer in the Garden* at Sargiano, mentioned by Vasari, is "still partly visible," while he believes the paintings in Perugia to be lost.

In 1775, DOLCI, in a manuscript containing a *Distinto ragguaglio delle pitture di Urbino*, records the presence in the cathedral there of the *Flagellation*, which seems to have been attributed to Mantegna at the time; but this reference will only be more widely publicized in 1822, by Pungileoni.

The question of Perugino's discipleship is dealt with in detail (1788) by the very subtle MARIOTTI who, correcting Piacenza's error, also mentions the *Perugia Polyptych*, already cited in the meantime by ADAMO CHIUSOLE in his *Itinerario delle pitture d'Italia* (1782).

And now we arrive at the incomparable—for the period—Abbé LANZI (1789). With all the academic limitations forced upon him by the tradition established by Bellori, but aided by an unbelievable erudition accompanied by an authentic gift for connoisseurship, he takes the first decisive step since Vasari. Tempering the historic conception of Italian art with the good judgment of his enlightened century, he confers beautiful proportions upon that conception, agreeably balancing personalities and circumstances of time and place.

As for the specific matter at hand, Lanzi brings Piero into the foreground. Although it is clear (and this is the only criticism one may offer of him) that he doesn't know the paintings at San Sepolcro very well, his evaluation of Piero is altogether novel, and far more "historical" than Vasari's. He praises the Arezzo frescoes; he sees in Piero an anticipation of Perugino and Raphael; he accepts Mariotti's opinion that Perugino was trained by Piero; he intuits that Piero's natural predecessors were Brunelleschi and Paolo Uccello; and he even goes so far as to emphasize the master's analogies with the Greeks, "who made geometry serve painting." As for Piero's influence, he perceives the mixed Pieresque and Paduan background of the Ferrarese artists, adding that he even suspects Bramante and the Milanese artists of Bramante's time of having learned something from him. It is worth noting that Lanzi arrives at this last conclusion without knowing the passage by Fra Sabba Castiglione; just as,

without knowing Maffei's old attribution, he proposes the good hypothesis that the Vatican fresco showing Platina before Pope Sixtus IV is not by Piero, but by Melozzo.

Compared with such luminous results, achieved after two centuries of almost complete silence, and at a time when some of Piero's most important works, such as, for example, the Borgo *Resurrection*, were still plastered over, what does it matter that Lanzi consistently confuses Piero with Fra Carnevale, or that he accepts the Santa Chiara *Assumption* as a work by the master, or that he makes an error regarding the Rimini fresco, or that there are mistakes in his chronology of the painter's life? After Vasari's lofty but historically limited evaluation, Lanzi's is the first to reconnect with Vasari and to go beyond him, marking a crucial moment in the history of criticism of Piero—a moment, however, that nineteenth-century culture wrongly ignored, with the result that its perception of Piero remained, for a long time, inferior to Lanzi's.

After Lanzi, the series of local studies resumes. For example, in 1794 the Rimini fresco is studied, with no more errors, by BATTAGLINI in his little volumes on the life and the literary court of Sigismondo Pandolfo Malatesta, and by ZANI in his *Enciclopedia artistica*, where he also debates the issue of Luca Pacioli. The same year, 1794, also brings us the truly instructive story of a missing reference. STENDHAL has the opportunity to be present when Bartolomeo della Gatta's *Saint Jerome* is being moved from a chapel in the Duomo into the sacristy; but this occasion in no way induces him to take any notice of Piero dei Franceschi, who doesn't even exist in his *Histoire de la peinture en Italie*, even though much of the latter work is copied straight out of Lanzi. Piero appears only in an appendix, in a chronological chart, next to the incomprehensible date 1443; while Masaccio, on the other hand, has been omitted from the chart.

In 1821 CICOGNARA sides so strongly with Piero against Pacioli as to add in the margin of his famous catalogue, when citing Pacioli's *De Divina Proportione*, an almost excessive gloss: "Piero della Francesca must be regarded as the author of this precious book." While he rightly challenges Buonarroti's chronology, itself based upon the shaky deductions found in certain passages of Pacioli, he accepts the alternative version offered by Bottari and Lanzi, by whom Vasari's date of 1458 is wrongly supposed to refer to the onset of the painter's blindness.

In 1822 there appear the first authentic documents concerning the artist: the ones published by PUNGILEONI in his *Elogio di Giovanni Santi* regarding Piero's stay in Urbino. The discussion of Piero's works broadens. There also appear the first attributions. Following in the wake of Dolci and Vernaccia, Pungileoni draws attention to the little panel of the *Flagellation*;

but he errs in failing to reject the attribution to Piero, proposed by Dolci, of the six *Apostles* then in the sacristy of the Duomo of Urbino and now in the Gallery there. He also fails to clear up the problem of Fra Carnevale, to whom, on the basis of the panel showing Saint Bernardine, he nevertheless ascribes— very logically, given the state of knowledge at the time—Piero's *Sinigallia Madonna*, describing it, very inappropriately, as a "sketch" for the aforementioned panel. He then proceeds with his own attribution to Piero of the polyptych in the sacristy of the church of San Bartolomeo, previously given by Lanzi to Antonio da Ferrara; Pungileoni bases his erroneous demonstration upon a comparison with the panels surrounding Piero's *Baptism* at Borgo San Sepolcro, which were also regarded as Piero's work; and we have already said [in *The Art of Piero della Francesca*] that this belief was the original cause of the legend according to which Piero's training was supposed to have been Sienese. One thing, at any rate, is clear: scholars of the time were beginning to make the journey to San Sepolcro more frequently, and were trying, with varying results, to enter into the peculiarities of Piero's forms.

At around the same period when Pungileoni offered his attributions, the painters Benvenuti and Montalvi gave to Piero the *Servite Altarpiece* at Borgo San Sepolcro (an ascription strangely accepted by Passavant). In 1826, the historian Mancini, who lived in Città del Castello, attributed to him the *Coronation of the Virgin* then in his possession, a work later correctly given by Cavalcaselle to the school of Ghirlandaio.

In the progress of local historical writing about Piero, this same MANCINI nonetheless played a most important role. During the years when D'Agincourt and von Rumohr either neglected or actively mistreated Piero's memory—which was already showing signs of revival, thanks to the Romantic taste, and generally favorable to painters prior to Raphael—Mancini usefully added to his *Memorie degli artefici di Città di Castello* an appendix in which all of Piero's principal works are precisely indicated—even some little panels in the church of Santa Chiara, the remains of which are perhaps to be recognized in the two saints in the Liechtenstein Collection. And as for criticism of the works, if he does not understand that the panels surrounding the *Baptism* are not from Piero's hand, he is still the first to assert that the *Assumption* in Santa Chiara, "which some say is by Piero della Francesca," seems to be "more probably of the school of Pietro Perugino": a truth which was to be generally recognized only in Cavalcaselle's time.

We have mentioned D'AGINCOURT and VON RUMOHR. The former, in his *Histoire des Arts par les Monuments*—in so many regards a noteworthy book—twice lets slip a good chance to meet up with Piero: initially when he rediscovers Lorenzo da Viterbo, and again when, misled by an erroneous read-

ing of a passage in Pacioli's *Summa*, he turns Melozzo da Forlì into a disciple of Mantegna. As for VON RUMOHR, with all the credit he deserves for his role in the rediscovery of fifteenth-century Italian painting, we can never suffi-ciently regret the grave error he commits in his evaluation of Piero. After the very high station assigned to Piero by Lanzi, it seems nearly incredible that to the German—the discoverer, along with D'Agincourt, of Lorenzo da Viterbo—Piero seems little more than an indecipherable legend and, even worse, one not worth the trouble of deciphering.

There is, in fact, no doubt that Rumohr's unfavorable judgment great-ly delayed not only the progress of a more favorable evaluation, but even that of historical research regarding the specific questions surrounding our painter's works. Rumohr actually goes so far as to doubt Vasari's attribution to Piero of the Arezzo frescoes: "mannered works," he says, "that can have influ-enced neither Perugino"—the issue at hand was, precisely, a weighing of the opinions of those who said that Piero had been Perugino's teacher—"nor the general development of art at the time." One may only hope that a trip to San Sepolcro might likely have led Rumohr to change his mind; but it is serious enough that the Arezzo frescoes did not suggest to him that he make such a trip.

The resurrection of Piero's reputation thus proceeds though alterna-tions of favor and denigration. In the several editions of his *Abbecedario*, TICOZZI certainly goes beyond Orlandi, devoting more attention to Piero. But the only work he specifically cites is the fresco in the Floreria depicting the faithfulness of Taja (giving, besides, a very inexact account of the subject mat-ter), a work in which Lanzi, as a good connoisseur, had already recognized the hand of Melozzo. In 1831-33, VALÉRY'S *Voyages . . . en Italie*, one of the most widely consulted books of the time, does not include the excursion to San Sepolcro and, upon reaching Arezzo, mentions only the *Magdalene* in the Duomo in these words: "a skillful Saint Mary Magdalene . . . by Pierre della Francesca, a great Florentine artist of the fifteenth century who lost his eye-sight at the age of 34." Here, the fact of Piero's being considered a Florentine artist is not intended to refer to Lanzi's discussion of Piero's dealings with Florence but instead goes back to Lacombe's list, still in common use at the time although written in the mid-eighteenth century, where Piero is also described as an "artiste florentin"—a deduction, we believe, based upon the prominent place that Piero's life occupies in the works of Vasari and Sandrart.

At this point in our story, we must not forget that the Romantic movement's general interest in the fifteenth century may have led historians to seek out Piero's works with greater ardor. There also exists an archival Romanticism. For example, local philology offers, in a little volume published

in 1835 for use as a wedding gift, a reprint of Vasari's *Life*, annotated by DRAGOMANNI; the book has its perfect counterpart in the Romantic painting of the time, more precisely in the frescoes in which Chialli perpetrates, on the walls of the Casa Marini-Franceschi in San Sepolcro (ca. 1830) two delightful historical falsehoods: *Piero and Pope Nicholas V* and *Piero Dictating the De Prospectiva to Luca Pacioli*. What is more, the international clan of painters was also beginning to take an interest in Piero, as is shown by the watercolors that Ramboux made of the Arezzo frescoes, just at the time when Rumohr was denigrating their worth; and this was a stroke of luck, because, even if they display only a mediocre comprehension, these watercolors can give us a summary idea of the frescoes in the passages that are, today, the most heavily damaged.

To go on: while PUNGILEONI and GAYE speak their pieces in the diatribes regarding Pacioli, and while NAGLER, in his *Dictionary*, takes into account all the most recent research, including Dragomanni's, regarding the works at San Sepolcro, there apears in Italy, between 1827 and 1839, the most regrettable *Storia della pittura italiana* by the purist ROSINI, who couldn't even write grammatical Italian.

Except for the use that can be made of certain plates included in this horrible book—which, on account of their rarity, fill modern researchers with delight—this is, beyond any doubt, the lowest point ever reached by Italian criticism. Piero is mentioned in the pathetic, honeyed, rhetorical preface to the *Epoca seconda*, where Angelico "raises, by his precepts and example, Gentile da Fabriano and Gozzoli to the second level of art . . . Third after them comes, with correct draftsmanship, truth in coloring, and simplicity of manner, that mysterious artist from Borgo San Sepolcro, whose few surviving works must make us regret the many that have been lost."

All this verbiage is intended to reach the conclusion that none of the three artists "had that grandeur of form that Masaccio inspired in Fra Filippo Lippi"; so the period as a whole is called "From Fra Filippo to Raphael." Leaving aside the diminution of Piero's stature with respect to the old judgment regarding him offered both by Vasari and, forty years before Rosini, by Lanzi, one might almost wish to praise this tendency to place Piero among the Florentines; but this placement is only apparent. It soon reveals itself to be a consequence of Rosini's division of artists according to "epochs" rather than "schools," and therefore marks a step backward rather than forward. When Rosini reaches the point where he must speak in detail of our artist, he can only hypothesize, upon examining the *Triumphs* on the back of the portrait diptych of the rulers of Urbino, that Piero must have been a pupil of the miniaturists of Perugia or Gubbio, for example of Matteo di Ser Cambio;

although this is in no way to deny Rosini credit for having drawn scholars' attention to the diptych, which Kugler, writing in the same period, does not even mention. But his critical discernment, when faced with the works, is almost nil, even if he displays a greater familiarity than does Lanzi with the pictures at San Sepolcro. In his opinion, the best part of the *Misericordia Altarpiece* is, precisely, the predella, to which Piero never set his hand. As for the Rimini fresco, which is signed, and the Borgo *Resurrection*, a work still very famous in Vasari's day, he doesn't believe them to be by the master but, instead, by Perugino. Nor does he see any reason to refute the hypothesis that a part of the Schifanoia frescoes [at Ferrara] may be by Piero. Rosini's only claim to praise is his ascription to the artist's early years of the Urbino *Flagellation*.

Almost contemporarily with Rosini there was published in Berlin, in 1837, the not unpraiseworthy and for many decades to follow unsurpassed, handbook by KUGLER As is well known, Kugler intended to present, so to speak, the scientific results of the Romantic taste as they had taken shape in the figurative arts since Wackenroder's time. It is therefore logical that the space devoted to medieval art and the primitives is, proportionally, much greater than in Lanzi; but, except for the resulting imbalance, it does not seem to us that the old ways have here been completely abandoned. Piero, at any rate, doesn't benefit much from the change. The treatment reserved for him is altogether summary; his art is said to combine Paduan, Umbrian, and Florentine forms. The insertion of this new Paduan source for Piero's art will be picked up, shortly afterwards, by Burckhardt, for whom Piero will unexpectedly become a Squarcionesque. EASTLAKE, translating Kugler's manual into English several years later, had space enough only to include a note saying that our artist might perhaps have deserved to be mentioned at greater length, citing also the Borgo *Resurrection*; but he had, by that time, certainly been influenced by the research of Passavant.

Dating from 1839, PASSAVANT'S monograph on Raphael was, in fact, the first book of the nineteenth century to be based exclusively on rigorous scholarship. In it, and more precisely in Appendix III concerning the painters working in Urbino, the writer has occasion to recapitulate all that is known about Piero.

The importance for criticism of Passavant resides in his having refuted Rumohr's unpleasant comments, in insisting on Piero's connection with Florentine painting, in particular with Masaccio, as already glimpsed by Lanzi, and in having noticed, in parts of the *Flagellation*, the connection with Flemish painting. Compared with this creditable showing as a true historian, the part based upon his pretenses to connoisseurship strikes us as rather less

felicitous. Here are some examples. The annotators of the German translation of Vasari (SCHORN and FÖRSTER) had proposed that, in the diptych in the Duomo at San Sepolcro, only the *Baptism* was to be ascribed to Piero; Passavant takes no position on the matter, instead expressing himself in a generic way regarding the work, all of which strikes him as quite weak. Accepting Benvenuti's attribution to Piero of the *Assumption* in the church of the Servites (which Passavant dates to Piero's earliest style) and stating that the predella of the *Misericordia Altarpiece* is entirely by the master's hand, he takes on particular responsibility for the formation of the opinion that the Master of Borgo had received a Sienese training. He thus falls into the error, quite common in the art criticism of the last century, of believing that one of two different stylistic tendencies appearing in spatial contiguity and, let us grant, in temporal succession, must be considered the consequence of the other, in accordance with the concept of "progress." Sienese art, appearing near Piero's, looked like its "precedent," or else like the youthful period (meaning "primitive") of Piero himself.

Another specific problem, regarding which Passavant did not succeed in getting beyond the confusion that had lasted from Vasari to Lanzi and to Pungileoni, was that of the relationship between Piero and Fra Carnevale; it was only much later that research was to scale the latter down into a near nonentity. Passavant does not doubt the attribution to Fra Carnevale of [Piero's] altarpiece, formerly in San Bernardino [in Urbino and now in the Brera, Milan], which Lanzi, too, had described, not very happily, as "deficient in perspective."

And yet, even in those times there was someone who, on purely stylistic grounds, aimed at attributing the *Brera Altarpiece* to Piero della Francesca; we learn of this from Padre VINCENZO MARCHESE, in his *Memorie dei Pittori Domenicani*, of which the first edition dates from 1845. Unfortunately, Marchese does not reveal the name of the "learned man" who had proposed the new attribution; and naturally, he himself [as a good Dominican] opposes it. The same Father Marchese, along with PINI and the two MILANESI, collaborated on supplying the new Le Monnier edition of Vasari's *Lives* with a good summary of recent scholarship on the painter from Borgo.

But a writer who shortly afterwards (1851), and with greater understanding, touched repeatedly, and with greater understanding, upon Piero was the learned English dilettante LORD DENNISTOUN, in his precious *Memoirs of the Dukes of Urbino*: seemingly a work of historical research, but one whose author is motivated by prevalently artistic and literary interests. He was, in fact, a follower of Ruskin's movement in favor of the primitives, and con-

tributed to that movement, in his book, some observations that remain far from ineffectual.

Let us here cite some of the passages that are most important for an understanding of Dennistoun's attitude toward Piero.

While Passavant had briefly mentioned the Uffizi diptych without offering any appreciation of it, Dennistoun examines it carefully and, often, acutely. To the Rimini fresco (even if he repeats the false date 1445) and the Arezzo frescoes he devotes several enthusiastic passages where such words as "broad, masterly in conception, flowing pencil," etc. show that the author has already become aware of the grandly pictorial character of Piero's work; and that its historical importance has not escaped him, either, is proved by the insistent comparisons between Piero's compositions and those of Raphael.

Less successful is his research regarding the painter's origins. Dennistoun is "puzzled" by the archaic and minute appearance of certain works believed to be by Piero (and which were probably, in large part, the portions by other hands in the paintings at San Sepolcro). Instead of omitting them from Piero's opus, he falls under the influence of Rosini's criticism and distinguishes two styles in Piero: the first related to Ottaviano Nelli [of Gubbio], Gentile da Fabriano and contemporary Umbrian painters; the second, broader and grander. He completely misses the importance of the dealings, ascertained only a short time before, between Piero and the Florentine school and the significance of Vasari's references to Piero's association with Domenico Veneziano. He also tries to propose some new but utterly untenable attributions to Piero. These include the two little panels in the Barberini Collection later given to Fra Carnevale and Laurana; the portrait of Duke Federigo and his son then commonly ascribed to Mantegna, later to Melozzo or Justus [of Ghent], but certainly by Berruguete; and the lunette with the *Mystic Marriage of Saint Catherine* over the portal of San Francesco at Mercatello.

As for Piero's activity as a theorist, he does not particularly dwell on it, but he is the first to indicate the existence of the *Libellus de quinque corporibus* in the Vatican; he cites its dedication in full; but he errs when he thinks that the treatise on perspective—which was known to such scholars as Bossi and Zani—can be identified with another, anonymous essay on perspective coming from the Urbino collections. As for Piero's followers, it is significant that Dennistoun, without getting to the bottom of the question, nonetheless places Fra Carnevale (to the extent anything was known or believed about him) within Piero's circle—something that Passavant had forgotten to do.

Lord Dennistoun's noble interpretation—along with the notes whereby Eastlake had rendered Kugler's "Romantic" treatise more "Humanistic"

where Piero was concerned—spread rapidly through European culture, creating ever greater interest in the artist. And this interest was reflected in the practical details of figurative culture, as in research and in the movements of works, their evaluation in economic terms, and their first appearances in travel guides.

In 1850 there entered the Accademia gallery in Venice, as part of the Hellmann-Renier bequest, the little panel of *Saint Jerome*; in 1855, the work is already mentioned, along with the others in San Sepolcro and Arezzo, in the Hachette guide to Italy, written by DU PAYS. Meanwhile, the new English collectors succeeded in bringing home some of Piero's original works. The Chapter of the Duomo of San Sepolcro sold, for 23,000 lire, the *Baptism of Christ*; having passed through various hands, the work entered the National Gallery in London in 1861. There also entered the same museum, in 1867, the *Saint Michael Archangel*, formerly in the Eastlake Collection; and, in 1874, after having passed through the hands of Florentine dealers and English collectors, the *Nativity* formerly in the Casa Marini-Franceschi.

For the history of the cash values assigned to Piero's works in comparison to those of other fifteenth-century painters or of artists of other periods, it is most interesting to look through the catalogue of artworks of the Marches and Umbria written in 1861 by CAVALCASELLE in collaboration with MORELLI. The two famous adversaries agreed to co-operate on this youthful project of theirs, translating into numbers the taste of the time, according to a scale of values which it will be worth our while to sample. Perugino's works are generally valued in hundreds of thousands of lire; the *Madonna of Sinigallia* (said in the catalogue to be by Piero or Fra Carnevale) is estimated at 2,500 lire; the Urbino *Flagellation* is rated at 15,000 lire, against a value of 30,000 lire assigned to Baroccio's *Martyrdom of Saint Sebastian*. These are figures that have a lot to say about the history of taste.

Meanwhile, GAETANO MILANESI was already at work, seeking out Tuscan documents that would provide precious information about Piero, among others. Even earlier than 1856, in fact, he informed HARZEN of the revelatory document in which Piero appears in Florence, working with Domenico Veneziano in the church of Sant' Egidio. It is regrettable that BURCKHARDT—who already in 1847, preparing the second edition of Kugler, had devoted more space to Piero than had Kugler in the first edition—did not have time to meditate on this document before publishing his *Der Cicerone* in 1855.

In this last-named book Piero's situation—admirably set forth by Lanzi at the end of the eighteenth century, further refined by Passavant, ennobled by Dennistoun—is curiously diminished and misinterpreted. It is true

that to Burckhardt, von Rumohr's unfavorable opinion of Piero "seems an enigma;" but what are we to make of the incredible opinion that now places Piero della Francesca among the followers of the [Paduan] Squarcionesque movement, and of the quite inappropriate, if generally positive, account of the Arezzo frescoes?

In truth, German criticism prior to Vischer's book on Signorelli (1879) cannot boast of having played any truly meritorious part in the revival of Piero's fortunes, nor in the matter of specific attributions. It will be enough to say that neither Burckhardt nor Harzen (1856) rules out Piero's having worked at Schifanoia. As for the German historians' curious obstinacy in placing Piero close to Mantegna, this is not only a product of their inaccurate reading of a passage in Pacioli but also, and above all, of the entirely exterior fashion in which they set about establishing the affinities between the various fifteenth-century artists. In this specific instance, the kinship between Piero and Mantegna was deduced from the interest that both had always displayed in perspective and in certain details of Classical art. Proceeding in such a way, these historians even managed to confuse the works of the two artists; for instance, Harzen attributes the Brera's strongly Mantegnesque *Saint Bernardine*, which is perhaps the work of Bonsignori, to Piero della Francesca.

And yet, the same writer, quite unlike Burckhardt in this regard, does not fail to make certain observations regarding the differences between the two artists, noting that Piero was the more gifted in painterly terms. Some of his phrases are almost felicitous: "das Furchbare und Gewaltige Mantegna's erscheint bei Piero sehr moderirt un vielmehr feierlich und wuerdewoll . . . " This is, perhaps, an echo of Dennistoun's judgment. As for Piero's chronology, Harzen repeats, on his own account, the erroneous calculations already made by Buonarroti, arguing on the basis of Pacioli's silence. Piero's death is thus still placed after 1509, although Passavant had already thought it wiser to base his dates only upon the information given in Pacioli's *Summa* and, establishing 1494 as a *termine post quem*, had come closer to the truth.

We will not discuss, among the historians of the period, RANALLI (1856) who, in his *Storia*, offers only paraphrases and manipulations of Vasari's account. It is necessary, however, to devote some attention to Selvatico and Rio.

The Catholics of the Latin countries found themselves, in this regard, at a disadvantage even in comparison with such a Puritan as Dennistoun. Wishing to offer a mystical interpretation of painting before Raphael but faced with the naturalistic interpretation of the Renaissance coming from Germany—which considered perspective, in particular, as a scientific adjunct to naturalistic research—they either indulged in contorted compromises, as

did Selvatico, or else did not hesitate to condemn Piero ever more severly, as did Rio.

SELVATICO deserves credit for having followed up Lanzi's work in linking Piero with all the Florentine students of perspective; but he also has the defect of having concluded that perspective, being nothing but a science, could not but harm the expression of ideas and sentiments. Nor must we expect of him anything new in the way of specific details of critical research. From the texts of his academic lessons, collected in the *Storia estetico-critica delle arti del disegno*, it is clear that this very feeble Italian Hegelian was entirely unacquainted with the frescoes in Arezzo.

RIO, a more seductive writer than Selvatico and also, usually, one given to subtly captious statements, justifies his unfavorable opinion of Piero by using the false keys of the most banal historical materialism. The fact that the master had been invited to work by a Humanist Pope, Nicholas V, and by an evil prince, Sigismondo Malatesta, is terribly distressing to this writer, who does not fear to draw from these circumstances all the deductions that his honeyed pietism led him to find plausible regarding the character of art. Piero, "because he emancipated himself too late from this patronage and from that of the Este family at Ferrara, was afterwards able to cultivate with any success only that part of his art that dealt in Naturalism," which is to say, "historical compositions." For Rio, "historical compositions" is thus the term that describes both the Vatican frescoes and those at Arezzo! We think it would be cruel to dwell upon the superficiality of such a conclusion. It will be enough to note the immense superiority of Dennistoun's evaluation of the Rimini fresco as an expression of "the spiritualised grandeur of a noble devotional composition" to Rio's regarding the same work: a true "profanation," to which Piero "had the misfortune to set his hand."

There is no need to demonstrate how such apparently innocent divagations on Rio's part were sometimes the product, sometimes the cause of frequent historical inaccuracies: some of these were pointed out and corrected by none other than a Dominican, the already cited Padre Vincenzo Marchese.

As we have already said, the admirable students of the archives of Tuscany were already at work. While Gaye had dug up nothing new regarding Piero for his *Carteggio* of 1839, so that even the commentaries in the Lemonnier edition of Vasari of 1848 seem out of date, GAETANO MILANESI— after having supplied Harzen with the precious document of 1439—himself published in 1862, in the *Giornale storico degli archivi toscani*, documents from 1466 and 1468 regarding a standard for the Compagnia dell'Annunziata of Arezzo: documents that are important, in part, because they cite Piero as the author of the famous frescoes in the church of San Francesco. In 1875, a

local scholar from San Sepolcro, CORAZZINI, published a document of 1478 that greatly reduced the duration of the period of Piero's blindness, and the artist's death certificate of 1492, thus putting an end to the complicated calculations with which the pedants had busied themselves. The town of San Sepolcro was thus in a position to affix to Piero's house, in 1876, a commemorative plaque containing no factual errors. Milanesi did not have time to make use of Corazzini's documents in the short biography—not devoid of mistakes—that he wrote as a preface to an example of Piero's handwriting published in *Scrittura di Artisti Italiani*. He did, however, use those documents shortly afterwards (1878) in order to update the commentaries on Vasari in the new Sansoni edition; and he also made use of new documents from 1454 and 1469 regarding the altarpiece for Sant' Agostino, and of the will of 1487. He published these documents, in their complete form, between 1885 and 1887, in the Roman periodical *Il Buonarroti*, adding the very important document of 1445 in which Piero receives the commision for the *Misericordia Altarpiece*.

Meanwhile, the great connoisseur G. B. CAVALCASELLE—who, as we are fond of saying, was lacking only the formal course of Classical studies that would have made of him the greatest art historian of the nineteenth century— in his indispensable *History of Painting in Italy*, published first in English in 1864, then in German in 1869, and finally in Italian between 1886 and 1900, treats Piero's work with a far greater degree of security than was common among the poor antiquarians and amateurs of the time.

It must be understood that no one should expect much more of Cavalcaselle than a great security as a connoisseur; for example, we should not expect the capacity to offer a new interpretation of the Master of Borgo. In such areas of criticism, his opinions are, in general, those of the rearguard of the "progressive" eighteenth-century academicism that was still entrenched and flourishing in the Italian Academies of Fine Arts of his time, with only the slightest hint of Romanticism, and with a touch more of the naturalistic explanations advanced by the Germans.

Some uncertainty as to the definitive judgment he was to pass on the artist was thus inevitable. After having praised Piero's excellence in this or that regard many times over, he seems to conclude that "he was otherwise lacking in the essential quality of an artist, that of the choice of forms, [which he would have needed] in order to rank among the most excellent." But despite these vacillations, how precious—even for the esthetic evaluation of Piero—is the wealth of observations in Cavalcaselle's text! Let us recall only his annotations regarding Piero's relationships with Van Eyck and Alberti; the frequent comparisons with Paolo Uccello; those with archaic Greek art and with the

most painterly parts of Raphael's *Vatican Stanze*; the observations on Piero's manner of applying perspective to the human form, of handling light, etc. It would take too long to recount here all of Cavalcaselle's contributions to the reconstruction of Piero's œuvre. Even if he does not always reach acceptable conclusions as to chronology, as when—in our opinion—he places the *Flagellation* and the *Baptism* too late, it is certain that his catalogue may still serve today as a point of departure for a consideration of the artist. He is the first to decisively reabsorb into Piero's corpus the works misattributed to Fra Carnevale; and he is equally severe in excluding from the canon such works as the *Villamarina Madonna*, the Madonna in Oxford, and the female portrait in the [Milanese] Poldi Museum and the ones in London, Florence, etc. In him, almost every controversy regarding an attribution finds a wise clarification. The lateral panels of the *Baptism* and the Servite *Assumption* are returned to Vecchietta and to Matteo di Giovanni, the *Assumption* in Santa Chiara to Francesco da Castello, the Città di Castello *Coronation of the Virgin* to the workshop of Ghirlandaio, etc. And even if he is less felicitous in his conclusions regarding Piero's origins—as when, perhaps confused by MÜNDLER'S notes drawing attention to the predella of the *Misericordia Altarpiece*, then separated from the rest of the polyptych, he indulges in chasing Sienese shadows rather than denying Piero's authorship of the predella—how right are his views with regard to the Schifanoia frescoes, views confirmed shortly afterwards by documents published by Campori; and how right are his intuitions regarding Piero's followers, whom he is the first to glimpse even in the painters of [the towns of] Camerino and Gualdo and in Lorenzo da Viterbo!

A level of criticism rather superior to Cavalcaselle's may be noted shortly afterwards in the pages devoted to Piero by VISCHER in his book on Signorelli. It is true that he accepts the hypothesis of a Sienese training advanced by Cavalcaselle, mentioning [the Sienese master] Domenico di Bartolo in this regard. But his observations concerning Piero's relationships with [the Florentines] Pesellino, Baldovinetti and, above all, Andrea del Castagno are not without significance. Also noteworthy is the fact that his attention is particularly drawn to Piero's chiaroscuro compositions, such as the *Dream of Constantine* and the *Stigmatization of Saint Francis* in the Perugia predella; and that, following in Harzen's footsteps, he feels the need to emphasize the difference between Piero and Mantegna. And there is one more point that it is a shame Vischer did not choose to go into more deeply: discussing Piero's dealings with intarsia workers, he notes quite accurately the manner in which the latter developed in their own way the "poetry of perspective." Brought to bear upon Piero himself, this observation would have spared Vischer from concluding that Piero was a "derber Realist," lacking the sense

of beauty and incapable of elevating himself to a state of pure idealism on account of his need to remain rooted in the soil in a coarsely elementary fashion.

Around the same years, other Germans were trying to clarify Piero's importance in the history of perspectival theory: JANITSCHEK in 1878, SITTE in 1879. The first showed the historical significance of the master's treatise vis-à-vis Alberti; the second demonstrated how Piero's theories had an impact even on Dürer. In 1880 JORDAN, following up on the catalogue of the sixteenth-century holdings of the Biblioteca Urbinate published in 1861 in the *Giornale storico degli Archivi*, carefully examined the little codex of the Urbino collection already known to Dennistoun, who had published its dedication; Jordan carefully delineated the true extent of Pacioli's plagiarism, overstated by Vasari and very accurately reported by Danti.

It should be understood that from this point on, with research on the fifteenth century in full swing, and following the discovery of specific documents (to which we have alluded), a more or less worthy place is reserved for Piero in every one of those art-historical handbooks that from Springer's onwards went on multiplying, especially in Germany. A. LÜBKE, in his little handbook of 1876, follows Harzen's old calculations regarding Piero's chronology; he situates him historically between the influences of Florence and Padua, combining, in an obviously eclectic fashion, the opinions of Burckhardt with those of Cavalcaselle. In WOLTMANN'S history of painting, a book not without value, all the new documents are taken into account; but the interpretation of Piero's art represents a step backward with regard to Cavalcaselle and Vischer. The style of the great master is defined as petrified by science and significant for the history of technique, not of art. It is quite strange that these scholars did not realize that such a "petrification," even if it was mathematical, could not lead to the "naturalism" of which they continually accused the artist. For Woltmann, Piero's horses are "successful."

The pedants, meanwhile, go their way, with new sufferings and new sufferers. Even after Jordan's demonstration, some Italian writers, failing to take note of it, continue with their stupid generic defense of Pacioli, even coming up with false attributions to Piero in order to support it. MANZONI, for example, in 1882, uses the oldest such attribution: the one by which BALDI, in his *Lives of the Mathematicians*, gave to Piero the portrait, then in the Palazzo at Urbino, of Pacioli explaining the regular bodies to the young Guidobaldo [da Montefeltro]. But as Gronau later demonstrated, the panel must be identified as the one in the museum in Naples, which was signed by one "Jaco. Bar." in 1495; it was thus painted after Piero's death, probably by a non-Italian imitator of Melozzo or Berruguete. It was also Manzoni who

raised the microscopic question of Piero's exact family tree: a debate which has continued, alas, down to our own time, with the victory of both sides.

Absolutely without merit is the critical study of Piero dei Franceschi by L. GIUNTI (1887); and the same may be said of the study with which VERNARECCI tried to answer him. The two did battle, naturally, over the story of the plagiarism, proving that they did not know of Jordan's demonstration. In 1888 a citizen of San Sepolcro, PICHI, reprinted the document previously published by Milanesi regarding the *Sant' Agostino Altarpiece*, with the sole objective of proving that the *Assumption* in the church of Santa Chiara was by Piero; as we have already said, this is an indefensible attribution. Woltmann had already made a similar attempt a few years earlier.

The large volume on Melozzo da Forlì published by AUGUST SCHMARSOW in 1885 is full of numerous and sometimes interesting observations; it is a weighty mixture of idealism and materialism, as is all the scholarly work of this noteworthy German historian.

Schmarsow's esthetic interest in Piero's art is evident in his insistence on Piero's "earthly realism," in his seeing in him the precursor of "modern truthfulness," in his recognition of Piero's capacity to treat appearances objectively, in his acknowledgement of the artist's ability to approach the miracles of imitation of a Van Eyck and, lastly, in his perception of Piero's great pictorial prowess. Overall, the naturalistic explanation prevails, although it is offset by a latent sense of Piero's powerful personality. Unfortunately, the claims for Piero's naturalism are used to account for certain peculiarities of Piero's style. Thus, the somewhat leaden tonalities encountered in the master's late works are, in Schmarsow's opinion, a probable result of Piero's failing and increasingly veiled visual faculties; the absence of movement and a certain rigidity in some of Piero's figures, with their cubical calves, are understood as the result of his having used clay models. Faced with such aberrations, one ends up preferring Cavalcaselle's modest observation that Piero went far beyond Mantegna in the application of perspective to the human form.

In his search for Piero's historical context, Schmarsow wisely follows in Cavalcaselle's footsteps, contributing to the abandonment, even in Germany, of that odd tradition of a link between Piero and Mantegna—a tradition that had persisted even in Burkhardt's *Cicerone*. He usefully insists, instead, on Piero's relationship to Alberti and [the architect Luciano] Laurana. Nor do we find unworthy of note the passages in which he tries to establish Melozzo's role in the Arezzo frescoes; for even if we cannot accept the name of the assistant, it is right to accept the fact of a collaboration.

It is barely necessary to cite the French scholars of these decades. There is no doubt that there was enthusiasm, however academic and rhetorical, for

Piero's works in France as well. BLANC devoted a monograph to Piero in the "Ecole Ombrienne et Romaine" portion of his *Histoire des peintres de toutes les écoles*—a title itself revelatory of the enthusiasm for "personalities" which the study of the Renaissance had transmitted to the French. While serving as Director of Beaux-Arts, he commissioned the painter Loyeux to make copies of the Arezzo frescoes; these paintings, intended for a projected museum of copies, ought still to be found in the chapel of the Ecole des Beaux-Arts. BLANC himself, in his *Histoire de l'art pendant la Renaissance*, published posthumously in 1889, and his pupil Müntz in another work bearing the same title, did indeed show a great enthusiasm for our artist; but it was an enthusiasm so confused as to mingle the highest praise with the most terrible accusations. In a milder form we have here, once again, that contrast between "ideal" and "naturalistic" interpretation that is a part of every technical and academic tradition: a contrast we have already found, in weightier guise, in such contemporary Germans as Woltmann, Vischer, and Schmarsow.

The French played only a modest role in detailed research. MÜNTZ, once again in 1889, attempted a comparison between the Borgo *Resurrection* and Mantegna's treatment of the subject in the predella of the *San Zeno Altarpiece* [painted for Verona]; but his derivation of the latter from the former is invalidated by an incorrect chronology since, out of confusion regarding a document concerning the *Misericordia Altarpiece*, Müntz assigns Piero's work to 1445. Shortly afterwards, there entered the Louvre, from the Duchâtel Collection, Baldovinetti's very beautiful Madonna; and despite the correct attribution's having already been made by Cavalcaselle and Berenson, GUIFFREY still insisted, as late as 1898, upon giving the work to Piero.

Let us return to our own Italian research.

An essay by FRIZZONI on the Italian art in the National Gallery in London reveals scant interest in the two great examples of Piero's art hanging there; the writer appears to blame his own cold reaction upon the restorations, to which he appears to give an excessive weight. The slight interest in Piero of this faithful disciple of Morelli's was, alas, perceptible in his teacher as well; aside from the already cited inventory of works from Umbria and the Marches compiled in collaboration with Cavalcaselle, Morelli dedicated to the Master of Borgo, in the course of his life, only a few scattered phrases of no critical importance.

Provincial Italy, in this period, did indeed rediscover the fresco [of the *Pregnant Madonna*] at Monterchi, thanks to the work of MAGHERINI-GRAZIANI and FUNGHINI. But it also gave forth an utterly rotten fruit in the book devoted to Piero by his fellow-townsman G. F. PICHI. It is not that Pichi's book is without any pretenses to thought; on the contrary, it lays claim

to philosophy. But his critical faculties are so slight and crude that we would do better to indulge him than to refute him. Let us cite just one example, where Pichi tries to clarify conceptually Cavalcaselle's opinion regarding the "Sienese fiber" that was supposed to be in Piero. Cavalcaselle's opinion is, in Pichi's view, correct insofar as it concerns "the harmony of the individual idea with the traditional type and the thing represented"; according to Pichi, in short, "Piero learned sentiment only from the Sienese school," which is to say: "he kept and improved the traditional Graeco-Roman type of the Sienese school . . . and, freeing it of a certain nebulousness within which Sienese art had confined it, he rendered it more human, thus preparing the way for the divine proportions of the Umbrian school."

This feeble criticism is matched by weak scholarship. Vasari's statements, uncritically accepted, are combined with the recently discovered documents in such a way as to give rise to new and fabulous inventions, as we may see simply by reading the titles of the chapters. Let us cite one of them: "Chap. II - Guido Antonio da Montefeltro takes care of the very young Piero della Francesca and entrusts him to the care of Domenico Veneziano." More than a historical statement, this sounds like the enunciation of a perfectly pictorial subject for another of Chialli's frescoes in the Casa Franceschi; as we have seen, these are delightfully typical of that rich series of "historical falsehoods" in which Romantic painting liked to indulge, with the most "historical" intentions in the world.

With matters standing thus, we will clearly perceive how useless it would be to seek any true or new information in Pichi. The lone exception regards the attribution to Piero of two little panels belonging to Funghini at Arezzo; these works were also noted by Cavalcaselle in the Italian edition of his *History*.

Equally futile is the article Pichi published the same year on the topic: "The Resurrection as it is represented by Giovanni Pisano and by Piero della Francesca."

We can find more that is useful in small practical events and other individual bits of research from the same period. In 1892, the year marking the four hundredth anniversary of Piero's death, the dismembered *Misericordia Polyptych* is reassembled at San Sepolcro, and the magazine *Archivio Storico dell'Arte* draws attention to the importance of conserving the *Madonna of Sinigallia*. In 1893, [ADOLFO] VENTURI, writing in the above-mentioned *Archivio*, rightly fights, following in Cavalcaselle's footsteps, for the restitution to Piero of the works still attributed to Fra Carnevale by Frizzoni, such as the *Saint Nicholas of Tolentino* in Milan and the London *Saint Michael*; less happily, he extends his views in this matter to include the

Oxford *Madonna*. CORRADO RICCI—who, in 1888, had seemed intent upon attributing the Ferrarese diptych of the Gozzadini to Piero or his immediate circle, in 1897 tracked down and published the precious sonnet written around 1470-75 by Nicolò Testa Cillenio where, among the names of several artists, Piero's is cited as follows: "el Borgho mio divino" [my divine Borgo].

In 1897, in a rich volume on Urbino, CALZINI provides an accurate update of opinions regarding the Pieresque paintings of the city, mentioning, among others, a painting still given at the time to Piero, the *Dead Christ with Angels*, now in the local museum; but he very wisely expresses his doubts as to the attribution. This is the picture that Venturi was later to give, rightly, to the school of Giovanni Santi. In 1901, in an article on the gallery at Urbino, this same Calzini repeats the attribution to Piero of the famous architectural view [*An Ideal City*] previously ascribed to [Luciano] Laurana by VON REBER.

In 1897 there also appeared the first edition of BERNARD BERENSON'S *Central Italian Painters of the Renaissance*. Therein, the subtle American writer uses the opportunity to devote to the Master of Borgo several elegant pages, taking up once again a problem already sketched out by Schmarsow and Vischer, that of the "impersonal" quality of Piero's works. Berenson adds some new, very select comparisons with the Parthenon (already hinted at by Cavalcaselle) and with Velázquez. He likens Piero's attitude to mankind to Wordsworth's to landscape. But so far as the true interpretation of Piero's works is concerned, Berenson is wide of the mark. The reason must be sought in the fact that, since the "Florentinism" of Berenson's theories is almost more intense than Vasari's own, the writer is led, almost automatically, to apply to Piero the standard of the "tactile values" of Giotto and Masaccio, the values of strength of Donatello, etc.—all newly tailored academic garments that are, one feels only too well, utterly unsuited to Piero's square back. Berenson does not fail to add, as well, the "values of illustration," so as to catch the artist in the net into which he hopes to gather, out of a love of unity, all the painters of central Italy; it is easy to sense the resulting inconsistency. It is, in fact, quite natural that Piero's mysterious assimilation of scientific data, even before natural data, should not fit into Berenson's "artistic" conception; so it does not sound strange when he is led to add: "At times you feel him to be clogged by his science." Here, a residue of affection for the "lightning inspiration" of Romanticism is quite evident.

The catalogue of Piero's works in the appendix to Berenson's little book follows in the footsteps of Cavalcaselle and is, as a result, very good. There are only a couple of minor flaws, and these are mitigated, as it were, by a question mark: the ascription to Piero of the *Blessing Christ* at Città di Castello, the work of a Fleming who, although an imitator of the master, was

not part of his immediate circle; and the New York Historical Society's *Triumph of Chivalry*, which certainly belongs to the author of many *cassoni*, the best of which is the *Adimari Wedding Chest* in Florence. Nor can one accept Berenson's proposals to reduce drastically Piero's autograph part in the *Perugia Polyptych* and to attribute to Lorentino nearly the whole of the execution of the Monterchi fresco.

In 1898 there appeared the first critical monograph devoted to Piero, the one by WITTING, a pupil of Schmarsow's. Above and beyond the many passages in which the author specifically states that he has benefited from his teacher's advice, the signs of Schmarsow's influence are evident in the entire construction of the book.

Witting's is a good summary of what was known about Piero up to the time; and yet, it is not distinguished for any particularly solid scholarly structure. The chronology is more or less the one suggested by Schmarsow. So the Arezzo frescoes are placed rather late, between 1460 and 1470, despite the availability of the document of 1466 in which they are described as finished and already famous. The *Perugia Altarpiece* is dated among the earliest works, while the *Annunciation* placed over this polyptych is held to be a later, independent work. The London *Nativity*, the *Baptism*, and the *Saint Jerome* are considered to form a single group; while the Urbino *Flagellation* and the Arezzo *Magdalene* are dated even later.

As for the attributions, Witting rightly denies to Piero the *Saint Louis* that forms part of the Arezzo frescoes; but he accepts as autograph works of the master the Oxford *Madonna*, the Borgo *Saint Louis*, the architectural views, and even some frescoes by Lorentino in the church of San Francesco. It is surprising that even the predella of the *Misericordia Altarpiece* seems to Witting to be almost entirely by Piero's hand, except for certain parts that he attempts, with no chance of success, to ascribe to Girolamo di Giovanni da Camerino.

As for Piero's forerunners, Witting does not fail to make some good observations regarding his relationship to Masaccio, Domenico Veneziano, Paolo Uccello, and Andrea del Sarto; but he goes too far when, following a suggestion of Schmarsow's, he thinks that he has spotted Piero's direct teacher in the author of the well-known predellas in Casa Buonarroti. As we have had occasion to say elsewhere in our text, the author of these works—long known as the Master of the Carrand Triptych, on the basis of his best work, and recently identified by Toesca as Giovanni di Francesco del Cervelliera (probably the Giovanni da Rovezzano cited by Vasari among the pupils of Andrea del Castagno)—is an artist who, having grown up side by side with Baldovinetti under the influence of Domenico Veneziano and Castagno, is

occasionally capable of arriving at results analogous to Piero's own. Piero's work, at any rate, must also have influenced him. So he is no precursor but, instead, a weaker cousin and perhaps, at times, an admirer.

The comparisons that Witting makes between Piero and Luca della Robbia and the Flemish artists, especially Rogier van der Weyden, strike us as irrelevant. What he claims to be the dependence of Piero's London *Nativity* upon Hugo van der Goes's treatment of the same subject, in Florence since the fifteenth century, is an impossibility, since the Flemish painter's work is now known to be much later (1475) than Witting supposed, and certainly later than Piero's picture.

Both the critical discussions of the individual pictures and the overall evaluation of the artist seem to us better than the discussion of Piero's sources. Here we find an obvious advance over those residues of naturalistic interpretation that were still evident in Schmarsow. The observations on Piero as a "Raumkünstler," a "painter of space," remain noteworthy, even if they are based upon a negative conception of "space" that is, in a sense, dealt with by passing over the topic in silence—an approach that was becoming widespread in German and English culture (as may be seen by looking at Berenson's "Space-composition"). Witting's observations on this matter, à propos of the *Misericordia Altarpiece*, may still today be read with profit, above all insofar as they concern the distinction between Piero and Masaccio. Other comments, also of a certain value, regard light and harmony in Piero's organization of color. Considering Witting's very real merits as an interpreter of Piero's art, we think that WEISBACH's criticisms of the monograph are a bit too harsh, even if Weisbach is almost always right about specific details. Among the latter, let us take note of his refusal to accept "dei Franceschi" as the only proper form of the family name; his unwillingness to see the hand of Girolamo di Giovanni in the Misericordia predella (even if his reason for this unwillingness is far from decisive, since he appeals to the clause in the contract forbidding artists other than Piero to set their hand to the work); his reluctance to accept the dismemberment of the *Perugia Altarpiece* into two independent works, a stance also supported by AUBERT's good reasoning, contemporary with Weisbach's own; his rejection of Witting's demonstrations of specific Flemish influences on certain of Piero's works; his scepticism regarding what we might call the "opthalmological" explanation for the leaden tonalities encountered in the late works; and lastly, his refusal to admit, in the sense intended by Witting, the relationship between Piero and the Master of the Carrand Triptych.

In 1900, GRONAU offered a very intelligent discussion of the question of Piero's family, demonstrating the validity of both versions of the artist's sur-

name; he based his arguments, in part, upon that unpublished document of 1462, which we today believe can be connected with the termination of work on the *Misericordia Altarpiece*.

In the same year, WEISBACH also found in the archives of the Uffizi some documents connected with the story of a little portrait that had formerly belonged to the Franceschi family, and which had been believed to be a self-portrait of Piero. Sent to Florence in 1824, in deposit at the Uffizi Gallery in 1825 along with the *Nativity*, returned to the family in 1835 and later lost in unclear circumstances, it struck Cavalcaselle, who had seen it in the Casa Franceschi, as a copy of the work that had served Vasari as a model when preparing the portrait of Piero that introduces the biography of the master in the Giutine editon of 1568.

Almost contemporary with Witting's book was WINTERBERG'S publication of the Parma codex of *De prospectiva*. It is not our task to discuss the philological value of this edition; however, since the editor did not shy away from expressing an opinion on Piero as an artist, we must say that this part is inferior even to the rest, and is overflowing with scientific and naturalistic preconceptions. As a scholar specializing in in the master's activities as a theoretician, Winterberg practically goes back to the point where Woltmann had been, stating that Piero's importance is primarily technical, and only secondarily artistic. So deep is his conviction in this regard as to lead him into some heavy-handed irony, as when, à propos of the angels in the *Baptism*, he says, "ist dabei nur die Rolle als Statisten gefallen." Furthermore, even in the chapter where he draws a quick sketch of the history of perspective, the "esthetic" significance of a particular moment in the development of this discipline—to be precise, Piero's moment—is completely misunderstood. We also think that in his examination of Piero's position with regard to Alberti and Leonardo, Winterberg even manages to diminish Piero's stature as a scientist—motivated, apparently, by a desire to differ with Schmarsow, who had rightly underlined Piero's great importance for theory.

Shortly afterwards, England also produced a monograph on Piero, commissioned from A. G. WATERS for the series *The Great Artists*.

The level of this little volume does not go beyond that of facile popularization and dilettantish research; Waters's evaluation of Piero's art does not seem in any way an advance on Dennistoun's fifty years earlier. Although Waters seems, at times, to possess good critical discernment, as when, for example, he takes issue with the chronology of Witting and Schmarsow, any partial good results are submerged by frequent errors and displays of naïveté. It will be sufficient to mention that the passage in Vasari's *Life* of Piero dealing with Bramantino is understood by Waters to refer to Piero, and that the

author wastes precious time in a confutation of Rosini, as though the latter represented, in 1901, the last word in Italian art-historical research.

Over the decade 1900-1910, local scholars keep interest in Piero alive to a certain extent, also attempting to add some new elements to the knowledge of his work. MELANI, in 1904, and TAVANTI, in 1906, both seem to lay claim to the discovery of the fresco fragments in Santa Maria delle Grazie in Arezzo, where Vasari mentions the presence of works by Piero; however, the rediscovered parts do not belong to the master, but rather to his assistant Lorentino. It is odd that both Berenson, in the new edition of his *Central Italian Painters* (1909), and Ricci, in his essay of 1910, willingly accepted the attribution to Piero himself.

Anyone wishing for an overall picture of the average state of knowledge regarding Piero in the first years of this century may leaf through the well-known *Répertoire des peintures* by SALOMON REINACH. There one finds attributed to Piero numerous portraits in profile, on the basis of vague similarities with the one in Milan; a *Madonna and Child* by Domenico Morone, now in the Widener Collection; a *cassone* panel in the Bordonaro Collection, probably by Bartolomeo di Giovanni; and other such things.

Meanwhile, people were starting to worry about the state of neglect into which the Arezzo frescoes had fallen. PITTARELLI spoke of Piero to a congress of mathematicians. M. LOGAN, properly reattributing the lateral panels of the *Baptism* to Matteo di Giovanni, tried to derive from them elements useful for the dating of Piero's central panel. RICCI had occasion to express his views regarding the *Brera Altarpiece*, the Venice *Saint Jerome*, and the Uffizi diptych in his notes on the color plates in the *Gallerie d'Europa* series. POSTI discussed the lost fresco in Ancona. Further contributions, of varying worth, came from EVELYN MARINI-FRANCESCHI.

L. VENTURI published for the first time a photograph of the Casa Villamarina *Madonna* that had been shown at the British Institution in London in 1865, attributing it to Piero against Cavalcaselle's old opinion. In the same year (1905), as we have already said elsewhere, A. CINQUINI found good circumstantial evidence for the dating of the Urbino dipytch [in the Uffizi] in a poem by the Carmelite Ferabò.

There are some observations on Vasari's *Life* of Piero in KALLAB'S precious *Vasari-Studien*, published in 1908; but we believe this critic to be in error when he maintains that Vasari's date of 1458 was intended to refer to the year of the master's death. Elsewhere, Kallab himself notes that the dates handed down to us by Vasari do not consistently have the same significance; in this specific instance, we believe that—given the detailed knowledge that the great biographer had of Arezzo and Piero—the date is intended to refer to

Piero's "flourishing," and thus to the Arezzo frescoes.

Also from 1908 is the part concerning Piero, written by PÉRATÉ, in the art-historical handbook directed by Michel. This rapid account is anything but ineffectual. He shows himself to be up to date with all the documentary research; as for his style, he writes about Piero with great elegance. He notes "l'harmonie du décor" in the Arezzo frescoes, a harmony which makes Piero almost "the last of the primitives, the heir of Giotto and Angelico; a primitive, nonetheless, who is not ignorant of the latest discoveries of science and who, using this science without ever flaunting it, makes everything subordinate to the tranquil rhythm of the lines and colors." We find especially good his observations on the *Procession of Heraclius*, where he says that the artist has achieved "the greatest decorative effect with an extreme simplification of the lines, a simplification that stops at the limit beyond which it would have become poverty." Nor should we fail to note that Pérate is also the first to make the far-reaching comparison according to which the lances of Constantine's army are the precursors to those in [Velázquez's] *Surrender of Breda*.

We have reached 1909, and this year marks the discovery of another document on Piero, the one documenting his stay in Rimini on April 22, 1482. The discovery was made by GRIGIONI, who rightly argues for a probable commission for works never to be executed, on account of the turbulence that followed upon the death of Roberto Malatesta a few months later. The same year also saw BOMBE'S unimportant study of the genesis of the fresco of the *Resurrection*, which is, in his opinion, little more than an insignia of the town of San Sepolcro. In 1910 and early 1911 there appeared, as well, the studies by Ricci and Venturi.

In the short text introducing the collection of plates of Piero's works published by Anderson, RICCI limits himself, if truth be told, to the narrow task of presenting a brief chronology of the life and works, to which he adds a descriptive list of the works and a quite detailed bibliography. In the chronology, the influence of the dates proposed by Witting and Schmarsow, which we find unacceptable, is evident. As for the choice of works, the influence both of Berenson's catalogue and of the new attributions is apparent; so we are not very surprised by the early dating of the London *Nativity*, the Arezzo *Magdalene*, and the Gardner *Hercules*, nor by the acceptance as autograph works of the Villmarina *Madonna*, the Borgo *Saint Louis*, the predella of the *Misericordia Altarpiece*—an altarpiece here dated, we have no idea why, 1445-46—and the *Miracles of Saint Donatus* in Santa Maria delle Grazie near Arezzo. Unless we are mistaken, Ricci does better when he declares the London *Baptism* to be an early work, as he also does (relatively speaking) the

Venice *Saint Jerome*; and he is also right to reject as autograph the architectural perspective views, accepting the ascription to Laurana suggested in 1902 by BUDINICH.

As always with this historian, A. VENTURI'S discussion of Piero, in the first part of the seventh volume of his *Storia*, is richer in new ideas. The position he assigns to Piero is, more or less, still the one proposed by Cavalcaselle, but the change resides in the fact that Venturi here abandons his opinions of 1893 and once again forms a group of works close to Piero which he ascribes to Fra Carnevale; these include the Villamarina *Madonna*, the London *Nativity*, the *Brera Altarpiece*, and the two matched *Saints* in the Poldi museum in Milan and the National Gallery in London. He attributes the *Saint Louis* in the Pinacoteca at Borgo, the *Perugia Polyptych*, and the *Madonna of Sinigallia* to another follower. To Lorentino, he very rightly assigns the fragments of the *Stories of Saint Donatus* in Santa Maria delle Grazie near Arezzo and, following in Berenson's footsteps, the *Pregnant Madonna* at Monterchi.

In the *Misericordia Polyptych*, not only does he deny Piero the predella and the saints in the little pilaster elements, but he also—and here he certainly goes too far—believes that in the *Annunciation*, as in the two saints and the *Crucifixion* in the cusp, only the design, and not the execution, is by the master.

Venturi resolves the vexed question of the Santa Chiara *Assumption* with another new proposal, suggesting that the work commissioned from Piero was executed in the master's workshop by Pietro Perugino; but in reality, aside from the picture's predominant mediocrity, the Peruginesque qualities are too exaggerated to belong to the first youth of the Umbrian master; at that time the young Perugino, executing a cartoon of the painter from Borgo, would have followed it in such a faithful fashion as to be practically indistinguishable from his teacher.

Very reasonably, the famous historian gives no credence to Vasari's words regarding Piero's journey to Loreto in the company of Domenico. He seems to us to lay out the chronology of the works in a very well-balanced fashion; we would tend to accept his chronology, with the exceptions of the overly late dating assigned to the *Flagellation* and the *Saint Jerome*. One must also give Venturi credit for insisting that the influence of Piero's art in central Italy, the Marches, and Emilia was wider and deeper than had generally been conceded. All this helps us to forget certain slight hints of revulsion towards Piero's style, evident, for example, when Venturi writes, à propos of the *Baptism*, "to a certain degree, geometric reasoning wins out over the artist": words presenting an analogy with Woltmann's term of "petrified" and with Berenson's "clogged by his science."

In 1912 the publisher Lapi, in Città di Castello, brought out another Italian book devoted exclusively to Piero. The author, EVELYN MARINI-FRANCESCHI, of English origin but related to descendants of Piero's family, had already—as we have said above—earned for herself a place of some distinction over the preceding decade, on account of her loving treatment of individual works by her brilliant forebear. In 1902, for example, she had written about the Monterchi *Madonna* and the *Hercules*; in 1911, about the Rimini fresco. These essays had been, in part, reprinted in the volume *Impressioni artistiche*. Now they were reworked in a book on Piero marked by a praiseworthy enthusiasm, even if one with no scholarly or esthetic pretensions. Hers is, in short, a popularizing volume of the sort brought out, a decade earlier, by Waters; and her book is, in fact, partly based upon the latter one. There is, therefore, no need to discuss her particular opinions or chronology. Far more useful is the contribution that the author made to our knowledge of Piero's life through her publication of the documents supplied to her by Dr. Degli Azzi, who was reorganizing the archives of San Sepolcro.

The year 1913 saw the rediscovery of the frescoes in the chapel of Saints Michael and Peter "ad vincula" [enchained] in Santa Maria Maggiore in Rome. These had been unknown up to that time, because they were hidden away in a storage space following the eighteenth-century transformations of the church. They were published, almost simultaneously, by MONSIGNOR BIASIOTTI, who identified them as the remains of a chapel attributed by Vasari to Benozzo [Gozzoli], and by G. GALASSI who—having posed the problem in better terms—noted the Pieresque characteristics of the only figure still legible, ascribing these ruined pictures to Lorenzo da Viterbo, a Roman follower of Piero's. This opinion was still shared by E. LAVAGNINO, around 1925, who wrote about the Basilica. But neither Lorenzo da Viterbo nor Antoniazzo [Romano], nor even Melozzo, could ever have thus transmuted themselves into the master. The old, indefensible attribution to Benozzo, found in Vasari and Mancini, leads us to think that we are dealing here with the usual early confusion of Benozzo with Melozzo; and we may, perhaps, concede, as a corollary, that the artist from Forlì carried on, in the rest of the chapel, the work certainly begun by Piero himself in the vault in the course of a stay in Rome.

Also in 1913, MÖLLER VAN DEN BRUCK, a mysterious German amateur of artistic culture and history, dealt extensively with Piero in a book of Italian impressions entitled *Die Italienische Schönheit*. The dedication to Th. Daübler will give an idea of the spiritual climate in which this book came into being. The volume is informed with the sort of culture associated with Chledowsky, only rendered more fantastic—perhaps by the first onset of the

ideas of Spengler. This culture is placed at the service of a certain sensibility that seeks, unfortunately, to explain the impressions received on the shaky basis of race and soil. Piero and Federigo da Montefeltro are here on the verge of being reduced to the results—and in Möller's view, the explanation is a very effectual one—of the union between a blond German and an Umbrian brunette: "Umbrische Erde, Toskanischer Geist" is the title of the chapter where Piero is discussed.

Despite all this, there are some acute and specific observations regarding Piero's style. After Witting, Möller also wrestles with the usual negative and mute conception of "space" so dear to German criticism. "Die Fläche ist die Dimension des Architektonischen wer der Raum die Dimension des Plastischen ist . . . "; starting from these bad premises, Möller still manages to arrive at the noteworthy conclusion that Piero knows how to offer us "space as surface." Other quite subtle passages aim to demonstrate that Piero's composition was not necessarily central, but free.

From such a book, one must not expect accuracy of critical detail: the Misericordia predella is not expelled from Piero's catalogue, but simply declared to be entirely Umbrian, in the style of Gentile [da Fabriano], as in the days of Rosini. So much for Piero's origins.

As for Piero's impact, Möller is less interested in the historical truth of his direct following than in the affinities he presents—according to the author—with Hodler, van Gogh, Munch, and von Marées. Viewed in such a way, the artist from Borgo runs the risk of becoming a Rathaus painter. Also in the part of the text devoted to Piero's followers, there is a surprising exaltation of the work of Giovanni Santi, a passage worth recalling as an instance of the incautious oscillations of modern taste.

Written in 1913, although published in 1914, was my unusually titled essay *Piero dei Franceschi e lo sviluppo della pittura veneziana* [Piero dei Franceschi and the Development of Venetian Painting]. On the basis of repeated formal analogies and in light of the fact that the chronology posed no obstacles, the article arrived at the conclusion that Antonello da Messina's style had been formed on Piero's and that Giovanni Bellini had also reworked his style on the basis of Piero's in the period 1475-80, beginning with the Pesaro Altarpiece. Such observations aimed at clarifying the problem, very obscure until then, of the origins of the new Venetian painting. The perspectival, and in a certain sense Classical, underpinnings of Bellini's painting—already known to Pacioli and Boschini—are thus clarified, as regards both their origins and their consequences, which reach all the way to the chromatic classicism of Veronese. The need to clarify the lyrical affinity between Bellini's and Antonello's spatial sense and the spatial sense of their source,

Piero, led me to seek the artistic significance of perspective, as developed by Piero on the basis of some hints from Paolo Uccello. The intellectual break-through that the chromatic style of the fourteenth century had obtained through perspective led me to define the new style as a "perspectival synthesis of form-color," although the explanation is offered, especially where the pre-ceding history is concerned, in a naïvely dramatic and dualistic fashion.

The essay did not get "good press," in part because it made for diffi-cult reading; on the other hand, the attribution it contained of the polyptych in the Venetian church of SS. Giovanni e Paolo [to Giovanni Bellini] was well received, and is today universally accepted.

As for the essay's underlying historical idea, GRONAU, writing his arti-cle on Piero for the new *Künstlerlexikon* (1916), expresses himself as follows: "The influence of Piero on Venetian painting has been recently claimed, but not demonstrated." But already VENTURI, who had, in the meantime, devot-ed an entire section, the second of his seventh volume, to the spread of Piero's art throughout central Italy, accepted my thesis with his habitual quickness; in 1915, the idea informs much of his treatment of Antonello and Bellini in the fourth section of the same volume. With such authoritative support, my con-viction was winning ground, although there is still no trace of it in the part devoted to Piero in 1918-19 by MAX DVORÀK in his lecture series on the Italian Renaissance, which nonetheless contains important observations con-cerning Piero's relationship to Northern art.

MANCINI, a very serious scholar, occupied himself with Piero's theo-retical works in 1915. The only charge that can be brought against him is that he considered himself the rediscoverer of the little volume *De quinque corporibus*, ever since he had mentioned it in his commentary on Vasari's *Life* of Luca Signorelli. Now he published Piero's text in complete form, in the *Atti dei Lincei*, with a long introduction in which he discussed at length the prob-lem of Pacioli's plagiarism—which, as we have seen, had already been solved by Jordan in 1880. There follow several appendices, in the first of which he provides detailed accounts of several documents (already mentioned, in part, by Milanesi in his commentary of 1878, but without information as to their location in the archives, now tracked down by Mancini). These documents dealt with the artist's family and relatives. From them, and from the phrase "in extremo aetatis meae calculo" in Piero's dedication of the little treatise, Mancini tries to show that the artist was born in 1406, a date that seems hard to accept for other reasons; in the first place, had he been born so early, Piero would have appeared on the scene long before 1439, the year in which he is nothing more than an assistant to Domenico Veneziano. In other appendices, there are good specific observations intended to prove that the Vatican Codex

is probably written in the master's own hand, as the notes in that volume certainly are; and we are also convinced by Mancini's analogous arguments regarding the Parma Codex of the *De Prospectiva*. As a fact useful for reducing to a minimum the years of Piero's blindness, Mancini offers us his discovery—made among the papers of the notary Fedeli—of a page of notes in Piero's own hand, meant to serve for the preparation of his will in 1487.

Among the partial studies of these years, we will cite RICCI'S proposal that certain frescoes rediscovered in Ferrara be attributed to Piero, and A. DEL VITA'S efforts to demonstrate, on the basis of documents, the existence in Borgo of a Monna Francesca who was, in his opinion, Piero's mother, thus validating Vasari's old story. Such statements have been shown to be entirely fallacious, and based on a confusion between different people, by MANCINI in a brief note written in 1918. Mancini takes advantage of the opportunity to cite the precise document regarding the marriage of Piero's father with Romana di Perino di Carlo da Monterchi: a document previously mentioned by Milanesi, who failed, however, to specify its precise location in the archives in Florence. Already in 1917 MANCINI had resumed his minute observations regarding Piero's chronology in his comments on Vasari's *Life*, republished in a little book along with his annotations on the same author's biographies of other artists. Here it seems to us that this critic is easily led into error by his disinclination toward a specific knowledge of the works of art. We may accept as valid (if only on formal grounds) the observation that, given the probable allusion in the *Flagellation* to the death of Oddantonio [da Montefeltro], the work must have been painted shortly after that event, which occurred in 1444; but it is absurd to claim, as does Mancini, solely on the grounds that Piero was in Umbria in 1438 with Domenico Veneziano, that the well-known polyptych for the church of Sant' Antonio, now in the Pinacoteca of Perugia, must have been painted at that time. Even a mediocre knowledge of art history makes it plain that this work cannot have been painted prior to 1460—not only on account of its relationship to the rest of Piero's work, but also on the basis of the whole context of Umbrian fifteenth-century painting. Other ineffectual observations regard the derivation of certain works from the Borgo *Resurrection*; and it seems strange that Mancini gives any weight to Müntz's old assertion regarding the connection between this work and Mantegna's treatment of the same subject in the *San Zeno* predella [painted for Verona but now] in Tours, since that claim had been immediately refuted by VENTURI. It is equally strange that he insists upon dating the Arezzo frescoes between 1460 and 1466.

Far more precise and, from the standpoint of connoisseurship, almost impeccable is GRONAU'S previously mentioned article on Piero in the

Künsterlexikon of Thieme and Becker. The article is so packed with information that more recent researchers have actually failed to note how much new information it contains. Nor has anyone, to date, taken into account a document of 1462, published by the same scholar as early as 1900, in which the Compagnia della Misericordia makes partial payment to Marcello di Benedetto for a panel painted by his brother: a panel which, in our view, may be the same one started as early as 1445. Another new bit of information regards a power of attorney conferred in 1473, thereby demonstrating Piero's presence in San Sepolcro in that year. (The document belongs to the heirs of Professor Giuseppe Bardelli.) Gronau's catalogue of Piero's works is almost unexceptionable; we disagree only in refusing to accept as autograph the Borgo *Saint Louis* and the architectural views in Urbino and Berlin. As regards the chronology, we cannot accept Gronau's late dating of the Arezzo frescoes.

The few notes on Piero's art and on the development of his painterly skills following his Florentine apprenticeship are well balanced, appropriate, and respectful of the master's great historical importance. And yet, we would not say that there has vanished every last trace of the reluctance to understand "esthetically" the immobility and lack of pulsing life in Piero's art, a reluctance already noted in the majority of nineteenth-century critics.

Two books published at around the same time are very similar to each other in their way of understanding Piero's activity as a theorist. The first is PANOFSKY'S on Dürer and his artistic theories, above all in relation to the theories of the Italians (1915); here, Sitte's old remarks are amplified into a precise demonstration of the passages in which it is evident that Dürer is drawing upon Piero's work. Three years later, there appeared OLSCHKI'S *Geschichte d. neusprachlichen wissenschaftlichen Literatur*, where the author has ample opportunity to discuss Piero as a theoretician and as a writer of scientific prose. In this area, Olschki's treatment strikes us as absolutely conclusive. Equally irrefutable, it seems to us, is the new importance he attributes to Piero as the inventor of a geometric discipline, a method that will come to fruition not in Leonardo, but in Galileo and his school. Olschki rightly perceives that Piero's work brings the empirical era—to which even Brunelleschi and Alberti had fundamentally belonged—to a close, and that it opens the scientific era.

It is unfortunate that, in order to corroborate these very acute views regarding Piero's role in the history of scientific literature, Olschki thought that he had to conclude that Piero was more important as a scientist than as an artist. He tries to find such insinuations in the judgments of Piero's contemporaries and successors, but his interpretations strike us as forced. We must object, on this score, that in the fifteenth and sixteenth centuries, to declare that a painter excelled in perspective was in no way to make a distinc-

tion between his scientific and artistic skills; and it is absolutely incorrect to claim that Vasari ranked Piero the theorist higher than Piero the painter. In fact, we have seen that Vasari keeps his observations on these two aspects of the painter from Borgo in perfect balance, and that he praises him almost as highly as he does Masaccio, in the very passage where he discusses his painting, not his skill in perspective. As for Pacioli, who was a mathematician, it is easy to understand why he placed such emphasis upon the theoretical abilities of the master from Borgo. Olschki would certainly have abstained from reading an allusion to the artist's specialization in perpective into Filarete's proposal to invite Piero to paint, in [the imaginary ideal city of] Sforzinda, the portraits of "astronomers and mathematicians," if only he had noticed that the others artists invited for the same purpose were in no sense specialists in perspective. In the same way, his observations regarding the excessively "problematical" nature of Piero's paintings seem to us a product of his relative inexperience in the field of art criticism—an area from which Olschki ought therefore to have kept his distance. His prejudice is, quite visibly, the same one that may be noted in Panofsky's book: i.e., that perspective was, for Piero, merely a means of resolving the "problem of exactitude" (Richtigkeitsproblem); while it was, in reality, profoundly connected with the problem of proportions. If we are to believe Olschki, the goal of creating a realistic illusion was so important to the master as to give rise to the rapid creation of Vasarian anecdotes. Unfortunately, the anecdotes he had in mind refer to Bramantino, not to Piero—something that Olschki failed to realize, on account of his misreading of Vasari's text. One might add that a correct understanding of art in no way entails the admission that Bramantino's perspective effects are intended, first and foremost, to create an illusion of realism.

In 1919, light was shed on another obscure point of Piero's chronology: GIUSEPPE ZIPPEL finally discovered the definite date of Piero's Roman sojourn. On April 12, 1459, the book of *Introitus et Exitus* [Income and Disbursements] from the time of Pope Pius II pays out 150 florins *da camera* to Master Pietro del Borgho for "certain paintings he is making in the room of His Holiness Our Lord Pope."

This would appear to render even more improbable Vasari's assertion that Piero came to Rome under Pope Nicholas V, a stay of which the fresco fragments in Santa Maria Maggiore may nonetheless represent vestigial evidence; not, however, the frescoes in the former Greek Library, which have no direct relationship with Piero, even if Zippel insists upon attributing them to him. The same scholar makes a great effort to demonstrate the authenticity of certain contracts already proven false by Mancini, and their falsity is all the more evident in the light of the naïveté with which they are meant to fit, in

248 *Roberto Longhi*

one case, the frescoes that Vasari tells us were painted by Piero in the Vatican Stanze but later destroyed to make way for those by Raphael, and in the other, the fresco in the old Sixtine Library which an old opinion, which remained current well into the nineteenth century, held to be by Piero. This last work is surely by Melozzo, as already stated in 1506 by Raffaello da Volterra and intuited, on stylistic grounds, by Lanzi; further confirmation arrived with the certainly authentic documents tracked down by Müntz.

In 1920 we have, aside from an article by A. DEL VITA dealing with the insoluble question of the self-portraits, a popularizing book by HANS GRABER—80 plates plus an introduction—the whole affair being of only modest worth. It will be sufficient to note that the place of honor among the plates goes to the predella panels of the *Misericordia Altarpiece*: panels far removed from Piero's own work. There are also some references to Piero in the guide to San Sepolcro written by O. H. GIGLIOLI. In the same year, VENTURI published for the first time the fragments by Piero in the Liechtenstein collection; there followed shortly afterwards, in early 1922, an essay by the same author that accompanied 72 plates published by Alinari. Although this essay is primarily popularizing in nature, Venturi nonetheless takes the opportunity to express his latest opinions about Piero della Francesca. The author shows himself to have fully accepted, by this time, our own thesis regarding the Pieresque renewal not only of Antonello's style, but also of Giovanni Bellini's. The book ends, in fact, with the sentence, "But a great heir received Piero's gift: Venice." So far as his brief corpus of the works goes, Venturi has here abandoned or very much toned down his convictions regarding Fra Carnevale and the other close followers. He now tends to give back to Piero the Borgo *Saint Louis* and the *Madonna of Sinigallia*; he places in greater or lesser proximity to Piero such works as the London *Nativity*, the Villamarina *Madonna*, the Oxford *Madonna*, and the *Brera Altarpiece*, in precisely the order of diminishing proximity in which we have cited these works. He is less radical than formerly in seeking out the non-autograph parts of the *Misericordia Altarpiece*; he returns to Piero the *Pregnant Madonna* at Monterchi. Lastly, he adds to his catalogue of original works a *Madonna* formerly in a private collection in Rome and now at the Boston Museum, as well as a little *Crucifixion* in the Hamilton Collection in New York, previously published in 1917 by Pope: a work quite close to the master on the whole but, in certain details, as for example the figure of Saint John, of somewhat inferior quality.

In KNAPP'S handbook of 1922, the part devoted to the master is of very dubious quality. The writer assigns apparently precise dates to several works; but these dates do not correspond to what has, up till now, been established with certainty about the artist's activity. In the same year, a more ample

treatment is accorded Piero by K. Escher in the volume of the *Handbuch der Kunstwissenschaft* dealing with Renaissance painting in central and southern Italy. The importance that the author assigns to Piero may be understood from the sentence in which Piero is called "in der Beschränkung künstlerisch-er Ausdrücksmittel Quattrocentist, in der glücklichen Synthese von Raum und Flächenstil und Freilicht aber der grösste Quattrocentomaler Italiens."

This explanation appears to be derived from our own study, of which Escher accepts the historical conclusions, even if in somewhat materialist terms: "Ja sein Einfluss erstreck sich auf Antonello da Messina und Giovanni Bellini"; and also, in part, from Möller, although without any particular understanding. Piero's "Flächenstil" is understood by Escher in an essentially fourteenth-century—and, what is worse, Giottesque—sense. He insists upon the "Vordergrund," as if Piero preferred to line up his figures in the foreground; he also stresses the linear definitions in Piero, without understanding their very limited nature. His handling of the documentary evidence seems no better. Not very aware of the recent bibliography, Escher does not know that Evelyn Marini-Franceschi's citation of a document of 1474-76 is the result of an error; equally unknown to him is the proof of Piero's Roman sojourn in 1459, ascertained four years earlier. There are many imprecisions as to dating and in various references: according to Escher, the codex *De quinque corporibus* is dedicated to Federigo, whereas it is, in reality, dedicated to Guidobaldo; the *Misericordia Altarpiece*, in which Cavalcaselle had already noted the oil technique, is said to be in tempera; the extremely weak *Saint Louis* in the Arezzo cycle is exalted as one of the master's most beautiful creations; the panels surrounding the *Baptism*, still *in situ*, are declared to be the work of "secondary artists," thus showing that Escher does not know of their precise ascription to Matteo di Giovanni. The chronology, while still based on the inadequate one supplied by Witting, is, if anything, even worse. The *Perugia Polyptych* becomes an early work; the Uffizi portrait diptych is placed before the Arezzo frescoes; the two *Saints* in London and Milan are held to be contemporary with the *Baptism*. The various opinions regarding Piero's training are cited without any personal scrutiny. The comments on the works and their spatial and coloristic structure are long, inappropriate, or arbitrary; see, for example, those on the Rimini fresco.

Other none-too-felicitous recent references to Piero are to be found in Meder's otherwise quite useful book—almost like a medieval collection of recipes—on drawing. Meder also misses completely the lyrical significance of perspective at the time of Paolo Uccello, Piero, and Melozzo; as a result, he does not grasp the distinction between this type of perspective and the practical sort. And when, turning his attention to the perspective of lighting, he

states that it was unknown to the Italians of the fifteenth century—with the aim of demonstrating that even the representation of individual and unexpected lighting effects had no influence upon the overall illumination of a picture—the only examples he cites are Paolo Uccello's *Flood* and Pintoricchio's "thunder"; it seems necessary to admit that such works as the *Dream of Constantine* or the *Madonna of Sinigallia* have slipped his memory.

MATHER, in his little and agreeably popularizing *History of Italian Painting*, devotes three very enthusiastic pages to Piero; but his interpretation seems overly influenced by facile comparisons with modern art. Thus, he does not hesitate to say that Piero, in order to "attain atmospheric envelopment sacrificed colour;" that "his figures merely exist rather splendidly, as do some of Manet's figures;" and that therefore, "it is futile to seek from him anything but fine painting." The chronology is full of false precision, as when he assigns—on what grounds we do not know—the date 1460 to the *Resurrection*, that of around 1465 to the Arezzo frescoes, and 1472 to the diptych that Ferabò's verses lead us to believe to have been painted prior to 1466.

In 1925, in his book on the [Riminese] *Tempio Malatestiano*, CORRADO RICCI demonstrates that the Chapel of the Relics was completed in late 1451, thereby confirming the authenticity of the date inscribed on the fresco by Piero. He thus puts a welcome end to the ingenuous diatribes that had originated with Marcheselli's inaccurate transcription, followed by Oretti and Lanzi—but which had exploded only in 1913, among several very local scholars who were, among other things, ignorant of certain details of the history of the issue.

In a short essay, BERENSON has recently proposed to gather together, under the name of the youthful Signorelli, a group of works that have always been assigned to Piero's immediate circle or ascribed to Piero himself, such as the Oxford *Madonna*, the one in Casa Villamarina, and the third one that has recently entered the Boston Museum. We have not yet had an opportunity to assess this important assertion, based by Berenson upon comparisons with the few remaining traces of Signorelli's early fresco at Città di Castello.

The most recent mention of Piero known to us is the one in the just-published *Handbuch der Kunstwissenschaft*, devoted by VAN DER BERCKEN to Renaissance painting in northern Italy. We are gratified to see accepted therein our old statement regarding the Pieresque foundations of Venetian painting.

PIERO'S REPUTATION OVER THE CENTURIES
CONTINUATION: 1927-1962

Update added to the third (1963) edition

Fifteen years ago, reviewing the second edition of my *Piero della Francesca* in the *Burlington Magazine*, BENEDICT NICOLSON complained of the absence of an updated bibliography and the lack of a continuation of the chapter on the artist's "critical fortune."

His complaint was well founded, since I had left both sections of the volume as they had appeared in the first edition. Today, as I work on the third edition of the book, which will form part of the series of my complete writings, I want to pay my debt, at least insofar as possible.

I say "insofar as possible" because it is a proven fact that, in the wake of the publication of a particularly thorough monograph about a major artist whose fame is in the ascendant, references to him multiply with inevitable rapidity, in every sphere of culture.

Modern novelists and poets had already mentioned Piero even prior to 1927. One of the first would seem to be André Gide, who, having visited the museum in Berlin in 1907 in the company of [the painter] Maurice Denis and looked at the portrait there attributed to Domenico Veneziano, said that the way the hair was dressed over the nape of the neck reminded him of Piero della Francesca. The reference was, however, unjustified, in that he was certainly basing his comparison on the Poldi-Pezzoli portrait [in Milan], still widely reproduced back then as a work of Piero's, but already on the brink of becoming—rightly—a picture by [Antonio] Pollaiuolo.

Dating from around 1910, the references to Piero by Gabriele D'Annunzio in his four sonnets on Arezzo, one of his "cities of silence," are not without impact and are, at any rate, more pertinent. The lovely passing reference in the first sonnet, "in San Francesco è Piero e il suo giardino" [In San Francesco are Piero and his garden], is further developed in the third poem of the sequence into a fine evocation of the fresco cycle: "e le chiare fiumane e i cieli schietti" [And the clear, full rivers and the clean skies], and again, "Come innanzi a un giardin profondo io stetti—o Pier della Francesca" [As before a deep garden I stood, O Pier della Francesca]. The selection of subjects to be mentioned in the poems is derived from guidebooks of the day— probably from those put out by Treves Bibliopola, also the poet's own publisher. But it doesn't matter. For the period, the choice is significant and even precocious. And even the classicizing interpretation of the *Magdalene* in the

Duomo is something more than mere rhetorical improvisation: "E un greco ritmo corse il pio silenzio" [And a Greek rhythm pervaded the pious silence].

New and more frequent references were only to be expected following [the publication of my book in] 1927; but I shall cite only some of the more important ones. In 1938 the Italian Scali, one of the main characters in André Malraux's novel *L'espoir*, is addressed by a Spanish Republican officer as follows: "You, the interpreter of Masaccio and Piero della Francesca!" After 1945 RAFAEL ALBERTI, in his collection of poems *A la Pintura*, gives us a quite beautiful poem entitled "Piero della Francesca", and two sonnets on related themes: "A la perspectiva" and "A la Divina Proporción". It would have been unfair not to mention them. But how can we possible give an account of all the more fashionable, superficial, or openly touristic mentions of the master in those years? I remember that around 1935, as one approached Tuscany along the Via Flaminia, the road signs for foreign visitors read: "Arezzo awaits you with its famous frescoes by Piero della Francesca." Is this, or is it not, part of the artist's "critical fortune"? It probably is. But in the space available for this updated text, I shall nonetheless have to restrict myself, as a general rule, to those references which have had, over the thirty-five years since my book first appeared, the greatest influence on our view of Piero.

I shall therefore begin with the first reactions to my book published in 1927—above all, with those reactions intended to clarify the interpretation of that book. This was no easy task, as I myself soon came to recognize.

In 1927 the "culture pages" were still an important part of Italian newspapers. I remember with gratitude the articles the dailies devoted to my book, written by such well-known critics, men of letters, and painters as CECCHI, BIANCALE, SPAINI, CARRÀ, TROMBADORI, OPPO, and many others—especially when I compare them with the silence of our historians. I wish to recall to what extent this satisfactory result was the outcome of the efforts of the publisher Mario Broglio, himself a painter and the director of the series of monographs *Valori Plastici*, in which my book appeared; he also had the merit of being one of the first to collect works by Carrà, Morandi, and De Chirico. Gifted with an extraordinary instinct for publishing and well aware of the difficulties of distributing abroad works written in such a nearly unknown tongue as Italian, he made sure that the monograph was promptly translated into French (1927) and English (1931). I want to recall this last aspect, since today our publishers, colonized as they are by foreign culture (and by what a culture!), translate avalanches of useless books into Italian, without lifting a finger to obtain the kind of reciprocity that Broglio was the first to promote, and that ought to be re-established. Never shall I forget the day when Broglio set off for Paris from Piazza San Silvestro [in Rome], with his Buick jam-

packed with equal portions of mortadella sausages, black truffles from Norcia, and copies of the French edition of my *Piero*.

Asking the reader's forgiveness for this anecdotal insertion, I shall now return to the first press reactions in Italy. Here I should like to recall that more than once, and especially in an article by Spaini, there were references to a motif that, despite its captiousness, was going to go far: i.e., the idea that Piero della Francesca's style came within a hair's breadth of producing a sort of fifteenth-century Cubism *avant la lettre*. Were such observations really aimed at Piero, or rather at the interpretation that I had offered of him? I believe the latter hypothesis to be the case: people tried to arrive at such an interpretation on the basis of my youthful contacts with Futurism and Cubism. But was the formula of the "perspectival synthesis of form-color," the one that I had proposed as early as my first essay of 1914 on Piero and the Venetians, really a Cubist formula? And how is it that, in my book, there appear the names of Cézanne and Seurat but not those of Picasso, Braque, or Juan Gris? But in order to nullify this motif of "Piero the Cubist," we shall have to return to it several times in the course of this account.

It is true that, as early as 1923, LÉON ROSENTHAL, in an essay entitled *Piero della Francesca et notre temps* that escaped my notice in 1927, had analyzed the *Death of Adam* at Arezzo in terms of the "golden section" and come to the conclusion that the fresco was "a symphony of 135° angles with chords of 110°." Even if I had known that essay, I don't see how I could have drawn any profit from it, given that it claimed that there was a profound analogy between Piero and contemporary painters, meaning those of around 1923. To whom was Rosenthal alluding? The neo-classical Picasso or the taste of the "Esprit Nouveau"? Things became clearer when, still prior to my book, and precisely at the beginning of 1926, that singular American fanatic named ALBERT C. BARNES, a great collector and an atrocious teacher—although he boasted of having studied with Dewey—discussed Piero della Francesca at some length in his volume *The Art of Painting*, insisting that it is important to "know him well" in order to appreciate Cézanne, Renoir, and . . . [Maurice] Prendergast. In another passage, Puvis de Chavannes is mentioned in the same connection; and elsewhere we find the explicit statement that Piero's qualities were taken up by Picasso and other modern artists. Even if nothing more need be said about the matter, please be so kind as to add these references to my old, pre-1927 bibliography.

In the meantime, the French edition of my book had appeared—and here I must insert another brief anecdotal recollection, in order to say that my many, inevitable disagreements with the skillful translator Chuzeville were smoothed out with the patient help of [the poet] Giuseppe Ungaretti. There

soon appeared in France several references to the book, of which the most important was that by ANDRÉ LHOTE in the *Nouvelle Revue Française* in 1929.

Here, too, needless to say, there recurs the by now widespread interpretation in terms of Cubism. What is significant is that Lhote places his review just after his own discussion of Jeanneau's book on Cubism, where he says that the latter volume is to be "read in parallel with M. Roberto Longhi's volume devoted to Piero della Francesca," and so forth, concluding that "in Piero della Francesca, [readers] will greet the first Cubist." For those familiar with Lhote's critical position, what will be readily apparent here is his desire to facilitate Cubism's entry into the École des Beaux-Arts by equipping it with an armature of intellectual concepts and precepts to which it had never laid claim. But the motif is not without interest when we discover that much later, in 1950, Lhote enthusiastically exhumed Rosenthal's old essay. Still, we note with surprise that Piero's name is barely cited in the circles promoting the abstract and purist movements of the twenties and thirties: such movements as Esprit Nouveau, De Stijl, Cercle et Carré, and the other equally inane lucubrations that have continued, alas, to be periodically revived, right down to the present.

Also around 1929 and 1930, scholarly specialists expressed various judgments regarding the book. Some of these judgments, if they are to be properly understood, need to be seen in the light of a chronological account of the personal relationships between critics. Even if I did not belong in those years to the Society for the Augmentation of Hatred between Art Critics (despite the exhortations of an American colleague who wanted me to join up), some notes on personal controversies may prove useful. VAN MARLE, for example, whose volumes on *The Italian Schools of Painting* I had called "horrible and indispensable," paid me back in kind when he got to his section on Piero, pretending that there was nothing to be gained from reading my book; the result was that he completely confused the chronological order of Piero's works. It will be sufficient to recall that he dates such an extremely late work as the London *Nativity* to the artist's earliest years, thus misplacing it by nearly half a century; that he puts the Uffizi portrait diptych earlier than the Arezzo frescoes; or that—as I warned in my preface of 1942 to the second edition of my book—he accepts a notorious fake that was knocking about the European market at the time. Also of interest is van Marle's cryptic reference to an unknown work of the master's that was on the the American market; published the following year by his friend Umberto Gnoli in *Dedalo*, it was the masterpiece now in the Clark Museum in Williamstown.

At around the the same time, JULIUS VON SCHLOSSER, in Vienna, gave a very favorable account of my book in his three-pronged study of Piero della

Francesca, Alberti, and Paolo Uccello. It is nonetheless difficult to accept his thesis—one very much in keeping with the ideas of Benedetto Croce—that, while Piero is a pure artist, Alberti is a non-artist. But I do not wish to dwell at greater length on a text that the Italian reader can find translated in *Xenia* (Laterza, 1939).

In contrast with the historicism wrapped in idealism of the Viennese scholar, the post-Romantic estheticism of English culture produced, also in 1929, a different sort of book and one that is, in several regards, quite singular.

This is ADRIAN STOKES'S *The Stones of Rimini*, bearing a title clearly decended from Ruskin. The author starts from an esthetic that seems almost infused *ab alto*, from above, into the artists's physical materials (in a sort of inverted doctrine of the innate permanence of things). His first chapter is emblazoned: "The Pleasures of the Limestone." Stokes spends a long time caressing the low-reliefs of the Tempio Malatestiano [in Rimini] until, meeting up with Piero's fresco there, he offers an interpretation of the artist that is, in its own way, fascinating. I do not know whether Stokes was acquainted at the time with my book or, rather, with my Italian; I do not think so. But if he was not, then the resemblance between my own slightly over-starched interpretation of the painting and Stokes's reading becomes even more significant. He writes: "In Piero della Francesca's painting, by the religious reverence for spatial intervals, by tonal and perspective organization, all feeling, all movement, all rhythm, all plasticity itself, was translated freely into panorama terms." This agrees quite well, I think, with my "calculated intervals," "unfurled spectacle," "broadly set forth spectacle of appearances," and similar expressions which, when first encountered, struck people as overly "difficult."

But the virtues of the English writer's interpretation of Piero do not come to an end with the publication of his book in 1929. I know nothing of the intimate processes of Stokes's development after that first date; but it seems legitimate to suppose that the following year (1930), he took advantage of the memorable opportunity to study in London nearly all the master's panel paintings; these had been dangerously dragged off to the great Italian parade at the Royal Academy. Just imagine: the *Flagellation* and the *Madonna of Sinigallia* from Urbino; the Montefeltro diptych from the Uffizi; not to mention such closely related things as the cassone panel from Urbino with its purely architectural view, the Villamarina *Madonna*, and the one from Oxford. When one adds the *Baptism*, the *Saint Michael*, and the *Nativity*, all on display a few hundred meters away in the National Gallery, one must recognize that never had so many of Piero's works been brought together in a single city; and this, too, was a sign—however ill-advised from a physical stand-

point—of the artist's "critical fortune" at the time.

At the start of 1931, the same year that saw the publication of BERENSON'S new "lists" (which, in reality, added nothing to those of 1909 where Piero was concerned), there appeared the English version of my volume. Unfortunately, it was shorn of the whole section on Piero's "critical fortune," on account of the stinginess of the Italian publisher. Many English reviewers complained about this amputation, and some were also so perplexed by the difficulty of my language when translated into English as to advise their readers to turn, instead, to the French edition. All of this is reflected in my long private correspondence with the able and patient British translator, who ultimately decided to conceal himself behind a pseudonym (Penlock); and it is my duty not to reveal his identity here.

Written in the same year, although published only in 1939 (in *Charmes et leçons de l'Italie*) was the Florentine and Tuscan notebook of [the painter] MAURICE DENIS, where Piero is extensively discussed. But it is surprising that the man who had created, in 1910, the famous definition of the "synthetic" in painting was not capable of finding, in the old master, anything more than a parallel with Corot—a parallel that doesn't get us very far, to tell the truth, being somewhere between the generic and the glibly sophisticated. To show the improvised nature of Denis's culture where things Florentine were concerned, it will be enough to reveal that he places the Spanish Chapel [really in Santa Maria Novella] in the Duomo [called Santa Maria del Fiore]. The decade was full of such ornamental Franco-Italian culture. Those were the days of Louis Gillet (and of René Piot, his illustrator) and of Ugo Ojetti, who was already thinking about the big panoramic show *De Cimabue à Tiepolo* that he was going to put on at the Petit Palais in 1935.

So we will do better by going back to STOKES who, in 1932, in his new book *The Quattrocento: a Different Conception of the Italian Renaissance*, returns to Piero, although the volume's subject matter was mostly restricted to architecture and sculpture. He proves himself to be aware of the new situation, given that, à propos of the relationship between Piero, Ferrara, and Venice, he draws openly and with obvious sympathy upon my essay of 1914.

In the winter of 1934-35, only students had the opportunity to follow the course that HENRI FOCILLON devoted to Piero at the Sorbonne; and it was only in 1952 that his pupils gathered together the contents of that course, completed them by adding other materials, and published the results. For French culture, which was rather hung up on the showier Renaissance of artists like Gozzoli and Ghirlandaio, Focillon's course was an important event. The historian still dwells at length upon Pisanello and Mantegna, obstinately believing the latter to be at the center of the problem of perspective; but he

does not fail to perceive Piero's artistic stature with increased clarity. He offers a highly praiseworthy example of French *clarté* in his definition of Piero's art as "dramaturgy that resolves itself, as do the shadows, in light: peace in intelligible space." Here we are far distant from the overblown and celebratory language of [such French art historians as] Gillet and Faure, who wrote during the same decade and who foreshadow those imaginary rodeos of André Malraux.

In the meantime, there appeared the first edition of my *Officina ferrarese* [Ferrarese Workshop], where I went somewhat more deeply into the relationship—which I had already pointed out in 1927—between Piero and the great artists who worked for the Este court, in particular the great masters of intarsia from Lendinara. But TOESCA did not take any notice of this important influence of Piero's in his article on the artist written for Volume XXXV of the *Enciclopedia italiana* in 1935. It was unfortunate that at that time (another jotting from my personal notebook) my relationship with my venerated teacher [Toesca] was having its ups and downs. Toesca abstained from citing my ideas, just as he refrained from including my essay of 1914 in his bibliography. But none of this will stop me from recognizing the fine quality of the literary style throughout the whole of his article and the excellence of certain of his specific observations. The most important of these regards the chronological precedence over Piero of the *Madonna* by the Sienese Domenico di Bartolo, painted as early as 1433. But when he says that that picture is full of reflections of "the new Florentine art of Domenico Veneziano," of whom we only begin to hear much later on, he surprises even me, who have always been inclined to admit the importance of [Domenico di Bartolo's work] as a precedent for Piero; a better grounded demonstration [of Domenico Veneziano's influence] would be necessary here. All the more so, since it still remains to be clarified how Domenico di Bartolo, so far ahead in 1433, shows himself already penitent and forgetful of every Florentine novelty in his *Perugia Polyptych*, which dates from 1437, still several years earlier than the colloration between Domenico Veneziano and Piero in Florence. Herein lies, most probably, the historical secret of a problem on which I have tried to shed some light in my essay of 1954 on the "Maestro di Pratovecchio."

As we have already said, 1935 also saw the big Italian parade at the Petit Palais in Paris, led by Ojetti. It is true that the *Flagellation* was spared the journey; but the *Madonna of Sinigallia* and the Montefeltro diptych, both of which had already been to London, once again made the trip. What real benefit accrued to French culture from this massive presence, I cannot say. I imagine the show to have been seen by Focillon's pupils, foremost among them the young Chastel; and I remember meeting Valéry, Jamot, and the young

Sterling, who had made a good contribution to the brief catalogue.

Still in that same year, we may also mention a brief dissertation presented at the University of Leipzig by HERBERT SIEBENHÜNER on *Colorism in the Early Renaissance, above all in relation to Alberti's Treatise and to a work by Piero della Francesca*, which turns out to be the Venice *Saint Jerome with a Donor*. Already the abstract quality of the key work *Kolorismus* reveals the formalism of Hetzer's seminary, from which this dissertation came. Beyond noting the date of around 1450 suggested for the picture—a date quite similar to my own proposal—and calling attention to the failure to cite any of the then-recent studies of the master, I shall limit myself to quoting the following passage: "In Piero there is fulfilled the process of achieving a synthesis of the expressive values of color for the representation of space and bodies, together with color's values in terms of beauty." The source, even if it here appears in an altered and garbled form, is still quite perceptible.

In the years that followed down to 1940, aside from GRANVILLE FELS'S article of 1936 presenting, for the first time, the *Saint* that had just entered the Frick Collection and from the Italian translation of the above-mentioned essay by Schlosser, there appeared studies of various importance by CARLI, FIOCCO, LAZAREV, and SALMI. The last-named scholar offered lucid comments on a series of plates of the Arezzo frescoes; but it is surprising that he sees a collaborator's hand in the *Trial of the True Cross*, a substantially autograph work.

Also in 1939, a Frenchman with a very eloquent style, ELIE FAURE, published *L'Art Renaissant*, the second volume of his *Histoire de l'Art*. Even though he begins from a position regarding our Renaissance which is not devoid of reservations (and this is a theme which will be further pursued in French criticism), he does not hesitate to offer an interpretation of Piero that makes use of modern readings—by which, however, I do not mean the Cubist ones. Here is an example: "In Piero . . . form is at once the crystallization and the core of the spatial poem that develops in the fresco with inexpressible grandeur. Perspective, which had been mechanical, becomes lyrical." And again: "Cylindrical torsos, broad shoulders, round arms, necks like columns, spherical heads looking straight ahead." And so on, with a flow of eloquence perhaps overabundant, but never without a certain sense of the limits.

Far more important was MILLARD MEISS'S article of 1941, "A Documented Altarpiece by Piero della Francesca." Unfortunately, since it appeared during the Second World War, it remained unknown in Italy until the end of the conflict. But this makes all the more significant the fact that, while working on the second edition of my book, I arrived at results almost identical to Meiss's: i.e., that the isolated panels [of *Saint Michael*] in London,

in the Poldi-Pezzoli Museum [in Milan], and (a still-recent addition) in the Frick Collection were the remains of Piero's altarpiece for Sant' Agostino at Sepolcro, a work documented in 1454 and 1469.

Meiss's was certainly the decade's most important contribution to the knowledge of Piero, and the author handles his material with a fine and subtle erudition that extends to matters of iconography. For example, his hypothesis that the Frick *Saint* may represent, rather than Saint Andrew, Saint John the Evangelist, is deserving of support; and I wish to second it here, recalling that the latter saint was particularly venerated at San Sepolcro and had even lent his name to the cathedral there since early times. As for the half-length figures in the Liechtenstein and Lehman Collections which, we both suspected, perhaps belonged to the same altarpiece, today I should like to point out that, while the hypothesis may still serve for the two Liechtenstein figures (and for the Rockefeller *Crucifixion*, not studied by Meiss), it cannot hold good for the Lehman *Saint Apollonia*, for the incontrovertible reason that the fictive light is coming from the opposite direction as compared with that in all the other figures in both the predella and the larger panels. However, given the similar dimensions of all three of the little panels and their presumable shared provenance, we may suppose that the *Saint Apollonia* appeared in another altarpiece by Piero, or at least in another predella by him, situated in the same church, but having an opposite light source. There is no alternative solution, given that we cannot conceive that Piero could have been careless in the execution of an altarpiece that cannot, in any way, have violated the "unities" of an integrated work.

It is difficult to agree with Meiss when he suggests that the polyptych, ordered in 1454 and for which final payment was made in 1469, was executed entirely in the decade 1460-70. In my opinion, even after the discovery in 1947 of the Lisbon *Saint Augustine*, the *Saint* in the Frick Collection shows itself to be far and away the earliest of the series; it may, perhaps, antedate even the last panels of the *Misericordia Altarpiece*. The Frick painting is followed, at various intervals, by the Milan *Saint Nicholas of Tolentino*, the Lisbon *Saint Augustine* and, last of the series, the London *Saint Michael*, where the preciously bejewelled and embellished style closely foreshadows the *Madonna of Sinigallia*, the large *Brera Altarpiece*, and the London *Nativity*.

In 1942 Professor CREIGHTON GILBERT returned to the idea, previously set forth by Toesca, that the Montefeltro portrait diptych in the Uffizi was, in reality, quite a bit later than Cinquini had deduced from Ferabò's sonnet of around 1465. But Gilbert does not demonstrate the validity of his claim, which has recently been disproved by Meiss, above all on the grounds of the notable difference in age between Federigo as he appears in the Uffizi

work and in the *Brera Altarpiece*, which may be dated to around 1472-74.

An excellent marginal note was provided that same year (1942) by FRANCESCO ARCANGELI, in a fine study entitled *Tarsie*. Arcangeli accepts and expands upon my suggestion that the noble works in intarsia by Lendinara at Modena are based upon models placed at the artist's disposal many years earlier by Piero, that "generous master."

Also dating from 1942 is GIUSTA NICCO FASOLA'S fine critical edition of Piero's treatise on perspective in painting, based on the autograph codex in Parma. The same writer's essay on the development of perspectival thought from Euclid to Piero, which appeared contemporaneously, is helpful for the historical and theoretical understanding of Piero's exact science, if not of his art.

In October of 1942, I delivered to my publisher the second edition of my monograph. Unfortunately, the increasingly intense warfare and the bombing of Milan, which seriously damaged Hoepli's printing plants, delayed the book's appearance until December of 1946. As the public is already aware of the work's principal themes, I shall limit myself here to a brief listing of the areas in which my opinions had developed since the first edition. These issues were the Florentine environment in which Piero was trained; the changes in my perception of Piero's relationship to Fra Angelico and Paolo Uccello; the new reading of the Rimini fresco following the first restoration; the sketchy reconstruction of the *Sant' Agostino Altarpiece* (in which I arrived, as has already been noted, at conclusions similar to those reached by Meiss in his study of 1941); and, on the topic of the artist's "critical fortune," the suggestion that Seurat's "Synthetism" was derived from Piero, by way of his more than probable acquaintance with the good copies of the Arezzo frescoes executed by the painter Loyeux on a commission from the historian of Italian art Charles Blanc in around 1880—copies which, I said, "are presumably still in the chapel of the Ecole des Beaux-Arts" in Paris.

In the years immediately following, Professor MARIO SALMI returned several times to the topic of Piero. In my opinion, his most important contribution in this area is the one (1943) in which he successfully sets out to find echoes of Piero's lost Ferrara frescoes in the [codex known as the] *Bible of Borso d'Este* (1455-61). These echoes are such as to suggest that, at the time of his Ferrarese sojourn, Piero had already developed the style which was to be more amply displayed at Rimini and Arezzo. In his book *Piero della Francesca e il Palazzo Ducale di Urbino*, Professor Salmi adds useful observations, along the lines of my own notes, regarding the shared ideas of Piero, [Leon Battista] Alberti, and [Luciano] Laurana, and proceeds to relate these ideas to fifteenth-century Venetian architecture. Less felicitous is his study of 1947, *Un'ipotesi su*

Piero della Francesca [A Hypothesis Regarding Piero della Francesca], where he suggests that the Cook panels—which I had tentatively related in 1940 to the youthful Angelico—belong to Piero's Florentine period. In the same study, there is a related suggestion that Piero had a hand in the landscape in Angelico's *Annunciation* at Cortona, and even an attempt to find a precedent for Piero in certain old things of Antonio Alberti's. Neither of these proposals opened the way to any further discussion.

In the meantime, the war had ended. Almost as if to make up for lost time, Europe and America asked each other for a quick summary of art-historical developments. The Italian Renaissance, of which so much had been made in Italy for excessively nationalistic purposes, took a back seat among Unesco's preferences. This was a long and complicated story, which gave too much space to the art of the colonies and to the worst sort of folklore, ending up by enslaving the Renaissance to Bantu culture. The victim of bad timing, Piero thus ran the risk of being excluded from general culture almost before getting across the threshold. In the first postwar art-historical handbook, LEICHT's *Kunstgeschichte der Welt* [Art History of the World], published in Zurich in 1945, Masaccio and Ghirlandaio survive, but there is no longer (or there is not yet) any trace of Piero della Francesca (nor of Antonello da Messina, nor of Giovanni Bellini). I mention this because such periods of silence also form part of artists' critical fortune (or misfortune).

It is not that a more civilized Europe did not attempt to survive. In 1947, in the first volume of his *Musée imaginaire* [published in English as *Museum without Walls*], ANDRÉ MALRAUX recalls in a lofty tone that "the beginning of our century saw four painters, hitherto considered minor, elevated to the ranks of the greatest: Piero della Francesca, El Greco, Georges de la Tour, Vermeer." But from this collision between four ill-assorted names, it is easy to foresee the coming slide into exoticism and timeless prehistory—the Sumerians, the Hittites, and other such cultures. The maps of artistic geography grow ever more capricious, and temporal relationships go to hell. That same year, for example, in the catalogue of a show in Paris of seventeenth-century painters from Toulouse, MESURET finds that the *Battle of the Roches Noires* by the Caraveggesque Tournier is derived from the *Battle of Constantine and Maxentius* painted by Piero at Arezzo.

Faced with such irresponsible anti-historicism, we are pleased to remember that an interpretation much more in keeping with historical fact had found expression, shortly before, in Rafael Alberti's short poem "Piero della Francesca." Although we should like to quote it in its entirety, we shall restrict ourselves to citing—as an invitation to read the rest—these four lines: "Arco puro la frente, / y basamento erguido / el cuello sostenido / melancóli-

camente." [The forehead a pure arch, / and an erect base / the neck held / in a melancholy fashion.]

Among the immediate postwar years, 1947 was thus the richest in contributions regarding Piero. I myself wrote an essay on a "Madonna della cerchia di Piero per il Veneto" [A Madonna from the Circle of Piero for the Veneto]. The picture in question was an incunabulum of Piero's, copied by a very faithful amanuensis shortly after 1450 and then variously imitated by painters of the Veneto region. The same year saw the happy discovery of the *Saint Augustine* in the museum in Lisbon, which at least completed the series of lateral panels from the altarpiece painted for the Augustinians of San Sepolcro. The work was very well presented by Sir KENNETH CLARK in the August 1947 issue of *The Burlington Magazine*. However, as clarified in my note on the painting, I am not convinced by Clark's attribution to assistants of the *Stories of the Life of Christ* that the artist has represented as embroidered along the borders of the saint's cope.

But since Clark showed himself more than receptive to Meiss's proposed reconstruction, I wrote him an open letter, published in the October issue of *The Burlington Magazine*, in which I drew his attention to the interesting similarity between Meiss's reconstruction and the one I had independently suggested in the second edition of my *Piero della Francesca*, written in 1942. An editorial note acknowledged the information, and from that moment, the new edition of my book started to circulate in England as well.

It was reviewed in the same magazine, in December of 1948, by BENEDICT NICOLSON. He cited the new elements (including those which, he said, might arouse controversy), but complained of the absence of an update on the literature and critical fortune—and if today, in this third edition, I am fulfilling the task, it is largely on account of the stimulus provided me by Nicolson. He also chose to conclude his review by quoting my words on the importance of Loyeux's copies of Piero's frescoes for the formation of Seurat's "Synthetism," adding at the end some cheering news: "I understand that these copies are still *in situ*."

This information was promptly picked up, in 1949, by Sir KENNETH CLARK in his very elegant book *Landscape into Art*. It is worth reproducing the relevant passage. "It has long been a puzzle how Seurat, who never went to Italy, could have come so close to these, then almost unknown, works. The answer is that copies of two of Piero's frescoes, by the painter Loyeux, hung in the Chapel of the École des Beaux-Arts. They had been commissioned in the 1870's by the director, Charles Blanc, whose pages on the geometrical basis of design in his *Grammaire des arts du dessin* had also influenced Seurat profoundly: so for once an art historian made a positive contribution to creative

art."

I could have hoped for nothing better; Clark's observation was in complete agreement with my note of 1942. So I felt the urgent need to return more extensively to the topic in my text on the Arezzo frescoes published in German and English translation in 1949 (Iris Verlag, Berne and Toronto), but with so many errors that I felt constrained to publish a more correct text (in *Paragone*, 1950), which the reader will find reproduced in this third edition [under its original title of *Piero in Arezzo*.] The problem [of Seurat's awareness of Piero], fundamental to an understanding of Piero's critical fortune, is exhaustively discussed in my essay of 1950 on the *Cultura formale di Seurat*.

But let us take a few steps back. The year 1948 had seen the brief, popular monographs of JEAN ALAZARD and VIRGILIO GILARDONI; while 1948 and 1949 marked the notes added by L. and C. L. RAGGHIANTI to the *Life* of Piero in the Rizzoli edition of Vasari. Professor Ragghianti tells us, in the preface to his volume of notes, that his manuscript was lost during the war, and this explains, at least in part, why, despite his efforts to reconstruct it, so many lacunae and imprecisions remain. There is, for example, no mention of Piero's autograph codex of the treatise on perspective—the one used by Nicco Fasola for her critical edition of 1942—in the account of the various manuscripts of this text. Ragghianti tells us that Bramantino's fresco of the *Dead Christ* in Milan is "datable," but fails to tell us the date (which, in fact, cannot be ascertained). As for the Augustian polyptych painted for San Sepolcro, the writer repeats the old error of identifying it with the *Assumption of the Virgin with Saints* in the local gallery, even as he admits that the latter is Peruginesque. To tell the truth, by the time Ragghianti published his notes, the altarpiece had already been almost entirely reconstructed by Meiss (1941), by the present writer (1942), and by Clark (1947).

There also dates from 1949 a new and welcome contribution from ADRIAN STOKES. His book *Art and Science* contains very important pages and some enchanting passages on Alberti and Piero. But his discussion, perhaps too insistent in its tone, is wrapped in an ambiguous mysticism, the conclusion of which is worth quoting here.

"There are, then, three starting points for the critique of Piero's painting. First, the potential coincidence of science and art in the early Renaissance, founded on the new victories of perspective. Secondly, his sense of colour as the basis of his sense of form. Although connections are many between these two approaches, only the first has a literature. To the detriment of art-criticism, form is rarely envisaged from the end of colour. The two roads prove to be but branches of the third, the quality of love by which Piero's bare geometry is seen by us as warm and rich as well as noble; a nakedness of love, num-

bers that in bareness may thereby be clothed by magnificence as may the study-object of anatomist and physiologist, shared also by poets and by every human being."

Upon this unexpected blossoming of neo-aetheticism [of the ideas and tone of the late-medieval Italian poetry], reminiscent of the *dolce stil novo*, we must reluctantly take our leave of Stokes, whose book contains other enchanting passages on the poetic—or, as he prefers to say, the "loving"—effect of Piero's art. We encounter, shortly afterwards, some echoes of Stoke's gifts in the book on Piero by Clark, who cites Stokes with great respect. In the history of English art criticism since Ruskin, Stokes probably occupies a mental position of his own, one we would wish to see more widely recognized, in Italy as well.

The year 1950 saw BERENSON'S elegant discussion, *Piero della Francesca o dell'arte non eloquente* [also published in English, in 1954, as *Piero della Francesca. The Ineloquent in Art*]. He begins with his surprise when, "a quarter of a century ago," there began the mass admiration for Piero della Francesca and for the analogies between Piero and Cézanne "discovered by today's painters." One may legitimately ask whether those analogies were really discovered by painters or, rather, by critics. It is true that Berenson likes to insist particularly upon Piero's opposition to every manifestation of emotion; but here, too, one might object that solemnity and calm are themselves expressible emotions. I do not doubt that Berenson intended, instead, to underline the absence in Piero of any form of "expressionism"; and the examples of impassivity that Berenson selects, starting with the temples of ancient Egypt and passing through Classical art, with many examples chosen from the field of the portrait, would seem to confirm this intention. But we are surprised again when, towards the end, he includes an example by van Gogh. Nonetheless, it is well worth indulging the mania for elegant conversation of an elderly sage who knows many things and who, out of the fear of forgetting them, tells us too many of them.

It is painful to have to cite, so close to such a beloved name and on account of mere reasons of chronology (1950), the lamentable volume *Piero della Francesca* written by the Lombard painter BORRA. To judge from his pictures, Borra sees Piero through the thick lenses of Lorentino d'Arezzo. Let us add that he reproduces as his Plate no. 137 (even if as an "attributed work") the shameful fake formerly in the Boston Museum: a portrait of a woman copied from a female onlooker in one of the scenes at Arezzo.

CLARK'S new monograph, *Piero della Francesca*, appeared the following year in the lucid series put out by the Phaidon Press. With its very readable and well written text and its modern and efficient graphic layout, it was,

for the cultivated public, an excellent replacement for my own old and almost impossible-to-find book; a book which had, in any event, never been meant to popularize its subject matter. Clark himself, while unstinting in his praise of my monograph, finds it "oddly unconvincing": a judgment that I myself can agree with, for the same reasons for which I find Clark's text highly readable and accessible to a wide public. The date of Clark's book can clarify the reasons for which we find in it, besides the by-then-obvious names of Cézanne and Seurat, frequent references to "Congolese masks" and "pre-Dynastic jars," while the volume is dedicated to Henry Moore.

As for certain disagreements regarding particular aspects of chronology and attribution, I can more suitably give an account of them in my notes. A topic more appropriate to the present chapter is the publication in 1951 of several reviews offering interesting comparisons between Clark's book and my own. One such was the anonymous review in the *Times Literary Supplement*, and BENEDICT NICOLSON followed the same procedure to an even greater extent in *The New Statesman* and the *Nation*. According to Nicolson, Clark's book, with its dedication to Moore, is a reflection of the end of abstractionism, just as my monograph of 1927, and even my essay of 1914, reflect its beginnings. But I had already refuted, ever since their first appearance, the Cubist interpretations of my book. In order to involve me in such a context, Nicolson would have had to draw upon a critical autobiography that I have never written, and probably never will. But here I have, at least, the right to say that never, in my *Piero*, do I refer to Picasso and Braque, nor to such movements as Section d'Or, De Stijl, Cercle et Carré, or similar aberrations. Nor do I try to compare Leon Battista Alberti with Docteur Princet, whose lack of substance has recently been demonstrated by Kahnweiler. The names which do turn up in my book, and most forcefully, are those of Cézanne and Seurat. It seemed to me that the two "sides"—the abstract movements on the one hand, Cézanne and Seurat on the other—were hermetically sealed off one from the other. And I should also like to recall that, as early as 1939, I had pointed out the relationship between the element of decadent arts-and-crafts intellectualism inherent in Cubism and related movements on the one hand, and the new collective infatuation with the thirteenth century typical of the circles of Bloomsbury and Montparnasse on the other.

I have chosen to dwell upon this fallacious critical stance because it has formed a curious accompaniment to practically the whole history of Piero's "fortune" over the past thirty-five years—and, as we shall see, it has not always been presented in the same good faith shown by Nicolson.

Already in 1950, for example, ANDRÉ LHOTE went back on the attack in *Traité de la figure*, evoking Rosenthal's old essay of 1923, with its analysis

of the Arezzo frescoes in terms of the golden section. I do not know whether it is an accident that there appears in Lhote's book, alongside a reproduction of Piero's horses from Arezzo, another showing Caravaggio's horse from the *Conversion of Saint Paul*, with the sole purpose of pointing out the latter's brutality—redeemed shortly thereafter, according to Lhote, by the winged stylistic solution of Georges de la Tour. And it is curious that this same idea also occurs, almost simultaneously (1950), in Malraux. The target of Lhote's arrow appears more clearly in his conclusion: "But realist brutality can always impose upon vulgar people. When they discover a painting of this sort, they become ecstatic, and finally take a rest from the effort they were making to enjoy, for example, the serene purity of a Piero della Francesca." I do not wish to go overboard, but anyone who knows the paintings of André Lhote will immediately understand the reasons for which the rediscovery of Caravaggio, in which I had a part, seemed to him a shameful negation of the rediscovery of Piero.

In those years immediately after 1950, while damaged museums were being repaired and there were an increasing number of traveling exhibitions serving the purposes of diplomatic and political prestige, publishers continued to ask German and Anglo-Saxon culture for easily read books offering brilliant and sparkling art-historical syntheses. The best and most readable of these is GOMBRICH'S; the most schematic is PAATZ'S (1953). Gombrich, in his *The Story of Art* (1950), is too caught up in schematic ideas of innate psychology, and therefore fails at times to respect the truth regarding specifically artistic connections. He links Piero's research regarding perspective with Mantegna's, as historians had habitually done a century earlier, in Burckhardt's day—just as though there had been no developments in the meantime.

The following year (1951), DAVID M. ROBB, despite his having studied Italian art under the tutelage of the excellent and much mourned E. Sandberg-Vavalà, is not much more careful; he nonetheless condescends to recognize affinities, at least of an ideal sort, between Piero and Seurat.

The same year also saw the regrettable mention of Piero in ARNOLD HAUSER'S *The Social History of Art*. The author's attractive but often unverifiable ideas about "cumulative" and prehistoric epochs are useless when it comes to dealing with periods characterized by individual artists whose poetic qualities cannot help but transmit themselves, thanks to their inherent power, to the society around them. So it is that, when Hauser reproduces the *Meeting of Solomon and the Queen of Sheba* from Arezzo, his caption limits itself to the observation that Piero was used to serving at court. Even if the sociological intention has been reversed, the implicit reproof is almost identical with the one that the bigoted Rio had directed at Piero a century earlier when he crit-

icized him for having painted a fresco that was an homage to Sigismondo Malatesta, the tyrant of Rimini. It is worth wondering whether Hauser, had he chosen the *Trial of the True Cross* and the *Death of Adam* instead of the *Meeting of Solomon and the Queen of Sheba*, might not have interpreted Piero as a peasant painter. Given that Hauser does not like to receive any specific communication from works of art as such, it was only to be expected that, a few pages earlier, the work that is perhaps the most "reactionary" of the entire fourteenth century—Andrea da Firenze's Spanish Chapel at Santa Maria Novella—is declared to be one of the most "artistically progressive" things of the entire century.

Quite different—to get a bit ahead of ourselves in our discussion of art-historical syntheses—is the part devoted to Piero della Francesca a few years later (1956) by ANDRÉ CHASTEL in his lucid little volumes on *L'art italien*, which were, on my advice, promptly translated into Italian (1958). Here we shall quote some passages in which there returns, in more modern form, the *clarté* of Chastel's teacher Focillon. "This 'monarch of painting,' to use Pacioli's term, was, for the generation of the middle of the century, a personality as complete as Giotto had been and, like the latter, one national, not provincial, in character . . . The admirable little painting of the *Flagellation* spreads this precise clarity through a perspective that is strict, and less clenched than Uccello's. Geometrical intuition and intensity of color are both carried to their highest level of effectiveness, transforming the universe into a luminous cage, without fissures, wherein humanity cannot wander.

"The impersonality of this art is what gives it its nobility; but it is softened by two aspects: the first is rustic, rural, evident even in the physical types: the second is lordly, heroic, legendary; and it is, perhaps, this that gives the work its epic tone. This is the case, above all, in the Arezzo cycle." Or again, à propos of the *Madonna of Sinigallia*: " . . . the interior, where the light fragments itself into delicate threads." (This last is an interpretation that comes very close to Seurat.)

The new decade [of the fifties], with which we approach the end of this supplementary chapter, does not offer us very much new material.

The *Enciclopedia della Pittura Italiana* of GALETTI and CAMESASCA (1951) contains a very extensive and, on the whole, accurate entry on Piero della Francesca.

Having created a new and imposing setting for the *Brera Altarpiece* in the Milanese museum, FERNANDA WITTGENS commented on it (1952) in a brief popularizing pamphlet.

URBANI discussed the restoration—in my opinion, not a very successful one—of the Urbino *Flagellation*. A year later, CESARE BRANDI reported on

the far better restoration of the *Perugia Altarpiece*.

Piero had, by this time, become a regular stock-in-trade of the publishing industry. An example is the little color book written for Skira by LIONELLO VENTURI (1953), worth citing for its strange "popular" interpretation of the humanity painted by Piero: a humanity seen, according to the author, through a screen of irony that I am unable to detect. Contemporaneously, Venturi also published an article on "Piero della Francesca, Georges Seurat, Juan Gris" in which he returned (but with an unwarrented extension to the third name) to the well-known problem [of Seurat's knowledge of the Arezzo frescoes] that I had clarified in 1950.

In the same year, RUDOLF WITTKOWER carried out a very careful study of the perspective in the *Flagellation*, demonstrating its complexity, even if he insisted excessively upon the symbolic meaning of Piero's perspectival research, thus investing it with too much of an abstract quality.

In 1954, JOHN POPE-HENNESSY offered a good, succinct commentary for a set of reproductions of the master's works published by the Metropolitan Museum in New York. Meanwhile, C. L. RAGGHIANTI—in a study of *L'inizio di Leonardo* [Leonardo's Beginnings] published in an unfinished state— thought that he had discovered, in a well-known fourteenth-century fresco of the Orcagnesque school in the Florentine church of the Santo Spirito, two inserted passages: one by Gentile da Fabriano, the other by Piero della Francesca. But this spectacular claim, already inadmissable on technical grounds, did not give rise to any real critical discussion. It was decisively refuted by MARIO SALMI in *Commentari* (1955), and cited in passing both in the catalogue of the *Mostra dei Quattro Maestri* held at Palazzo Strozzi in Florence in 1954, and in Bianconi's book of 1957, where it is called an "audacious attributional suggestion." For a precise history of Piero's "fortune," it is more useful to recall that the Strozzi show included less well-known works by the great artist from Borgo, such as the two from the Contini-Bonacossi Collection (added by me to the second edition of my book), the Berlin *Saint Jerome*, and even the Lisbon *Saint Augustine*.

More important for academic studies was, in the same year, MILLARD MEISS'S very erudite study, bearing an almost "mysteriosophical" title: *Ovum Struthionis—Symbol and Allusion in Piero della Francesca's Montefeltro Altarpiece*. [An *ovum struthionis* in an ostrich egg.] Already in my book, recalling that object suspended over the Virgin's head, I had spoken of a "sacred egg," but without exploring the implications that such a symbolic choice might have for the subject matter of the picture and its precise dating. The implication, based on minute observations [on Meiss's part] that cannot be repeated here, is that the altarpiece must allude to the birth of Guidobaldo [da

Montefeltro] in 1472, which was also the year of the death of Guidobaldo's mother, Battista Sforza. As for the *terminus post quem*, Meiss deduces that the work must date from earlier than 1474 from the fact that Federigo is not yet wearing the Order of the Garter conferred upon him in that year—an honor which he is, contrariwise, seen displaying in the Windsor portrait, where he is accompanied by the infant Guidobaldo. Meiss also cites several documents relating to the presence of ostrich eggs in Italian churches, where they often figured as counterweights to lamps. However, he leaves out—unless I am mistaken—the oldest surviving example, the one hanging over the enthroned Virgin from the frescoed aedicule on the Fissiraga Tomb at Lodi, dated 1327 and published by Toesca fully fifty years ago. This note may help complete the valuable additional information that Meiss provided, also in 1954, in his special *Addendum Ovologicum*.

Meiss's precious research did not much alter the general time frame already commonly proposed for the *Brera Altarpiece*; it did, however tighten it up. This greater precision may also serve, I think, to suggest that the Duke's hands, painted by Pedro Berruguete, show that this Spanish painter arrived at Urbino long before he is finally documented there in 1477.

Another useful piece of erudite research was, in 1955, TOLNAY'S article on Piero's Borgo *Resurrection*. I had already had occasion to refer to the work's underlying symbolism as "a difficult change of season"; and Tolnay goes more deeply into the meaning of this naturalistic symbolism. But the study is also important for its citation of a document brought to Tolnay's attention by Procacci; this document establishes 1474 as the date when the fresco was moved from its first location to the room in the Palazzo Comunale where it is still found today. However, while Tolnay dates the fresco to after 1470, it seems to me that the documentation of that early transfer confirms that the work should be dated much earlier—to the period of the Arezzo frescoes, as I have always proposed.

The same year (1955) also saw what I hope was the last flare-up of the interpretation of my old book in para-Cubist terms. OTTO KURZ uses his (less than fully enthusiastic) commemorative article on Schlosser, published in an Italian magazine, as a pretext to complain that the two monographs particularly appreciated by the late Viennese scholar—Rintelen's on Giotto and my own on Piero della Francesca—reflect the incorrigibly modernist culture of their authors. Behind Rintelen's Giotto, he sees Hodler; behind my Piero, De Chirico's piazzas. This was a final variant of the interpretations offered by Lhote and Nicolson, and a particularly ill-chosen one. (See my essay of 1919 on De Chirico.) But then, everyone must acquire a culture of one sort or another; and underlying Kurz's attitude, I can see only the culture of an

abstract erudition so linked to chronology as to become anti-historical—as is true for the whole of the school he represents. A healthy approach to history, on the other hand, cannot help but take the present as its vantage point, the better to open a window onto the past. But—what present? My own modern culture, which took shape in the years around 1910, was based—as I am here forced to repeat once again—not on the moment of Cubism, and even less on the moment of "metaphysical" painting, which was still in the future. It was based on the moment of the reconstructive Post-Impressionism of Cézanne and Seurat who, with their ability to achieve a synthesis of form and color by means of perspective, set in motion, not the esthetic confusion of the past fifty years of art but, at the very least, a critical search capable of recovering the history of a great poetic idea that had arisen in the first half of the fifteenth century. (We may well believe in the authenticity of a saying attributed to Cézanne: "Le tout mis en perspective" [everything put in perspective].) Critically speaking, Piero was rediscovered by Cézanne and Seurat (or by others on their account), and not by the brilliant rhapsodist Picasso.

There is not much more to add to the "critical fortune" of the master from 1955 to the present. At the start of that year there spread the news of the discovery, which had taken place on December 23, 1954, of a mutilated fresco by Piero in the church of Sant' Agostino at San Sepolcro; and this information, commented upon by R. PAPINI and M. SALMI (with the latter, however, expressing many doubts) turned out to be correct. BIANCONI already took notice of it in his smoothly written little volume on the master, published in 1957 as part of the publisher Rizzoli's well-conceived series. The fresco's prompt detachment from the wall made possible its presentation at the exhibition of detached frescoes held in 1958 at the Forte di Belvedere in Florence.

The year 1957 also saw the publication of DINO FORMAGGIO'S brief but serious little volume on Piero della Francesca, where the emphasis on the "realistic" significance of Piero's perspective is accompanied by useful and frequently pertinent cultural references.

In 1960 a German publisher brought out, I don't know how wisely, the late-nineteenth-century correspondence between the famous art critics GIOVANNI MORELLI and J. P. RICHTER. The volume proved useful, if only because it contained references to many works that were turning up at the time the letters were being written. I had the good luck to discover in the book—I say "discover" because there is no trace of the subject in the index—a reference to a portrait of Sigismondo Malatesta brought from Saint Petersburg to Milan in 1889 by Delaroff, a Russian follower of Morelli's. In this painting, the celebrated Morelli immediately recognized the hand of Piero, an artist of whom he had never had a high opinion. It was not difficult

for me to conclude—as I said in a review written in 1961—that the painting, left in Milan for restoration, was the same one that passed from the D'Ancona collection into Contini-Bonacossi collection in Florence around 1930, where it is still to be found, and where it was reproduced in the second edition of my book (1942-46).

Still in 1960, one might, perhaps, have expected greater illumination regarding Piero from the brief but good essay by MALLÉ, "Il mondo in prospettiva" [the world in perspective] included in the volume *Civiltà nell'arte*, a sort of small but lively encyclopedia of art edited in accordance with E. Castelnuovo's plan. The year 1961 saw the good entry on Piero in the *Encyclopaedia Britannica*, volume IX, cryptically signed—P.J. MY.—which may be decoded as Peter John Murray.

As for the most recent years, let those who so desire snatch at the references to Piero to be found in illustrated histories that stride through time and place shod in seven-league boots, or from the lightweight prefaces to shows of modern artists who are, at best, adepts of the cult of purist, Platonic abstractionism. As for myself, I have already set forth the reasons for which I regard such references as illicit, importunate, and even indecent. Far more worthy of being remembered, I believe, is the poetry devoted to Piero by Pier Paolo Pasolini, who thus follows in the wake of D'Annunzio and Rafael Alberti.

I may also cite two very recent entries in the field of specialist studies. The first is A. PARRONCHI'S interesting, and not at all ill-considered, proposal to give to Piero—and not to Paolo Uccello, as has usually been done—the Uffizi's magnificent drawing presenting, in all its perspectival complexity, a multifaceted crystal vase. The second is G. PREVITALI'S pithy set of annotations to the *Life* of Piero in the Club del Libro's new (1962) edition of Vasari.

It may well be that, selective as it is, this chronicle of Piero's "fortune" over the past thirty-five years may still strike some readers as overabundant. It will not seem so, however, to those for whom Piero is still a living artist: one capable not just of resting on the laurels of his past, but also of providing for his own future. Any presage or bit of evidence in this regard is always welcome. Is it still fashionable to go to Arezzo? Do the Brothers of San Francesco keep a register of visitors' signatures? This head-count might lead to some interesting discoveries. For example, the name of [the painter] Giorgio Morandi ought to turn up more than once. And [the poet] Giuseppe Ungaretti tells me that, in just a few days, we shall be able to read there—and I find the news cheering—the signature of [the painter] Jean Fautrier.

LONGHI'S BIBLIOGRAPHY[1]
(1927)

1460-65 ANTONIO AVERLINO. *Trattato dell'Architettura.* Edited by W. v. Oettingen in *Quellenschriften für Kunstgeschichte.* N. F., III Band., p. 302. Vienna, 1890.

1466 FERABÒ. *Carme* published by A. Cinquini in "De vita et morte illustris D. Baptistae Sfortiae Comitissae Urbini," song by Ser Gaugello de la Pergola. Opuscolo per Nozze, Rome 1905. (Mention of the portrait of Federigo da M. painted by P. d. F.)

1470-75 NICOLÒ TESTA CILLENIO. *Sonetto.* Published by Ricci ("Un sonetto artistico del Sec. XV") in *Arte e Storia*, 1897, p. 27.

1490-95 GIOVANNI SANTI. *Cronica rimata.* Edited by Holtzinger. Tübingen, 1893.

1494 LUCA PACIOLI. *Summa Arithmeticae*, etc. (passim). Venice, 1494.

1502 CAMILLO LEONARDI (LEONARDO PESARESE). *Speculum lapidum.* Venice, 1502.

1506 RAFFAELLO MAFFEI (RAPHAEL VOLATERRANEUS). *Commentariorum Urbanorum Libri. Anthropologia, lib. XXI ; De Optice et Catoptice, lib. XXV.* Rome, 1506.

1509 LUCA PACIOLI. *De Divina Proportione.* Venice, 1509. Edition published 1889 (Vienna), pp. 123, 160.

[1] The dates in the column at the left, when they do not match those of the works cited, refer to the date when the work was written. We have excluded from this bibliography those works in which Piero is mentioned exclusively as a theoretician: i.e., general histories of mathematics and perspective. We have also omitted the oldest iconography of the works of Piero, almost never used today, in the various series of engravings from the early nineteenth century, such as the Pinacoteca di Milano (1812) and the Reale Galleria di Firenze (1817; or later iconographic collections, such as the plates of the Arundel Society or the Klassischer Bilderschatz. (RL)

1521 CESARE CESARIANO. Translation and commentary by
Vitruvius. Como, 1521, fol. X b.

1536 G. B. CAPORALI. Translation and commentary by Vitruvius.
Perugia, 1536, fol. 16 a.

1549 FRA SABBA DA CASTIGLIONE. *Ricordi overo Ammaestramenti.*
Venice, 1549. Ricordi 109 and 110.

1550 GIORGIO VASARI. *Le Vite.* Florence: Torrentino, 1550.

1556 BERTO DEGLI ALBERTI. *Codicetto di memorie,* with a reference
to Piero, cited by G. degli Azzi in *Archivi della Storia d'Italia,*
IV. Rocca S. Casciano, 1915.

1568 GIORGIO VASARI. *Le Vite.* Florence: Giunti, 1568.

1569 DANIELE BARBARO. *La pratica della prospettiva.* Venice, 1569.

1583 EGNAZIO DANTI. *Le due regole della prospettiva pratica di I.
Barozio da Vignola.* Rome, 1583. (In the preface.)

1585 ROMANO ALBERTI. *Trattato della nobiltà della pittura.* Rome,
1585, p. 32.

c. 1585 A. M. GRAZIANI. *De Scriptis invita Minerva.* Florence, 1746,
I, pp. 41, 42.

1587 B. BALDI. *Vite de' Matematici.* Ms. in the Bibl. Boncompagni,
vol. II, c. 186.

1630 J. VON SANDRART. *Academia nobilissimae artis pictoriae.*
Edition lat. Noribergae, 1683, fol. 103.

1695 G. P. BELLORI, *Descrizione delle immagini dipinte da Raffaello
d'Urbino* etc. Rome, 1695 (1751 edition, pp. 1, 2).

1698 F. BUONARROTI. *Osservazioni istoriche sopra alcuni medaglioni
antichi.* Rome, 1698, p. 256.

1697-1722 G. BARUFFALDI. *Vite de' pittori e scultori Ferraresi*. Ferrara, 1844, I, pp. 9, 50, 69.

1704 P. ORLANDI. *Abbecedario pittorico*. Bologna, 1704.

1715 A. TAJA. *Descrizione del Palazzo Apostolico Vaticano*. Rome, 1750, p. 412.

c. 1720 J. RICHARDSON. *The Works*. (In *Historical and Chronological Series of the Principal Professors of Painting*, p. 284). London, 1792.

1730 L. PASCOLI. *Vite de' pittori* etc. Rome, 1730, I, 290.

1752-54 LACOMBE. *Dictionnaire portatif des Beaux Arts*. Paris, 1766 edition, p. 525.

1754 C. F. MARCHESELLI. *Pitture delle chiese di Rimino* (sic). Rimini, 1754.

1756 D. M. MANNI. *Vita di Luca Signorelli*. In the *Raccolta milanese*, 1756. Milan: Agnelli.

1759 VASARI. *Le Vite*. Annotated by G. BOTTARI. Rome, 1759.

c. 1765 M. ORETTI. *Miscellanee manoscritte*. (Bibl. Comun. di Bologna.)

1765 G. B. COSTA. *Il tempio di S. Francesco di Rimini*. Lucca, 1765, pp. 98, 99.

1767-72 VASARI. *Le Vite*. Livorno edition continued in Florence, 1767-1772. With notes by BOTICELLI. Vol. II, 1771, pp. 205-214.

1770 F. BALDINUCCI. *Notizie de' professori del disegno da Cimabue in qua*. Annotated by G. PIACENZA. Turin, 1770. Vol. II, pp. 67-73.

1772 A. REPOSATI. *Della Zecca di Gubbio* etc. Bologna, 1772, I,

153. (Concerning the interpretation of the painting of the *Flagellation* in Urbino.)

1775 M. A. DOLCI. *Distinto ragguaglio delle pitture... in Urbino*, 1775. Ms. formerly in the possession of Pungileoni.

1782 A. CHIUSOLE. *Itinerario delle pitture etc. ... d'Italia*. Vicenza, 1782, p. 215.

1788 A. MARIOTTI. *Lettere pittoriche perugine*. Perugia, 1788, pp.125-127.

1789 L. LANZI. *Storia pittorica della Italia*. Bassano, 1789 (passim).

1791 A. COMOLLI. *Bibliografia dell'architettura civile*. Rome, 1788-1792. Vol. III, 1791, pp. 186, 187.

1791 B. ORSINI. *Risposta alle lettere pittoriche del sig. Annibale Mariotti*. Perugia, 1791, p. 10.

1794 F. G. BATTAGLINI. "Della Vita di S. P. Malatesta". In *Basinii Parmensis opera*. Arimini, 1794 (with an engraving by Rosaspina of the Rimini fresco), p. 272.

1794 A. BATTAGLINI. "Della corte letteraria di S. P. Malatesta". Ibid., 1794, p. 68.

1794 P. ZANI. *Enciclopedia etc. ... delle Belle Arti*. Parma, 1794. 2nd Parma edition, vol. IX (1822).

1795 VASARI. *Le Vite*. Annotated by DELLA VALLE. Siena, 1795.

1797 LAZARI. *Dizionario storico degli artisti professori di B. A. di Urbino*. In COLUCCI. *Antichità Picene*. Vol. XXXI.

1801 LAZARI. *Delle Chiese di Urbino e delle pitture in essa esistenti*. Urbino, 1801.

1803 J. H. FIORILLO. *Kleine Schriften artist. Inhalts*. I. (1803), pp. 318 ff. (On the question of plagiarism.)

1807 VASARI. *Le Vite.* Published in the series Classici italiani. Annotated by DE PAGAVE. Milan, 1807-11.

1810 G. BOSSI. *Del Cenacolo di Leonardo da Vinci.* Milan, 1810.

1816 STENDHAL. *Histoire de la peinture en Italie.* Paris, 1868.

1818 S. TICOZZI. *Dizionario dei pittori.* Milan, 1818.

1818 A. RICCI. *Memorie storiche delle arti e degli artisti nella Marca di Ancona.* Macerata, 1818, I, 182.

1819 [ANGELUCCI] *Memorie istoriche per servire di guida al forestiero in Arezzo.* Florence, 1819, pp. 87, 130.

1821 L. CICOGNARA. *Catalogo ragionato dei libri d'arte e d'antichità* ... Pisa, 1821, I, p. 59.

1822 L. SIEPI. *Descrizione topologico istorica della Città di Perugia.* Perugia, 1822, I, p. 257.

1822 L. PUNGILEONI. *Elogio storico di Giovanni Santi.* Urbino, 1822, pp. 12, 75. (Documents.)

1823 W. OTTLEY. *The Italian Schools of Design.* London, 1823, p. 58.

1826 GIACOMO MANCINI. "Lettera... al sig. marchese e comm. Andrea del Monte... ove parlasi di una tavola di P. d. Fr." In *Giornale Arcadico*, X X XII, 1826, p. 370.

1826-28 M. VALÉRY. *Voyages... en Italie.* Paris, 1831, IV, p. 346.

1827-31 C. FR. VON RUMOHR. *Italienische Forschungen.* Edited by Julius Schlosser. Frankfurt, 1920, pp. 432, 517.

1829 G. ANDREOCCI. *Breve ragguaglio etc. ... in Città di Castello.* Arezzo, 1829, p. 37. (Regarding the Coronation owned by Mancini, then attributed to Piero.)

1830 S. TICOZZI. *Dizionario degli architetti, scultori e pittori*. Milan, 1830. I, p. 109.

1832 G. MANCINI. *Istruzione storico-pittorica per visitare le chiese e i palazzi di Città di Castello*. Vol. I, pp. 340-343 ; vol. II, with an *Appendice... delle più eccellenti tavole di San Sepolcro*, pp. 268-279 *passim*. Perugia, 1832.

1832-38 VASARI. *Le Vite*. With notes. Florence: Passigli, 1832-38.

1832 VASARI. *Le Vite*. German translation by SCHORN and FÖRSTER, with notes. Stuttgart, 1832-1849.

1835 L. PUNGILEONI. "Luca Pacioli." *Giornale Arcadico*, 1835, vols. LXII and LXIII.

1835 F. GHERARDI-DRAGOMANNI. *Vita di Pietro della Francesca* by Vasari, with notes. Florence, 1835.

1836 GAYE. (Regarding the ascription to Piero of the *Assumption* in S. Chiara a Borgo and Punglileoni's defense of Pacioli.) *Stuttgarter Kunstblatt*, 25 October 1836.

1837 NAGLER. *Künstlerlexikon*, vol. IV (1837), pp. 434-435. Munich, 1835-1852.

1837 F. KUGLER. *Handbuch der Geschichte der Malerei*. Berlin, 1837.

1837-39 G. ROSINI. *Storia della pittura italiana*. Pisa, 1837-41, vol. III.

1839 GAYE. *Carteggio inedito d'artisti dei secoli XIV, XV, XVI*. Florence, 1839, I, 276. (The architectural view in the gallery at Urbino is here attributed to Baccio Pontelli.)

1839 J. D. PASSAVANT. *Raffaello d'Urbino e il padre suo Giovanni Santi*. Florence, 1882-91. (Appendix III.)

1845 V. MARCHESE. *Memorie dei più insigni pittori... domenicani*. Florence, 1845, I, pp. 358 ff.

1846 G. B. Pericoli. *Passeggiata nella Città di Urbino*. Urbino, 1846, p. 18.

1847 Kugler-Burckhardt. *Handbuch der Geschichte der Malerei*. Berlin, 1847.

1848 Vasari. Lemonnier edition ed. Marchese, Pini, Milanesi. Florence, 1845-1852. Vol. IV (1848), pp. 13-23.

1851 J. Dennistoun. *Memoirs of the Dukes of Urbino, illustrating the arms, arts, and literature of Italy from 1440 to 1630.* London, 1851, I, pp. 272-296, II, pp. 192-201.

1852 F. Barciulli. "Riflessioni critiche sulla vita di Piero della Francesca scritta da G. Vasari." In *Giornale Arcadico*, vol. CXXVI. Rome, 1852, p. 177. (On the question of Pacioli.)

1852-56 P. Selvatico. *Storia estetico-critica delle Arti del disegno.* Venice, 1852-56, vol. II, pp. 329-332.

1854 Ugolini. *Storia dei conti e duchi d'Urbino*. Florence, 1854, vol. I, p. 292. (Gives a highly individual interpretation of the *Flagellation*.)

1855 Kugler-Eastlake. *Handbook of Painting. The Italian Schools.* London, 1855. Vol. I, pp. 215-220.

1855 A. J. Du Pays. *Itinéraire de l'Italie.* Paris: Hachette, 1855, pp. 204, 343, 345, 346.

1855 J. Burckhardt. *Der Cicerone*. 1855. Reprint of the 1st edition. Leipzig, 1907. III. 812.

1856 P. Gherardi. *Degli uomini illustri di Urbino*. Urbino, 1856.

1856 E. Harzen. "Ueber der Maler Piero dei Franceschi und seinem vermeintlichen Plagiarius, den Franziskanermönch Luca Pacioli". In *Archiv f. die zeichnenden Künste*. Leipzig: Weigel, 1856, pp. 231-244.

1856 F. RANALLI. *Storia delle Belle Arti in Italia*. Florence, 1856, I, 142, 144, 158.

1856 C. LADERCHI. *La pittura ferrarese*. Ferrara, 1856, pp. 24-26.

c. 1860 *Cataloghi del Museo Campana*. n. d. Catalogo della Classe VIII, pp. 20-21.

1861 G. B. CAVALCASELLE and G. MORELLI. "Catalogo delle opere d'arte nelle Marche e nell'Umbria". In *Le gallerie nazionali italiane*, II, 1896, pp. 237-261.

1861 A. E. RIO. *L'art chrétien*. Paris, 1861, Vol. II, Chapters VI, VIII.

1862 G. MILANESI. "Le Vite di alcuni artefici florentini scritte da G. Vasari...: Vita di Piero d. Francesca." In *Giornale storico d. Archivi toscani*, VI. pp. 10-15. Florence, 1862. (Documents.)

1864 G. B. CAVALCASELLE and J. A. CROWE. *History of Painting in Italy*, London, 1864.

1865 P. GHERARDI. *Iscrizioni ai grandi italiani. I letterati e gli artisti*. Urbino, 1865, p. 80.

1867 O. MÜNDLER. (Review of the English edition of Cavalcaselle). *Zeitschr. f. bild. Kunst*, 1867, p. 280.

1869 G. GRUYER. *Les Vierges de Raphaël*. Paris, 1869.

1870 CH. BLANC. *Hist. d. peintres de toutes les écoles. École ombrienne et romaine*. Paris: Renouard, 1870.

1870 G. B. CAVALCASELLE and J. A. CROWE. *Geschichte d. Ital. Malerei*. Vol. III (1870), *Umbro-Florent. Kunst*, pp. 294-325. Leipzig, 1869-76.

1871 G. B. RISTORI. *Nuova guida di Arezzo*. Florence, 1871, pp. 53, 76.

1872	M. GUARDABASST. *Indice-Guida... dell'Umbria*. Perugia, 1872, p. 218. (Concerning the *Perugia Polyptych*.)

1872 M. GUARDABASST. *Indice-Guida... dell'Umbria*. Perugia, 1872, p. 218. (Concerning the *Perugia Polyptych*.)

1873 G. MILANESI. *Scritti vari sulla Storia dell'Arte Toscana*. Siena, 1873, pp. 299-302. (Documents.)

1875 F. CORAZZINI. *Appunti storici e filologici su la valle Tiberina*. San Sepolcro, 1875, pp. 57-63. (Documents.)

1875 P. GHERARDI. *Guida di Urbino*. Urbino, 1875.

1876 Inauguration of the commemorative plaque in the house where Piero della Francesca lived. San Sepolcro, 1876.

1876 C. PINI and G. MILANESI. *La scrittura degli artisti italiani*. Florence, 1876, I, pl. 63.

1876 W. LÜBKE. *Grundriss d. Kunstgeschichte*. Vienna, 1876, II, p. 154.

1878 VASARI. *Le Vite*. With notes by G. MILANESI. Florence: Sansoni, 1878. Vol. II. pp. 487-503.

1878 H. JANITSCHEK. "Des Piero d. Francesca drei Bücher von der Perspektive." In *Kunstchronik*, XIII, 1878, pp. 670-674.

1879 C. SITTE. "Die Perspektivlehre des P. d. Fr." (On the scientific content of the Parma codex De Prospectiva.) In *Mitteilungen d. K. K. Oesterr. Museum f. Kunst u. Industrie*. Vienna, 1879, p. 325.

1879 L. TONINI. *La nuova guida del forestiere nella Città di Rimini*. Rimini, 1879.

1879 R. VISCHER. *Luca Signorelli*. Leipzig, 1879.

1879 CH. YRIARTE. "Un condottière au XVème siècle." In *Gazette des Beaux-Arts*, vol. XIX, 1879, p. 454.

1880 A. Springer. "Ueber die Quellen der Kunstdarstellungen in Mittelalter." In *Berichte über die Verhandlungen d. Kgl. Sachs. Gesell. d. Wissensch*, 1880. I, p. 6, note I. (On the interpreta tion of the subject of the *Annunciation* in the Arezzo cycle.)

1880 K. Jordan. "Der vermisste Traktat des Piero della Francesca über die fünf regelmässigen Körper." In *Jhrb. d. K. Preuss. Kstsml*, I, 1880.

1880 A. and U. Pasqui. *La cattedrale aretina e i suoi monumenti.* Arezzo, 1880.

1882 C. Winterberg. "Der Traktat des Piero della Francesca über die fünf regelm. Körper und L. Pacioli." In *Rep. f. Kstw.*, 1882. V. 33.

1882 Woltmann and Woermann. *Geschichte d. Malerei.* Leipzig, 1882, vol. II, pp. 215-220.

1882 G. Manzoni. *Studi di Bibliografia analitica.* Bologna, 1882, II, 148-91. (On the question of Pacioli's plagiarism.)

1882 A. and U. Pasqui. *Nuova guida di Arezzo.* Arezzo, 1882, p. 72.

1884 G. B. Cavalcaselle. *Raffaello.* Florence: Lemonnier, 1884, I, 9, 85 ff, II, 163.

1884 F. Harck. "Die Fresken in Palazzo Schifanoja in Ferrara." *Jahrb. d. K. Pr. Kstsml.*, 1884; see also the translation with notes by A. Venturi. Ferrara, 1886.

1884 A. Venturi. "I primordî del Rinascimento artistico in Ferrara." *Rivista storica italiana*, I, 4, 1884.

1885-87 G. Milanesi. (Publication of documents regarding the *Madonna della Misericordia*, the *Assumption* in Sant' Agostino in San Sepolcro and Piero's will.) In *Buonarroti*, 1885. S. III, V. II, Q. IV, p. 116; 1885, S. III, V. IV, Q. V, p. 141; 1887, S. III, V. II, Q. VII, p. 218; 1887, S. III. V. II. Q. XI.

1885 A. VENTURI. "Gli affreschi del Palazzo di Schifanoja in Ferrara." In *Atti e Memorie della R. Deputazione di Storia Patria per le provincie di Romagna etc.*, Series III, vol. III. Bologna, 1885.

1885 A. SCHMARSOW. *Melozzo da Forlì*. Berlin, 1885 (passim).

1886 L. COLESCHI. *Storia di San Sepolcro*. Florence, 1886, p. 173. (On the local traditions regarding P.'s self-portraits.)

1886 G. CÀMPORI. "Pittori degli Estensi nel sec. XV." In *Atti e Memorie della Deputazione di Storia Patria per le provincie modenese e parmense*. Series III, vol. III. Modena, 1886.

1886 B. BERENSON. (On the *Brera Altarpiece*.) In *Gaz. d. B.-A.*, 1886, pp. 80, 81.

1887 L. GIUNTI. "Piero d. Francesca dal Borgo San Sepolcro." In *Arte e Storia*, 1887, p. 205.

1887 L. TONINI. *Rimini nella Signoria dei Malatesta*. Rimini, 1887, vol. V, p. 297.

1887 A. VERNARECCI. "Intorno a Piero d. Francesca." In *Arte e Storia*, 1887, p. 229. (Reply to the above-mentioned article by L. Giunti.)

1888 G. F. PICHI. *L'Assunzione di M. Vergine... nella chiesa di S. Chiara di San Sepolcro è opera di Piero della Francesca*. Bologna, 1888.

1888 C. RICCI. "L'esposizione dell'arte antica. I pittori ferraresi e il Francia." In *L'Esposizione illustrata delle provincie dell'Emilia, in Bologna*. Bologna, 1888, p. 323.

1888 G. SACCHETTI. *San Sepolcro*. San Sepolcro, 1888.

1889 V. FUNGHINI. "Scoperta di un pregievole dipinto." *La Prov. di Arezzo*, 13 January 1889. Also in *Arte e Storia*, 1889, p. 23.

1889 VON REBER. (On the attribution to Laurana of the
 architectural views of Urbino, etc.) In *Sitz. Berichte d.
 Münchener Akad.*, 1889, II.

1889 CH. BLANC. *Histoire de l'art pendant la Renaissance.* Paris,
 1889 (posthumous). Vol. II, pp. 96-106.

1889 E. MÜNTZ. *Histoire de l'art pendant la Renaissance.* Paris,
 1889.

1889 E. MÜNTZ. "A. Mantegna e Piero della Francesca." *Archivio
 storico dell'arte Italiana*, 1889, p. 273.

1890 J. BURCKHARDT. *Der Cicerone.* Bode e v. Fabriczy, eds., 1890.

1891 A. VENTURI. "La letteratura artistica del 1890." In *Nuova
 Antologia*, 1891, p. 208.

1891 G. FRIZZONI. *Arte italiana del Rinascimento.* Milan, 1891, pp.
 245, 291-93.

1892 G. F. PICHI. *La vita e le opere di Piero della Francesca.* San
 Sepolcro, 1892.

1892 G. F. PICHI. "La Resurrezione come viene rappresentata da
 Giovanni Pisano e da Piero della Francesca." In *Arte e Storia*,
 1892, pp. 202-203.

1892 (Information regarding the reconstitution of the triptych
 belongining to the Church of the Misericordia in San
 Sepolcro, on the occasion of the centennial of Piero's death.)
 In *Arte e Storia*, 1892, p. 232.

1892 (Information on the condition of the Madonna of Sinigallia.)
 In *Arch. Stor. d. Arte*, 1892, p. 362.

1892 (Information on the *Madonna di Sinigallia.*) In *Nuova Rivista
 Misena*, V, 1892, no. 10, p. 159. Arcevia, 1892.

1893 A. VENTURI. "Nelle Pinacoteche minori d'Italia." In *Arch. Stor.*

d. Arte, 1893, p. 415. (On the question of Fra Carnevale.)

1894 E. MÜNTZ. *L'arte italiana del '400*. Milan, 1894.

1895 F. MADIAI. "Dei quadri tolti a Urbino sotto il Regno italico." In *Nuova Rivista Misena*. Arcevia, 1895, p. 84 ff.

1895 G. GRUYER. *L'art ferrarais à l'époque des Princes d'Este*. Paris, 1895.

1897 G. MAGHERINI-GRAZIANI. *L'arte a Città di Castello*. Città di Castello, 1897.

1897 E. CALZINI. *Urbino e i suoi monumenti*. Rocca S. Casciano, 1897.

1897 A. PHILIPPI, *Die Kunst der Renaissance in Italien*. Leipzig, 1897, I, pp. 269 ff.

1897 B. BERENSON. *Central Italian Painters*. London, 1897 and, for the catalogue of the works, also the 2nd edition of 1909.

1898 G. B. CAVALCASELLE and J. A. CROWE. *Storia della pittura in Italia dal sec. II al sec. XVI*. Florence, 1898, vol. VIII, pp. 188-259.

1898 F. WITTING. *Piero dei Franceschi*. Strasbourg, 1898.

1898 J. GUIFFREY. (On the attribution to P. d. F. of the *Madonna* by Baldovinetti in the Louvre.) In *L'Arte*, 1898, p. 46.

1899 A. AUBERT, "Bemerkungen über das Altarwerk des P. d. Fr. in Perugia." In *Zeitschr. f. bild. Kst.* N. F., X, 1898-99, pp. 263-266.

1899 W. WEISBACH. (Review of Witting's book of 1898.) *Repertorium f. Kstw.* 1889, pp. 72-77. Also in *Das Museum*. VII, 1901, p. 53.

1899 C. WINTERBERG. *Petrus Pictor Burgensis. De prospectiva pingendi*. Strasbourg, 1899. (Complete edition of the original Parma codex.)

1899 F. WICKHOFF, *Abhandl., Vörtrage u. Anzeigen*. Berlin, 1913, II, p. 159. "Ueber einige italienische Zeichnungen in British Museum." (From the *Jahrbuch der Königl. Preuszischen Kunstsamml.*, XX, 1899).

1900 W. WEISBACH. "Ein verschollenes Selbstbildniss des Pietro della Francesca." In *Rep. f. Kstw.*, 1900, p. 388.

1900 S. BRINTON. *Masters of Umbrian Art*. London, 1900, pp. 134 ff.

1900 G. GRONAU. "Piero della Francesca oder Piero dei Franceschi". In *Rep. f. Kstw.*, 1900, pp. 393-94. (Documents.)

1900 G. FOGOLARI. (Review of Winterberg's publication of 1899.) *L'Arte*, 1900, p. 129.

1900-1905 C. RICCI. (Comments on the *Brera Altarpiece*, the *Urbino Diptych* in the Uffizi, and the Venice *Saint Jerome*.) In *Le Gallerie d'Europa*. Bergamo, n. d., plates 288, 324, 575.

1901 E. CALZINI. "La Galleria... d'Urbino." In *L'Arte,* 1901, p. 367.

1901 [F. W. BURTON]. *Descriptive and historical Catalogue of the National Gallery*. London, 1901.

1901 W. G. WATERS. *Piero della Francesca*. London, 1901.

1902 B. BERENSON. *The Study and Criticism of Italian Art, II.* London, 1902. (In the essay "Alessio Baldovinetti and the New Madonna of the Louvre.")

1902 C. BUDINICH. *Un quadro di Luciano Dellauranna nella Galleria... di Urbino*, Trieste, 1902.

1902 G. MANCINI. *Vita di L. Signorelli*. Florence, 1902. (Contains

some information on the treatise *De quinque corporibus*.)

1902 G. MANCINI. *Vita di L. B. Alberti*. Florence, 1902. (On p. 344 there is a discussion of the portrait of Pacioli in Naples.)

1902 EVELYN MARINI-FRANCESCHI. "P. d. F. e la sua opera." In *Rivista d'Italia*, V, Jan. 1902, pp. 77-79.

1902 EVELYN MARINI-FRANCESCHI. "La Madonna del Parto di P. d. F." In *Cronache della civiltà elleno-latina*. Rome, 1902, pp. 102-104.

1902 EVELYN MARINI-FRANCESCHI. "L'Ercole di P. d. F." In *Cronache della civiltà elleno-latina*. Roma, 1902, pp. 140-141.

1904 F. WICKHOFF. (Review of Berenson's article on Baldovinetti.) *Kstgeschichtl. Anzeigen*, 1904 (Reprinted in *Abhandl. u. Anaeigen*. Berlin, 1913, p. 340).

1904 A. MELANI. "Di fronda in fronda. Nuovi affreschi di Piero della Francesca in Arezzo." In *Arte e Storia*, 1904, p. 127.

1904 (Information on the state of neglect of the Arezzo frescoes.) In *L'Arte*, 1904, p. 82.

1904 G. PITTARELLI. "Intorno al libro 'De prospectiva pingendi' di Pier dei Franceschi." In *Atti d. Congresso Internaz. di scienze storiche*, XII. Rome, 1904, pp. 251 ff.

1905 G. GRONAU. (On the portrait of Pacioli, formerly attributed to Piero dal Baldi, now in Naples.) In *Rassegna d'Arte*, 1905, II.

1905 S. REINACH. *Répertoire de peintures etc*. Paris, 1905 (passim).

1905 M. LOGAN. "Due dipinti inediti di Matteo da Siena." In *Rassegna d'Arte*, 1905, pp. 49-53.

1905 L. VENTURI. "Un'opera giovanile di Piero della Francesca." In *L'Arte*, 1905, p. 127.

1905 P. MAZZONI. "Di alcune figurazioni della leggenda della Croce." In *Esercitazioni della letteratura religiosa in Italia nei sec. XIII-XV*, published under the direction of G. Mazzoni. Florence, 1905.

1905 A. CINQUINI. (On the Uffizi diptych.) In *Classici neolatini*. Aosta, 1905, I, 119-121.

1906 A. CINQUINI. "Piero d. Francesca a Urbino e i ritratti degli Uffizi." In *L'Arte*, 1906, p. 56.

1906 U. TAVANTI. "Scoperta di affreschi di Piero d. Francesca ad Arezzo." In *L'Arte*, pp. 305-306.

1906 G. LIPPARINI. *Urbino*. Bergamo, 1906.

1907 C. POSTI. (On the lost work by Piero in Ancona.) In *Le Marche*, anno VII, N. S. II, 1907, p. 127.

1907 C. RICCI. *La Pinacoteca di Brera*. Bergamo, 1907, pp. 90, 304.

1908 W. KALLAB. "Vasari-Studien." In *Quellenschr. für Kstgesch*. N. F. Vol. XV. Vienna, 1908, pp. 219, 253, 262.

1908 E. SOLMI. "Le fonti dei manoscr. di Leonardo da Vinci." In *Giorn. Stor. d. Letter. Ital.* 1908. Suppl. no. 10/11, pp. 344 ff. [See also *Rass. d'Arte*, IX, 1909, no. 4, p. 4].

1908 F. MALAGUZZI-VALERI. *Catalogo della R. Pinacoteca di Brera*. Bergamo, 1908, pp. 325-327.

1908 A. PÉRATÉ. (Dicussion of Piero d. Fr.) in *Histoire de l'art*, published under the direction of A. Michel, III, 2, pp. 703-10.

1908 EVELYN MARINI-FRANCESCHI. *Impressioni artistiche*. Milan, 1908, pp. 109-114.

1909 C. GRIGIONI. "Un soggiorno ignorato di Piero d. Francesca in Rimini." In *Rassegna bibliografica dell'Arte Italiana*, 1909, XII, 1l8-121.

1909 R. MUTHER. *Geschichte d. Malerei*, I, pp.135-154. Leipzig, 1909.

1909 G. FRANCIOSI. *Arezzo*. Bergamo, 1909.

1909 C. GRIGIONI. "I decoratori del Tempio Malatestiano di Rimini." In *Rass. bibliogr. dell'Arte Italiana*, 1909.

1909 W. BOMBE. "Zur Genesis der Auierstehungsfreskos von P. d. Fr." In *Rep. f. Kstw.*, 1909, p. 331.

1909 A. LUPATTELLI. *La pinacoteca Vannucci in Perugia*. Perugia, 1909, p. 101.

1909 A. SPRINGER. *Manuale di Storia dell'Arte*. Bergamo, 1909, III, pp. 154-157.

1909-13 (On paintings attributed to Piero in Russian collections.) In *Starye Gody*, 1909, p. 109; 1912, pp. 15, 17, 19; 1913, p. 55.

1910 OKKONEN. *Melozzo da Forlì*. Helsingfors, 1910.

1910 M. FALCIAI. *Arezzo*. Florence, 1910, pp. 54-61, 101, 158.

1910 C. RICCI. *Pier della Francesca*. In the series *L'opera dei grandi artisti italiani*, I. Rome, Anderson, 1910.

1910 C. RICCI. *Santi ed artisti*. Bologna, 1910.

1911 A. VENTURI. *Storia dell'Arte*. Milan, 1911, VII, I, pp. 434-486.

1911 EVELYN [MARINI-FRANCESCHI]. "P. d. Fr. Ritrattista." In *Rivista di Roma*, April, 1911.

1912 EVELYN MARINI-FRANCESCHI. *Piero della Francesca*. Città di Castello, Lapi, 1912.

1912 A. B. BALDINI. "Piero della Francesca." In *La Voce*, 20 June 1912.

1912	W. BOMBE. "Die Kunst am Hofe Federigo von Urbino." In *Monatshefte fur Kstwiss.*, 1912, pp. 469 ff.
1912	A. WARBURG. "Piero della Francesca Costantinschlacht in der Aquarellkopie des Johann Anton Ramboux." In *Atti del X Congresso Internaz. di Storia dell'Arte in Roma* (1912). Rome, 1922, pp. 326-327, plates LXXIX-LXXX.
1913	OTTO BRAUN. *Diario.* Italian translation, Bari: Laterza, 1923.
1913	G. BIASIOTTI. "Affreschi di Benozzo Gozzoli in S. Maria Maggiore." In *Bollettino d'Arte*, 1913, pp. 76-86.
1913	G. Galassi. "Appunti sulla scuola pittorica Romana del '400." In *L'Arte*, 1913, pp. 107-112.
1913	A. VENTURI. *Storia dell'Arte.* Milan, 1913, VII, 2nd.
1913	C. RICCI. "Affreschi di Pier d. Francesca in Ferrara." In *Bollettino d'Arte*, 1913, pp. 197 ff.; see also Venturi, Vol. VII, 3rd (1914), p. 500.
1913	C. RICCI. *Note d'arte.* Rome, 1913. (With a republication of Ricci's "Affreschi di Pier d. Francesca in Ferrara").
1913	MÖLLER VAN DEN BRUCK. *Die Italienische Schönheit.* Munich: Piper, 1913, pp. 437-505.
1913	H. MARCEL. "La peinture dans la haute Toscane et les Marches: Piero della Francesca, Melazzo da Forlì". In *Mélanges Lemonnier*, 1913, p. 399.
1913	EVELYN MARINI-FRANCESCHI. "Alcune notizie inedite su Piero della Francesca." In *L'Arte*, 1913, pp. 471-73. (Documents.)
1913	L. SIGHINOLFI. "Sigismondo Malatesta e Pier della Francesca." In *Il Resto del Carlino*, 7 June, 1913 ; more in issue of 17 July, 1913.

1913 A. MASSERA. (On the dating of the Rimini fresco.) In *Arte e Storia*, 1913, pp. 199-202 ; also in *Il Momento*, Rimini, 12 June, 1913.

1913 O. R. MÜLLER. *Ueber die Anfänge u. über das Wesen der malerischen Perspektive (Rektoratsrede)*. Darmstadt, 1913.

1913 R. LONGHI. "Piero d. F. e lo sviluppo della pittura veneziana." In *L'Arte*, 1914, pp. 198-221, 241-256.

1914 A. VENTURI. (Review of the article by Sighinolfi regarding the date of the Rimini fresco.) In *L'Arte*, 1914, p. 237.

1914 EVELYN MARINI-FRANCESCHI. "Alcune curiose notizie su Fra Luca Pacioli." In *L'Arte*, 1914, pp. 224-226.

1914 G. DEGLI AZZI. "L'inventario d. archivi di San Sepolcro." In *Archivi della Storia d'Italia*, 1914, IV, 128. Rocca San Casciano, 1914.

1915 A. VENTURI. *Storia dell'Arte*. Milan, 1915, vol. VII, 4.

1915 GEROLAMO MANCINI. "L'opera 'De corporibus regularibus' di Pietro Franceschi detto della Francesca." In *Atti della R. Accademia dei Lincei - Memorie della classe di Scienze Morali Storiche e Filologiche*, Series V, vol. XIV, pp. 446-487. Rome, 1915.

1915 J. V. SCHLOSSER. "Materialien zur Quellenkunde der Kunstgeschichte." II Heft. "Frührenaissance," pp. 50-58. In *Sitzungsberichte der Kais. Akad. d. Wissensch. in Wien*. Philosophisch-Historische Klasse. 179 Band, 3 Abhandlung. Vienna, 1915.

1915 E. PANOFSKY. *Dürers Kunsttheorie*. Berlin, 1915.

1916 G. GRONAU. "Piero dei Franceschi." In *Thieme-Beckers Künstlerlex.*, XII (1916), pp. 289-94. (Documents.)

1916 A. DEL VITA. "Notizie sulla famiglia e sulla madre di P. d. F."

In *Bollettino d'Arte*, 1916, p. 273. (Documents.)

1916 M. SALMI. "La scuola di Piero della Francesca nei dintorni d'Arezzo." In *Rassegna d'Arte*, XVII, 1916, pp. 168 ff.

1916 M. SALMI. "I Bacci di Arezzo nel sec. XV e la loro cappella nella chiesa di S. Francesco." In *Rivista d'Arte*, 1916, p. 224.

1917 G. MANCINI. *Vasari: Vite cinque, annotate*. Florence: Carnesecchi, 1917. (Contains the *Life* of P. d. F.)

1917 "Relazione sul restauro degli affreschi di Arezzo." In *Cronaca delle Belle Arti*, 1917, pp. 11-13.

1917 A. VENTURI. "L'ambiente artistico urbinate nella seconda metà del Quattrocento." In *L'Arte*, 1917, I.

1917 A. POPE. "A Small Crucifixion by Piero d. Francesca." In *Art in America*, V, 1917.

1918 G. GRONAU. "P. d. F." In *Kunst u. Künstler*, 1918.

1918 G. MANCINI. "La madre di P. d. F." In *Bollettino d'Arte*, 1918, p. 61.

1918 L. OLSCHKI. *Geschichte d. neusprachlichen wissenschaftlichen Literatur*. Heidelberg, 1918, I, pp. 137-151.

1918 L. SERRA. "Il Palazzo Ducale di Urbino e la Galleria Naz. Delle Marche." In the series *Il piccolo Cicerone moderno*, no. 15. Milan, Alfieri e Lacroix, n. d., pp. 47-49, 65-67.

1918 A. VENTURI. "Un quadro di Piero d. Francesca in America." In *L'Arte*, 1918. (See also Salmi, "La scuola di Piero...," 1916.)

1918 A. VENTURI. "L'atmosfera artistica umbra all'arrivo di Raffaello a Perugia." In *L'Arte*, 1918, II-III.

1918-19 M. DVORÀK. *Geschichte der. ital. Kunst im Zeitalter d. Renaissance* (Akad. Vorles.). Munich: Piper, 1917, pp. 159-

161.

1919	G. Zippel. "Piero della Francesca a Roma". In *Rassegna d'Arte*, 1919, pp. 87 ff. (Documents.)
1920	A. Del Vita. "Il volto di Pier della Francesca." In *Rassegna d'Arte*, 1920, p. 109.
1920	F. Rintelen. *Piero della Francesca*. Reprinted in *Vorträge*, 1927.
1920	H. Graber. *Piero d. Francesca*. Basel, 1920.
1921	O. H. Giglioli. *Guida di San Sepolcro*. Florence, 1921.
1921	A. Venturi. "Frammenti di polittico di Piero d. Francesca nella Galleria Liechtenstein." In *L'Arte*, 1921, IV.
1921	A. Bonnard. "A propos de P. d. F." In *Revue de l'Art Anc. et Moderne*. Paris, 1921.
1922	A. Venturi. *Piero della Francesca*. In the series *I grandi maestri dell'arte italiana*. Florence, Alinari, 1922.
1922	F. Knapp. *Die künstlerische Kultur des Abendlandes*. Bonn, 1922, vol. I, pp. 390-394.
1922	G. Habich. *Die Medaillen der italienischen Renaissance*. Stuttgart and Berlin, 1922, pp. 46-47.
1922	K. Escher. "Die Malerei der Renaissance in Mittel-und Unteritalien." In *Handbuch der Kstwissenschaft*. Berlin: Athenaion, 1922, I, pp. 89-110.
1923	J. Meder. *Die Handzeichnung*. Vienna: Schroll, 1923 (passim).
1923	F. J. Mather. *A History of Italian Painting*. New York, 1923, pp. 169-172.

1923	L. ROSENTHAL. "P. d. F. et notre temps." In *L'Amour de l'Art*, 1923.
1924	J. SCHLOSSER. *Die Kunstliteratur*. Vienna: Schroll, 1924, pp. 122-129.
1925 the	E. LAVAGNINO and V. MOSCHINI. *Santa Maria Maggiore*. In series *Le Chiese di Roma illustrate*. Rome, n. d., p. 94.
1925	C. RICCI. *Il Tempio Malatestiano*. Milan: Bestetti e Tumminelli, 1925, pp. 26, 150, 214, 221, 241.
1925	A. C. BARNES. *The Art in Painting*. New York, 1925.
1926	B. BERENSON. "An Early Signorelli in Boston." In *Art in America*, April 1926, pp. 105-117.
1927	E. VAN DER BERCKEN. "Die Malerei der Früh- und Hochrenaissance in Oberitalien." In *Handbuch der Kunstwissenschaft*. Potsdam: Athenaion, 1927.

LONGHI'S BIBLIOGRAPHY
FROM 1927 TO 1962

Update added to the third (1963) edition

1927	R. LONGHI. *Piero della Francesca*. Rome: Valori Plastici, 1927.
1927	A. SPAINI. "P. d. F." In *Il Resto del Carlino*, 9 August 1927.
1927	E. CECCHI. "P. d. F." In *Il Corriere della Sera*, September 1927.
1927	C. CARRÀ. "P. d. F." In *L'Ambrosiano*, 5 September 1927.
1927	M. BIANCALE. "P. d. F." In *Il Popolo di Roma*, 4 October 1927.
1927	C. E. OPPO. "P. d. F." In *La Tribuna*, 19 October 1927.
1927	F. TROMBADORI. "P. d. F." In *Il Piccolo della Sera*, 19 October 1927.
1927	LEO FERRERO. "P. d. F." In *Solaria*, Florence, 2 December 1927.
1927	R. LONGHI. *P. d. F* (French translation). Paris: Crès, 1927.
1927-32	G. VASARI. *Le Vite*. With notes by A. M. CIARANFI. Florence: Salani, 1927-32.
1928	(J. AL.). "P. d. F." In *Vient de paraître*, 1 February 1928.
1929	A. LHOTE. "P. d. F." In *La Nouvelle Revue Française*, 1 January 1930.
1929-33	J. VON SCHLOSSER. "P. d. F." In *Sitzungberichte der Wiener Akademie*, Vienna, 1929-33.
1929	A. STOKES. *The Stones of Rimini*. London: Faber & Faber, 1929.

1929	R. Van Marle. *Italian Schools of Painting*. Vol. XI. The Hague: Nijhoff.
1930	Exhibition of Italian Art at Royal Academy, London, January–March 1930.
1930	U. Gnoli. "Una tavola sconosciata di P. d. F." In *Dedalo*, August 1930.
1931	R. Longhi. *P. d. F.* (English translation by Leonard Penlock). London: Warne, 1931.
1931	"P. d. F." In *Yorkshire Post*, 18 February 1931.
1931	"P. d. F." In *Art Trade Journal*, March 1931.
1931	"P. d. F." In *The Scotsman*, 6 March 1931.
1931	"P. d. F." In *Spectator*, 14 March 1931.
1931	"P. d. F." In *Sunday Times*, 12 April 1931.
1931	"P. d. F." In *Apollo*, April 1931.
1931	(L. H.) "P. d. F." In *Manchester Guardian*, 13 April 1931.
1931	"P. d. F." In *Bristol Times and Mirror*, 15 April 1931.
1931	"P. d. F." In *Catholic Times*, 26 June 1931.
1931	"P. d. F." In *The Connoisseur*, June 1931.
1931	"P. d. F." In *The Times Literary Supplement*, 2 July 1931.
1932	A. Del Vita. "Notizie sulla famiglia e sulla madre di P. d. F." In *Il Vasari*, V, 1932.
1932	B. Berenson. *Italian Pictures of the Renaissance: A List*. Oxford, 1932.

| 1932 | A. STOKES. *The Quattrocento: A Different Conception of the Italian Renaissance*. London: Faber & Faber, 1932. |

| 1933 | L. VENTURI. *Italian Paintings in America*. 1933, vol. II. (On the Rockefeller *Crucifixion* and the Lehman *Saint Apollonia*.) |

| 1934 | R. LONGHI. *Officina ferrarese*. Rome: Edizioni d'Italia, 1934. |

| 1934 | M. SALMI. "P. Uccello, D. Veneziano, P. d. F. e gli affreschi del Duomo di Prato." In *Bollettino d'Arte*, 1934. |

| 1934-35 | H. FOCILLON. (Course on P. d. F. at the Sorbonne. Subsequently collected, completed, and published by his students in 1952.) |

| 1935 | P. TOESCA. "P. d. F." Entry in the *Enciclopedia Italiana*, vol. XXVII, 1935, pp. 208-213. |

| 1935 | H. SIEBENHÜNER. *Über den Kolorismus der Frührenaissance vornehmlich dargestellt an dem Trattato della Pittura des L. B. Alberti und an einem Werke des P. d. F.* (Dissertation at the University of Leipzig.) |

| 1935 | M. L. GENGARO. "Orientamenti della critica d'arte nel secolo ventesimo." In *L'Arte*, 1935. |

| 1935 | *Exposition de l'Art Italien de Cimabue à Tiepolo*. Paris, Petit Palais, 1935. |

| 1936 | B. BERENSON. *Pitture Italiane del Rinascimento. Indici*. Milan: Hoepli, 1936. |

| 1936 | H. GRANVILLE FELS. "A Rare Panel for New York." In *The Connoisseur*, 1936. |

| 1938 | J. VON SCHLOSSER. *Xenia*. Bari: Laterza, 1938. |

| 1938 | M. MARANGONI. *Saper vedere*. Milan: Treves, 1938. |

1938	E. CARLI. "La pala Urbinate di P. d. F." In *Emporium*, November 1938.
1939	G. FIOCCO. "P. d. F. e la prospettiva." In *Domus*, March 1939.
1939	M. DENIS. *Charmes et leçons de l'Italie*. Paris: Colin, 1939.
1939	A. CHASTEL. "La légende de la Reine de Saba." In *Revue d'Histoire des Réligions*, 1939.
1939	R. LONGHI. "Giudizio sul Duecento." In *Proporzioni*, I, 1943.
1939	ELIE FAURE. *Histoire de l'Art: L'Art Renaissent*. Paris: Plon, 1939.
1940	V. LAZAREV. "P. d. F." In *Iscusstvo*, Moscow, 1940, I, pp. 127-144.
1940	M. SALMI, *Gli affreschi di S. Francesco in Arezzo*. Bergamo, 1940.
1940	R. LONGHI. "Fatti di Masolino e di Masaccio." In *La Critica d'Arte*, Florence: Sansoni, 1940.
1940	R. LONGHI. "Genio degli anonimi. I, Giovanni di Piemonte." In *La Critica d'Arte*, 1940.
1941	M. MEISS. "A Documented Altarpiece by P. d. F." In *The Art Bulletin*, March 1941.
1941	CREIGHTON GILBERT. (On the date of the Montefeltro Diptych.) In *Marsyas*, 1941.
1941-42	J. LAUTS. "Zur P. d. F. verlorene Fresken in Ferrara." In *Zeitschrift für Kunstgeschichte*, 1941-42.
1942	F. ARCANGELI. *Tarsie*. Rome: Tumminelli, 1942.
1942	G. NICCO FASOLA. *Il trattato "De Prospectiva Pingendi" di P. d. F.* (critical edition). Florence: Sansoni, 1942.

1942	G. Nicco Fasola. "Lo svolgimento del pensiero prospettico nei trattati da Euclide a P. d. F." *Le Arti*, December 1942.
1942	M. Salmi. "P.d.F. e Giuliano Amedei." In *Rivista d'Arte*, 1942.
1942	R. Longhi. *P .d. F.* (Expanded second edition; on account of the war, it only appeared in 1946.) Milan: Hoepli.
1943	M. Salmi. "La Bibbia di Borso d'Este e P. d. F." In *La Rinascita*, 1943.
1945	"The Condition of Paintings in Italy" (editorial.) In *The Burlington Magazine*, April 1945.
1945	M. Salmi. *P. d. F. e il Palazzo Ducale di Urbino*. Florence, 1945.
1945	H. Leicht. *Kunstgeschichte der Welt*. Zurich, 1945.
1945-52	Rafael Alberti. *A la Pintura* (poems). Buenos Aires: Losada, 1953.
1947	R. Mesuret. *L'age d'or de la peinture Toulousaine* (catalogue of the exhibition at the Orangerie in Paris). Paris, 1947.
1947	M. Salmi. "Un'ipotesi su P. d. F." In *Arti figurative*, 1947.
1947	R. Longhi. "Una Madonna della cerchia di P. d. F. per il Veneto." In *Arte Veneta*, 1947, n. 2.
1947	Kenneth Clark. "P. d. F's St. Augustine Altarpiece." In *The Burlington Magazine*, August 1947.
1947	R. Longhi. (Letter to Sir Kenneth Clark). In *The Burlington Magazine,* October 1947.
1947	A. Malraux. *Le Musée Imaginaire*, I. Paris: Skira, 1948.
1948	B. N(icolson). (Review of the second edition of my *P. d. F.*).

In *The Burlington Magazine*, December 1948.

1948	C. L. RAGGHIANTI. *Profilo della critica d'Arte in Italia*. Florence, 1948.
1948	G. VASARI. *Vite scelte* (with notes by A. M. BRIZIO). Turin: Utet, 1948.
1948	J. ALAZARD. *P. d. F.* Paris, 1948.
1948	V. GILARDONI. *P. d. F.* Geneva and Paris, 1948.
1948-49	G. VASARI. *Le Vite* (with notes by L. and C. L. RAGGHIANTI). Milan: Rizzoli, 1949.
1949	KENNETH CLARK. *Landscape into Art*. London: Murray, 1949.
1949	R. LONGHI. *Gli affreschi di P. d. F.* (German and English translation). Bern and Toronto: Iris Verlag, 1949.
1949	A. STOKES. *Art and Science*. London: Faber & Faber, 1949.
1949	A. CHASTEL. "La rencontre de Salomon et de la Reine de Saba dans l'iconographie mediévale." In *Gazette des Beaux-Arts*, 1949.
1950	R. LONGHI. "Piero in Arezzo." In *Paragone*, 1950.
1950	R. LONGHI. "Un disegno per la Grande Jatte e la cultura formale di Seurat." In *Paragone*, 1950.
1950	B. BERENSON. *P. d. F. o dell'arte non eloquente*. Florence, 1950.
1950	A. LHOTE. *Traité de la figure*. Paris: Fleury, 1950.
1950	P. BORRA. *P. d. F.* Milan: Istituto Editoriale Italiano, 1950.
1950	P. ROTONDI. *Il Palazzo Ducale di Urbino*. Urbino, 1950-51.
1950	E. GOMBRICH. *The Story of Art*. London: Phaidon Press, 1950.

1951	A. HAUSER. *The Social History of Art*. London: Routledge & Kegan Paul, 1951.
1951	KENNETH CLARK. *P. d. F.* London, Phaidon Press, 1951.
1951	Review of Clark's *P. d. F.* In *The Times Literary Supplement*, 23 March 1951.
1951	B. NICOLSON. Review of Clark's *P. d. F.* In *The New Statesman and the Nation*, 5 May 1951.
1951	R. LONGHI. *La Leggenda della Croce*. Milan: Belli, 1951.
1951	GALETTI and CAMESASCA. *Enciclopedia della Pittura Italiana*. Entry under "P. d. F.," in the second volume, pp. 1932-1949. Milan: Garzanti, 1951.
1951	D. M. ROBB. *History of Painting*. New York: Harper, 1951.
1952	H. FOCILLON. *P. d. F.* (This is the course delivered at the Sorbonne in 1934-35 and published by Focillon's students). Paris, 1952.
1952	R. LONGHI. "II Maestro di Pratovecchio." In *Paragone*, 35, 1952.
1952	F. WITTGENS. *La pala Urbinate di Piero*. Milan, 1952.
1952	L. URBANI. (On the restoration of the Urbino *Flagellation*.) In *Bollettino dell'Istituto Centrale del Restauro*. Rome, 1952.
1953	C. BRANDI. (On the restoration of the *Perugia Altarpiece*.) In *Bollett. d. Istit. Centrale di Restauro*. Rome, 1953.
1953	W. PAATZ. *Die Kunst der Renaissance in Italien*. Stuttgart: Kohlhammer, 1953.
1953	L. VENTURI. *P. d. F.*, Skira, 1954.

1953 L. VENTURI. "P. d. F., Seurat, J. Gris." In *Diogene*, 1953.

1953 R. WITTKOWER. (On the Urbino *Flagellation*.) In *Journal of the Warburg Institute*, London, 1953.

1954 C. L. RAGGHIANTI. "Inizio di Leonardo." *La Critica d'Arte Nuova*, January 1954.

1954 *Catalogo della Mostra dei Quattro Maestri in Palazzo Strozzi*. (The part on Piero was written by L. BERTI). Florence, 1954.

1954 J. POPE-HENNESSY. *P. d. F.* New York: The Metropolitan Museum of Art, 1954.

1954 M. MEISS. "Ovum Struthionis, Symbol and Allusion in P. d. F.'s Montefeltro Altarpiece." In *Studies in Art Literature for Belle da Costa Green*. Princeton Univ. Press, 1954.

1954 M. MEISS. "Addendum Ovologicum." In *The Art Bulletin*, September 1954.

1955 M. SALMI. (On the fragment in the manner of Orcagna attributed by Ragghianti to Piero). In *Commentari*, 1955.

1955 O. KURZ. "J. von Schlosser." In *La Critica d'Arte Nuova*, II, 1955.

1955 C. TOLNAY. "La Resurrezione di P. d. F." In *Corvina*, XXVI, 2°.

1955 R. PAPINI. (On the *Saint* by P. d. F. rediscovered at San Sepolcro.) In *Il Corriere della Sera*, 15 January 1955.

1955 M. SALMI. (On the *Saint* by P. d. F. rediscovered at San Sepolcro on 23 December 1954.) In *Bollettino d'Arte*, 1955.

1956 R. LONGHI. *Officina ferrarese*. 2nd edition with additions. Florence: Sansoni, 1956.

1956 A. CHASTEL. *L'Art Italien*. Paris: Larousse, 1956.

| 1957 | P. BIANCONI. *P. d. F.* Milan: Rizzoli. |

| 1957 | D. FORMAGGIO. *P. d. F.* Milan: Mondadori, 1957. |

| 1958 | *Catalogo della Mostra di Affreschi staccati.* Forte di Belvedere, Florence. |

| 1960 | J. P. RICHTER and G. MORELLI. (Correspondence). Baden-Baden, 1960. |

| 1960 Z. | (L. MALLÉ). "Il mondo in prospettiva." In *Civiltà nell'Arte.* A. Collection. Bologna: Zanichelli, 1960. |

| 1961 | O. KURZ. Introduction to: J. von Schlosser, *L'Arte medievale.* Republication of the essay published in 1955. Turin: Einaudi, 1961. |

| 1961 | P(ETER) J(OHN) M(URRA)Y. Entry on P. d. F. in *Encyclopaedia Britannica*, IX, pp. 662-663. 1961 |

| 1961 | R. LONGHI. "Il carteggio Morelli-Richter." In *Paragone*, 134, May 1961. |

| 1961 | F. ZERI. *Due dipinti, la filologia e un nome.* Turin: Einaudi, 1961. |

| 1961 | A. PARRONCHI. "Paolo o Piero?" In *Studi di Storia dell'Arte per R. Longhi*; 1961 edition of *Arte Antica e Moderna*, Bologna. |

| 1962 | A. PARRONCHI. "L. B. Alberti as a Painter." In *The Burlington Magazine*, 1962. |

| 1962 | G. VASARI. *Le Vite.* (*Life* of P. d. F. with introduction by L. GRASSI and notes by G. PREVITALI), pp. 371-384 of the second volume. Rome: Edizione per il Club del Libro. |

ILLUSTRATIONS

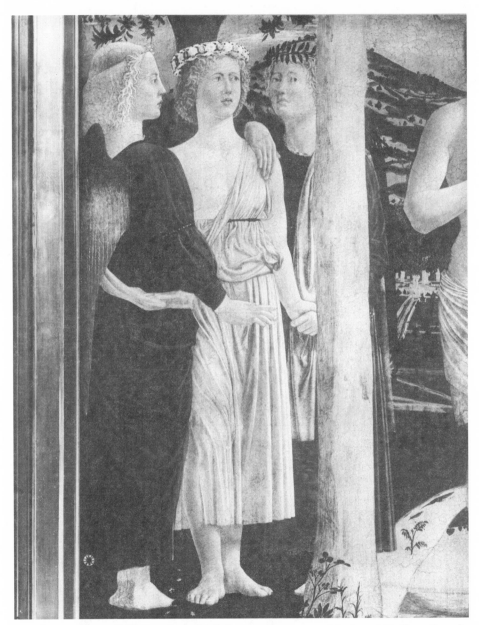

1. The Baptism of Christ. Detail of the angels *National Gallery, London*

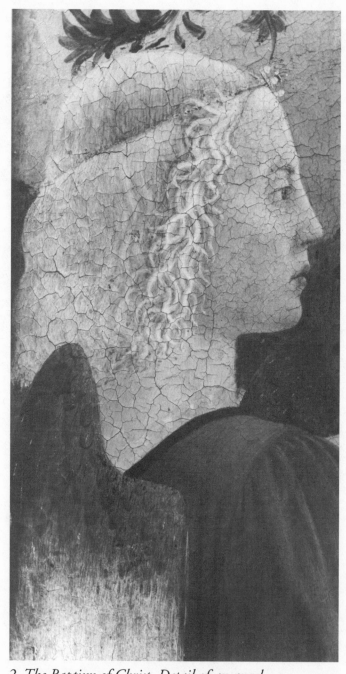

2. The Baptism of Christ. Detail of an angel
National Gallery, London

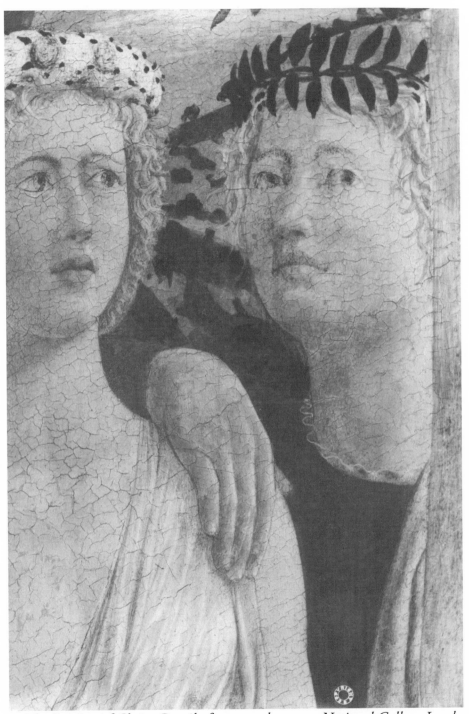

3. The Baptism of Christ. Detail of two angels *National Gallery, London*

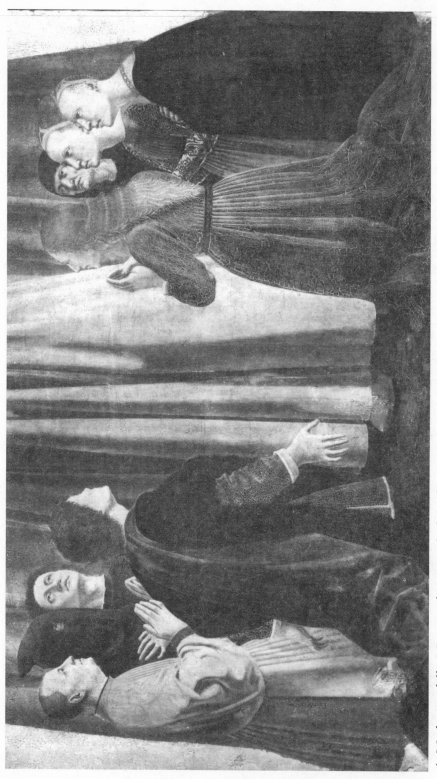

4. *Madonna della Misericordia. Detail of the devout donors*

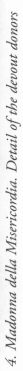

San Sepolcro

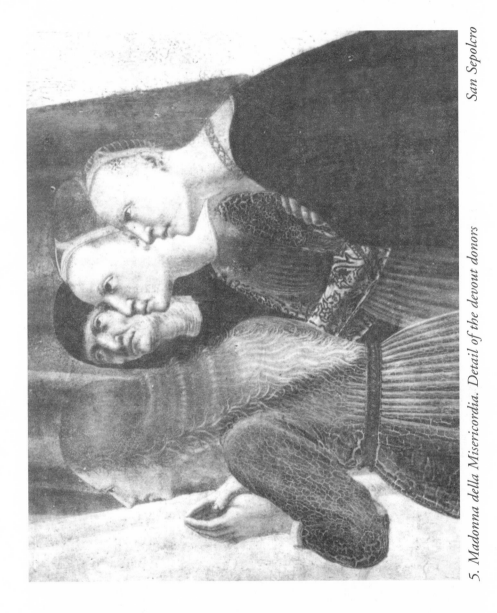

5. *Madonna della Misericordia. Detail of the devout donors* San Sepolcro

313

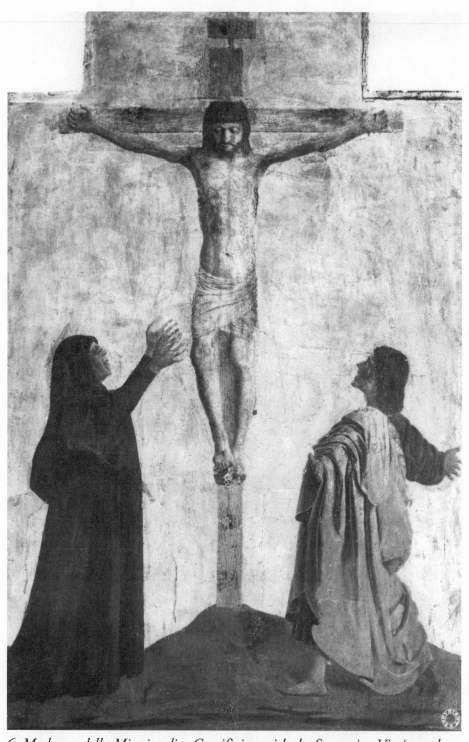

6. Madonna della Misericordia. Crucifixion with the Sorrowing Virgin and Saint John *San Sepolcro*

314

7. *Madonna della Misericordia. Detail of the Crucified*

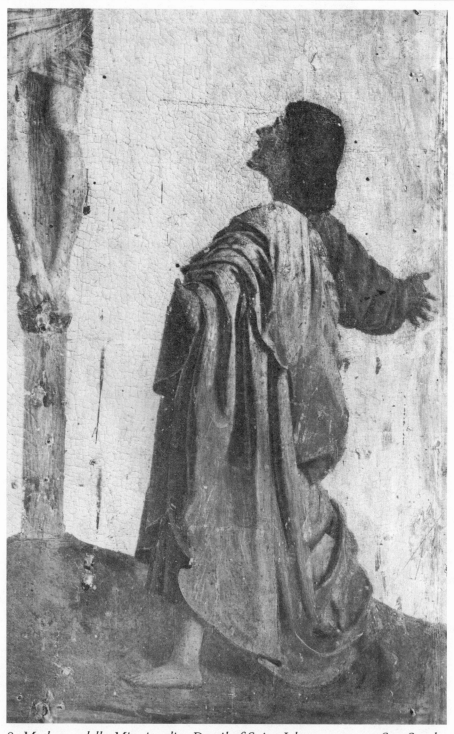

8. Madonna della Misericordia. Detail of Saint John *San Sepolcro*

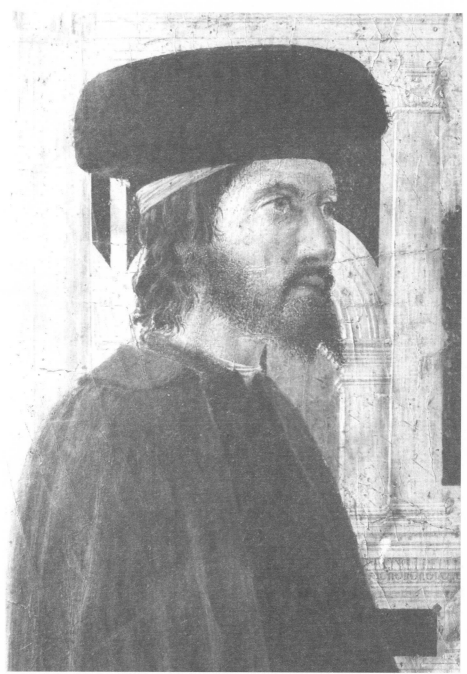

9. The Flagellation of Christ. Detail *Urbino*

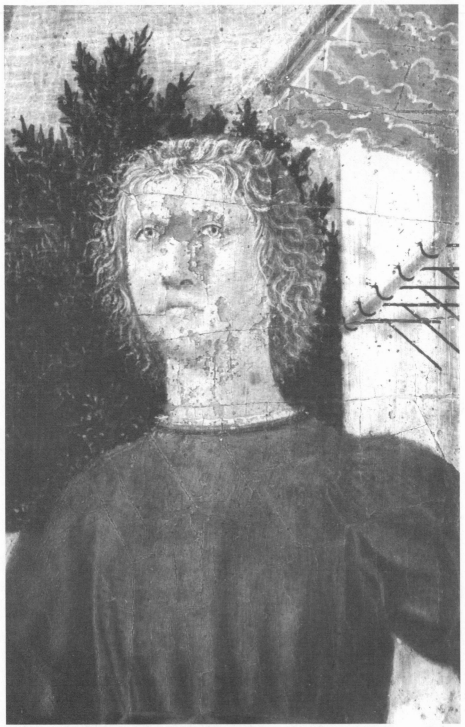

10. The Flagellation of Christ. Detail　　　　　　　　　　　　*Urbino*

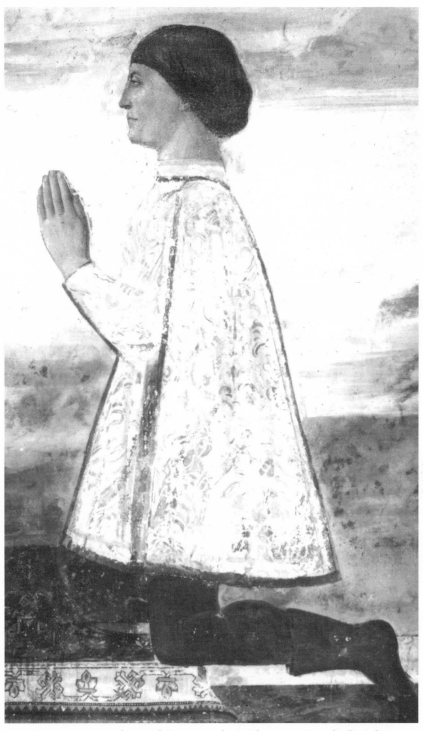

11. Saint Sigismundus and Sigismondo Malatesta. Detail of Malatesta kneeling *Tempio Malatestiano, Rimini*

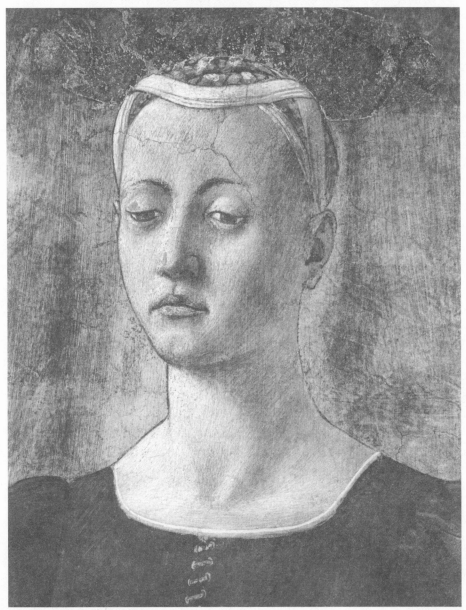

12. The Madonna del Parto. Detail *Monterchi*

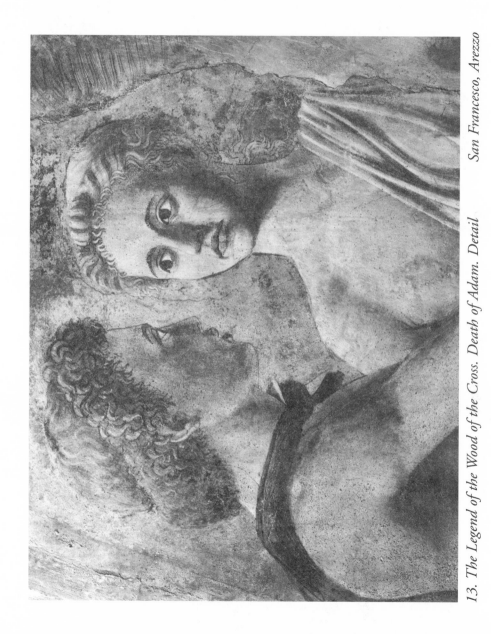

13. *The Legend of the Wood of the Cross. Death of Adam. Detail* *San Francesco, Arezzo*

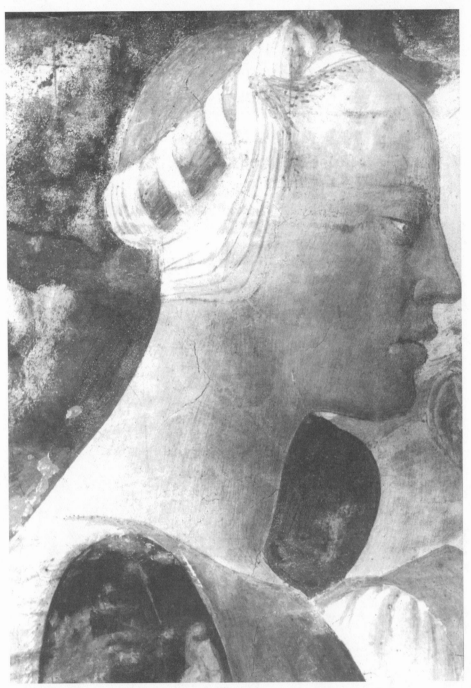

14. *The Legend of the Wood of the Cross. Visit of the Queen of Sheba to Solomon. Detail* *San Francesco, Arezzo*

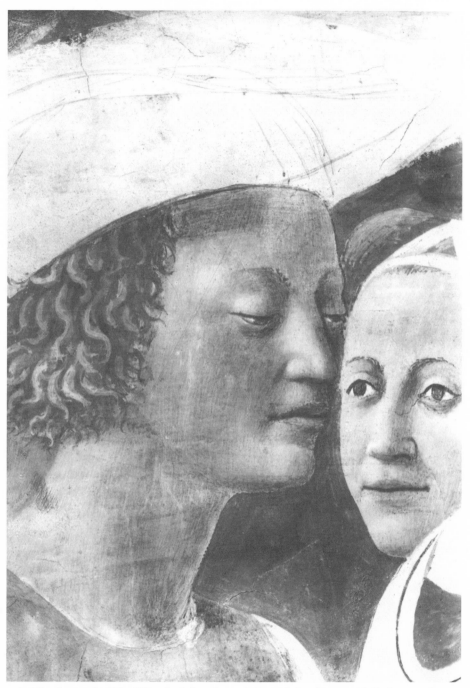

15. The Legend of the Wood of the Cross. Visit of the Queen of Sheba to Solomon. Detail *San Francesco, Arezzo*

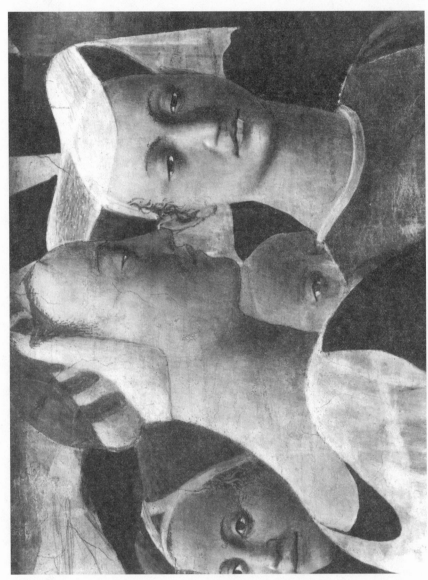

16. *The Legend of the Wood of the Cross. Visit of the Queen of Sheba to Solomon. Detail*
San Francesco, Arezzo

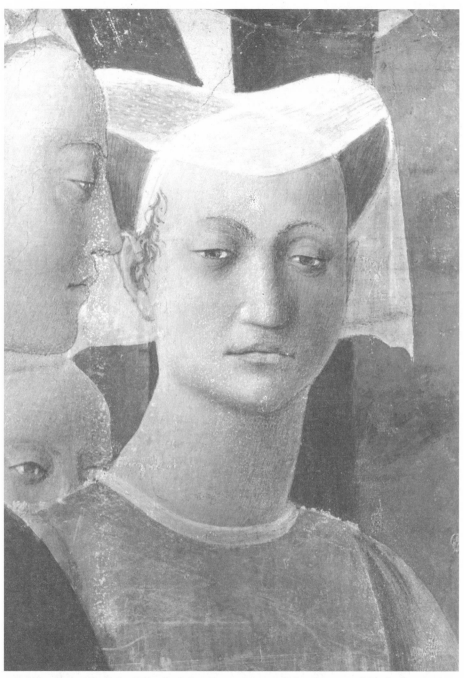

17. The Legend of the Wood of the Cross. Visit of the Queen of Sheba to Solomon. Detail *San Francesco, Arezzo*

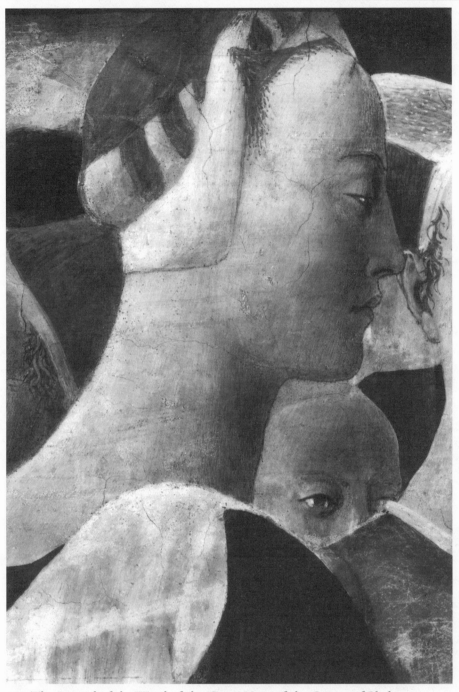

18. The Legend of the Wood of the Cross. Visit of the Queen of Sheba to Solomon. Detail *San Francesco, Arezzo*

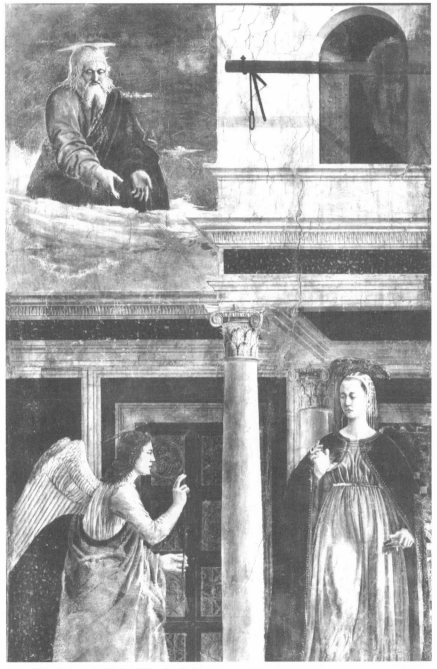

19. The Legend of the Wood of the Cross. Annunciation.
San Francesco, Arezzo

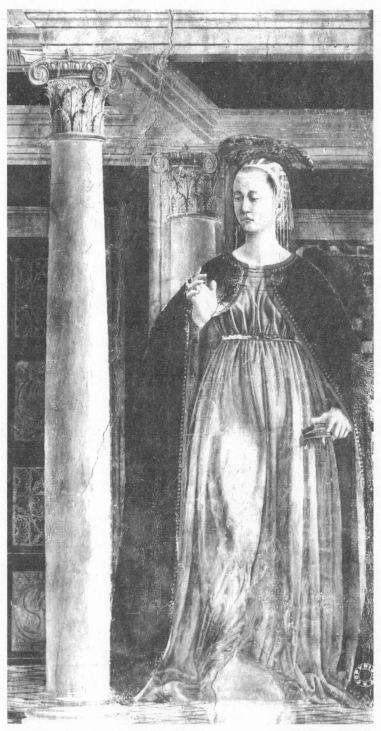

20. The Legend of the Wood of the Cross. Annunciation. Detail of the Virgin *San Francesco, Arezzo*

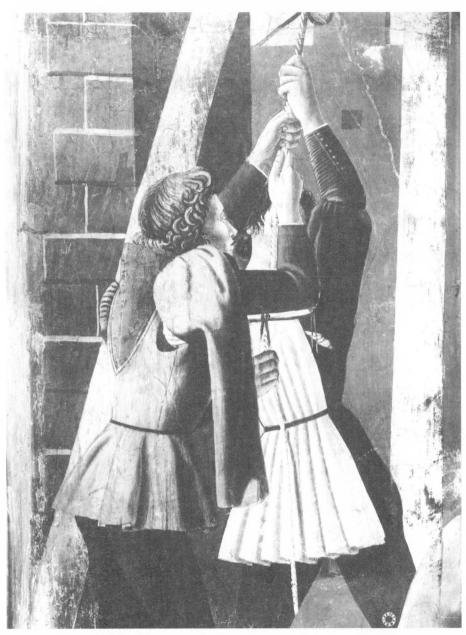

21. The Legend of the Wood of the Cross. Torture of the Jew. Detail

San Francesco, Arezzo

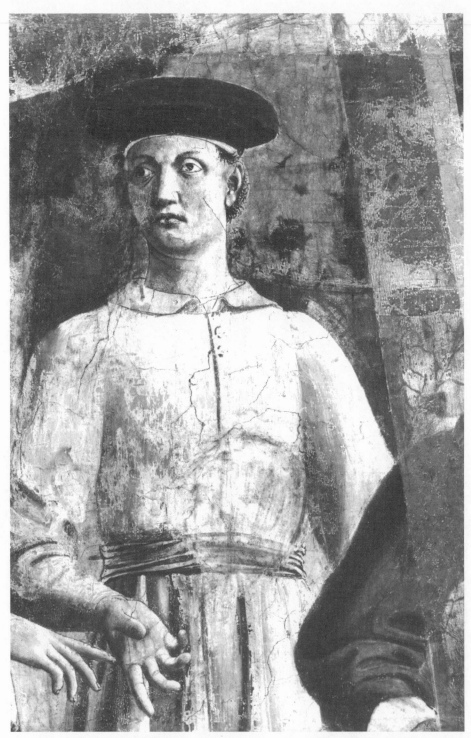

22. The Legend of the Wood of the Cross. Invention of the Cross. Detail
San Francesco, Arezzo

330

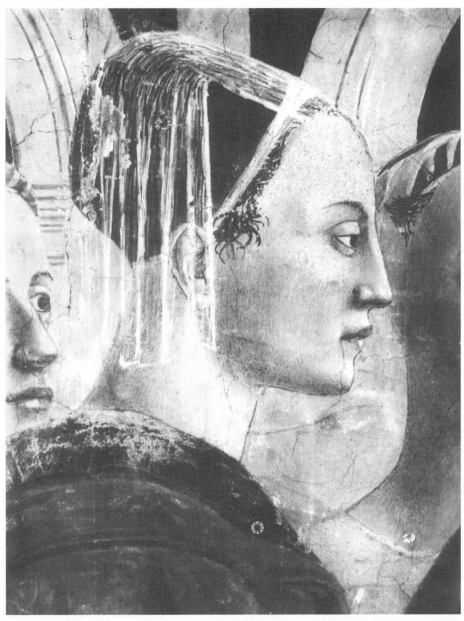

23. The Legend of the Wood of the Cross. Trial of the Cross. Detail
San Francesco, Arezzo

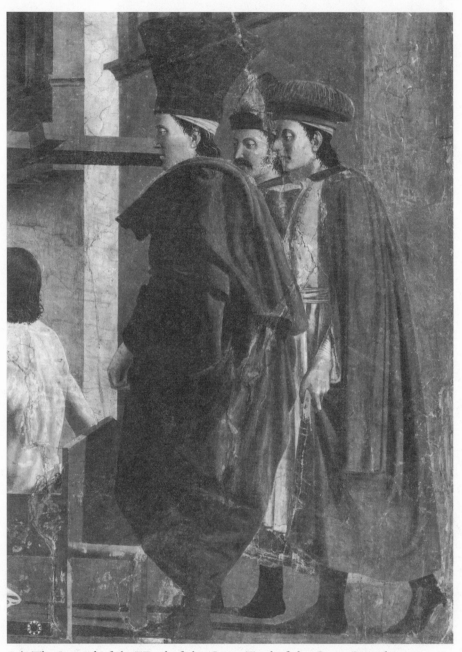

24. The Legend of the Wood of the Cross. Trial of the Cross. Detail

San Francesco, Arezzo

25. *The Legend of the Wood of the Cross. Defeat of Chosroes.*
San Francesco, Arezzo

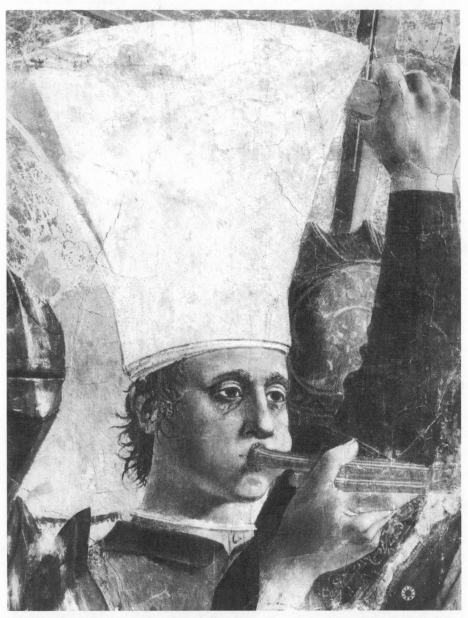

26. The Legend of the Wood of the Cross. Defeat of Chosroes. Detail of the trumpeter *San Francesco, Arezzo*

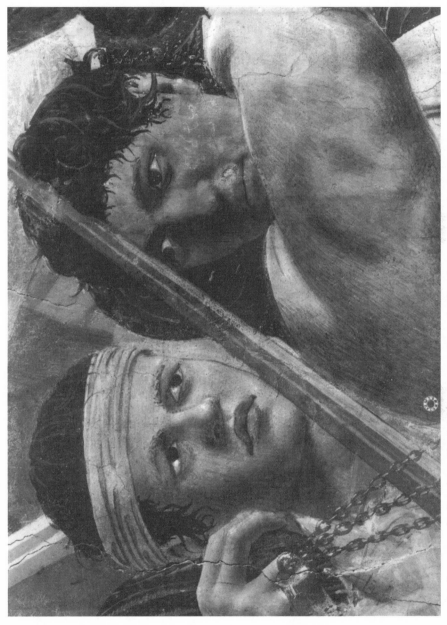

27. *The Legend of the Wood of the Cross. Defeat of Chosroes. Detail of two warriors*

San Francesco, Arezzo

335

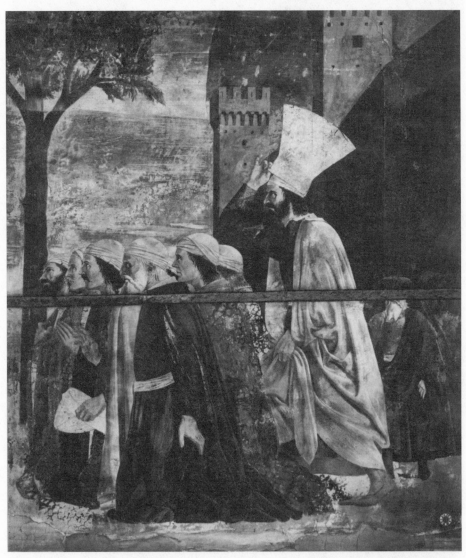

28. The Legend of the Wood of the Cross. Restitution of the Cross to Jerusalem.
Detail *San Francesco, Arezzo*

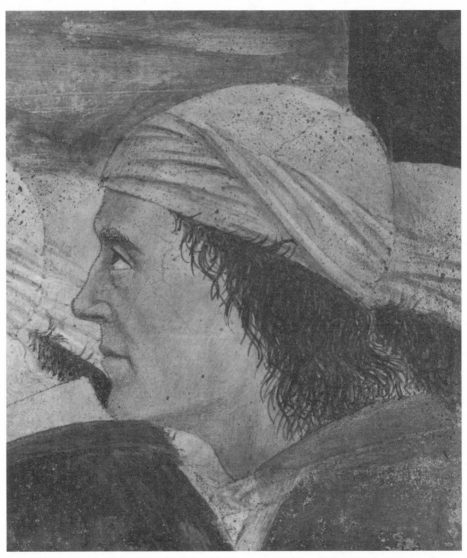

29. The Legend of the Wood of the Cross. Restitution of the Cross to Jerusalem.
Detail *San Francesco, Arezzo*

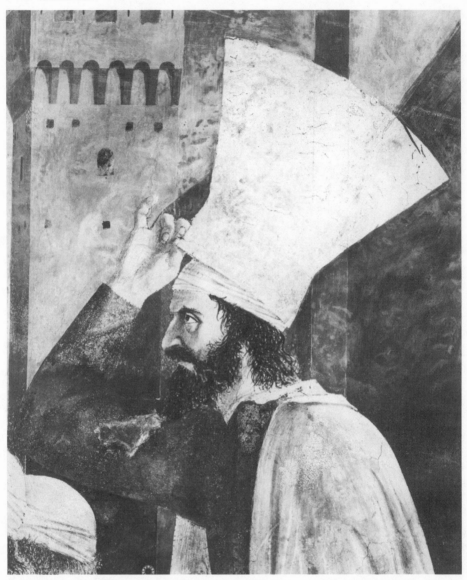

30. The Legend of the Wood of the Cross. Restitution of the Cross to Jerusalem. Detail *San Francesco, Arezzo*

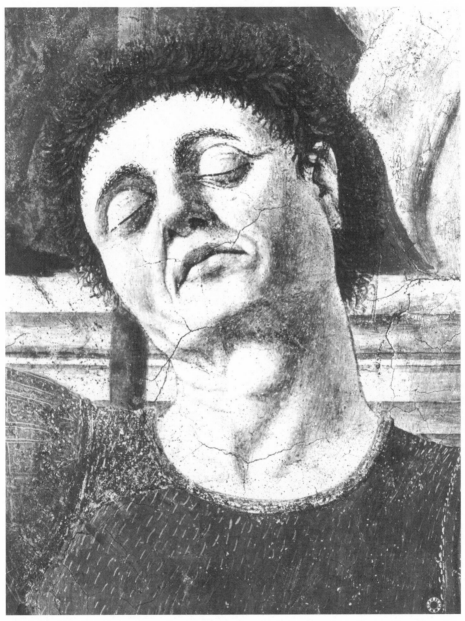

31. The Resurrection of Christ. Detail of a sleeping guard *Borgo San Sepolcro*

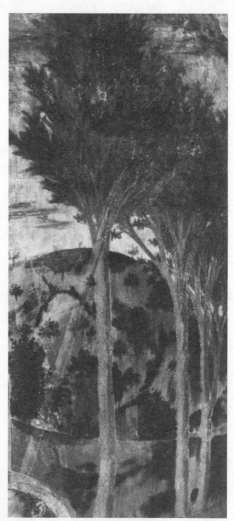

32. The Resurrection of Christ. Detail of the landscape *Borgo San Sepolcro*

340

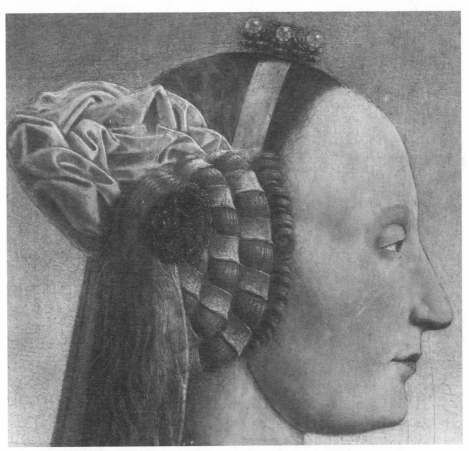

33. Portrait Diptych of the Rulers of Urbino. Battista Sforza. Detail

Uffizi, Florence

34. *Portrait Diptych of the Rulers of Urbino. Battista Sforza. Detail*

Uffizi, Florence

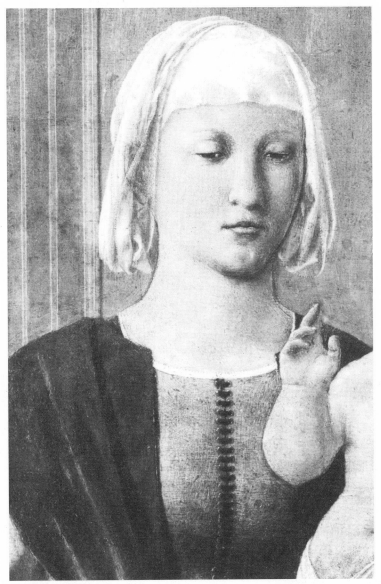

35. The Madonna of Sinigallia. Detail *Urbino*

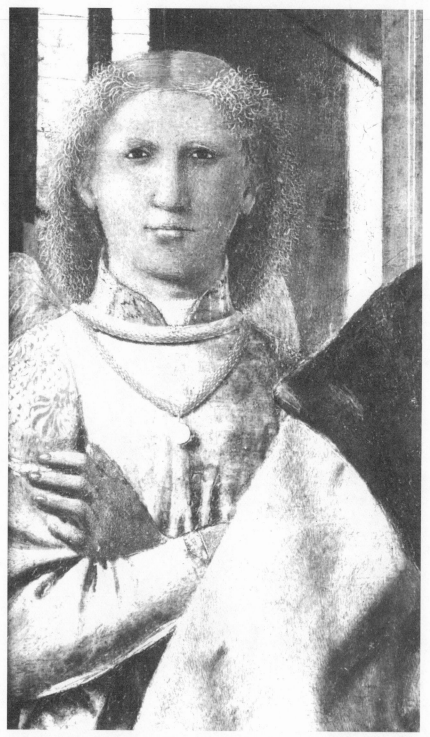

36. *The Madonna of Sinigallia. Detail of an angel* *Urbino*

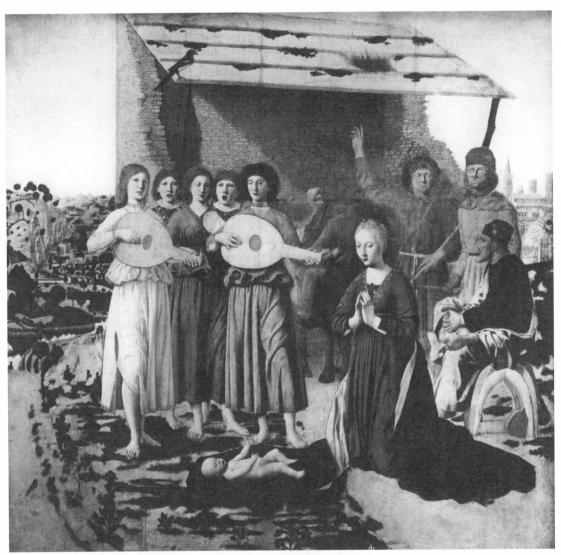

37. The Nativity. *National Gallery, London*

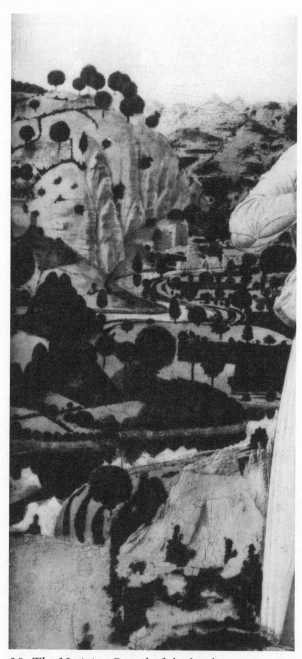

38. The Nativity. Detail of the landscape
National Gallery, London

39. Proposed reconstruction of the Augustinian Altarpiece from Borgo San Sepolcro

347

Index of Names

ILLUSTRATIONS

DATE DUE

MAY 1 8 '05 A		
MAY 0 5 2001		

GAYLORD PRINTED IN U.S.A.